Old Philadelphia in Early Photographs

1839-1914

215 PRINTS FROM THE COLLECTION OF
THE FREE LIBRARY OF PHILADELPHIA

Robert F. Looney

Head, Print and Picture Department

Published in Cooperation with
The Free Library of Philadelphia by
DOVER PUBLICATIONS, INC., NEW YORK

Published in Canada by General Publishing Company, Ltd., 30 Lesmill Road, Don Mills, Toronto, Ontario.
Published in the United Kingdom by Constable and Company, Ltd.

Old Philadelphia in Early Photographs, 1839–1914, 215 Prints from the Collection of The Free Library of Philadelphia is a new work, first published by Dover Publications, Inc., N.Y., in 1976, in cooperation with The Free Library of Philadelphia.

International Standard Book Number: 0-486-23345-6
Library of Congress Catalog Card Number: 75-41688

Manufactured in the United States of America
Dover Publications, Inc.
31 East 2nd Street
Mineola, N.Y. 11501

Introduction

THE earliest surviving American photograph is a daguerreotype made in Philadelphia by Joseph Saxton in October 1839 (No. 1). Saxton was an employee at the United States Mint, and his little view, taken from his office window, is of rooftops at Center (now Penn) Square, the most prominent of which is that of the Central High School for Boys. This is not, however, the first photograph made in America, for there is documentary evidence showing that experimental photographs were made earlier in other cities. Naturally, Saxton's picture is also the first photographic view of Philadelphia, and the logical place for any photographic study of Philadelphia to begin.

The photographs in this book have been drawn largely from the Samuel Castner Collection of Philadelphia Views in the Free Library of Philadelphia. This collection was begun in the late nineteenth century by Mr. Castner, a prominent merchant and native of this city, and it continued to be of consuming interest to him until his death in 1932. It was then sold at auction and, after passing through other private hands, was acquired by the Free Library in 1947.

Mr. Castner's collecting activities seem to have been widely known, for along with photographs, prints, booklets and clippings there are letters from prominent citizens who express interest in his hobby, and "herewith send several photographs which may be of interest." When the collection came to the Free Library it con-

1. VIEW OF THE CENTRAL HIGH SCHOOL FOR BOYS AND THE PENNSYLVANIA STATE ARSENAL, 1839. This famous view, shown here actual size, is the earliest surviving American photograph. See also No. 151. (Reproduced through the courtesy of the Historical Society of Pennsylvania.) *Daguerreotype by Joseph Saxton.*

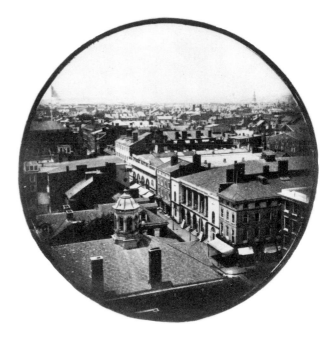

tained some 8000 items, and was rich in photographs and original prints which have proved to be of invaluable aid to researchers and scholars, professionals and amateurs, and almost anyone interested in the history of Philadelphia.

Among early photographers represented in the Castner Collection are William and Frederick Langenheim, William S. Mason, F. D. Richards, Robert Cornelius, James E. McClees and James Cremer.

Many other photographs have been donated to the Free Library by interested patrons. Among these are collections given by famed Philadelphia artist and writer Frank H. Taylor, John Gibb Smith and Mrs. Sue Paxton Edmunds. Philadelphia publishers have also from time to time contributed photographs of great value to the existing collections. They include J. B. Lippincott and N. W. Ayer, and the newspapers *The Philadelphia Evening Bulletin* and *The Philadelphia Inquirer*.

Philadelphia is fortunate in that so many of its early landmarks and portions of the old city have been preserved. Anyone may wander in the areas of the earliest settlements and still see original buildings and streets whose Colonial character is intact. The city emergent in the early photographs therefore retains much that is Colonial in fact and provincial in atmosphere. It is also a city in which growth and change are evident, in the shift of resident society and the expansion of commerce and industry. There are many details in the early photographs, such as the covered wagons, the horse-drawn carts and small taverns, that suggest the frontier town. At the same time spacious residences, hotels, and buildings under construction show that it was an affluent, thriving city as well.

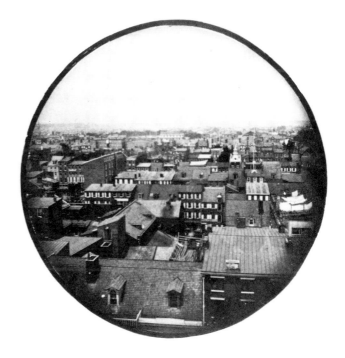

2–5. PANORAMIC VIEWS FROM THE STATE HOUSE STEEPLE, 1850. The German-born Philadelphians William and Frederick Langenheim produced a collection of *Views in North America*, and these four bird's-eye panoramas, taken in June and July of 1850, are among thirty or more pictures of the Philadelphia area included in that collection (they correspond to original Nos. 4, 1, 3 and 5, respectively, of "Series I, Pennsylvania"). The location of the State House at 5th and Chestnut Streets made its steeple a popular vantage point from which to view the city. In the west view (No. 2) can be seen two landmarks, the Chestnut Street Theatre and, beyond it, the Philadel-

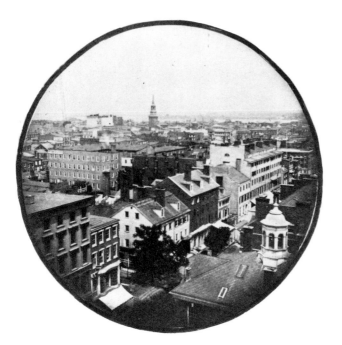

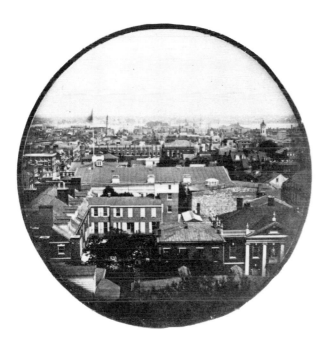

phia Arcade, "the first office building in the United States." The north view (No. 3) reveals a density of habitation that persisted until recent years, when this site was cleared to make way for Independence Mall. In the northeast view (No. 4) the tower of Christ Church dominates the skyline. The cupola in the foreground belongs to the east wing of the State House. The east view (No. 5) is toward the water-front across the roofs of the Philadelphia Library (lower right) and the Customs House, or Second Bank of the United States (center). *Talbotypes by William and Frederick Langenheim.*

In selecting the photographs for this book, the plan was to focus on the old city, and principal landmarks and areas of interest between the Delaware River front and the Schuylkill River, and within the old city limits of South Street on the south and Callowhill Street on the north. The earliest photograph included is, of course, Saxton's view of 1839, and the latest is a view taken in 1914.

But some flexibility of choice was also necessary, and there are occasional departures from geographical restrictions. The most obvious is the group of photographs of the great Centennial Exposition of 1876 held in West Fairmount Park across the Schuylkill River northwest of the city. This celebration was an event of major importance in the history of Philadelphia and of the United States, and it so dominated the local scene that to exclude it from this book would have left a serious gap in the total picture.

Many people assisted in the preparation of this book, and to them I wish to express my sincerest thanks: to Mr. Hayward Cirker of Dover Publications, who originally suggested that this book be written and gave me much sound advice; to my colleagues in the Free Library who assisted in the research and in writing the captions—Jeremiah Post, Frances Ritchey, Grace Perkinson and Robert D. Newkirk. I am especially indebted to my entire staff in the Print and Picture Department for their cooperation and assistance: Diane W. Kazlauskas, John Whiteley, Diane DeMarco and Bernice V. Kazlauskas; and to Robert Jordan for assistance in research.

I am also grateful to the Historical Society of Pennsylvania for permission to use Joseph Saxton's daguerreotype.

List of Photographs

INTRODUCTION
1. View of the Central High School for Boys and the Pennsylvania State Arsenal, 1839
2–5. Panoramic Views from the State House Steeple, 1850

I. SOUTHWARK
6. Swanson Street, 1856
7. Queen Street, c. 1856
8. Queen Street, c. 1865
9. Swanson Street, c. 1868
10. Front Street at Christian, 1869
11–14. Four Panoramas of Philadelphia, 1870
15. 2nd Street at Washington Avenue, 1870
16. 316 Shippen (now Bainbridge) Street, c. 1868
17. Gloria Dei (Old Swedes') Church, Swanson Street near Christian, 1854

II. THE DELAWARE RIVER FRONT
18. Dock and Water Streets, c. 1860
19. Front Street, South of Dock, c. 1868
20. Dock Street, West Side, 1860
21. 3rd and Dock Streets, c. 1874
22. Dock Street at Walnut, c. 1890
23. Merchants' Exchange Building, 3rd Street at Walnut, c. 1859
24. First Bank of the United States, 3rd Street at Dock, 1859
25. Slate Roof House, 2nd Street at Sansom, c. 1864
26. Water Street at Spruce, 1859
27. 2nd Street at Dock, 1866
28. Front Street at Pine, 1868
29. Water Street at Market, 1868
30. London Coffee House, Front Street at Market, 1854
31. Front and Market Streets, 1880
32. Market Street at the Delaware River Front, c. 1894
33. Delaware Avenue, North from Market Street, c. 1890
34. Warehouses, 14–20 South Delaware Avenue, c. 1900
35. Elfreth's Alley, 1910
36. Race Street Wharf, Delaware Avenue at Race Street, c. 1856
37. Front Street at Race, c. 1868
38. Front Street at Vine, c. 1868
39. 2nd Street, North of Callowhill, 1841/42

III. SOCIETY HILL
40. Hill Meeting, Pine Street, East of 2nd, 1859
41. Houses on East Pine Street, c. 1860
42. Market House, 2nd Street at Pine, 1900
43. Market Sheds, 2nd Street, c. 1889
44. Old Plough Tavern, 2nd Street at Pine, c. 1885
45. St. Peter's Church, Pine Street at 3rd, c. 1870
46. Spruce Street, West from 4th, c. 1859
47. 3rd Street, South of Walnut, c. 1871
48. Powel House, 3rd Street, South of Locust, 1903
49. 3rd Street at Gaskill, 1870
50. 4th Street at Walnut, c. 1868
51. Fourth Street at Prune (now Locust), c. 1859
52. Pine Street Presbyterian Church, Pine Street at 4th, 1868
53. Donnelly's Hotel, 4th Street at Pine, c. 1860
54. Pine Street at Penn, 1868
55. Physick Residence, 4th Street at Delancey, c. 1865
56. Hurst Mansion, 5th and South Streets, c. 1859
57. Washington Square, South, c. 1870

IV. THE INDEPENDENCE SQUARE AREA AND THE BUILDINGS OF THE STATE HOUSE GROUP
58. Congress Hall, the State House and Old City Hall, Chestnut Street at 6th, c. 1855
59. The State House and Independence Square, 1868
60. The State House, 1873
61. Lincoln in Philadelphia: the State House, 22 February 1861
62. View Southeast from the State House, 1867
63. Carpenters' Hall, Chestnut Street at 4th, c. 1855
64. Carpenters' Hall, 1900
65. Mercantile Library, 5th Street at Library, Southeast Corner, c. 1870
66. Philadelphia Dispensary, 5th Street, c. 1902

V. MARKET STREET, ARCH STREET AND ADJACENT AREAS
67. Market Terminus, Market Street at Front, c. 1859

68. Market Street, East from 6th, c. 1859
69. Market Street at Delaware Avenue, c. 1900
70. Market Street at Delaware Avenue, from Front Street, 1906
71. R. Smith's Brewery, 20 South 5th Street, 1859
72. Black Bear Inn, 5th Street at Market, c. 1859
73. Tower Hall, 518 Market Street, c. 1898
74. Market Street at 6th, c. 1902
75. Declaration House, 7th and Market Streets, c. 1856
76. *The Item* and *The Call*, North 7th Street, c. 1889
77. First United States Mint, 39 North 7th Street, 1861
78. Market Street at 8th, North Side, 1846
79. Bell Tavern, 48 South 8th Street, c. 1859
80. Lit Brothers, Market Street at 8th, Northeast Corner, c. 1898
81. 8th Street, North from Market, c. 1860
82. Espen's Store, 31 North 8th Street, c. 1856
83. Strawbridge and Clothier, Market Street at 8th, c. 1898
84. Gimbel Brothers, Market Street at 9th, Southeast Corner, c. 1899
85. United States Post Office, Market Street at 9th, c. 1890
86. Market Street, West from 9th, 1907
87. Market Street, East from 10th, 1907
88. Market Street, East from 12th, c. 1880
89. Market Street at 12th, c. 1912
90. Market Street, West from 12th, 1907
91. Market Street at 13th, Northeast Corner, c. 1894
92. Market Street, East from City Hall, 1889
93. John Wanamaker's Store, 13th and Market Streets, c. 1900
94. Market Street, West of 15th, 1859
95. Western Market, Market Street at 16th, Northeast Corner, c. 1859
96. C. A. Brown & Co., 4th and Arch Streets, c. 1854
97. Henderson Publishing Company, 5th and Arch Streets, 1857
98. 5th Street at Arch, 1860
99. 5th Street at Arch, 1860
100. Zion Lutheran Church, 4th Street at Cherry, c. 1868
101. The German Lutheran School and Parish House, Cherry Street at 4th, 1859
102. 8th Street at Arch, Northeast Corner, 1840/47
103. Arch Street Theatre, Arch Street at 6th, 1860
104. Arch Street Theatre, Arch Street at 6th, c. 1865
105. C. A. Bradenburgh's Museum, 9th and Arch Streets, c. 1890
106. St. George's Hall, Arch Street at 13th, c. 1895
107. Locker's Restaurant, 8th and Vine Streets, 1868
108. Philadelphia Circus, Callowhill Street at 10th, c. 1890
109. Old Fairmount Engine House, Ridge Avenue at Vine Street, c. 1880
110. 18th Street at Logan Square, c. 1913
111. Cathedral of Sts. Peter and Paul, 18th Street at Logan Square, 1902
112. St. Clement's Church, 20th and Appletree Street, c. 1865

VI. CHESTNUT STREET, WALNUT STREET AND ADJACENT AREAS
113. Chestnut Street at 2nd, Northeast Corner, 1843
114. Chestnut Street from Front to 2nd, 1843
115. Chestnut Street at 2nd, Southwest Corner, c. 1854
116. John McAllister's Store, 48 Chestnut Street, 1843
117. Philadelphia Bank, Chestnut Street at 4th, 1859
118. Second Bank of the United States, 420 Chestnut Street, 1859
119. Chestnut Street, West from 3rd Street, c. 1885
120. Chestnut Street, East from 5th, 1865
121. Chestnut Street, West from 4th, c. 1895
122. Chestnut Street, West from 5th, c. 1865
123. Public Ledger Building, 6th and Chestnut Streets, c. 1870
124. Chestnut Street, East from 6th, c. 1859
125. Chestnut Street Theatre, Chestnut Street at 6th, 1855
126. Chestnut Street, West from 6th, c. 1889
127. Pierce Butler Mansion, 8th and Chestnut Streets, c. 1855
128. Chestnut Street, East from 8th, c. 1902
129. University of Pennsylvania, 9th and Chestnut Streets, c. 1865
130. Chestnut Street, West from 9th, 1859
131. View of 10th Street, South from Sansom, c. 1854
132. The Academy of the Fine Arts, 1029 Chestnut Street, 1869
133. Fox's New American Theatre, Chestnut Street at 10th, c. 1885
134. Union League, 1118 Chestnut Street, 1863
135. Girard Row, Chestnut Street between 11th and 12th, 15 April 1865
136. Third Chestnut Street Theatre, 1211 Chestnut Street, 1898
137. Free Library of Philadelphia, Chestnut Street at 12th, 1910
138. Second United States Mint, Chestnut Street at Juniper, c. 1901
139. Chestnut Street at Broad, Southeast Corner, c. 1897
140. John Krider's Shop, Walnut Street at 2nd, c. 1871
141. Freeman's Auction House, Walnut Street at 3rd, c. 1859
142. Walnut Street, West from 4th, c. 1870
143. 6th Street, North from Walnut, c. 1902

144. Walnut Street Theatre, Walnut Street at 9th, c. 1865
145. Herkness Bazaar, 9th Street at Sansom, c. 1910
146. Walnut Street, West from 17th, c. 1865
147. Weightman Mansion, 18th Street at Rittenhouse Square, c. 1865
148. Joseph Harrison Residence, 221 South 18th, East Rittenhouse Square, 1866
149. Locust Street, West from 16th, c. 1869
150. Pennsylvania Hospital, Pine Street, from 8th to 9th, 1876

VII. PENN SQUARE
151. Central High School for Boys, Juniper Street at Center Square, c. 1854
152. Broad Street at Filbert, North Penn Square, c. 1867
153. Penn Square, Northwest Corner, c. 1868
154. Penn Square, Market Street to Filbert, c. 1868
155. Center Square, Site of City Hall, 1868
156. Penn Square, City Hall under Construction, 1873
157. First Independent Presbyterian Church (Chambers' Church), Broad and Sansom Streets, 1856
158. Pennsylvania Railroad Station, Market Street West at Penn Square, 1889
159. Market Street at Broad, 1907
160. Penn Square, West Side, 1903
161. Masonic Temple, North Broad Street at Penn Square, 1902
162. Penn Square at Filbert Street, 1906
163. West End Trust Building, Broad Street at South Penn Square, 1905

VIII. BROAD STREET
164. Broad and Sansom Streets, 1865
165. La Pierre House, Broad and Sansom Streets, c. 1869
166. Broad and Chestnut Streets, Southwest Corner, c. 1876
167. Chestnut Street at Broad, c. 1902
168. Dundas-Lippincott Mansion, Broad and Walnut Streets, c. 1890
169. Broad Street, North from Walnut, c. 1894
170. Bellevue Hotel, Broad Street at Walnut, Northwest Corner, c. 1899
171. Stratford Hotel, Broad Street at Walnut, Southwest Corner, c. 1895
172. Stratford Hotel, Broad Street at Walnut, Southwest Corner, c. 1902
173. Academy of Music, Broad and Locust Streets, c. 1865

174. Academy of Music and Horticultural Hall, Broad Street at Locust, c. 1880
175. Hotel Walton, Broad Street at Locust, c. 1898
176. Broad Street Theatre, Broad Street at Locust, 1898
177. Hotel Stenton, Broad Street at Spruce, c. 1898
178. Broad Street at South, 1914
179. Court of Honor, Peace Jubilee, 1898
180. Parade, Peace Jubilee, 1898
181. Citizens' Volunteer Hospital, Broad and Prime Streets, 1864

IX. SCHUYLKILL RIVER AREA
182. View from Lemon Hill, 1876
183. Chestnut Street Bridge, c. 1868
184. West from Chestnut Street Bridge, c. 1869
185. Market Street Bridge and the Schuylkill River, 1900
186. Wire Bridge on the Schuylkill River at Spring Garden Street, c. 1875
187. Fairmount Water Works, Forebay and Pleasure Steamer, c. 1870
188. Girard College, Main Building, 1869

X. THE CENTENNIAL EXPOSITION OF 1876
189. Opening Day, May 10, 1876
190. Art Gallery
191. Main Building
192. Main Building, Interior, Nave
193. Main Building, Brazilian Exhibit
194. Carter, Dinsmore and Company's Exhibit
195. H. Doulton and Company's Pottery Exhibit
196. View from the Main Building
197. Avenue of the Republic, from Machinery Hall
198. Machinery Hall
199. Machinery Hall, Interior
200. Krupp's Guns, German Exhibit
201. Grant's Calculating Machine
202. General View of State Buildings
203. State Buildings on New Hampshire Day
204. United States Government Building
205. Horticultural Hall
206. Fountain Avenue
207. Arm and Hand of the Statue of Liberty
208. Agricultural Hall
209. Agricultural Hall, Interior
210. Pacific Guano Company's Building
211. Brazilian Building
212. Centennial Photographic Company
213. View from the Reservoir
214. Prismoidal Railway
215. Exposition from the Observatory

I

Southwark

SOUTHWARK, along the Delaware River just south of South Street, is the oldest section of Philadelphia, having been settled by the Swedes, who first arrived in the area early in the seventeenth century. It was originally an independent area just below the southern boundary of the city and was named after its counterpart in London. It was the location of the first shipyards in Philadelphia and the trades and services that kept the American navy and merchant marine afloat.

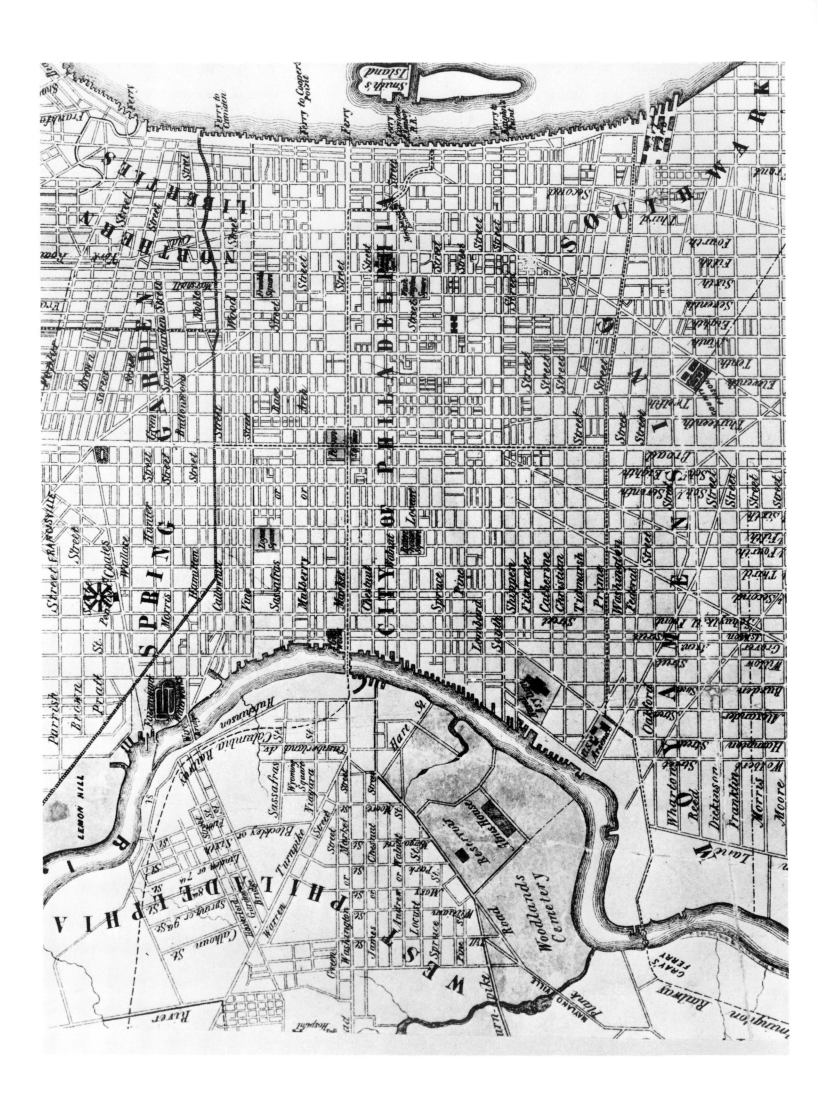

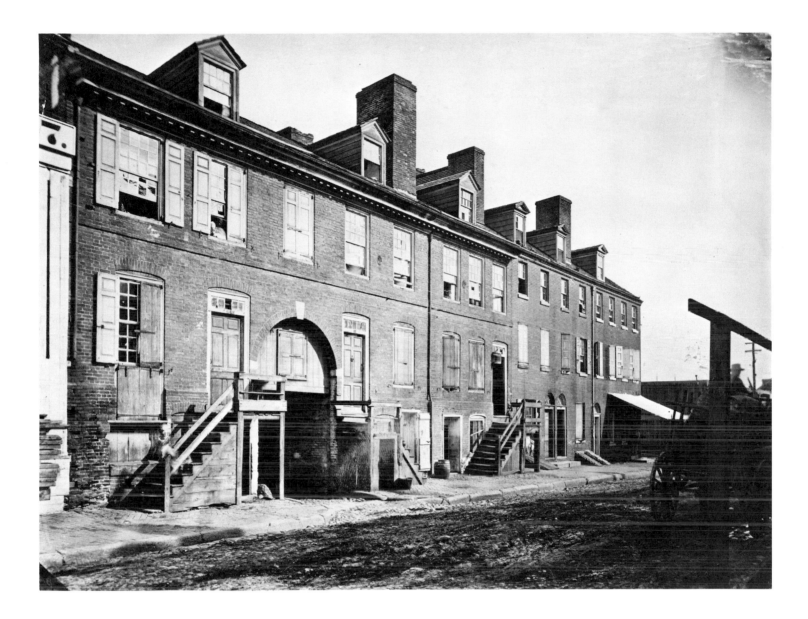

6. SWANSON STREET, 1856. The street was named after the original owner of the property in this area. These houses near the waterfront were originally built on higher ground than is shown in this photograph. Where the street was graded, enough earth was cut away to allow a ground floor to be built beneath the houses. In order for the entrances to remain useful, the staircases were built to permit access from the street level. These houses were once occupied by Swedish settlers. *Photo by John Moran.*

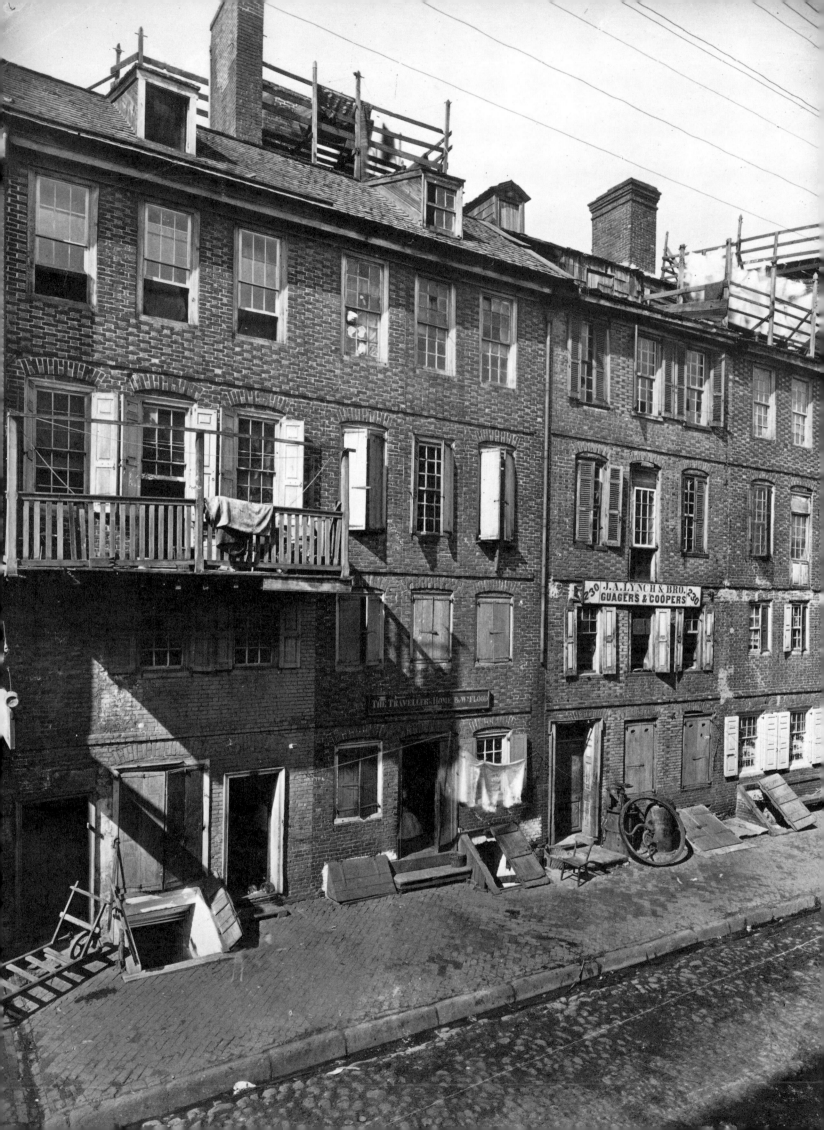

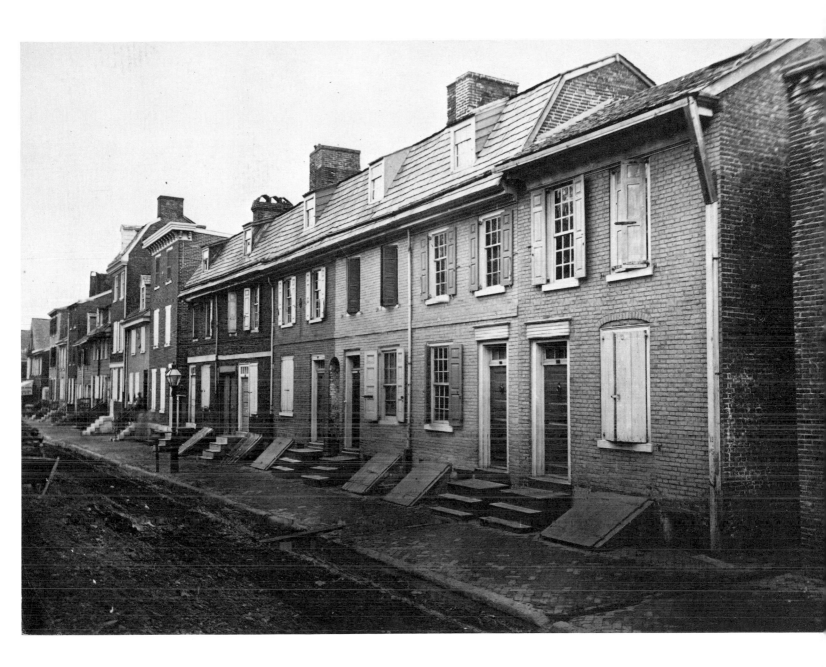

Opposite: 7. QUEEN STREET, C. 1856. Queen and Christian
Streets in the heart of Southwark were both named for Queen
Christina of Sweden by the early settlers. *Photo by John Moran.*
Above: 8. QUEEN STREET, C. 1865. Shown here are old Swedish
houses on Queen Street, near the river front, between Front and
Water Streets. *Photo by John Moran.*

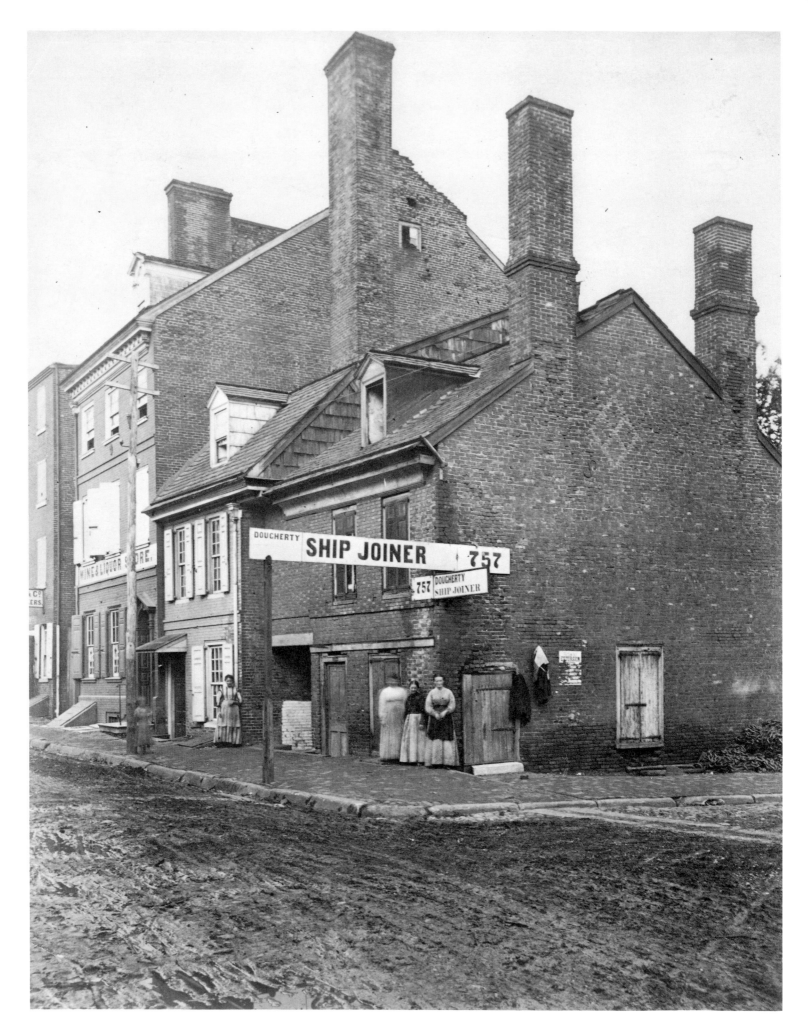

4

Opposite: 9. SWANSON STREET, C. 1868. The view shows one of the oldest houses in the street, occupied by a ship joiner whose service was vital to the navy. Philadelphia's shipyards were but a short distance away. *Photo by John Moran.* *Right:* 10. FRONT STREET AT CHRISTIAN, 1869. Half-houses such as this were frequent in the old city and were built as both space and money savers. According to the sign, this house was the residence of a painter of houses, ships and signs. The symbol of his trade in the form of a birdcage can be seen over the doorway. Beyond the house, at the left rear, is Sparks' shot tower, still standing today. *Photo by John Moran.*

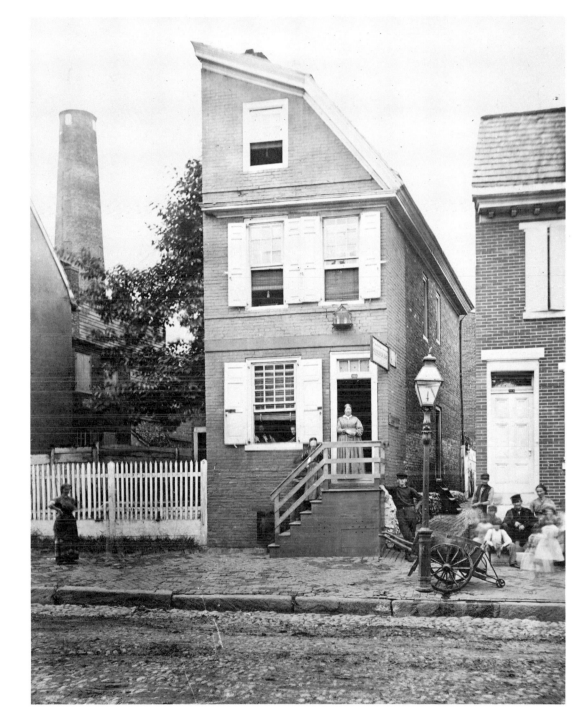

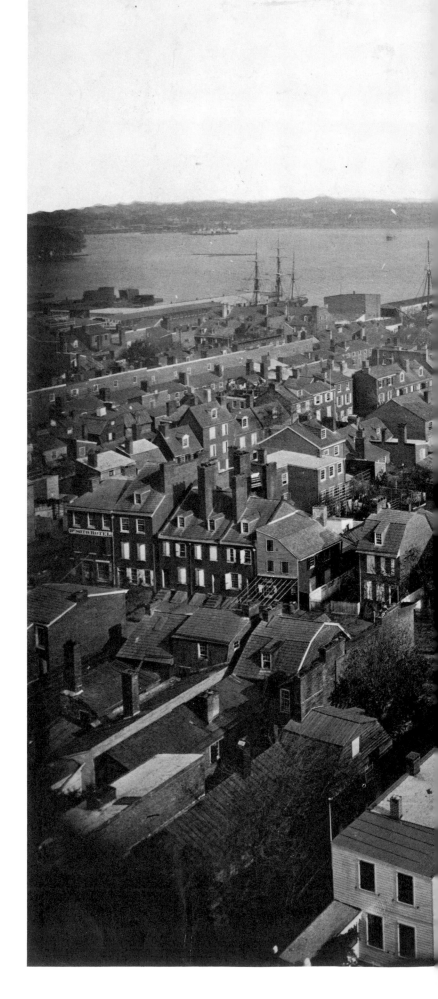

11–14. FOUR PANORAMAS OF PHILADELPHIA, 1870. The old city as viewed from Sparks' shot tower, located not far from Old Swedes' Church in Southwark, appeared to be busy and crowded with residences as well as buildings for trade and commerce. The tall ship houses and dry dock of the Navy Yard, and the waterfront warehouses and docks, are visible in the east and east-southeast views (Nos. 11 and 12) above Old Swedes' Church (with the white spire) and Bethel Baptist Church in Front Street. The west view (No. 13) is along Carpenter Street, and the northwest view (No. 14) looks down upon the intersection of 2nd and Christian Streets and Moyamensing Avenue.

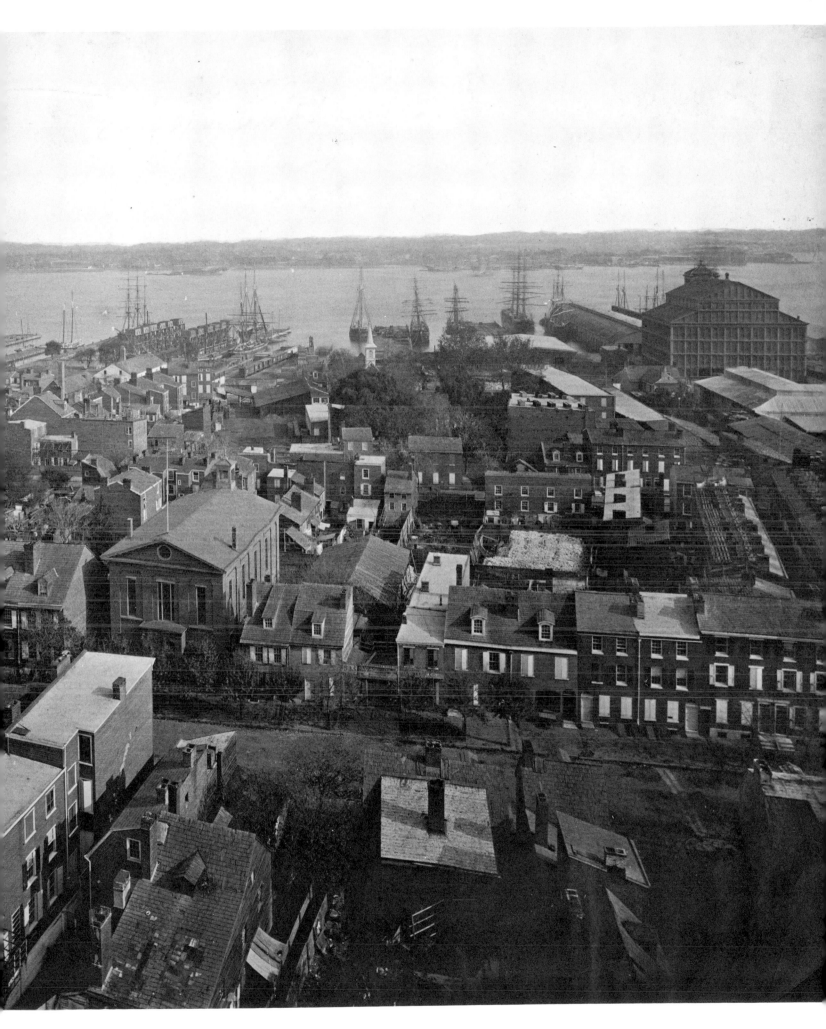

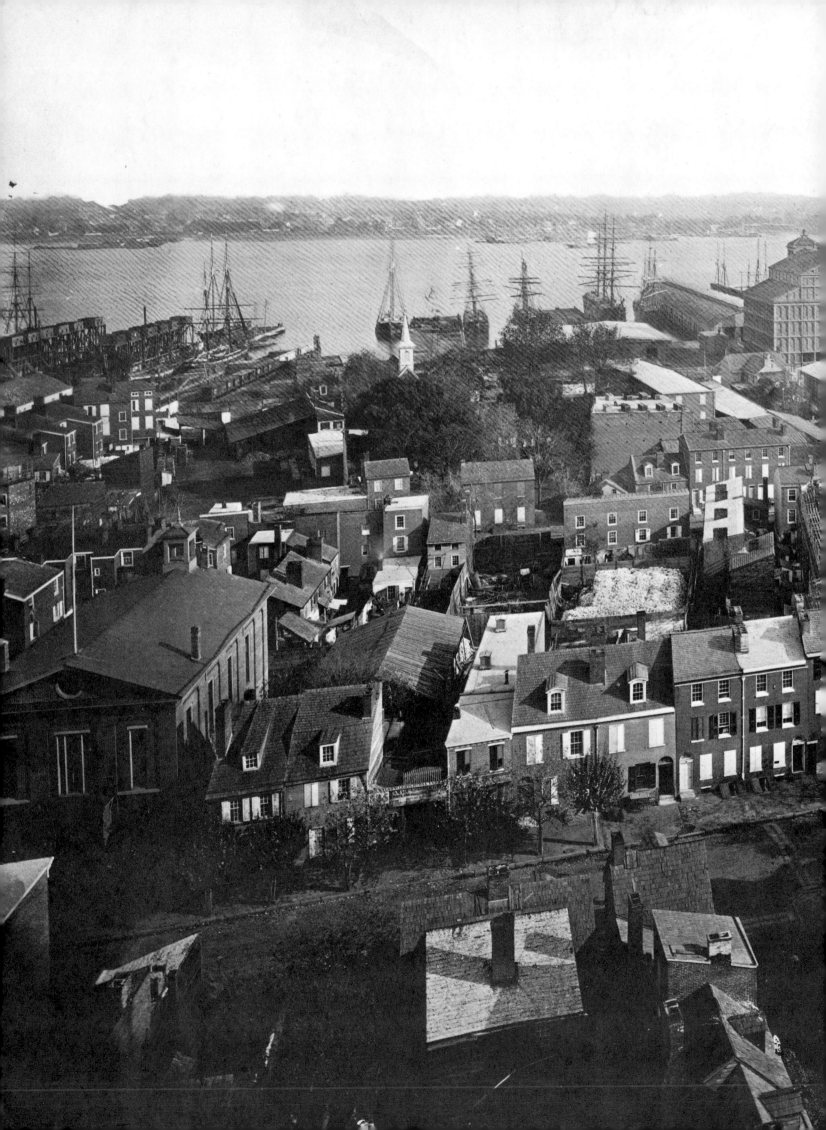

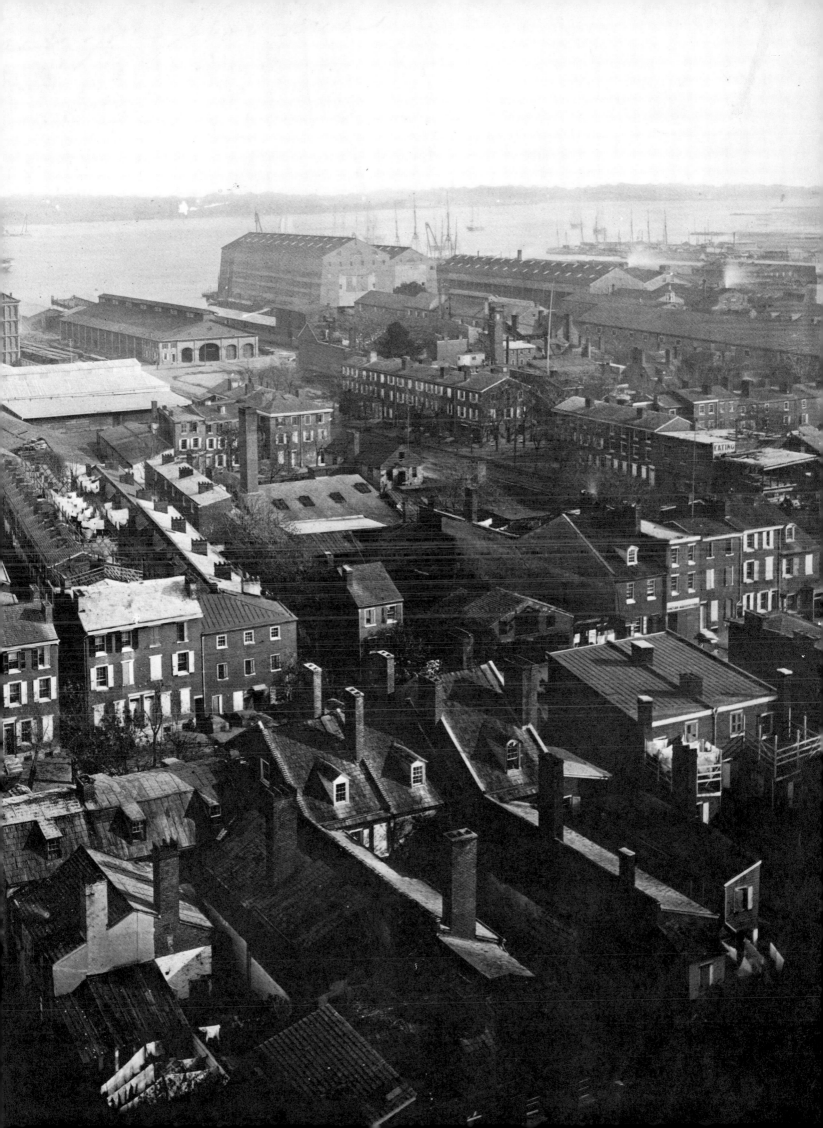

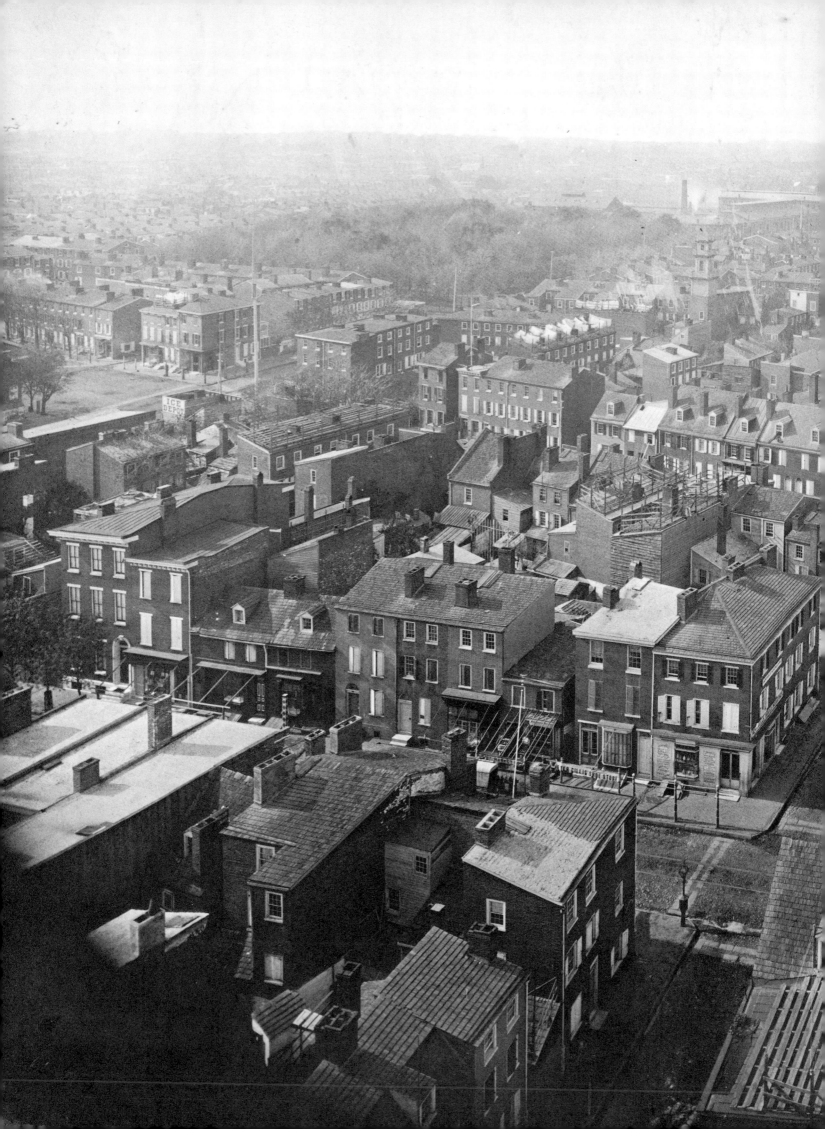

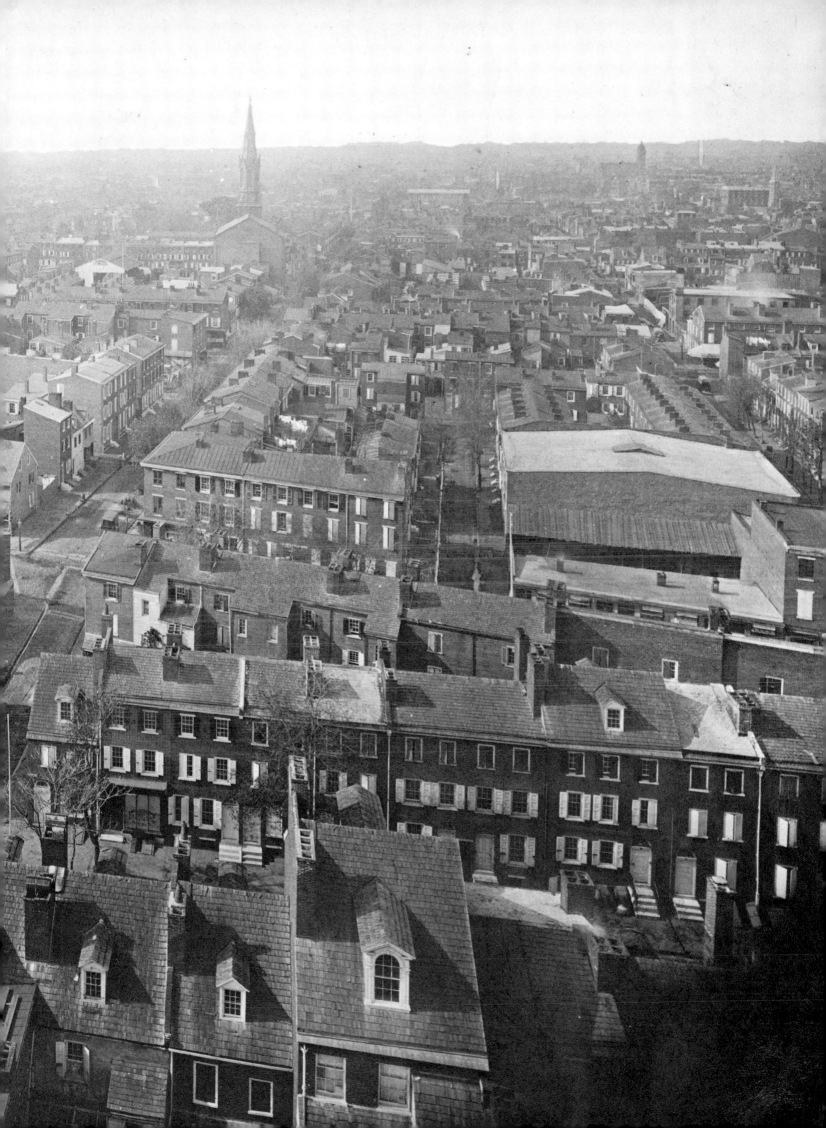

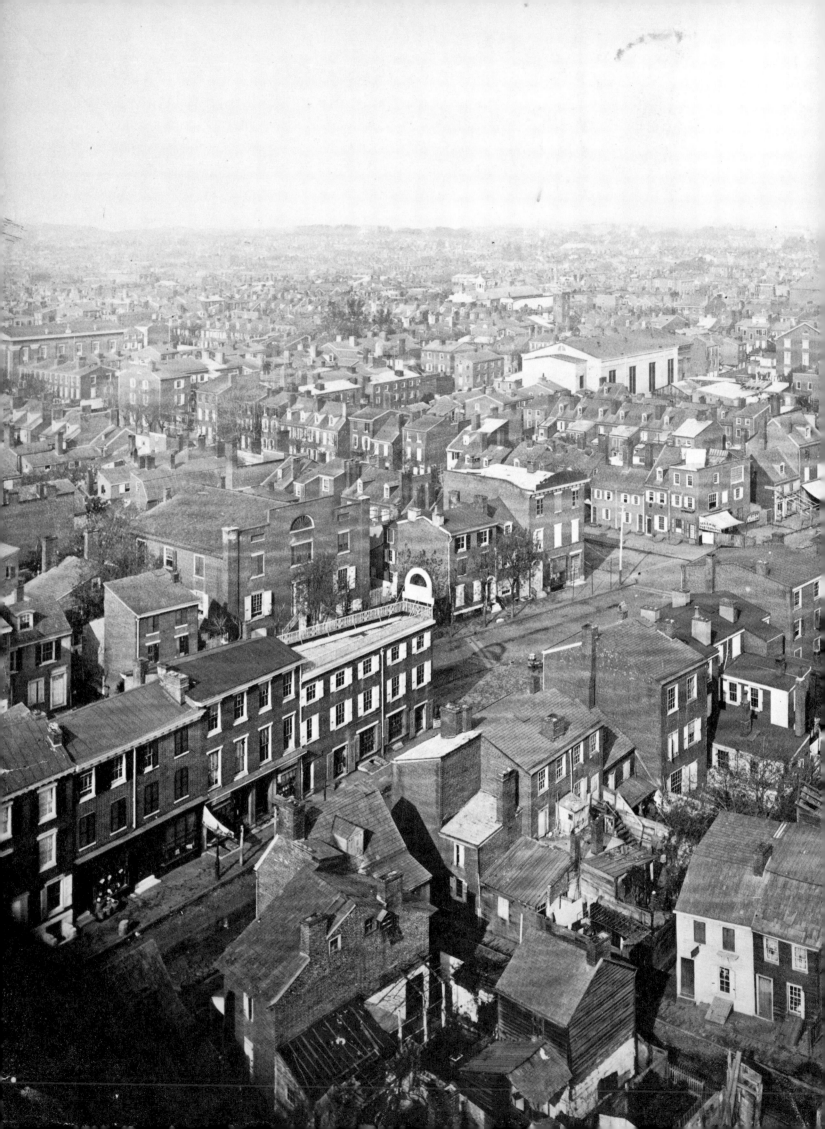

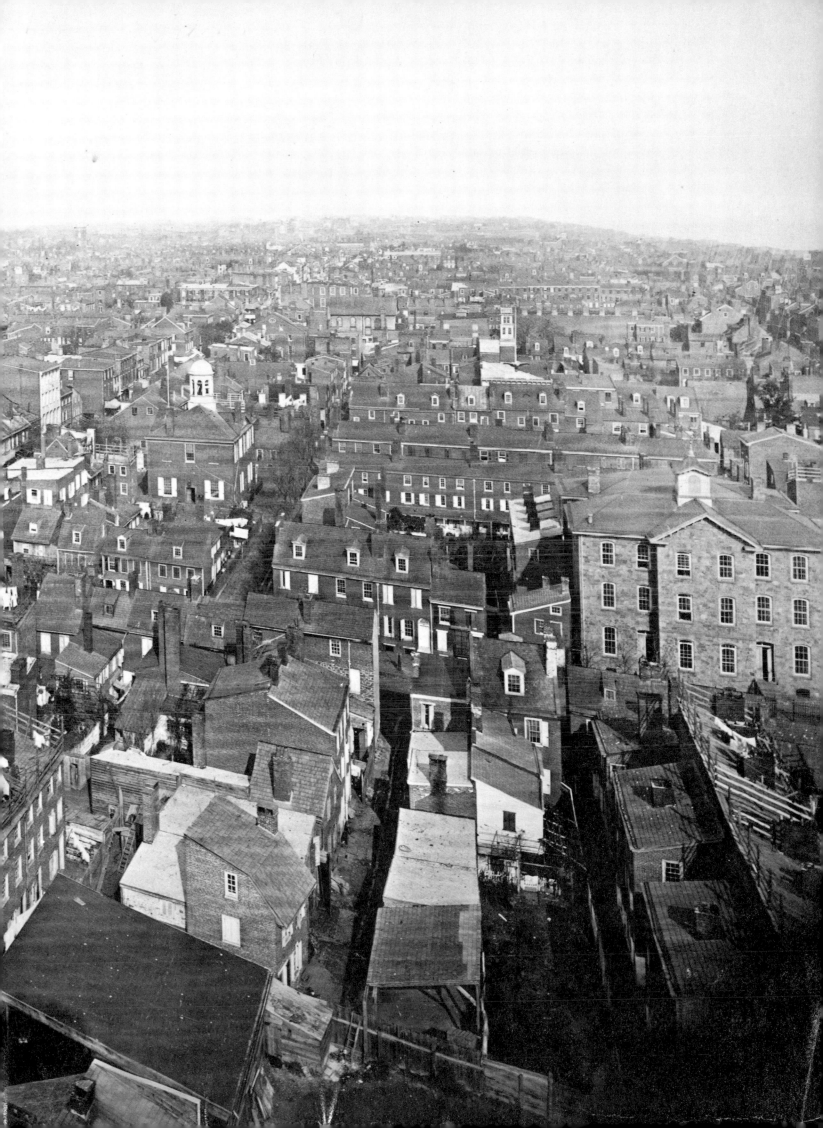

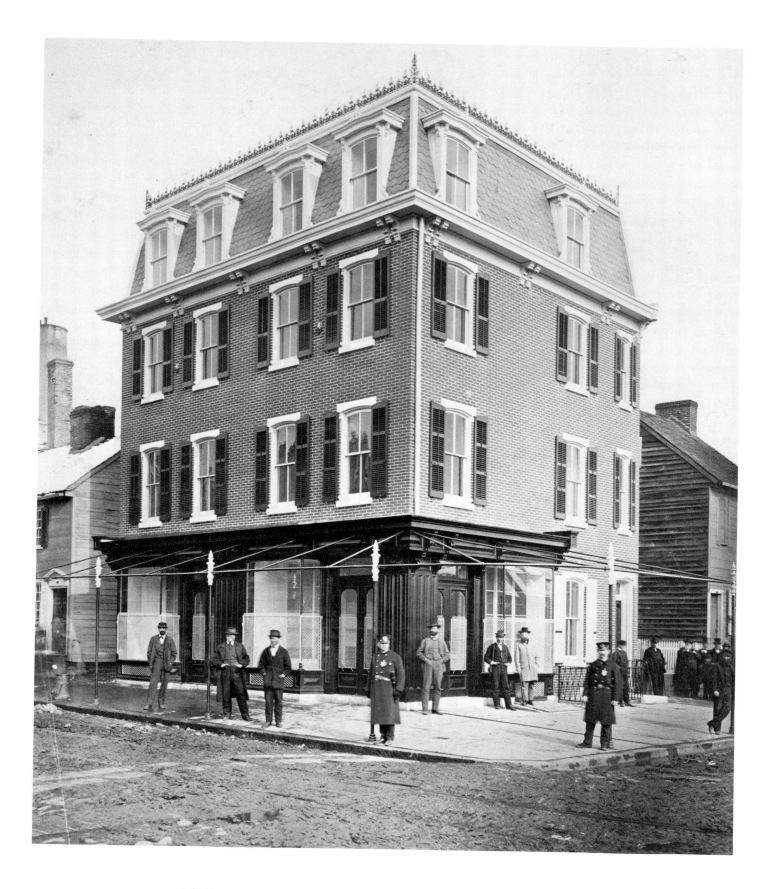

15. 2ND STREET AT WASHINGTON AVENUE, 1870. In this section of Southwark the streets were virtually unpaved in 1870. Police patrol outside the building, whose newness contrasts markedly with the wooden residences on either side. The clothing of the group posing for the camera is of simple cut. All this is in sharp contrast to the exactly contemporary view of 3rd and Gaskill Streets (No. 49), just a few blocks to the north, where the atmosphere was decidedly more prosperous.

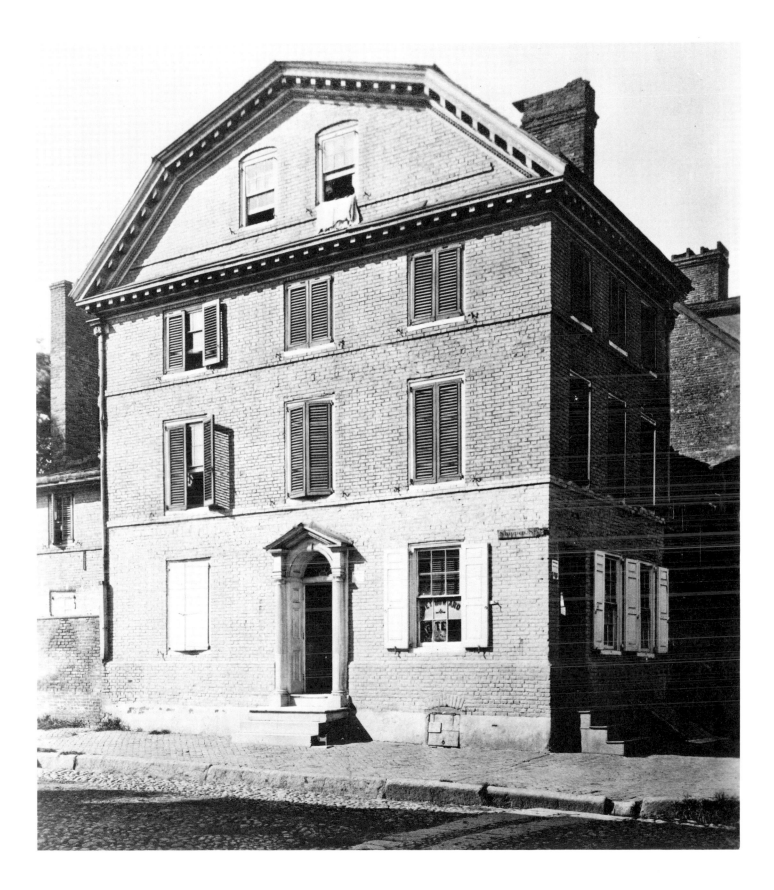

16. 316 SHIPPEN (NOW BAINBRIDGE) STREET, C. 1868. This handsome old Colonial building was located just outside the southern boundary of the Society Hill section.. The sign in the window indicates that the building was George Howard's Hotel. The city directory lists this also as the address of Eaton Howard, laborer. In 1868 this area was largely inhabited by laborers. *Photo by John Moran.*

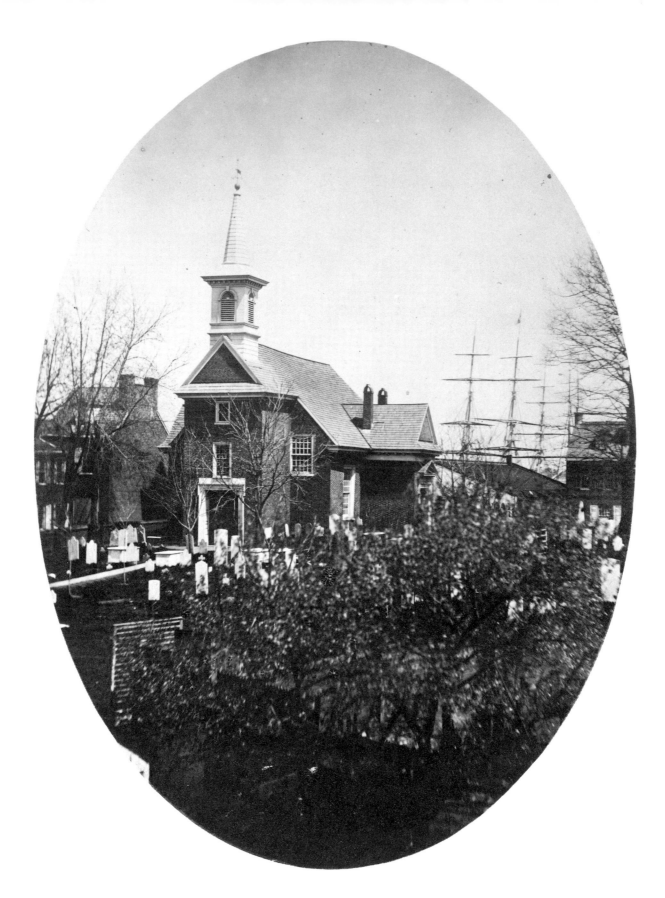

17. GLORIA DEI (OLD SWEDES') CHURCH, SWANSON STREET NEAR CHRISTIAN, 1854. One of the most famous and enduring of Philadelphia's landmarks, this old church in Southwark is one of the few seventeenth-century buildings still standing. Erected between 1698 and 1700 by the Swedish community, it stood originally on the banks of the Delaware close enough for the water to touch its foundations. In the nineteenth century it was surrounded by buildings of the shipping industry, but it now stands isolated by expressways for automotive traffic. During the eighteenth century Gloria Dei remained a mission of the National Church of Sweden, which was Lutheran. After the Revolution, however, the little church, in a spirit of independence, requested and received permission from Sweden to elect its own pastor. The incumbent pastor was permitted to remain until his death in 1831, after which the English-speaking congregation sought yet another change and joined the Episcopal communion in 1845. The famous ornithologist, artist and poet Alexander Wilson is buried in the churchyard of Gloria Dei. *Photo by Richards and Betts.*

II

The Delaware River Front

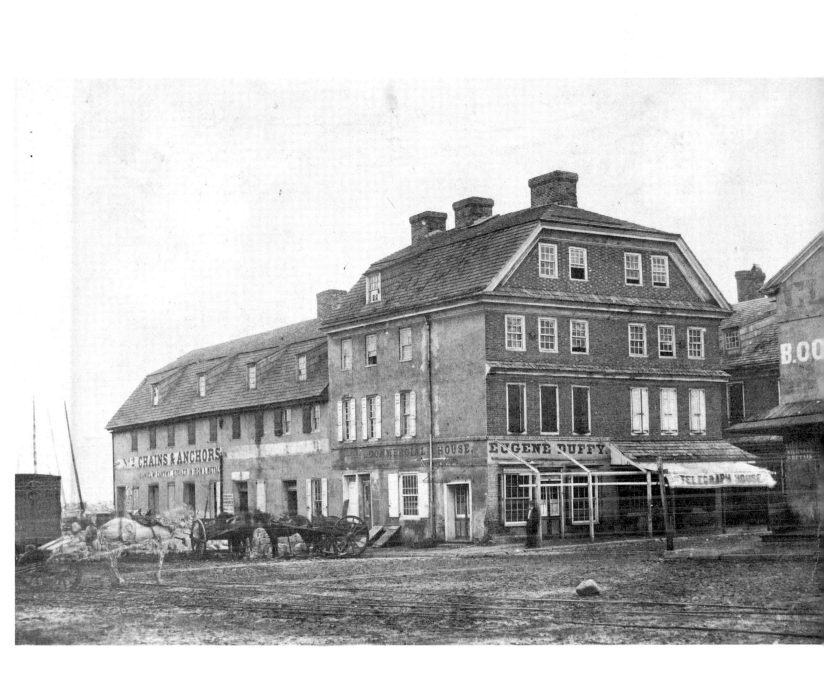

18. DOCK AND WATER STREETS, C. 1860. In 1860, Water Street was actually the river front and the location of wharfs and riverfront activity. This scene is close to the historic point of William Penn's landing and the Blue Anchor Inn, which marked the spot just north of Dock Street.

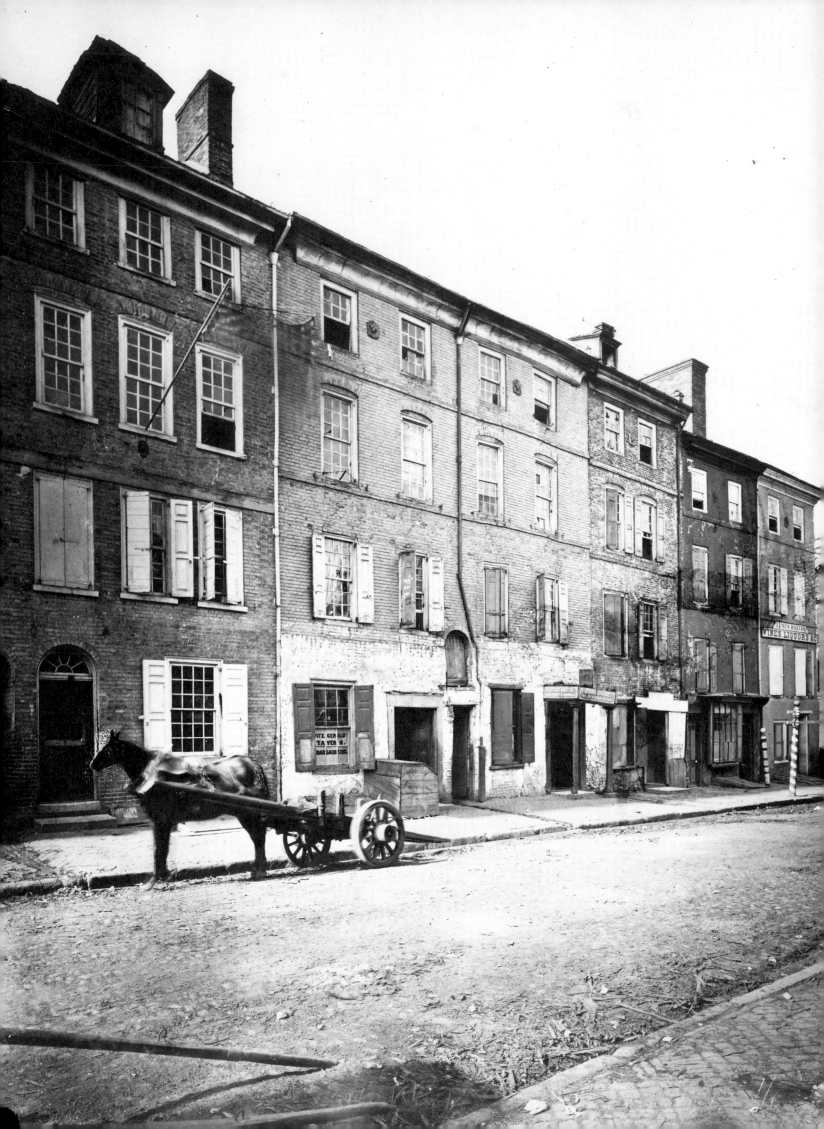

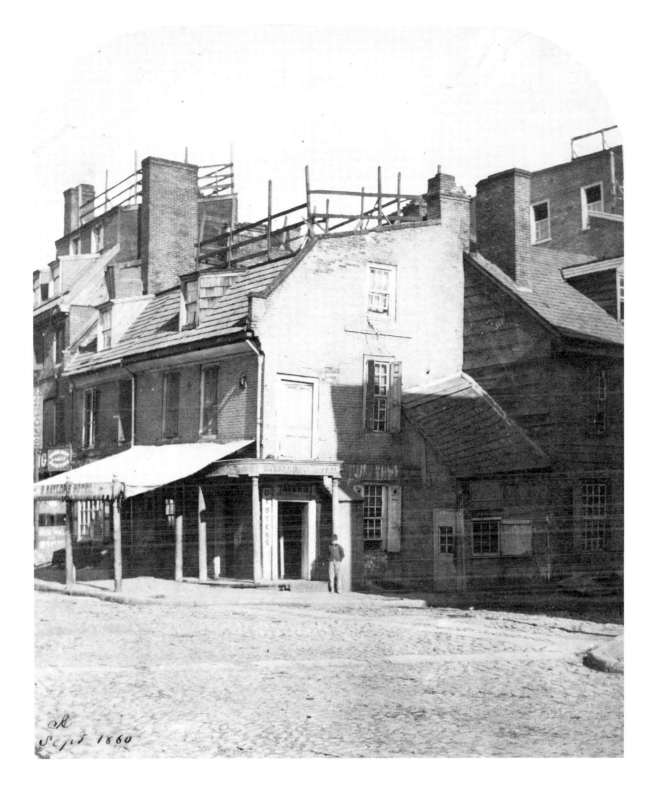

Sept 1860

Opposite: 19. FRONT STREET, SOUTH OF DOCK, C. 1868. Located just within the limits of the old city, these waterfront houses bear on their top story the iron plates of the Philadelphia Contributionship for the Insurance of Houses from Loss by Fire. Founded 1752 by Benjamin Franklin, this was one of the earliest fire insurance companies in America. It is still in business, occupying quarters built in 1836 on South 4th Street. *Photo by John Moran.*
Above: 20. DOCK STREET, WEST SIDE, 1860. Dock Creek extended from the Delaware River near Spruce Street as far north as Market Street at 5th. It was so called because in the early city it was the location of the public dock. Dock Street was laid out on either bank and was one of the earliest streets to be planned. Naylor's Hotel, shown here, has already been altered to accommodate a tavern on the street level. The doorway above was in better days the main entrance, approached by means of a staircase. *Photo by John Moran.*

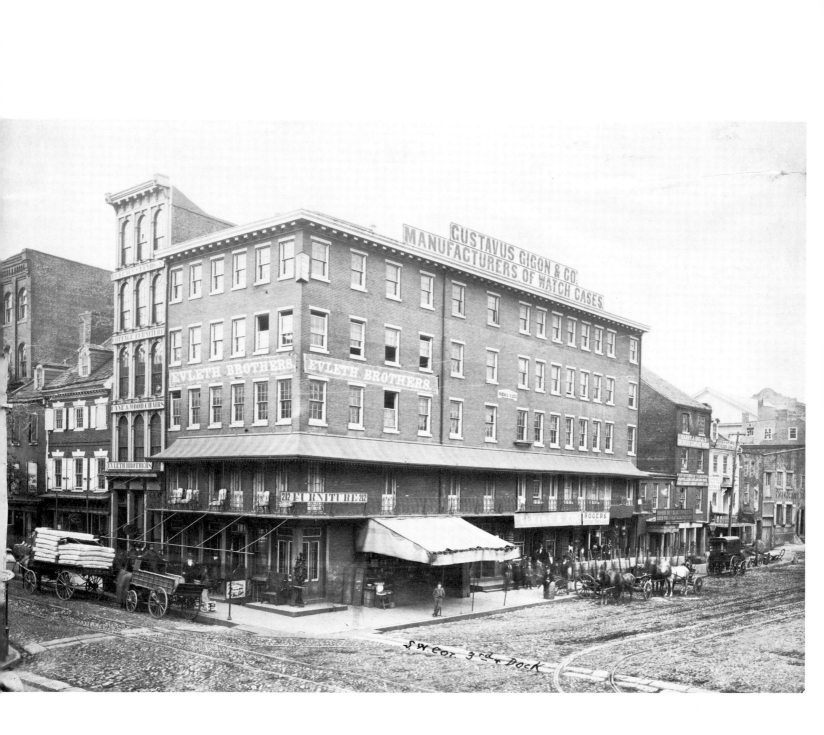

21. 3RD AND DOCK STREETS, C. 1874. This once-busy corner on the fringes of Society Hill was in the wholesale market district serving the shipping industry. Dock Street itself was in the heart of this district and dense with markets, warehouses and vehicular traffic.

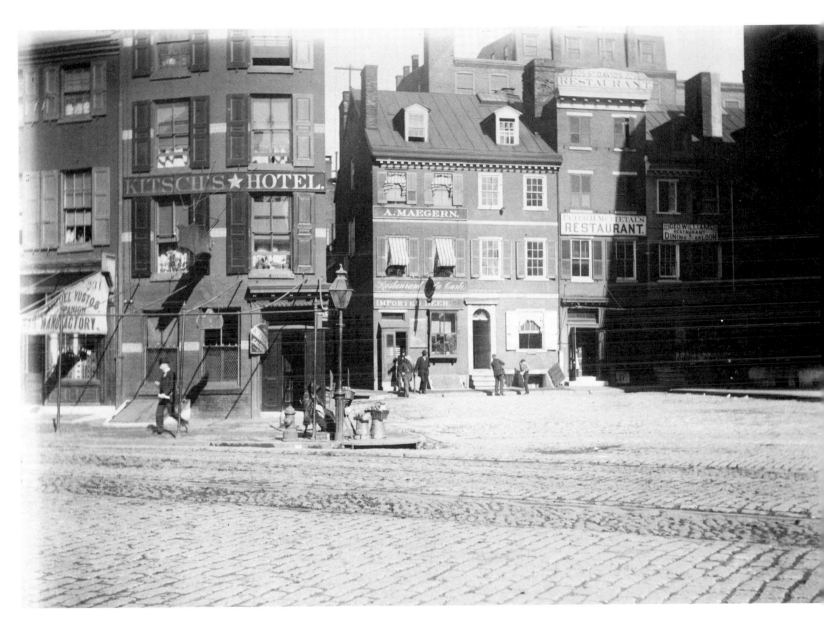

22. DOCK STREET AT WALNUT, C. 1890. This view is of the
intersection of Dock and Walnut Streets, where a collection of
restaurants catered to longshoremen, traders and seamen alike.

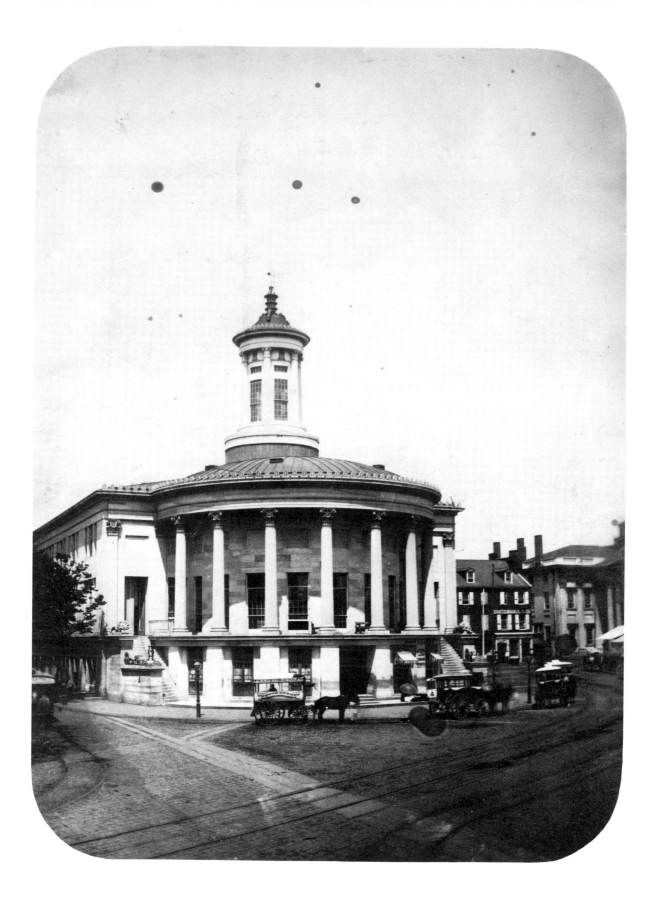

23. MERCHANTS' EXCHANGE BUILDING, 3RD STREET AT WALNUT, C. 1859. Designed and built between 1832 and 1834 by William Strickland, this was the first permanent home of the Philadelphia Stock Exchange. Its purpose was to provide a place for local merchants to gather for the barter and sale of goods. It is now part of the Independence National Historic Park complex and, since restoration in the 1950s, has housed the regional office of the National Park Service. The buildings in the background at the right are seen up close in the next picture.

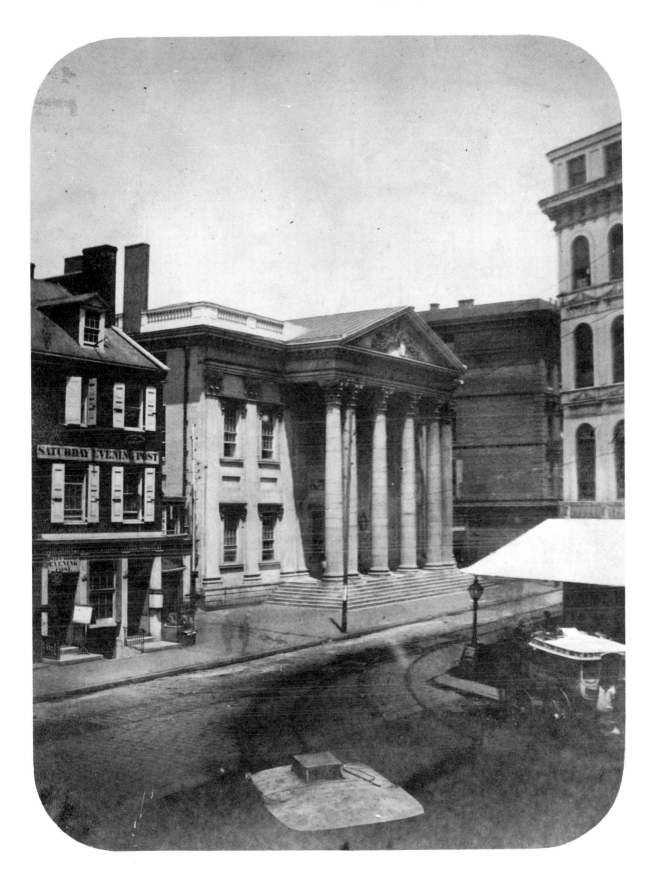

24. FIRST BANK OF THE UNITED STATES, 3RD STREET AT DOCK, 1859. This neoclassical building was constructed in 1795 to house America's first bank, which had been chartered in 1791. When Congress refused to renew its charter in 1811, the bank was taken over by Stephen Girard, then one of the country's three wealthiest men, and became known as Girard's Bank. It was used by Girard for his private banking business until his death twenty years later. In 1859 this location was the center of Philadelphia's banking district, across the street from the Merchants' Exchange and one block from the old Customs House on Chestnut Street. Next to the bank in this photograph is an early home of *The Saturday Evening Post*, and in the right foreground is a West Philadelphia omnibus.

Above: 25. SLATE ROOF HOUSE, 2ND STREET AT SANSOM, C. 1864.
Originally built between 1687 and 1699, this house was once a residence of
William Penn. Having passed through numerous transformations and abuses
largely resulting from the commercial uses to which it was subjected, the
building was ultimately abandoned. Its gradual deterioration through lack of
care led to its demolition in 1867, a few years after this photograph was
taken. *Opposite:* 26. WATER STREET AT SPRUCE, 1859. Ale houses,
oyster bars and a hotel awaited seafarers in this block of Water Street near
the old Navy Yard in Southwark.

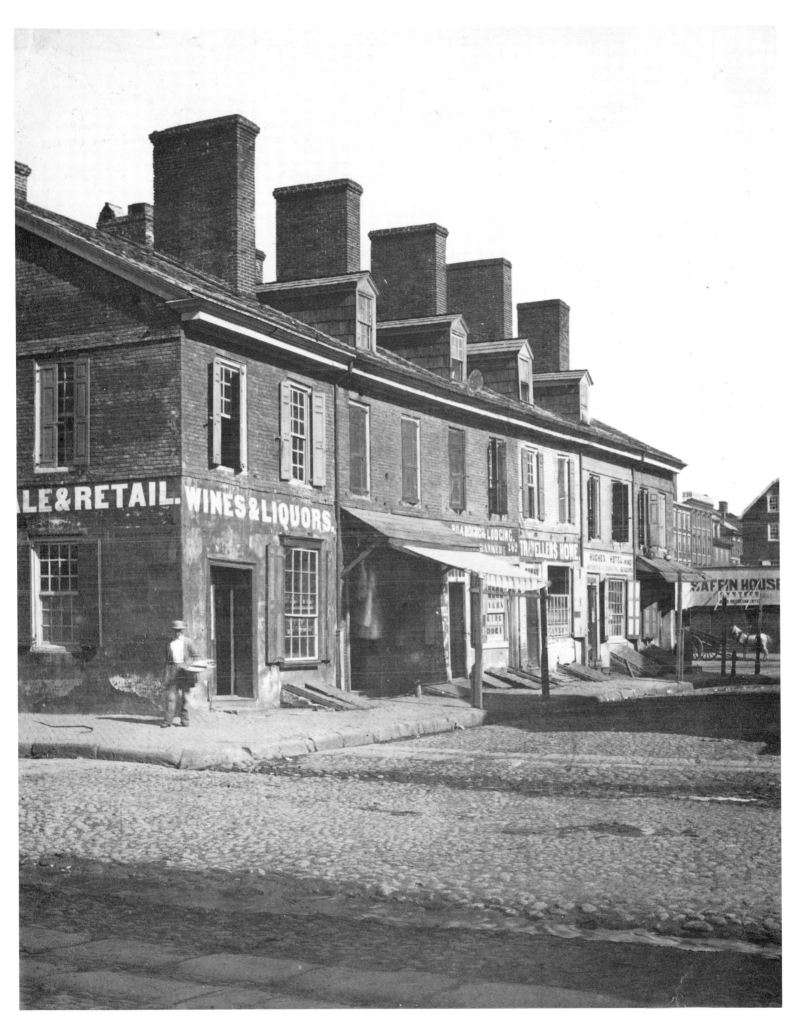

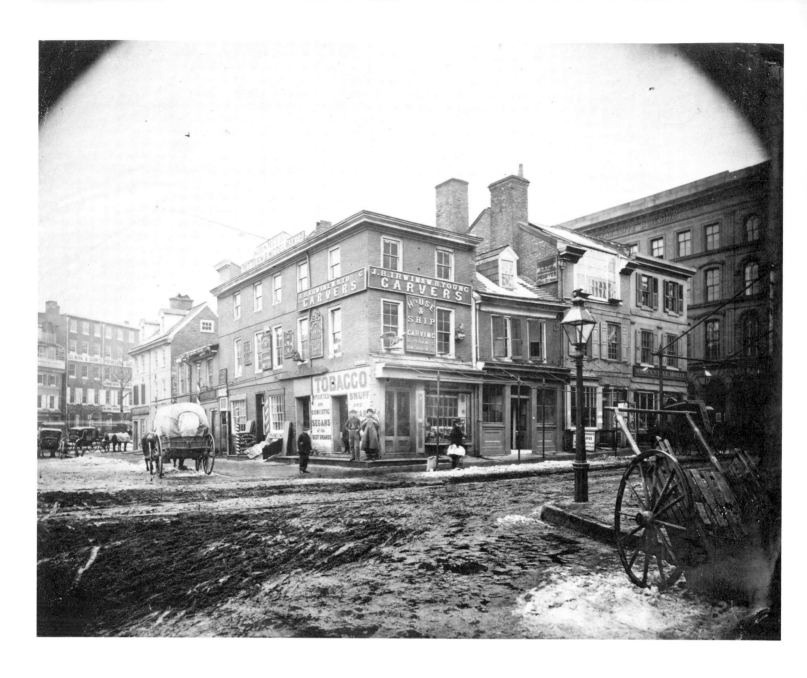

Above: 27. 2ND STREET AT DOCK, 1866. It would have been mostly seafarers who took advantage of the great variety of services offered at this establishment near the waterfront. Each proprietor had an eye-catching display, but none so arresting as the ship carver's models at the second floor windows. Before these businesses moved into the building, the *Public Ledger* was published here in 1837. The Anthracite Building in the background is reminiscent of the early coal business in Philadelphia, which developed into a big industry after 1820. At this time the city received its first shipment of anthracite coal, weighing over 300 tons. *Opposite:* 28. FRONT STREET AT PINE, 1868. Edward Thornton had his taproom, called the Great Ale Vaults, in the basement of this handsome old building. Water Street is visible at the extreme right. *Photo by John Moran.*

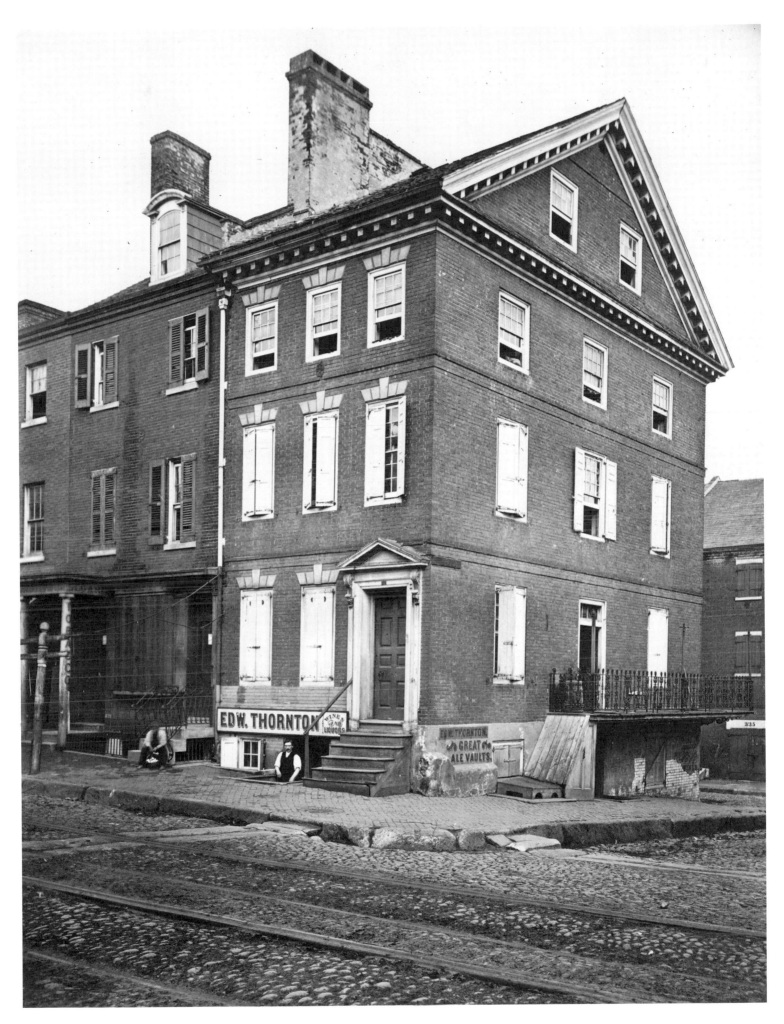

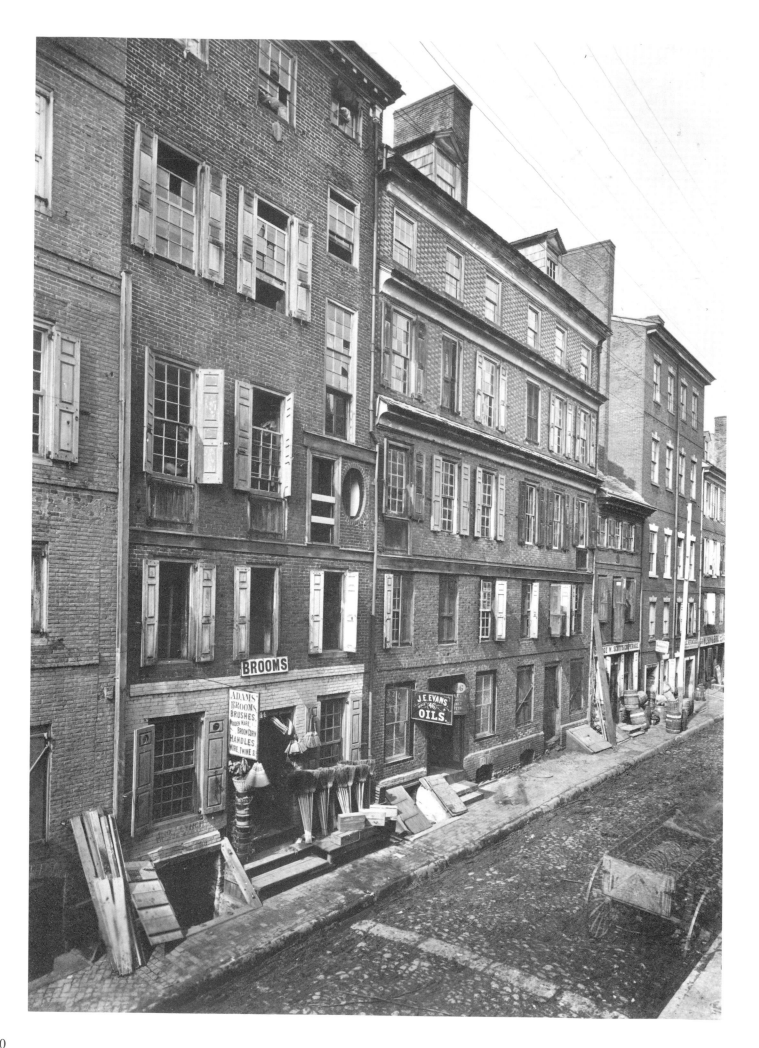

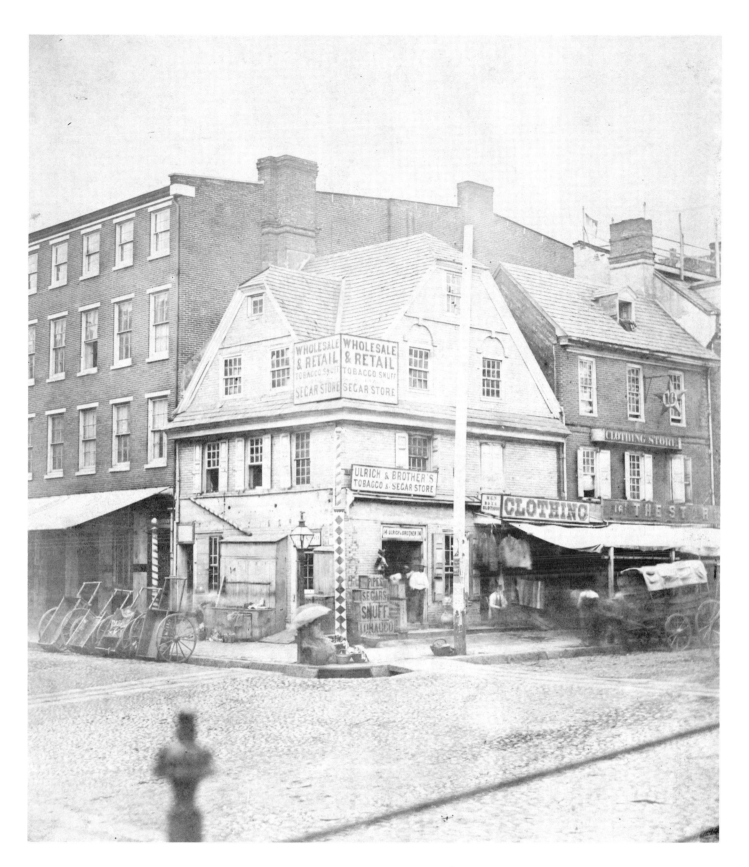

Opposite: 29. WATER STREET AT MARKET, 1868. The mid-nineteenth century was a time of transition, and growth of cities was commensurate with the expansion of business and trade. Some of the details in this picture indicate the effects of such expansion, the ground floors of some of the buildings having been invaded by businesses, crowding residents to upper floors. The height of these buildings may be explained by the fact that Water Street was a steep drop from Front Street immediately behind, and the buildings were actually entered from Front Street at a higher level. *Photo by John*

Moran. Above: 30. LONDON COFFEE HOUSE, FRONT STREET AT MARKET, 1854. The London Coffee House was originally built in 1702 on property obtained by its owner, Charles Reed, from Letitia Penn. It remained standing until 1883, and during its long and colorful history changed hands many times and housed businesses other than that for which it was originally intended. G. and A. Ulrich, whose family had owned the coffee house since 1813, were its final occupants. *Photo by James E. McClees.*

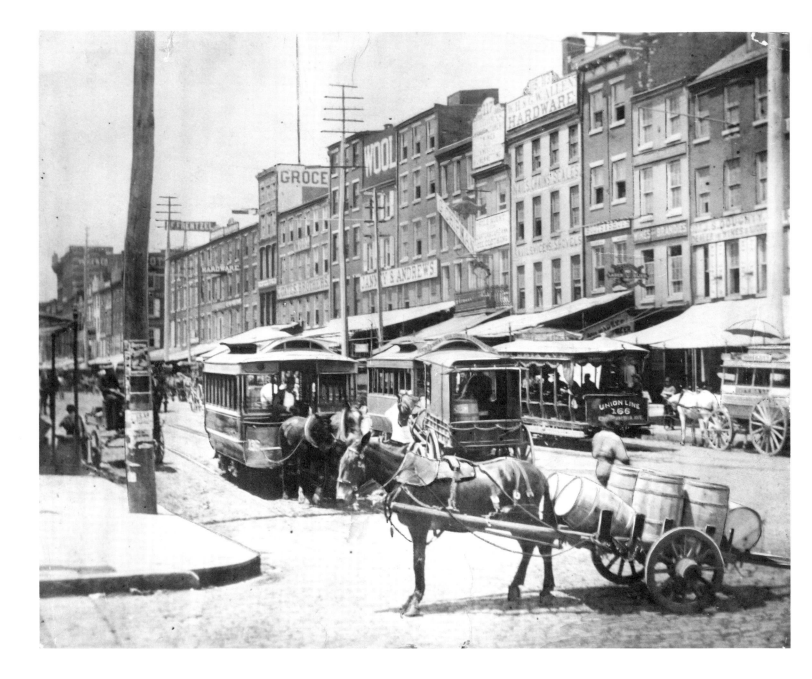

31. FRONT AND MARKET STREETS, 1880. This intersection was the end of the line for horsecars and trolleys because the grade from here to the waterfront was too steep for the horses. In the foreground is a carter's dray and, at the extreme right, an omnibus.

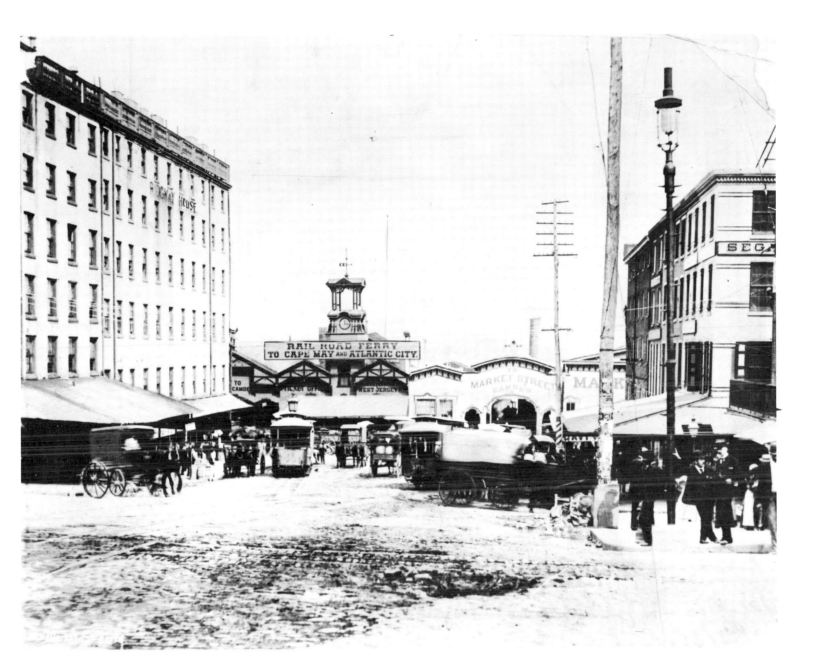

32. MARKET STREET AT THE DELAWARE RIVER FRONT, C. 1894.
The ferry buildings, the horsecar turn-around and the delivery wagons all
indicate the intensity of activity at the waterfront in 1894. Ridgway House,
left, was originally a company of grain and flour merchants, a business
founded early in the century.

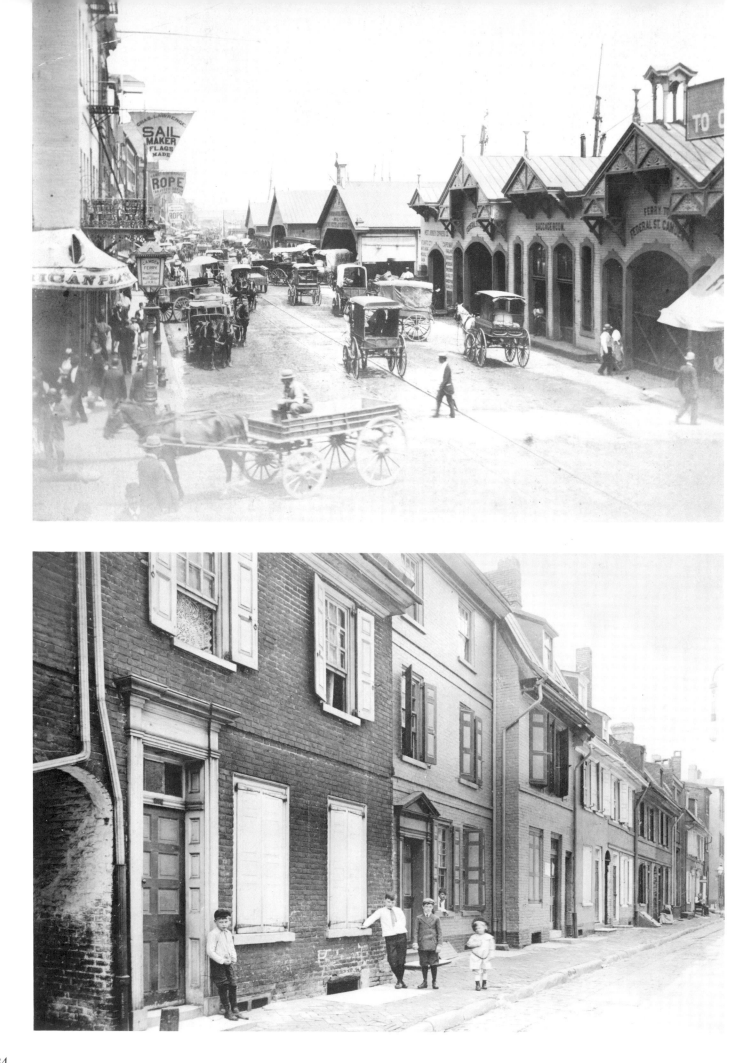

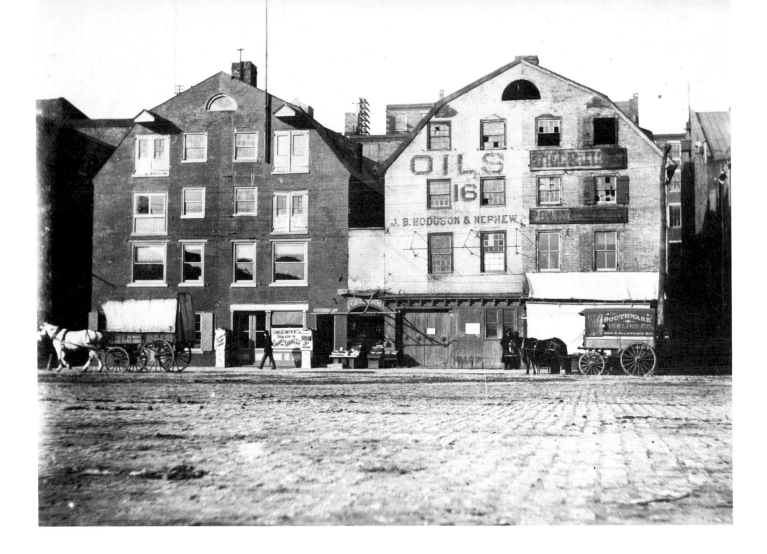

Opposite above: 33. DELAWARE AVENUE, NORTH FROM MARKET STREET, C. 1890. The Philadelphia waterfront receded from its original shoreline at Front Street partly because the channel in the Delaware River was deepened to accommodate larger ships. Delaware Avenue was the principal waterfront thoroughfare by the 1890s. Before the Delaware Avenue Bridge was opened in 1926, the ferries to Camden, N.J., across the river, were an important part of the scene. *Above:* 34. WAREHOUSES, 14–20 SOUTH DELAWARE AVENUE, C. 1900. These two waterfront warehouses were built around 1796, and were in continuous use until just after 1900. They were built by Paul Beck, a well-known merchant in his time, and builder of a shot tower on Cherry Street at 21st in 1808. Visible for some distance, the shot tower was for twenty years a landmark on the Schuylkill River. *Opposite below:* 35. ELFRETH'S ALLEY, 1910. Said to be the oldest street in the United States in continuous use, Elfreth's Alley was named after Jeremiah Elfreth, a blacksmith who came to Philadelphia in 1690, and whose family later owned all the properties in the street. It is located near the waterfront just north of Arch Street and runs one block west from Front Street to 2nd Street. Its houses date from 1713 to 1811. Now one of Philadelphia's showplaces, its early character has been carefully preserved, and Elfreth's house at 126, one of the oldest, has been opened as a museum. The view is toward the west and No. 126 is near the far end on the left. (It is not distinguishable in the picture.) *Photo by W. G. Deschamps.*

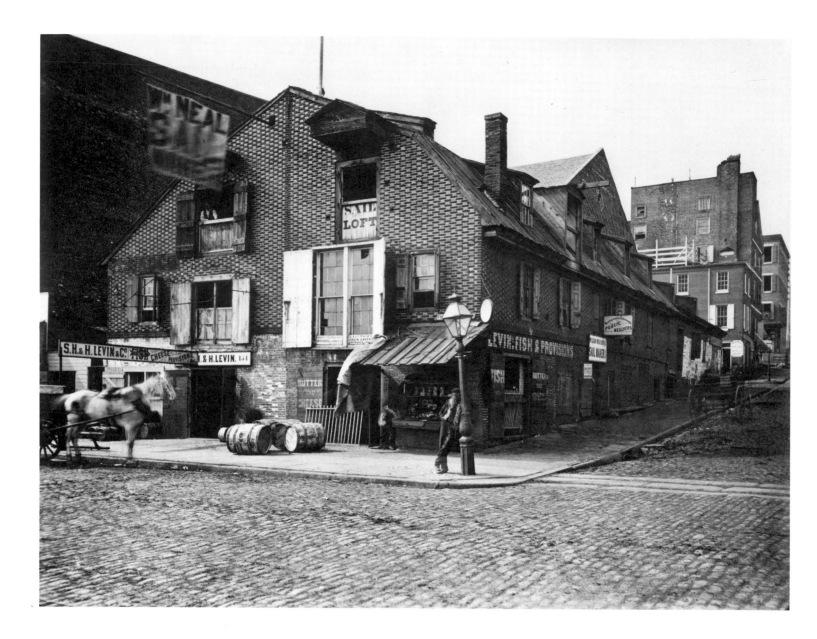

36. RACE STREET WHARF, DELAWARE AVENUE AT RACE STREET, C. 1856. This old warehouse for salt and salt fish, also called a salthouse, was built in 1705, one of the first buildings to be erected on the Delaware waterfront. Its bricks and timbers were brought from England and were still sound when the building was taken down after 1900. The building housed a variety of businesses when the photograph was made around 1856. Besides William Neal, sailmaker, there were grain carters, public weighers and S. H. & H. Levin, whose business in fish and provisions later became a firm of some size and importance. During the Revolution a troop of British soldiers was quartered here. *Photo by John Moran.*

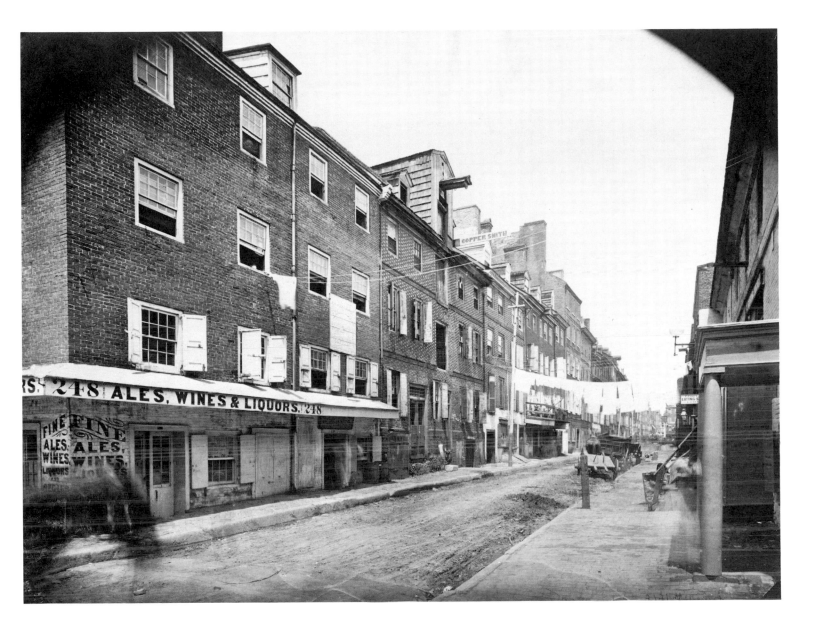

37. FRONT STREET AT RACE, C. 1868. Residences, warehouses and tradesmen's shops alike are crowded into this block at the waterfront. *Photo by John Moran.*

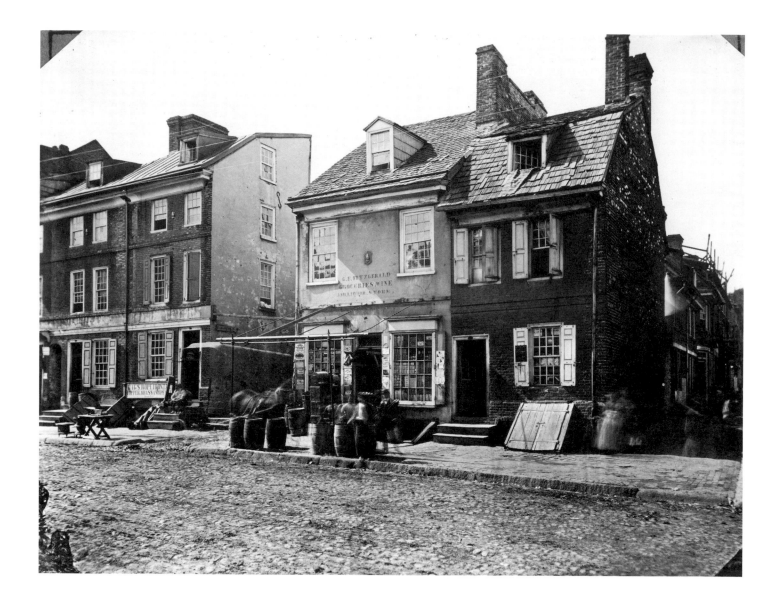

38. FRONT STREET AT VINE, C. 1868. Fitzgerald's grocery shop, with its firemark between the upper windows, stands in a group of Colonial buildings among the oldest in the river-front area. These buildings are just inside the northern boundary of the old city. *Photo by John Moran.*

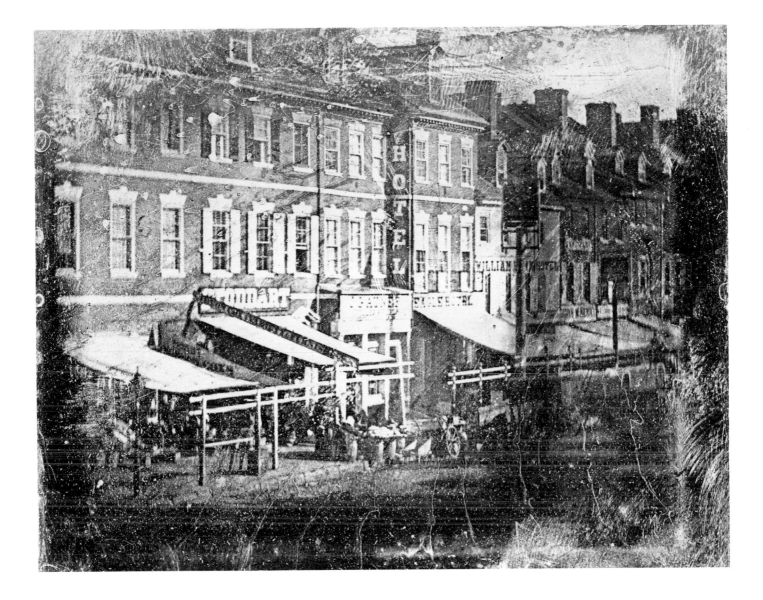

39. 2ND STREET, NORTH OF CALLOWHILL, 1841/42. In the seventeenth century, 2nd Street was only one block from the waterfront, and Callowhill Street was outside the city limits on the north; 2nd Street was also largely residential. By the 1840s, however, as details in this photograph indicate, much business activity was concentrated here. Before the hotel a crowd of wagons suggests a gathering place for the Jersey farmers, and small shops of various kinds occupy the ground floors of buildings that were once residences.

III

Society Hill

SOCIETY HILL is that part of old Philadelphia extending south
from Walnut Street to South Street, bounded on the west by 7th
Street and on the east by Front Street. It was so named because
the property in that area, actually a hill, was deeded by William
Penn to the Free Society of Traders, organized by Penn as a stock
company for purposes of promoting Philadelphia and Pennsyl-
vania. Originally the area was a parade ground, but later, in the
eighteenth century, it was graded and built upon by prominent
citizens of Philadelphia.

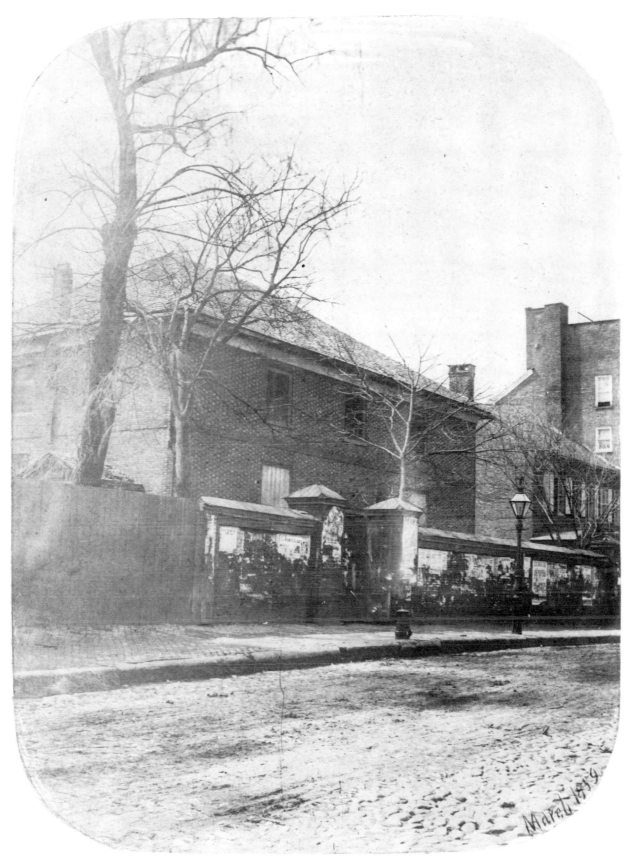

40. HILL MEETING, PINE STREET, EAST OF 2ND, 1859. This meetinghouse, built in 1753, was once the center of a thriving community of Quakers. The property on which it stood was donated by a Samuel Powel whose relationship to Samuel Powel, later mayor of Philadelphia, is uncertain. Mayor Powel's own mansion two blocks away on 3rd Street is a landmark of eighteenth-century architecture (No. 48). The Meeting flourished under the patronage of succeeding generations of Powels until it was deprived of a large percentage of its membership in 1832 by the newly built Orange Street Meeting. By the 1850s the Hill Meeting was no longer in use. It was taken down in 1861.

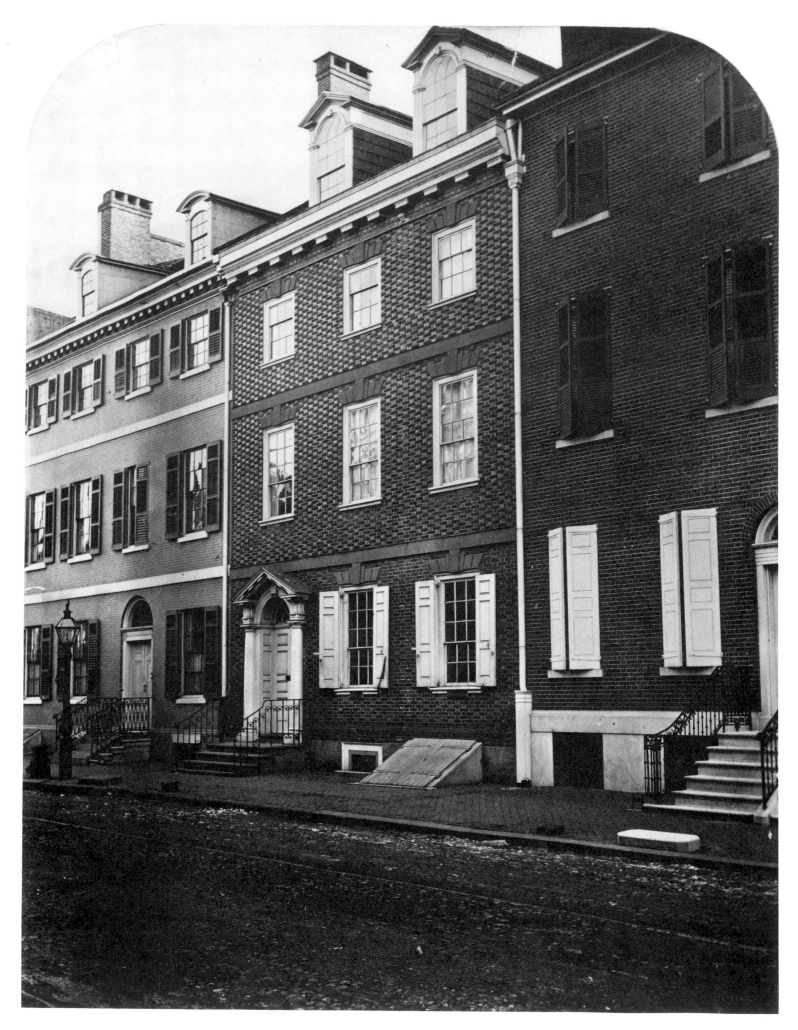

44

Opposite: 41. HOUSES ON EAST PINE STREET, C. 1860. These houses in the 200 block of Pine Street stood just around the corner from the market houses on 2nd Street (next picture). The center house, No. 224, was built in 1764 by John Stamper, mayor of Philadelphia in 1759, and was occupied successively by William Bingham, Stamper's son-in-law; Rev. Robert Blackwell, rector of St. Peter's Church (No. 45), who lived there until 1831; and the family of the great banker Thomas Willing. The house ultimately fell prey to commerce and was taken down, along with the other houses in the photograph, around 1930. These houses have been replaced by new ones of Colonial design, and a lane called Stamper-Blackwell Walk has been cut part way through the block from Pine Street from a point at the left in the photograph. The lane turns left at right angles into 2nd Street, probably through what was the innyard of the old Plough Tavern (No. 44). *Right:* 42. MARKET HOUSE, 2ND STREET AT PINE, 1900. Often called "Head House," this building was constructed in 1804 at the head of the market sheds which extended southward on 2nd Street for a distance of two blocks to South Street. The original sheds dated from 1745. This photograph and the next show the transformation wrought by various late nineteenth-century architectural excrescences which have since been removed. In the 1960s the buildings were restored to their original appearance and designated historical landmarks. *Photo by Franklin D. Edmunds.*

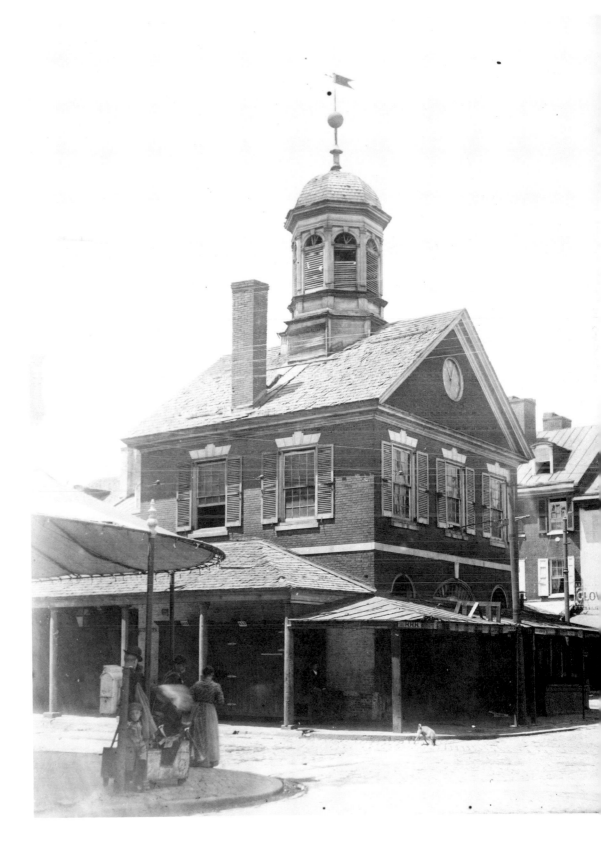

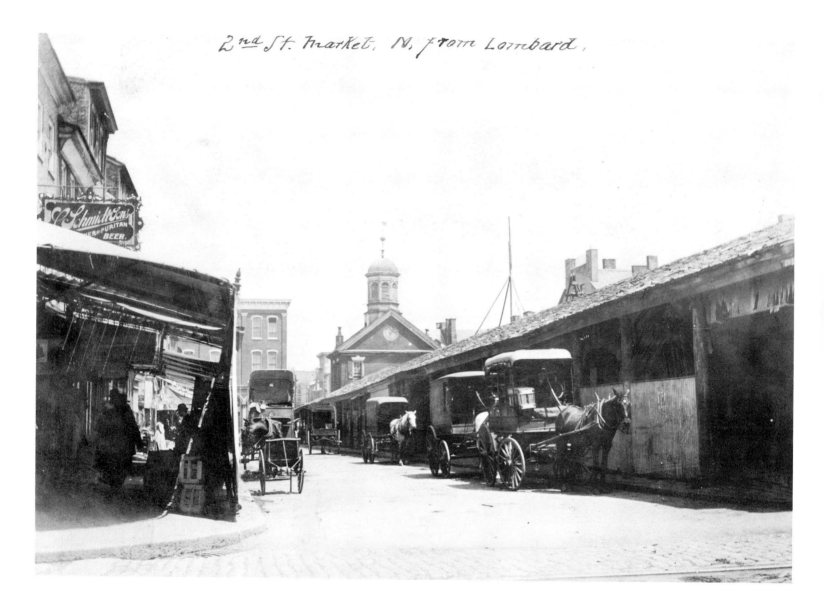

2nd St. Market, N. from Lombard.

43. MARKET SHEDS, 2ND STREET, C. 1889. The view here is toward
the north from Lombard Street. Any traces of the original sheds that may
have existed by this time are quite invisible in the photograph.

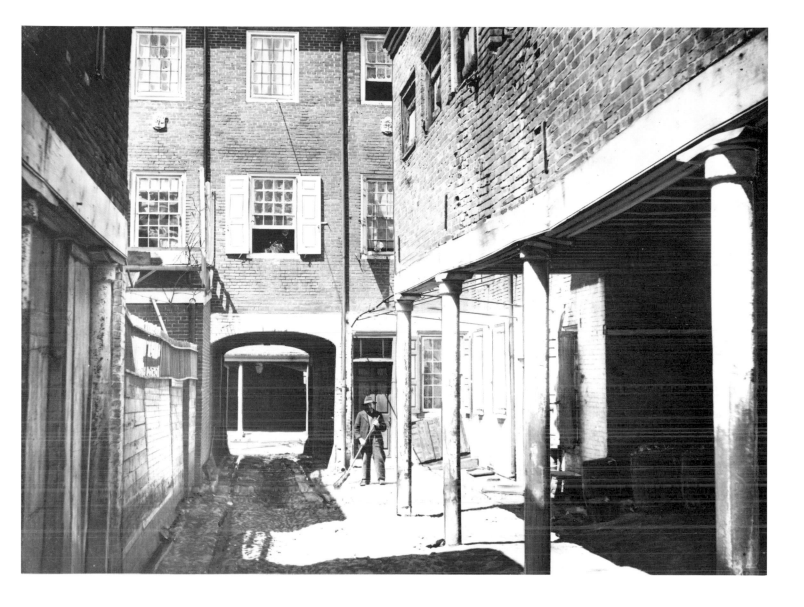

44. OLD PLOUGH TAVERN, 2ND STREET AT PINE, C. 1885. The Old Plough Tavern faced on 2nd Street, and through the archway, in this photograph, can be seen the columns of the old 2nd Street market shed. The rear court shown here is reminiscent of old-world innyards. On the right are the stables and through the door beside the archway are the public rooms where a good pint of ale was drunk by many a visiting farmer.

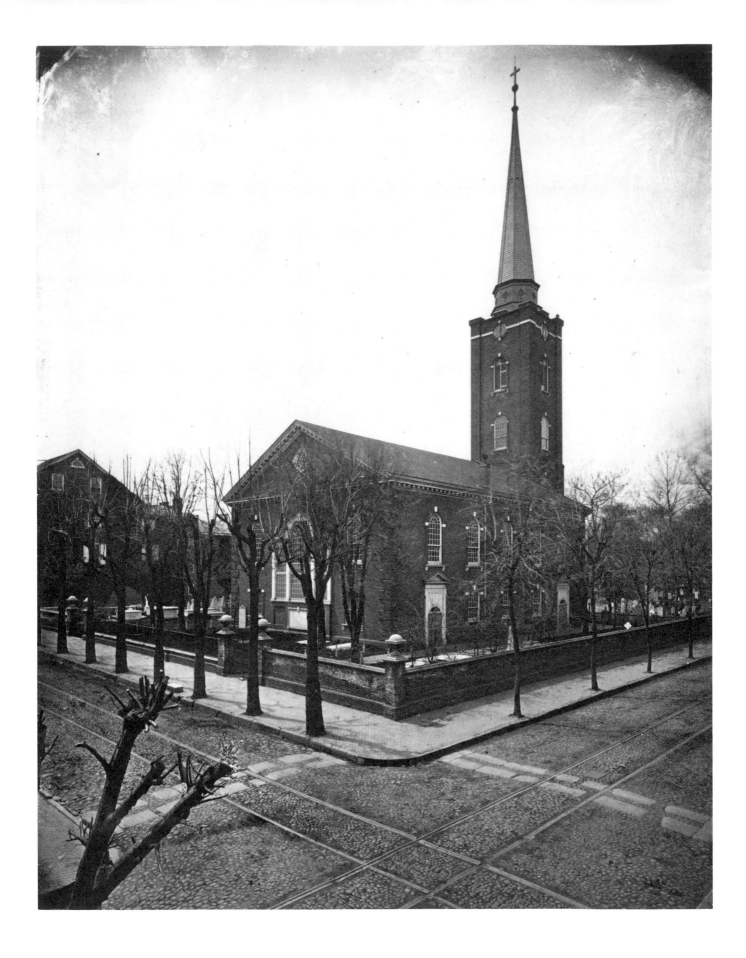

45. ST. PETER'S CHURCH, PINE STREET AT 3RD, C. 1870. The building of this church was begun in 1758 and completed in 1761, except for the tower and spire which were added in 1842. The ground was given by Thomas and Richard Penn. It was originally conceived as a chapel of Christ Church, the mother church, at 2nd and Market Streets. In its yard are buried many patriots, among them Stephen Decatur, the naval hero, and Charles Willson Peale, the great American painter.

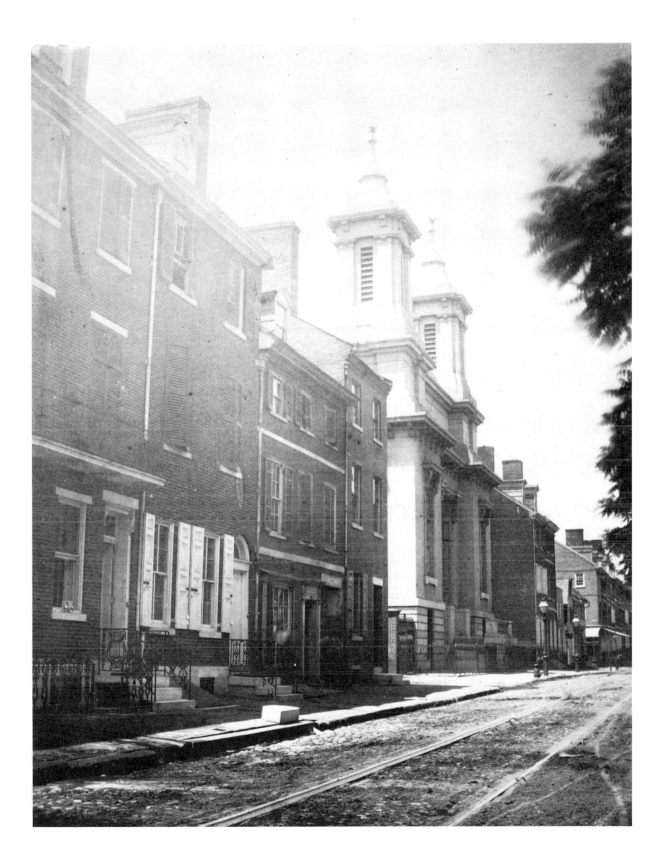

46. SPRUCE STREET, WEST FROM 4TH, C. 1859. The old houses shown here clustered around the old Spruce Street Baptist Church are characteristic of the early city. The church was sold to a Jewish congregation and its facade remodelled by the renowned architect Thomas U. Walter in 1851. It is now the Society Hill Synagogue.

S. 3ᵈ St. bel. Walnut St.

Opposite: 47. 3RD STREET, SOUTH OF WALNUT, C. 1871. The tall building in the foreground, according to records, belonged originally to the Pennsylvania Railroad, but by the 1870s was owned by the Lehigh Valley Railroad. To the left of this imposing structure are private residences. *Right*: 48. POWEL HOUSE, 3RD STREET, SOUTH OF LOCUST, 1903. This mansion at 244 South 3rd Street was the home of Samuel Powel, mayor of Philadelphia at the time of the Revolution. Now a fully furnished museum with a Colonial-style garden, it was once threatened with demolition. Built in 1765, it is one of the finest Colonial houses in the city.

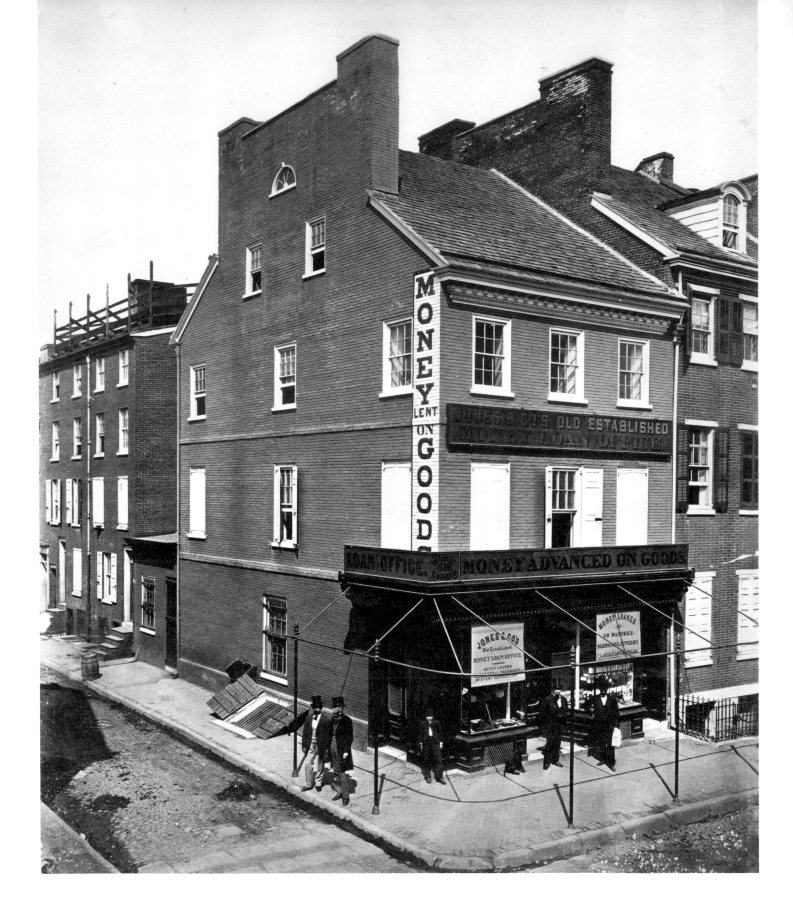

49. 3RD STREET AT GASKILL, 1870. Gaskill Street is just within the
limits of Society Hill on the southern boundary. The well-dressed gentlemen
on the sidewalk and the substantial houses on either side of the pawn shop
suggest the affluence customarily associated with this area.

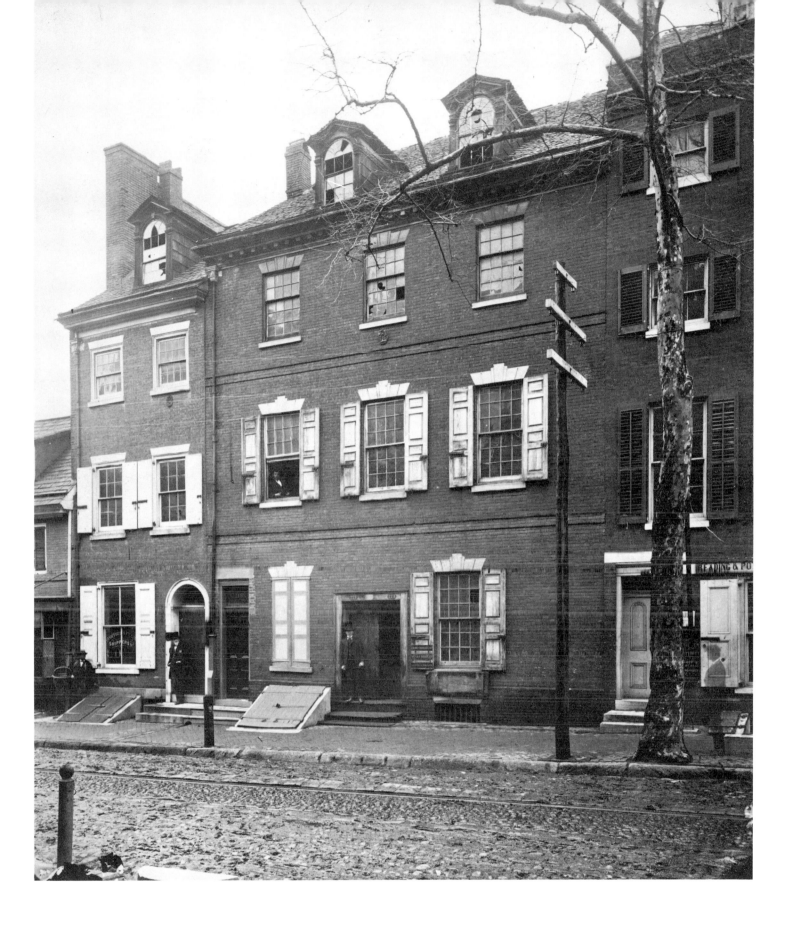

50. 4TH STREET AT WALNUT, C. 1868. This once elegant building is here seen in the last stages of disrepair after following the usual pattern of change from residence, to business, to abandonment. It was demolished in 1871.

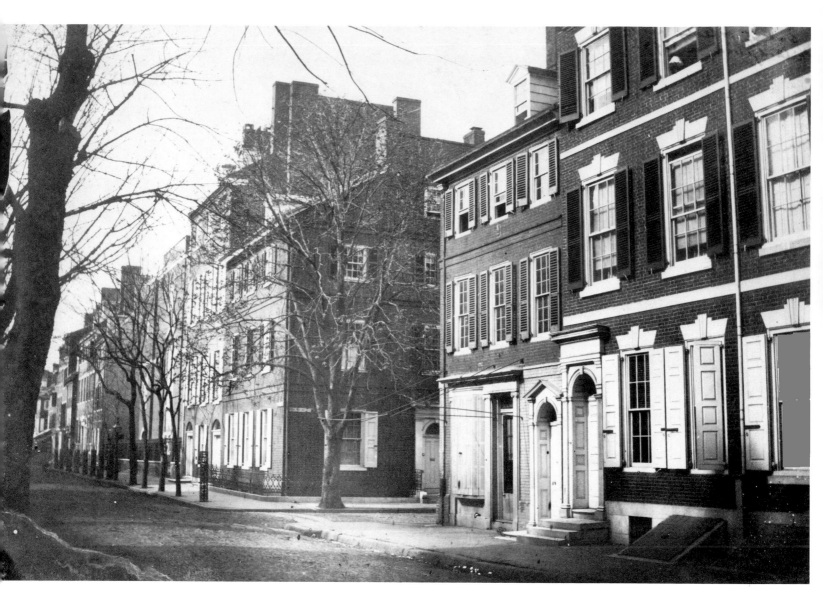

51. 4TH STREET AT PRUNE (NOW LOCUST), C. 1859. 4th Street at this intersection is filled with historic associations. On the southwest (far) corner is the residence of Dr. Caspar Wistar, famed professor of anatomy at the University of Pennsylvania. This house, built about 1750, was the scene of Saturday evening parties, a kind of salon, to which gentlemen of social and intellectual distinction were invited. Continued after Wistar's death in 1818, they became known formally as the Wistar Parties and were a social function to which guests were admitted only by membership. On the northwest corner opposite Wistar's house is a small house occupied from 1796 to 1800 by Louis-Philippe, Duc d'Orléans (later King of France), and his brother the Duc de Montpensier.

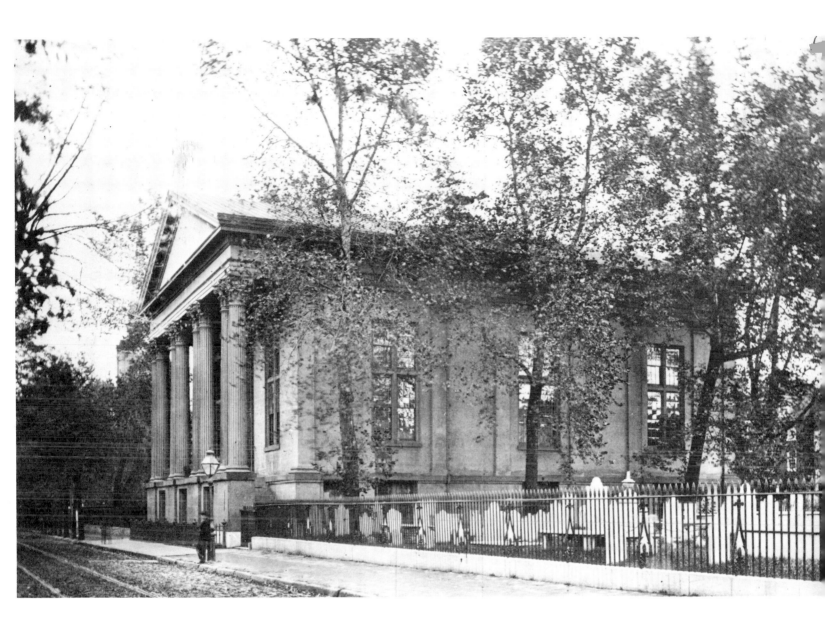

52. PINE STREET PRESBYTERIAN CHURCH, PINE STREET
AT 4TH, 1868. Known as Old Pine Third and Scots Presbyterian,
this church was built in 1768 on property donated to the original
congregation by Thomas and Richard Penn. At first an outgrowth
of the First Presbyterian Church, then at Market and Bank Streets,
it became an independent church in 1771. During the Revolution
the British used it first as a hospital, then as a stable. In its historic
churchyard lie buried many soldiers of the Revolution and other
patriots, William Hurrie who rang the Liberty Bell in July 1776,
and William C. Houston, member of the Continental Congress
from New Jersey. This photograph was taken at the time of the
church's hundredth-anniversary celebration.

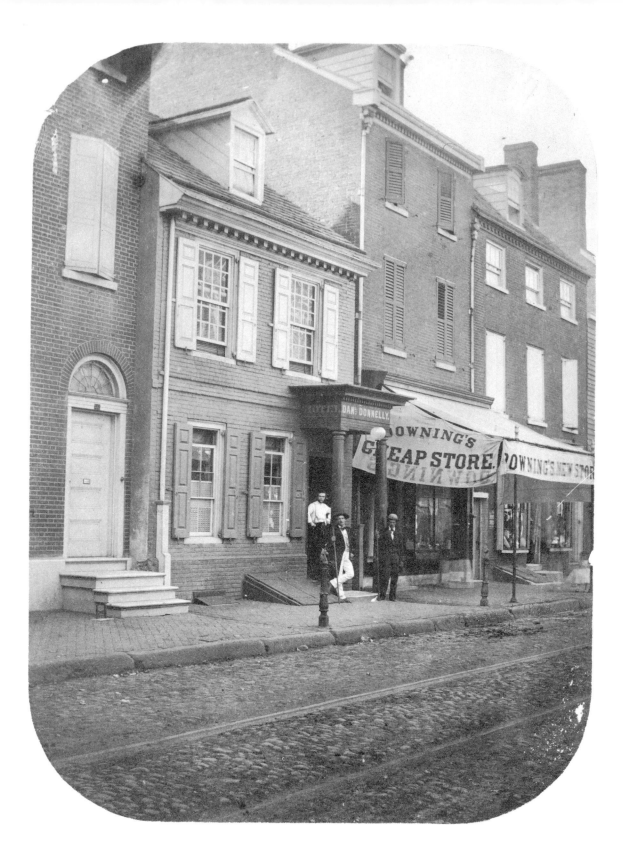

Above: 53. DONNELLY'S HOTEL, 4TH STREET AT PINE, C. 1860. This small building, next to Downing's Cheap Store, was older than its neighbors, as is evident in part from the lower construction. The portico was a later addition. A traveler might wonder about the limit of accommodations in so small a house, though in all likelihood such an establishment was more a tavern than a hostelry. *Opposite:* 54. PINE STREET AT PENN, 1868. Scaffolding on the front indicates the impending invasion of a commercial enterprise at this erstwhile residence dating from the early 1800s. Water Street at this point was called Penn Street. It is now obliterated by recent construction of roadways.

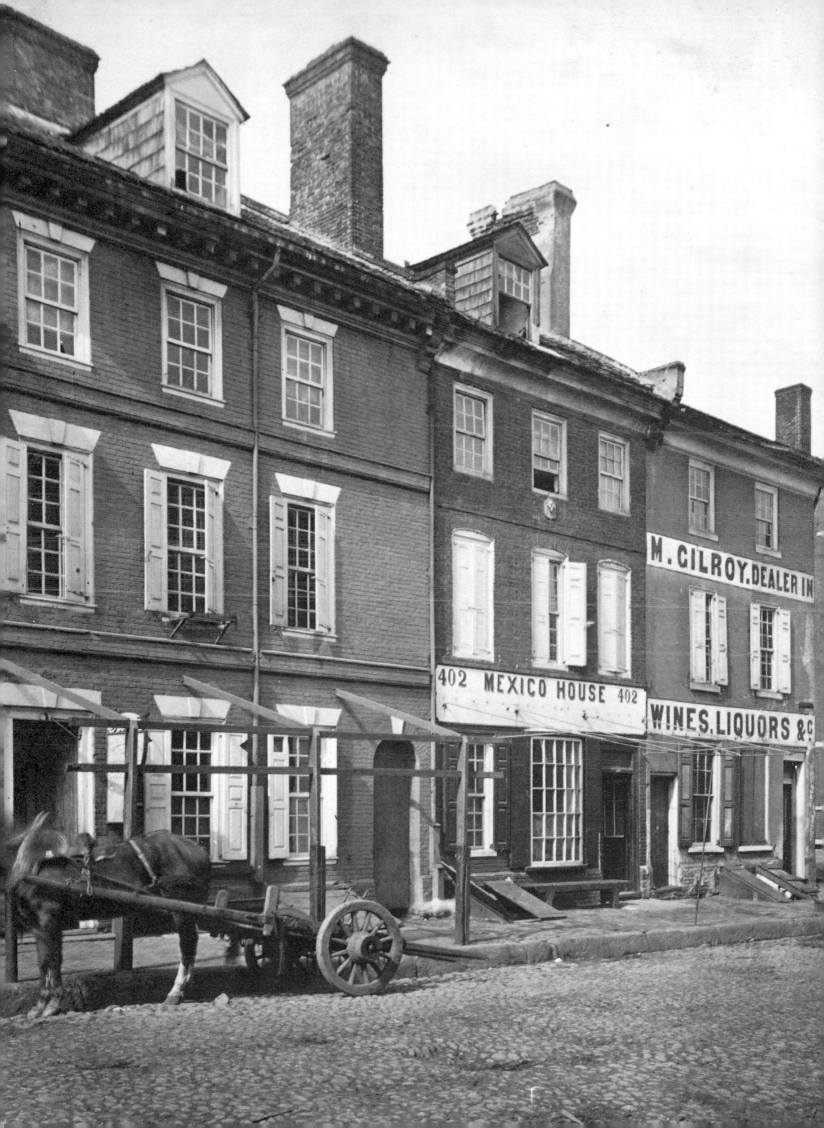

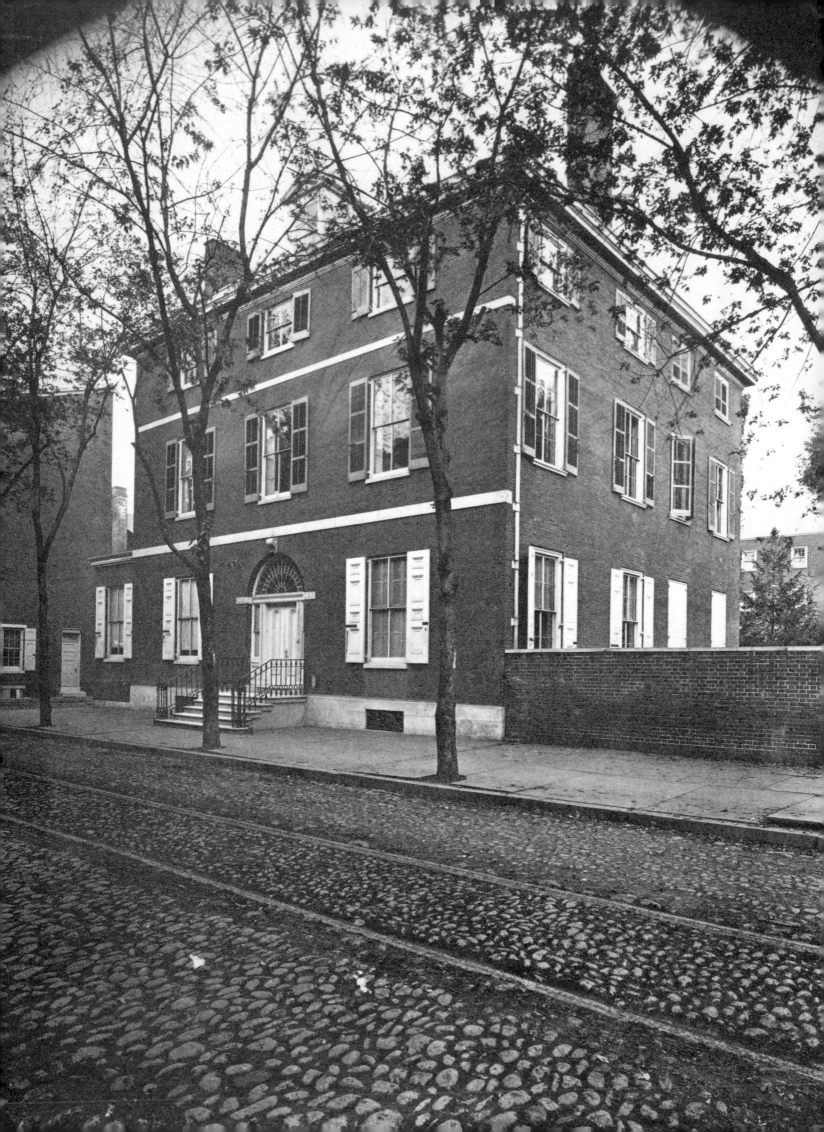

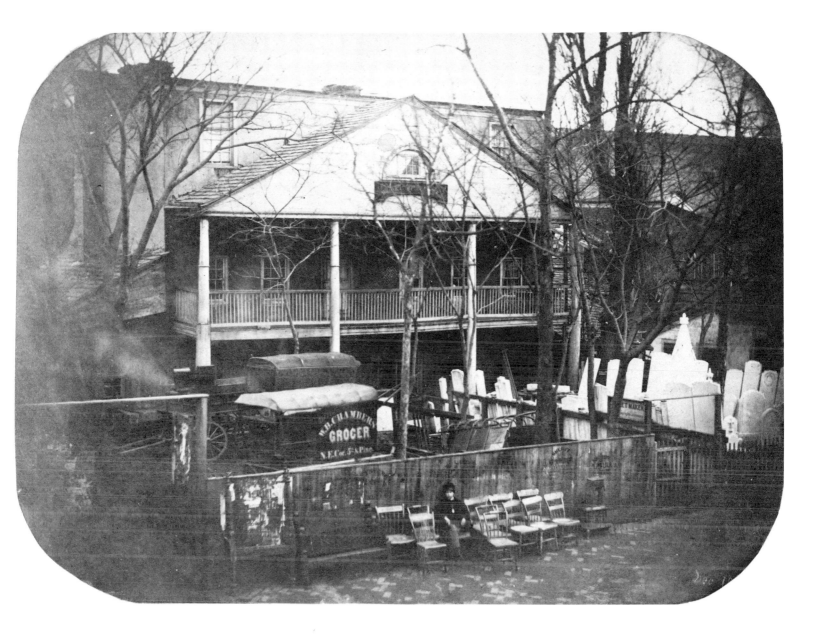

Opposite: 55. PHYSICK RESIDENCE, 4TH STREET AT DELANCEY, C. 1865. A short distance south of the Wistar house at Pine Street is the Hill-McCall-Randolph-Physick house, built in 1786 by Henry Hill, famous importer of Madeira wine. The fourth resident, Philip Syng Physick (1768–1837), member of the faculty of the University of Pennsylvania and often called the "father of American surgery," occupied the house from 1817 until his death. Restored to its original Colonial elegance, it is now a museum.
Above: 56. HURST MANSION, 5TH AND SOUTH STREETS, C. 1859. The Hurst Mansion was built about the time of the Revolution by an English gentleman, one Baron Hurst, who owned much property in the Society Hill area. The tract extending west from the mansion to about 10th Street and lying between South and Lombard Streets was in 1787 a burial ground for persons not affiliated with any church. By 1859, when this photo was made, the property had passed from the hands of the Hursts. The gravestones collected here were removed from the burial ground to make way for housing. The mansion was later a tavern.

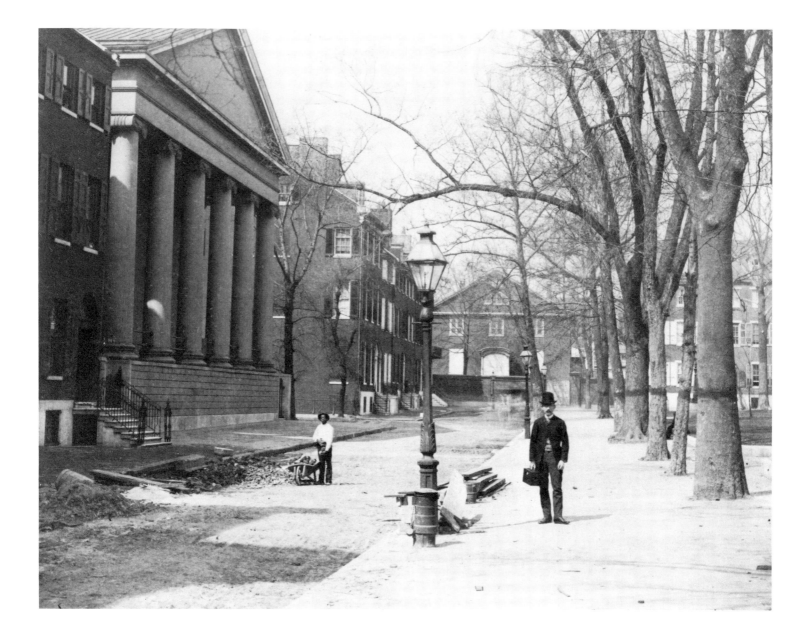

57. WASHINGTON SQUARE, SOUTH, C. 1870. The residential atmosphere of old Washington Square persists today, though few of the buildings shown here are still standing. On the site of the First Presbyterian Church and the residences at the left now stands the Hopkinson House apartment building. The meetinghouse, center, was demolished long ago, and the space taken for commercial enterprises.

IV

The Independence Square Area and the Buildings of the State House Group

THE BUILDINGS of the State House, or Independence Hall, group because of their association with the winning of American independence, and also because of their architectural splendor, are probably the richest in historic significance of any in America. They were built between 1732 and 1791 as public buildings, but their original purpose of serving city and state was interrupted by key events of the Revolutionary period, with the result that they have become international shrines of American ideals. They are now the central monuments of Independence National Historic Park, maintained by the National Park Service under the supervision of the United States Department of the Interior.

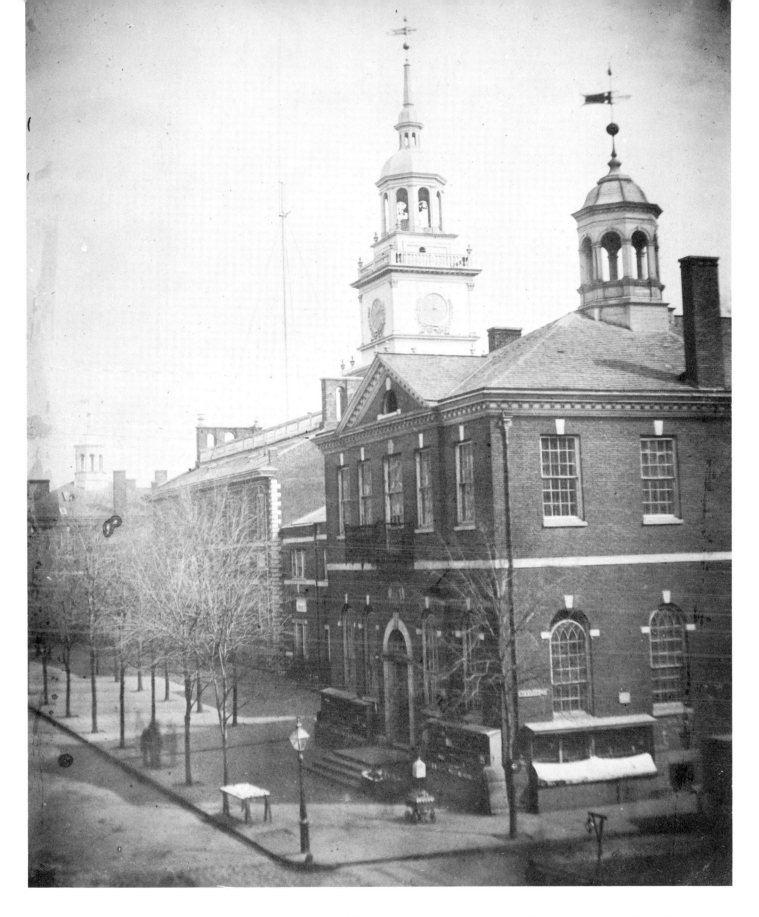

58. CONGRESS HALL, THE STATE HOUSE AND OLD CITY HALL, CHESTNUT STREET AT 6TH, C. 1855. In the foreground of this photograph is Congress Hall. It was built 1787–1789 as the county court house, but was the meeting place of congress when Philadelphia was the capital of the United States. Next to the left is the State House, begun in 1732 and completed in 1756. It served as the meeting place for the Provincial Assembly, and was the scene of many important events of the Revolution, among them Washington's appointment as general and the adoption of the Declaration of Independence. Old City Hall, barely visible in this picture, was built 1790–1791, and while the Federal government met in Philadelphia, the Supreme Court sat here. The buildings continued to be used by the city government until 1911, when they became a National Historic Site.

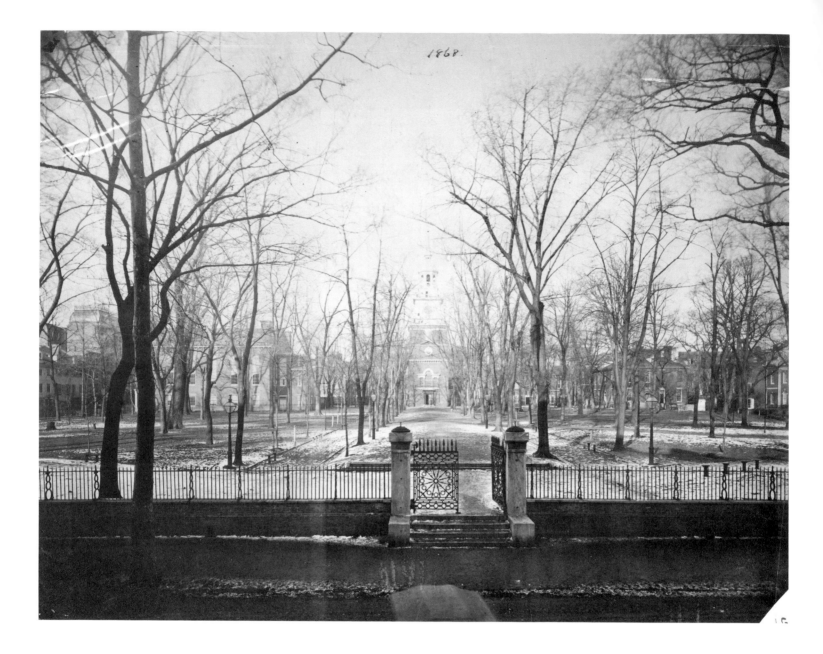

Above: 59. THE STATE HOUSE AND INDEPENDENCE SQUARE, 1868. The State House group is seen here from Walnut Street northward across Independence Square. The County Court House extension can just be seen through the trees, left. *Opposite:* 60. THE STATE HOUSE, 1873. Select and Common Councils of Philadelphia, which met in the State House from 1854 to 1895, were probably in session when this photograph was taken from a building standing opposite across Chestnut Street. *Photo by R. Newell.*

64

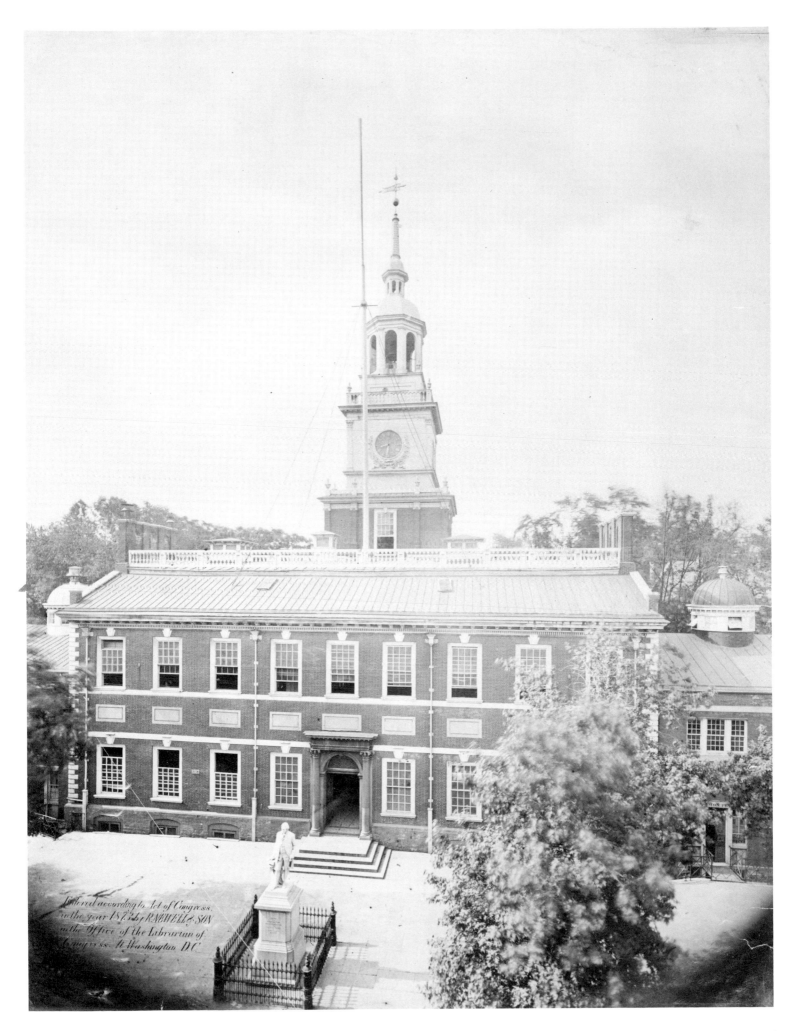

Entered according to Act of Congress, in the year 1876 by R. Newell & Son in the Office of the Librarian of Congress, at Washington D.C.

65

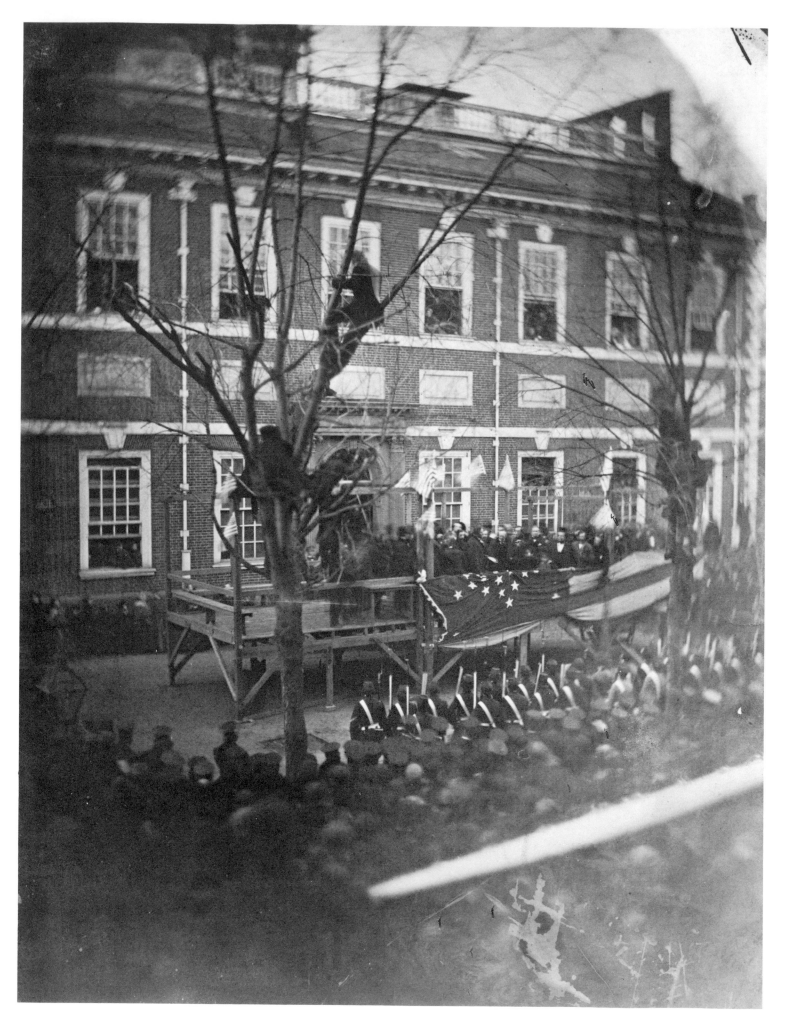

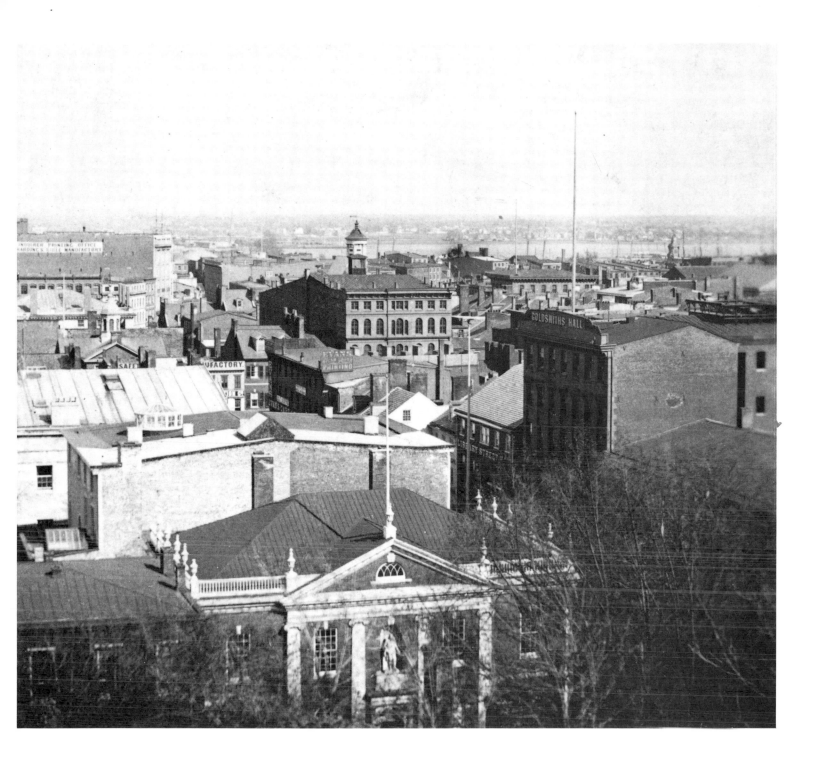

Opposite: 61. LINCOLN IN PHILADELPHIA: THE STATE HOUSE, 22 FEBRUARY 1861. This is one of the first three photographs of a President-Elect ever made. On his way to Washington, Lincoln stopped in Philadelphia and at Independence Hall raised the flag in honor of the admission of the state of Kansas to the Union. *Above:* 62. VIEW SOUTHEAST FROM THE STATE HOUSE, 1867. In the foreground of this view from the State House toward the Delaware River is the original Library Hall. This building, which had housed Franklin's Library Com-

pany, was taken down in 1888 to give space for an office building. In 1956 the site was cleared again and the Library Hall was rebuilt in its old location for the American Philosophical Society. At the extreme left center in the photograph is the white rooftop of the Second Bank of the United States, and just above it Carpenters' Hall. In the center (middle distance) rises the cupola of the Merchants' Exchange. The area seen here is now part of Independence National Historic Park.

 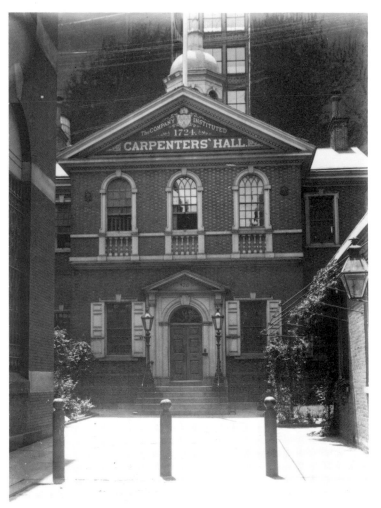

Above left: 63. CARPENTERS' HALL, CHESTNUT STREET AT 4TH, C. 1855. Built between 1770 and 1775, Carpenters' Hall is associated with many events of historical interest and importance. It was the headquarters of the Carpenters' Company, probably the oldest trade guild in America, and it once housed the Library Company founded by Franklin. It was the scene of the first Continental Congress in 1774, and of the adoption of the first resolutions of independence in 1776. During the Revolution the British used it as a hospital. By the 1850s the building had become surrounded by structures of varying description and was almost lost from view. Now a part of Independence National Historic Park, the area has been cleared and Carpenters' Hall restored to its original character and beauty. *Above right:* 64. CARPENTERS' HALL, 1900. *Opposite:* 65. MERCANTILE LIBRARY, 5TH STREET AT LIBRARY, SOUTHEAST COR- NER, C. 1870. Across 5th Street from the eastern side of Independence Square stood three landmarks: right to left, the Philadelphia Dispensary (see next picture), the Mercantile Library and Franklin's Library Company. The Mercantile Library was built in 1845, having been organized in 1817 for the use of students of various mercantile enterprises in Philadelphia. The building was demolished in 1925, and its contents moved to the Franklin Building on 10th Street. The library was ultimately absorbed by the Free Library.

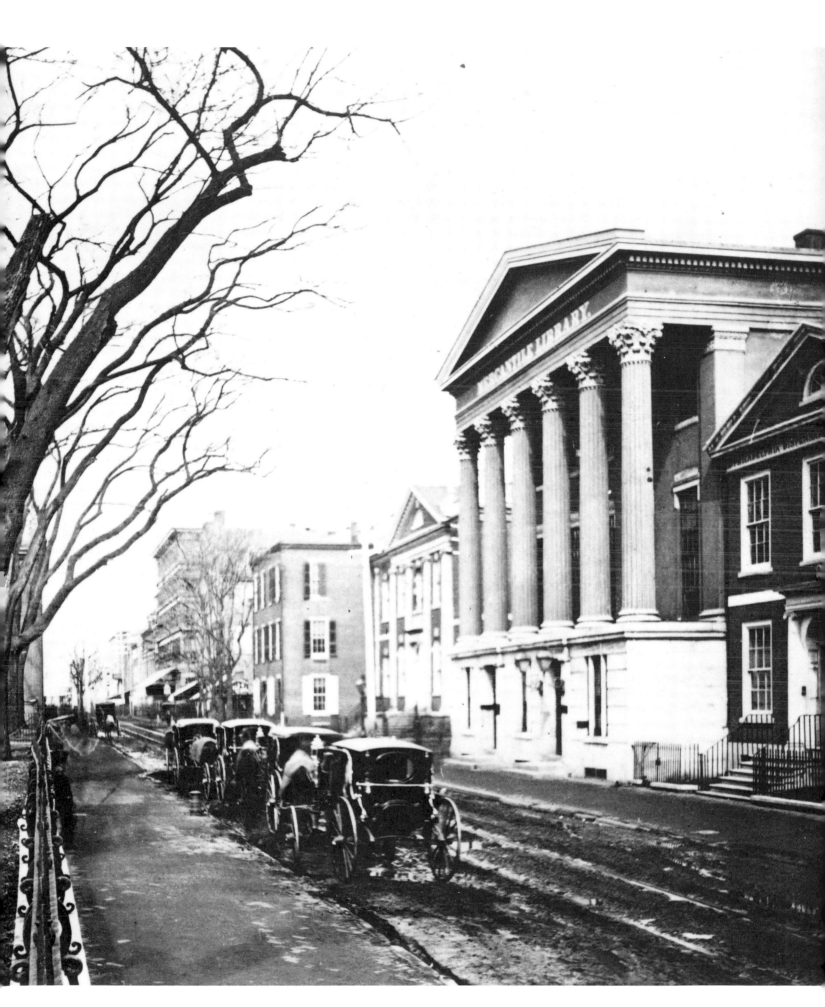

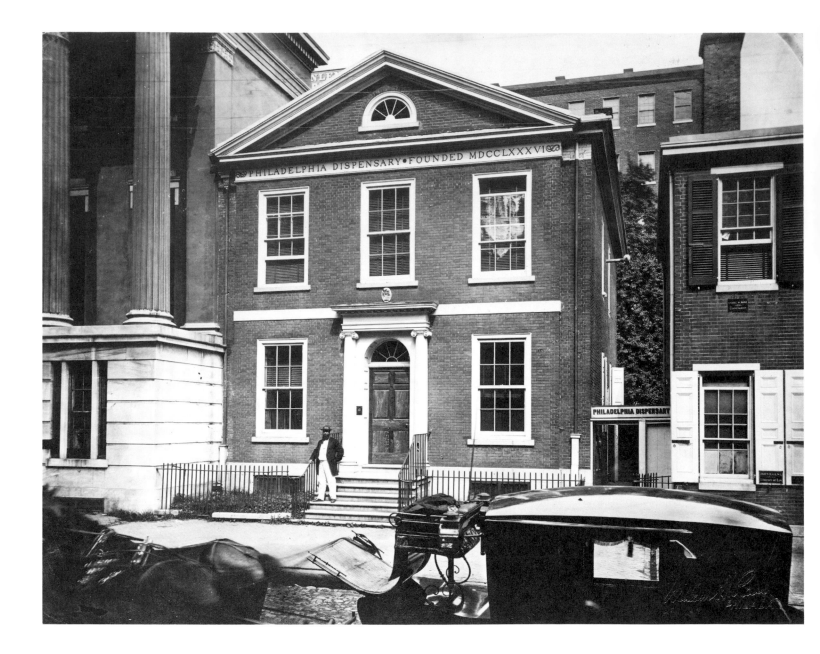

66. PHILADELPHIA DISPENSARY, 5TH STREET, C. 1902.
The Philadelphia Dispensary, on 5th Street next to the Mercantile
Library (on the left in this picture), was a charitable institution,
the oldest of its kind in the United States. It was established in
1786, with a clinic and an outpatient service whose purpose was
to minister to the sick and poor in their homes. The building
shown here, however, was not occupied until 1801. It was demol-
ished in 1922.

V

Market Street, Arch Street

and Adjacent Areas

MARKET STREET forms the east-west axis of the city, extending westward from the Delaware River across the Schuylkill River and through West Philadelphia to its western terminus at 69th Street in the suburb of Upper Darby. It has been referred to as America's most historic thoroughfare because of its importance as the High Street of the early city, and because of the various historic sites along its eastern section. At present it is one of the principal locations of business and industry in Philadelphia.

Arch Street, parallel to Market on the north, was in early days as much residential as commercial in character. Like other principal streets, in the nineteenth century it had its share of theaters, vaudeville houses and "circuses." Chinatown is now located around its eastern section, and a few residences and historic buildings remain to recall earlier splendor.

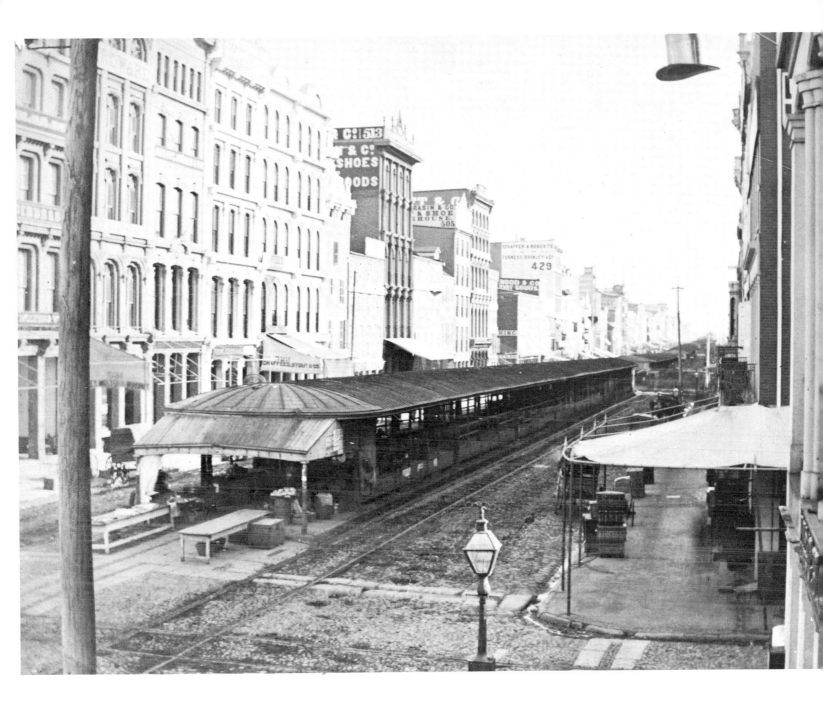

Opposite: 67. MARKET TERMINUS, MARKET STREET AT
FRONT, C. 1859. Market Street, originally High Street, was the
location of the early markets where fresh produce was brought for
sale to city residents. The earliest market shed was built in 1683
near the waterfront with access to the ferries from western New
Jersey, the chief source of farm products at that time. By the
1850s sheds had been built in Market Street as far west as 18th
Street. The terminus shown here was built in 1822. It contained
a clock, a bell to signal the opening and closing of business, and
sometimes a stall for the market clerk who functioned as a general
manager for the sheds. *Above:* 68. MARKET STREET, EAST
FROM 6TH, C. 1859. This view shows the market sheds of High
(now Market) Street. The hat at the upper right is a tradesman's
sign.

69. MARKET STREET AT DELAWARE AVENUE, C. 1900. At the turn of the century the foot of Market Street was a busy center of a variety of activities from shipping to painless dentistry. The streetcar turn-around shown here was the eastern terminus of the Market Street trolley line. The view was taken from the roof of the Pennsylvania Railroad Ferries terminus, which is seen in the next picture. *Photo by W. N. Jennings.*

70. MARKET STREET AT DELAWARE AVENUE, FROM FRONT STREET, 1906. Six years after the previous view was made, the construction of the Market Street subway was well under way. The work in progress can be seen at the right.

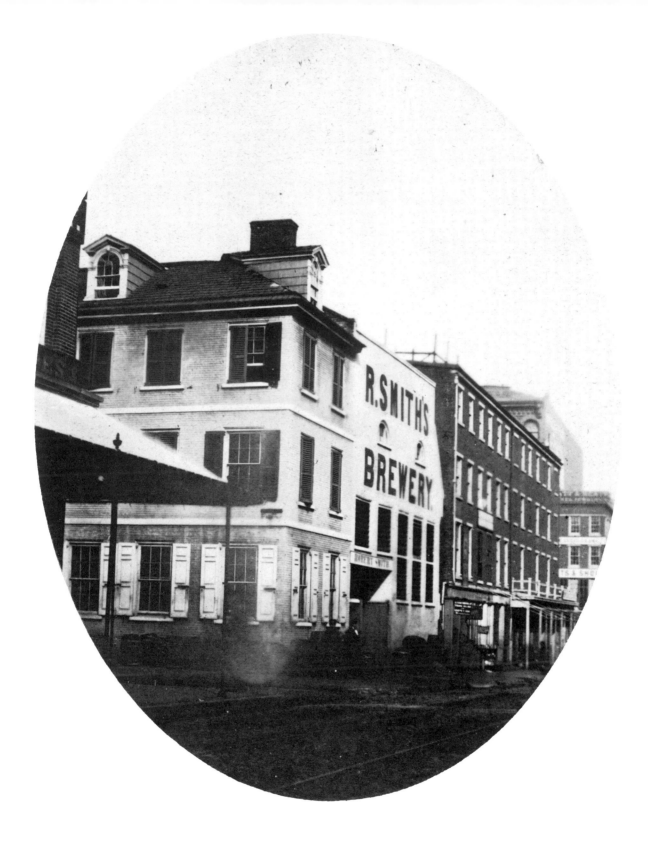

71. R. SMITH'S BREWERY, 20 SOUTH 5TH STREET, 1859. Breweries in early Philadelphia were plentiful, and seem to have been concentrated for a time in the area around Market Street at 5th, and eastward to the waterfront. Robert Smith started in the business probably in the 1820s, entered into partnership with Frederick Seckel and David Pepper in 1837, and by the 1850s had his own brewery, which is shown here. *Photo by William and Frederick Langenheim.*

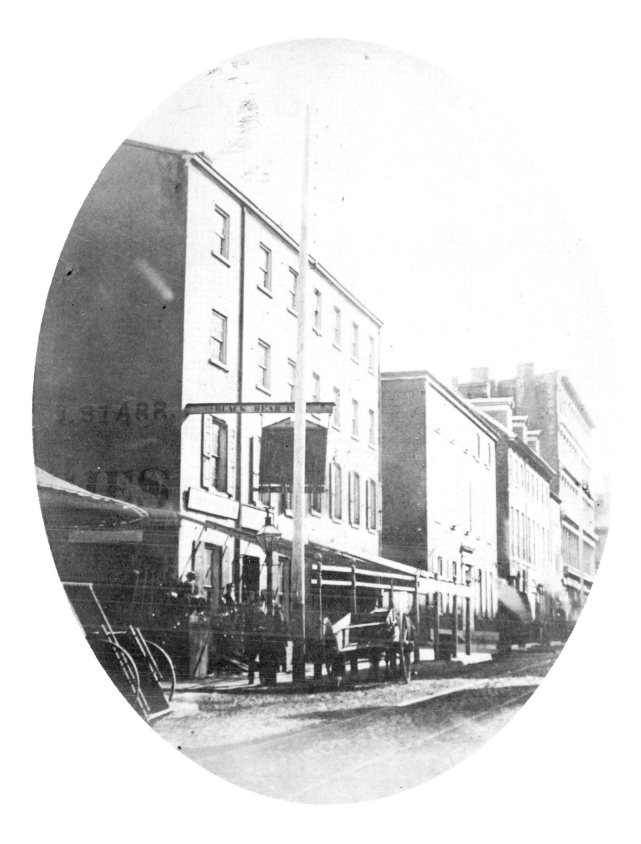

72. BLACK BEAR INN, 5TH STREET AT MARKET, C. 1859. The Black
Bear once stood near the site of the present Bourse. It is said to have been
a great gathering place for people from the West, and was one of at least
three such inns in the vicinity. *Photo by William and Frederick Langenheim.*

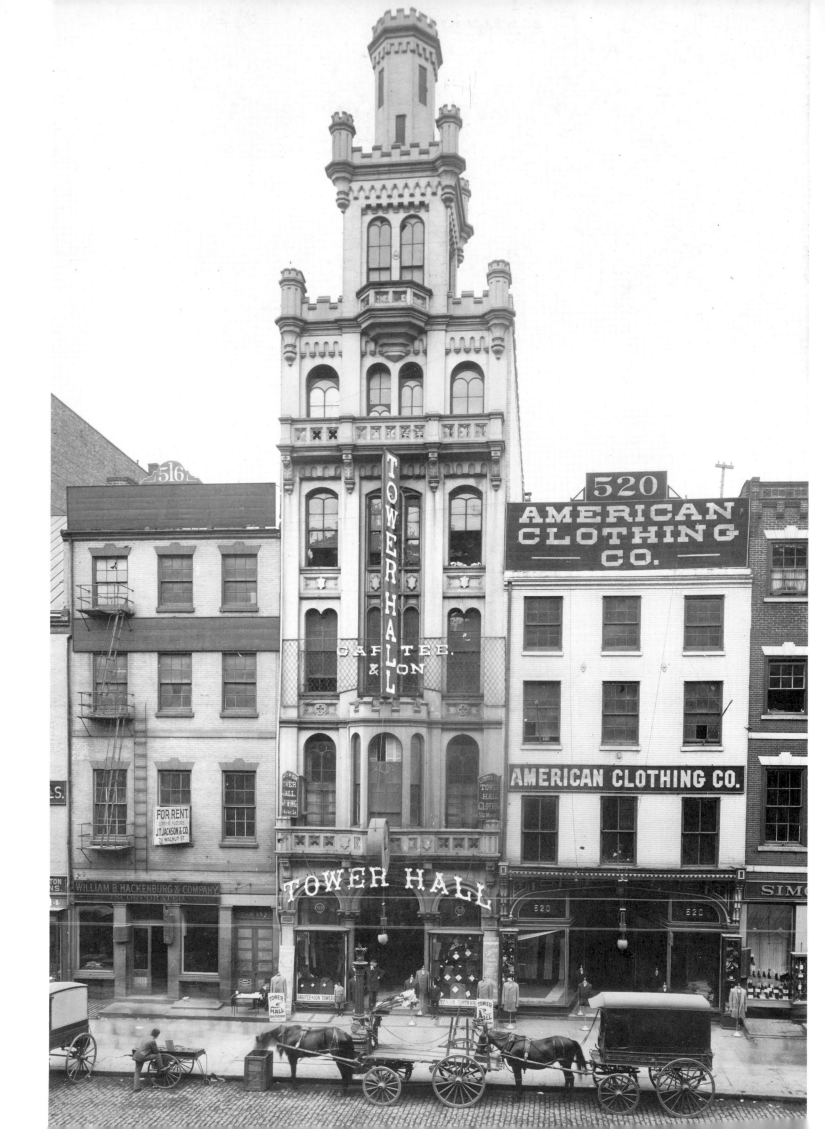

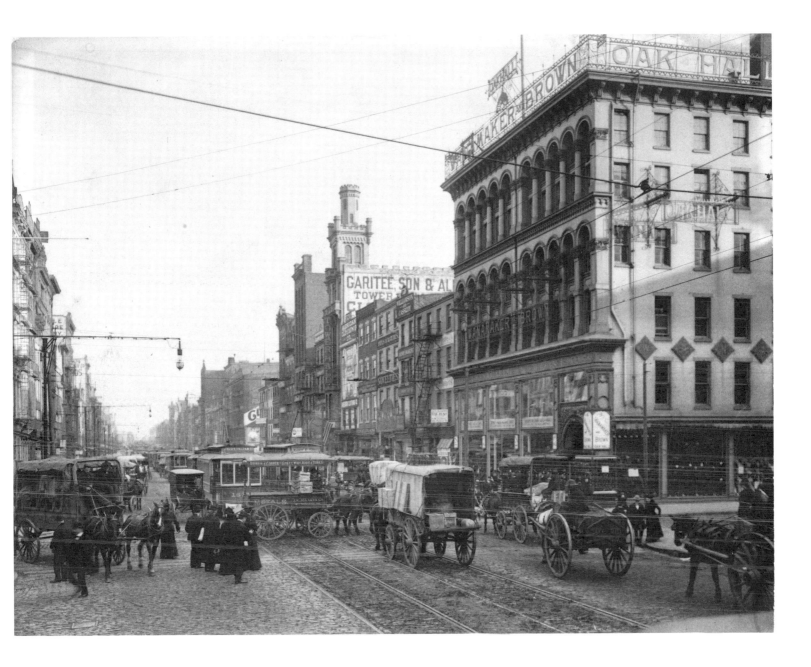

Opposite: 73. TOWER HALL, 518 MARKET STREET, C. 1898. This fanciful bit of Victoriana was erected for Col. Joseph M. Bennett, who rose to fame as a clothier and by the 1850s was owner of one of the largest businesses in the city. He attributed his success in part to his method of advertising. His printed notices were always written in verse by a specially hired "resident poet," and he also attracted the general public by means of this spectacular building, printing his name in large letters on one side, then reversing the letters exactly on the opposite side. John Wanamaker was employed in this store in his early years and here learned the clothing business and probably the power of advertising. The building was sold in 1879 to Garitee and Son, who occupied it until after 1900. *Above:* 74. MARKET STREET AT 6TH, C. 1902. The character but not the density of the traffic at this intersection has changed in the many decades since this photograph was made. On the right is John Wanamaker's first store at the corner of 6th Street. This store was opened in 1861, but continued to carry his name after he opened what became America's first department store at Market and 13th Streets. Tower Hall is also visible, center.

Above: 75. DECLARATION HOUSE, 7TH AND MARKET STREETS, C. 1856. Also called the "birthplace of liberty," this house was the residence of Joseph Graff, father of engineer Frederick Graff, when Thomas Jefferson, a delegate to the Continental Congress, wrote the Declaration of Independence while boarding here. This house was transformed completely in the nineteenth century by commercial enterprises, but now has been restored to its original state and opened as a historic site. *Opposite:* 76. *THE ITEM AND THE CALL*, NORTH 7TH STREET, C. 1889. *The Item* and *The Call* were among the earliest newspapers of Philadelphia, the former boasting on its delivery wagons a circulation of 100,000 a day. 7th Street seems to have been a center of news printing. *The Star* was also published here, and a type foundry was adjacent to *The Item*.

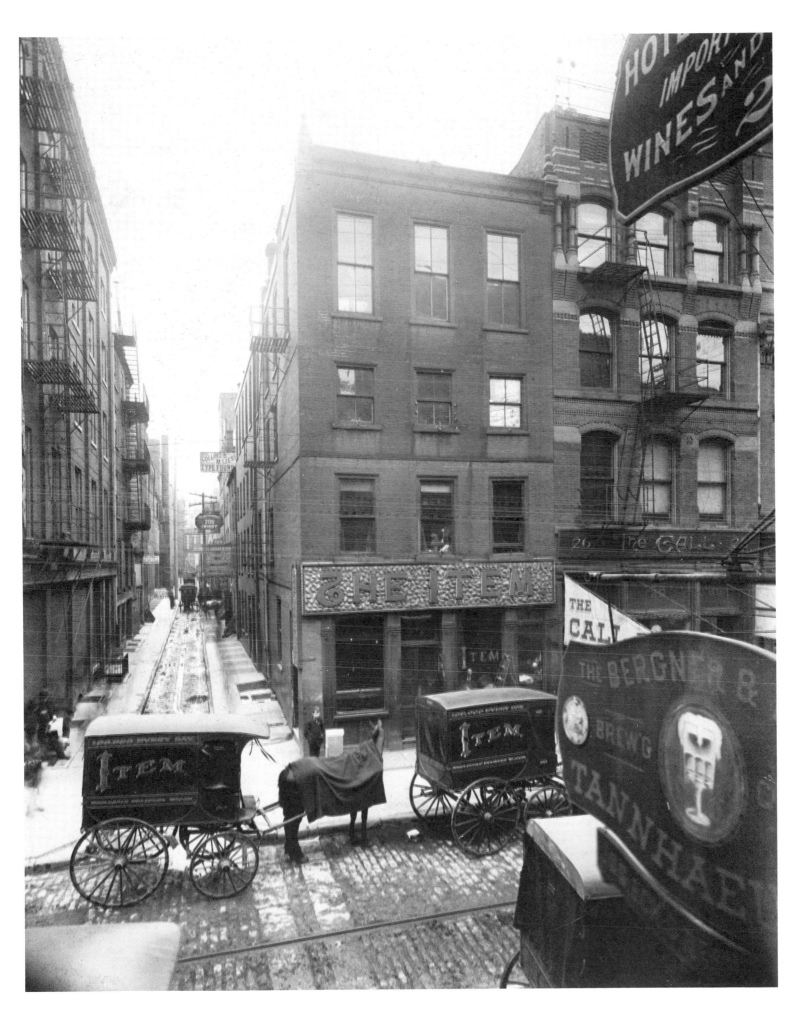

Above left: 77. FIRST UNITED STATES MINT, 39 NORTH 7TH STREET, 1861. Built in 1792 under the supervision of George Washington, this was the first property owned by the government of the United States. David Rittenhouse was the first director. Superseded in 1833 by a newer building at what is now Penn Square (see No. 138), the mint was later moved to 16th and Spring Garden Streets, and is now in new quarters opened in 1969 at 5th and Arch Streets. Caldwell's store now stands on the site of the second mint. *Above right:* 78. MARKET STREET AT 8TH, NORTH SIDE, 1846. Market Street in this photograph resembles a town of the old West, with its covered wagons and sheltered walks. The awning poles at the curbs doubtless served as hitching posts, and the sentry box at the corner, with gas lamp on top, was probably used as a board for posting advertisements and other broadsides. *Photo by Robert Cornelius. Opposite:* 79. BELL TAVERN, 48 SOUTH 8TH STREET, C. 1859. Built before 1828, this small tavern, described as a "hole in the wall," is said to have been a popular gathering place for politicians. James Boylen, whose name is on the sign beneath the window, was the owner after 1845. *Photo by William and Frederick Langenheim.*

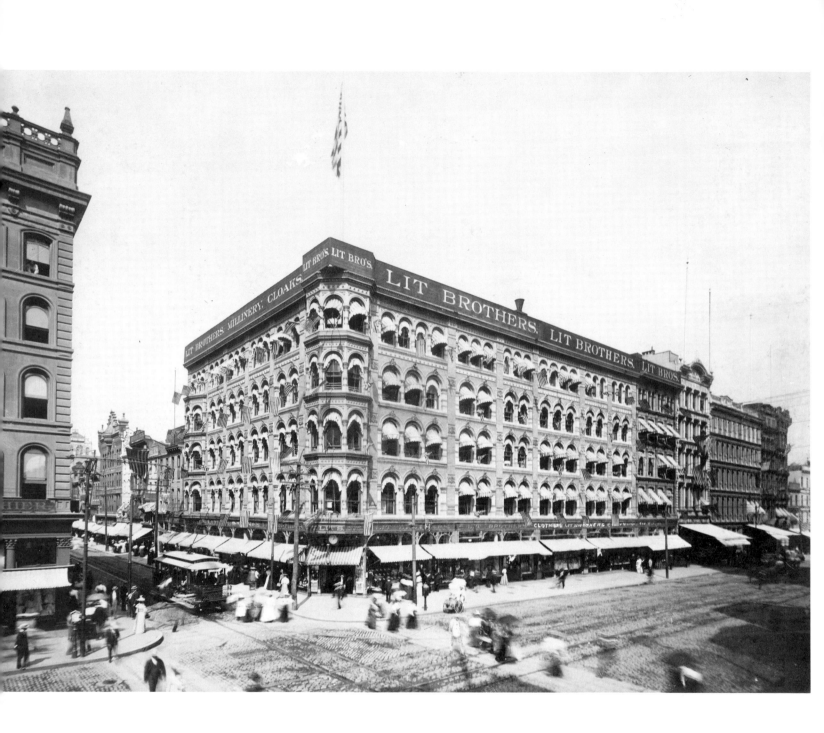

Above: 80. LIT BROTHERS, MARKET STREET AT 8TH, NORTHEAST CORNER, C. 1898. The cast-iron facade of Lit Brothers Department Store is one of the very few remaining in the city today. Built from designs of Collins and Autenrieth, the building is now an architectural landmark. *Opposite:* 81. 8TH STREET, NORTH FROM MARKET, C. 1860. Store fronts in this busy thoroughfare offer many curiosities designed to attract passersby. Northward from a point outside the present Lit Brothers Department Store, a menagerie of ornamental signs is visible: an ostrich on the drapery store, and beyond it an elephant; the figure of Justice atop the cupola in the distance, and the eagles of a furniture company and Espen's lace emporium.

86

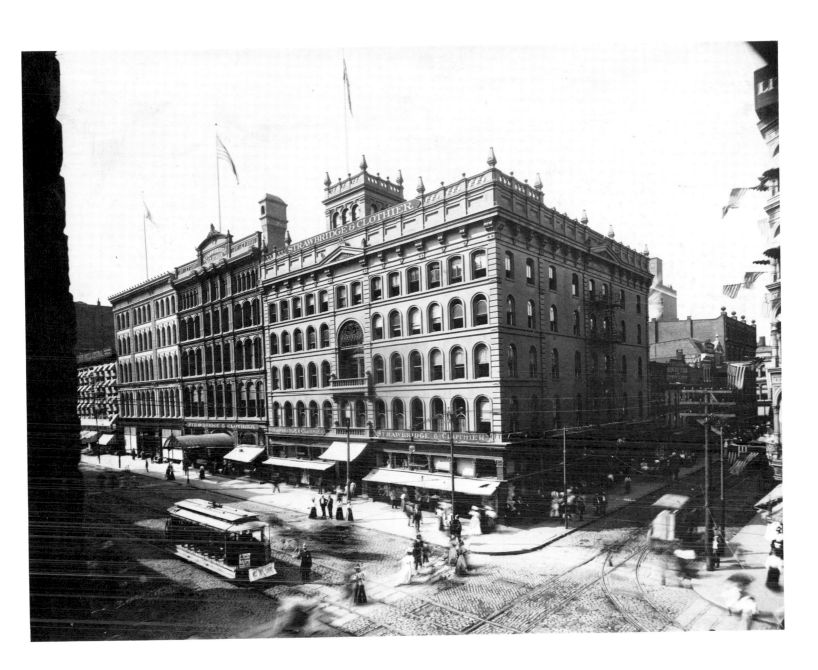

Opposite: 82. ESPEN'S STORE, 31 NORTH 8TH STREET, C. 1856. Ornamental eagles were frequently used above store fronts, hotel cornices and clock towers. Samuel and Jacob Espen erected this ornate clock tower with eagle partly to give height to the store front, and also to provide an eye-catching signboard upon which to proclaim their merchandise of fancy lace and embroideries. The objects in the immediate foreground are the awning and awning poles of the building from whose second-story window the photo was made. *Above:* 83. STRAWBRIDGE AND CLOTHIER, MARKET STREET AT 8TH, C. 1898. This famed department store was founded in 1868, the first of three large firms to be established in this area. It extended progressively along Market Street almost to 9th, and on 8th Street to Filbert. The pure Victorian facades shown here were remodeled in the 1920s to a modern design. The many flags out are possibly for the Peace Jubilee of October 1898 (see No. 179).

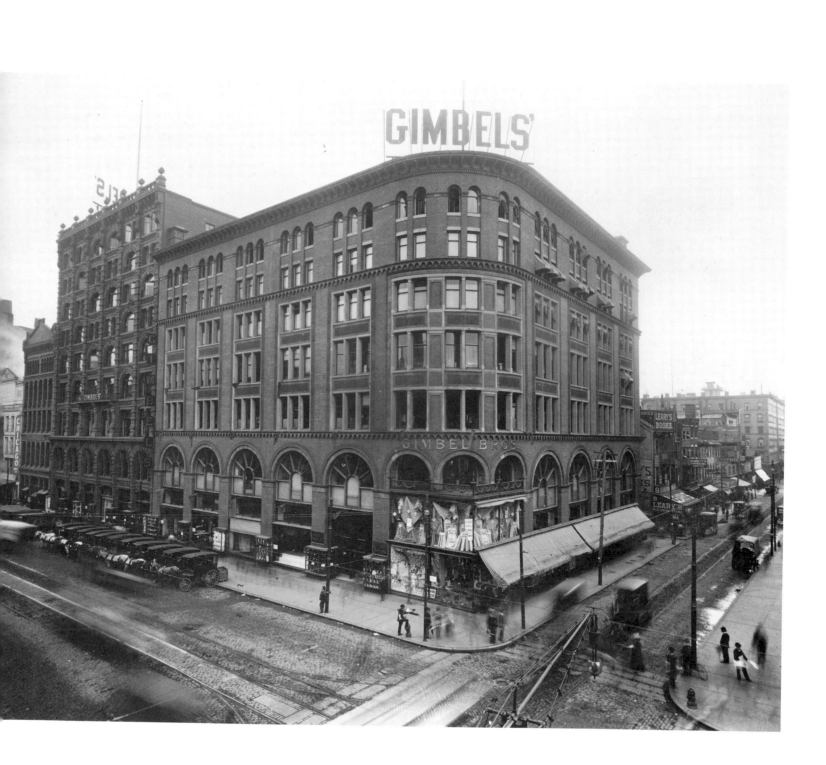

84. GIMBEL BROTHERS, MARKET STREET AT 9TH, SOUTHEAST CORNER, C. 1899. Gimbel Brothers was the last of the three big department stores to open in the 9th Street area. It is seen here with its fleet of horse-drawn delivery trucks, left. On 9th Street, right, is Leary's Book Store, another landmark.

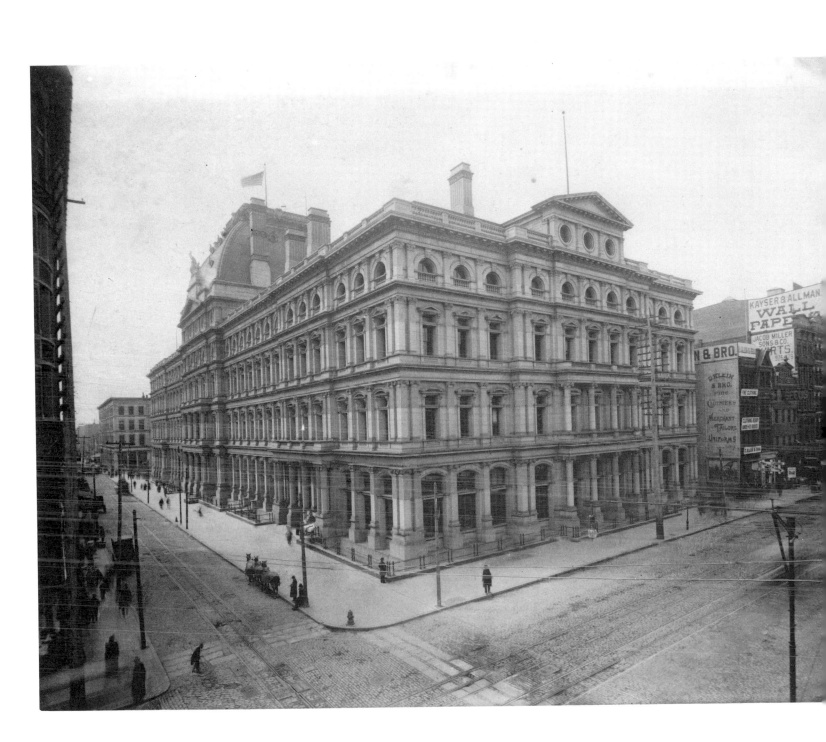

85. UNITED STATES POST OFFICE, MARKET STREET AT 9TH,
C. 1890. Built between 1873 and 1884, the United States Post Office and
Federal Building stands on what was once the site of the University of
Pennsylvania. The building shown here was replaced in 1935 by the present
structure.

86. MARKET STREET, WEST FROM 9TH, 1907. This photograph belongs to a group that formed a study of Philadelphia trolley cars. The detail in focus here is the side track at the United States Post Office, left, which provided for loading and unloading the fleet of mail trolleys then in use. Mail trolleys were discontinued after 1915.

87. MARKET STREET, EAST FROM 10TH, 1907. A mail trolley is just
visible (at the very center) on the siding at the Post Office, right, in this busy
scene from the same series as the preceding photo.

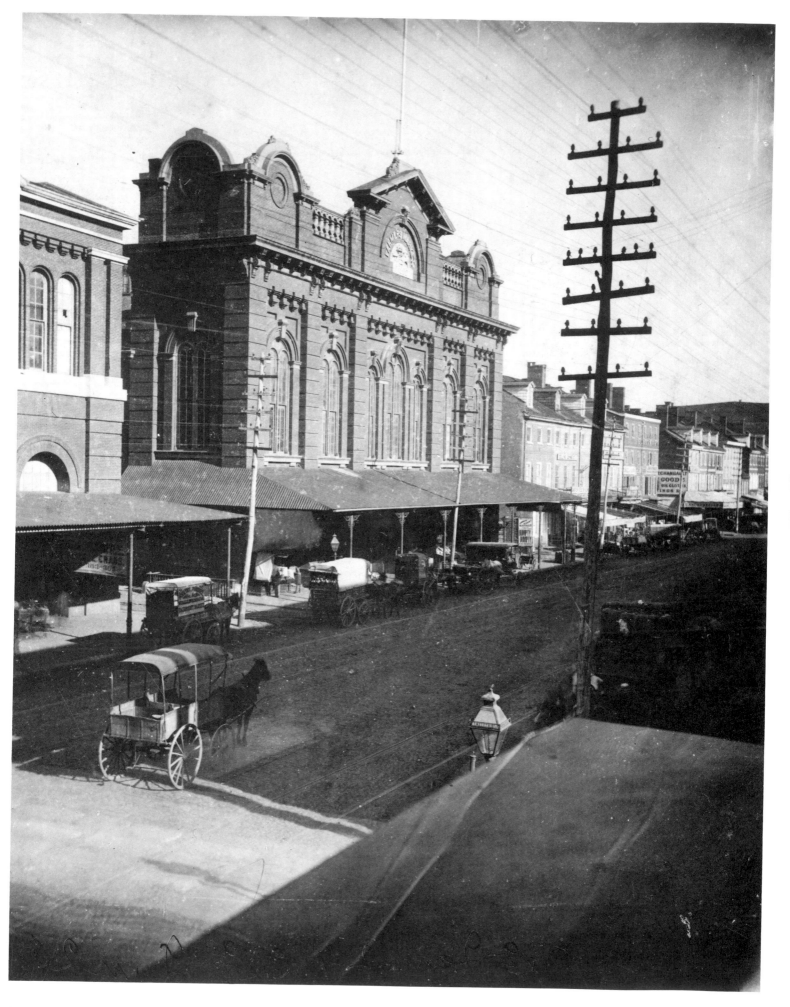

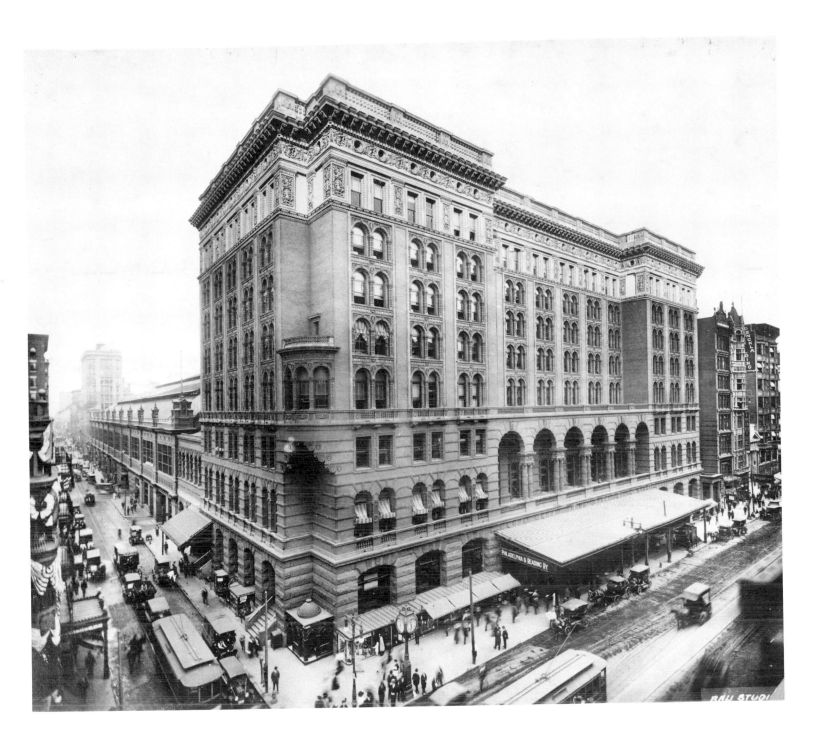

Opposite: 88. MARKET STREET, EAST FROM 12TH, C. 1880.
The Farmer's Market house was one of many built to replace
sheds which had stood in the middle of streets. This house was
the largest of all and was the predecessor of the well-known
Terminal Market in the Reading Railroad Terminal, which now
occupies this site. *Above:* 89. **MARKET STREET AT 12TH**,
C. 1912. Traffic at this intersection was no less heavy in 1912 than
it is in the 1970s. Professional and business men, travelers, laborers
and shoppers all converged at this busy crossing. Well-dressed
ladies and gentlemen suggest an affluence that is rarely to be seen
here now. Reading Terminal occupies most of the foreground,
and the old Hotel Vendig is at the left. *Photo by William H. Rau.*

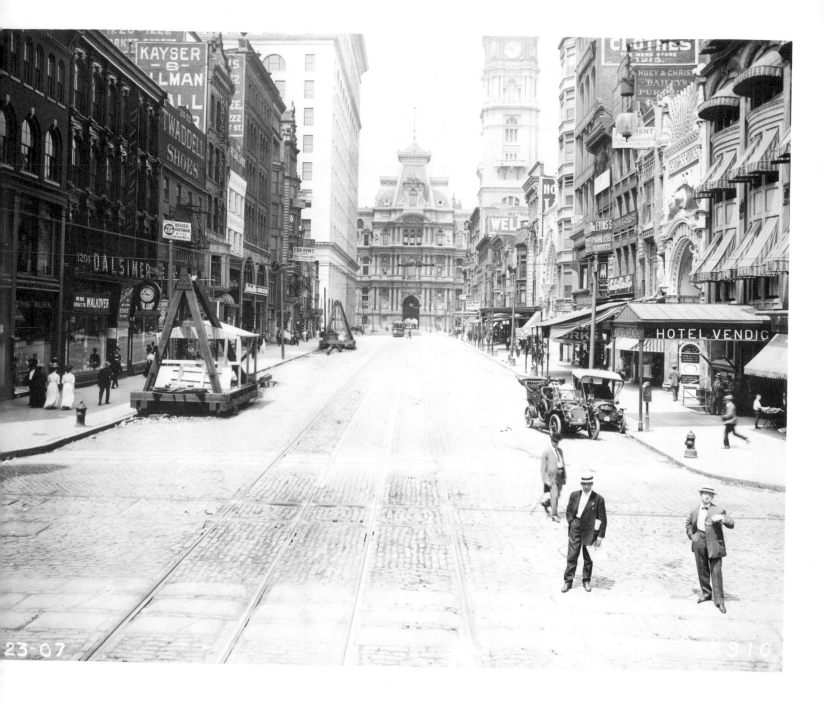

Above: 90. MARKET STREET, WEST FROM 12TH, 1907. The machines on the left side of the street in this view were in position for the construction of the Market Street subway. Some of the city's first automobiles stand before the Hotel Vendig, opposite. Next to the hotel the Bijou-Dream Theatre advertises all that is best in life-motion pictures. *Opposite:* 91. MARKET STREET AT 13TH, NORTHEAST CORNER, C. 1894. A shoestore now occupies this site across Market Street from John Wanamaker's, and the building at the far right, once a residence, was long ago displaced by a clothing store.

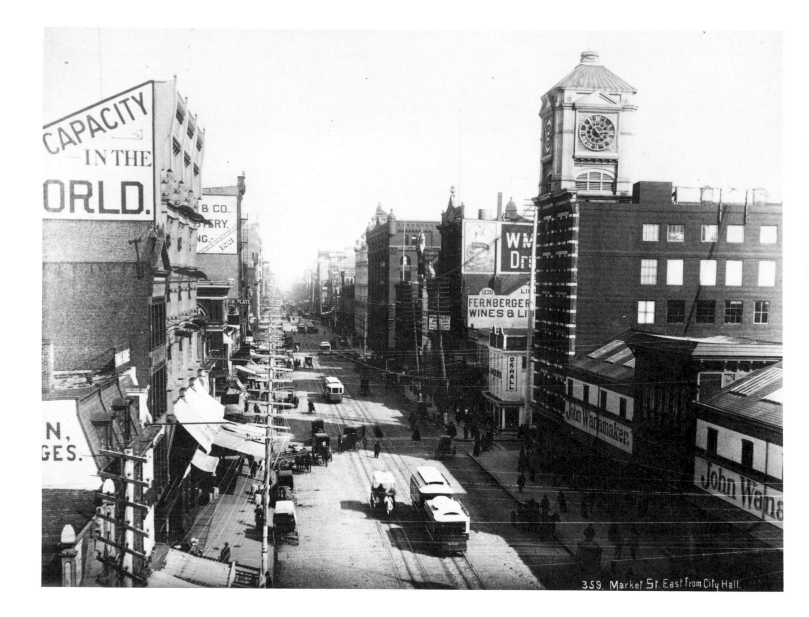

359. Market St. East from City Hall.

92. MARKET STREET, EAST FROM CITY HALL, 1889. This view to the east along Market Street shows the old Wanamaker emporium, or Grand Depot, as it was once called, on the right. The building with the clock tower also became part of the store before the present building was erected in 1905.

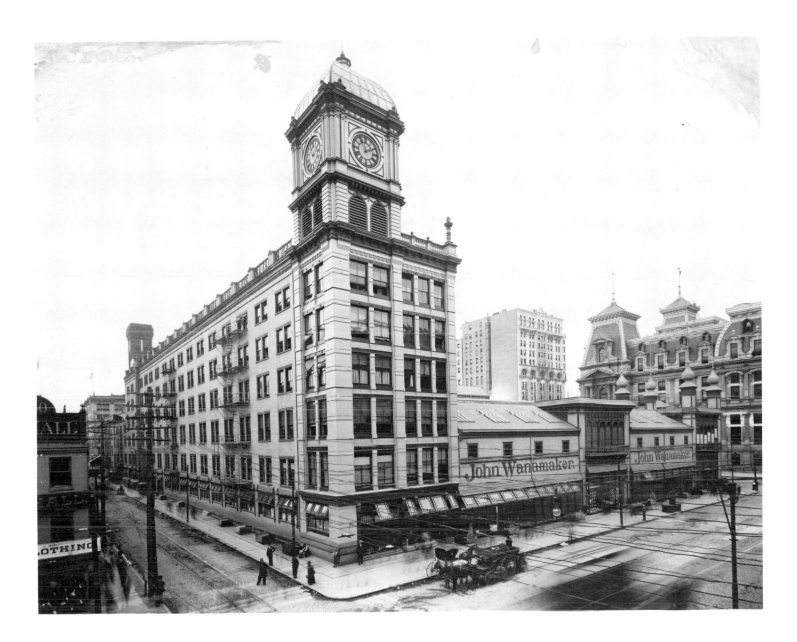

93. JOHN WANAMAKER'S STORE, 13TH AND MARKET STREETS, C. 1900. John Wanamaker's Grand Depot was originally opened in 1876 on the site formerly occupied by the Pennsylvania Railroad Freight Depot. This photo was made before the Grand Depot was taken down and the new store opened in 1905.

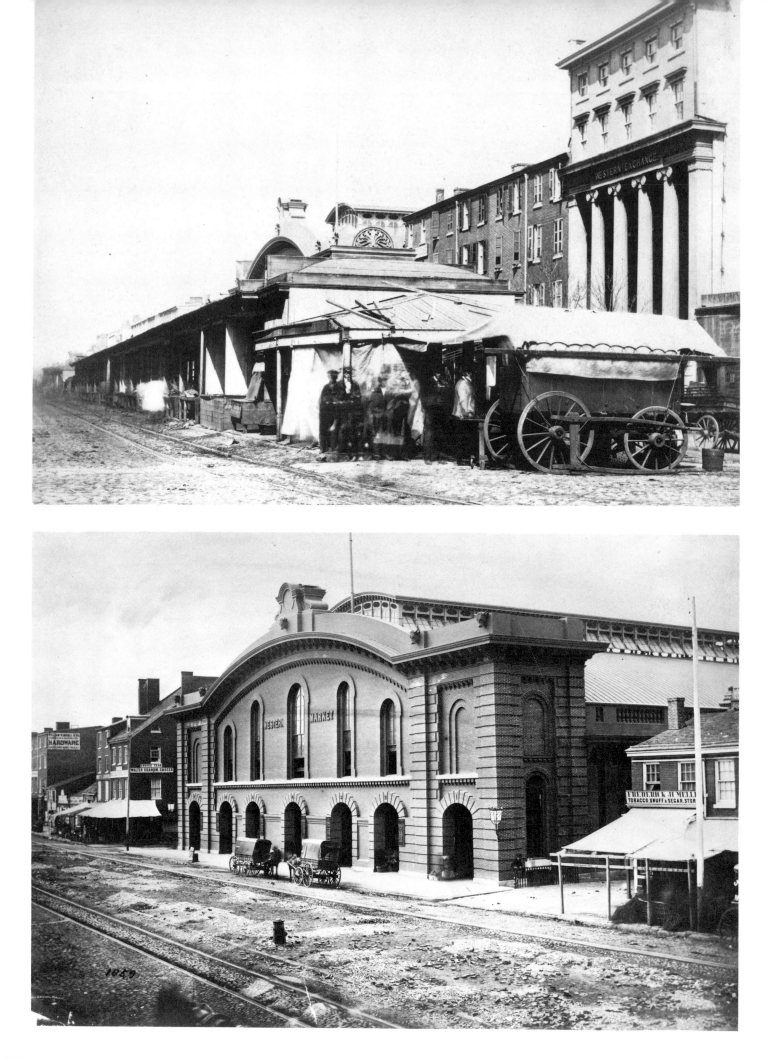

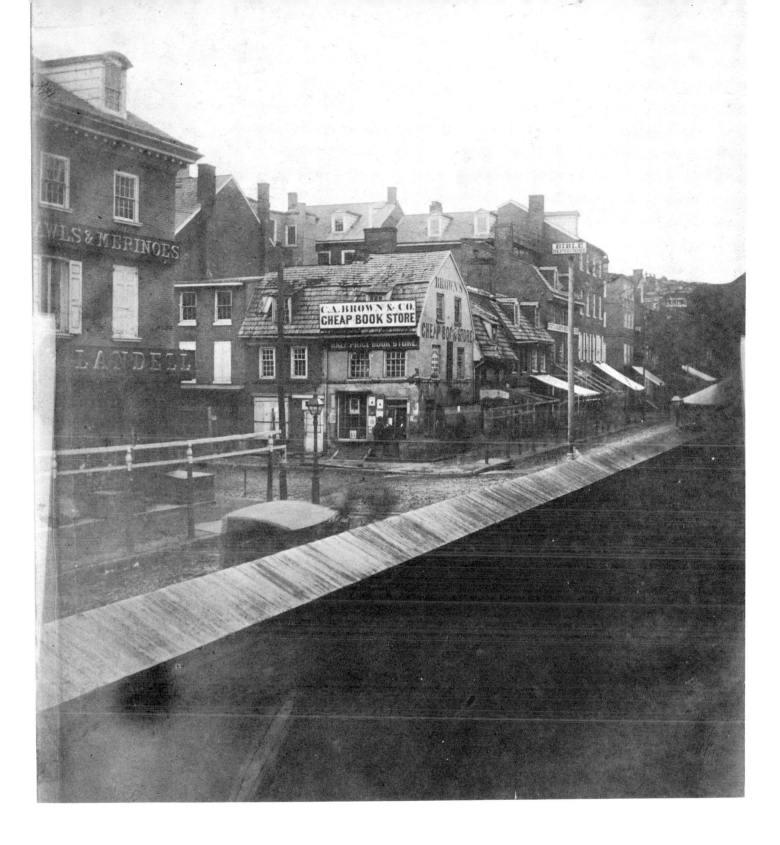

Opposite above: 94. MARKET STREET, WEST OF 15TH, 1859. Visible beyond the market sheds just left of center in this photograph are the Western Farmers' Market, residences and business houses standing on the site subsequently occupied by the old "Chinese Wall" (see No. 158), Broad Street Station and, at present, the Penn Center complex. *Opposite below:* 95. WESTERN MARKET, MARKET STREET AT 16TH, NORTHEAST CORNER, C. 1859. This was the westernmost market house in Market Street, built to replace the market sheds which were removed by city ordinance after 1859. It received the fresh produce brought in by farmers from areas to the north and west and beyond the Schuylkill River. *Above:* 96. C. A. BROWN & CO., 4TH AND ARCH STREETS, C. 1854. Brown's Book Store, advertising books at half-price, was but one of a number which called themselves cheap. The poor condition of the Dutch Colonial buildings here seems in odd contrast to the cultivated atmosphere of the trades announced by the signs—Bible Depository, Stationery and Brown's Books. A note attached to this photograph indicates that these buildings were demolished soon after the picture was taken. In the foreground is the wall surrounding the Friends' Meeting House, on the southeast corner of this intersection, which is still standing in that location.

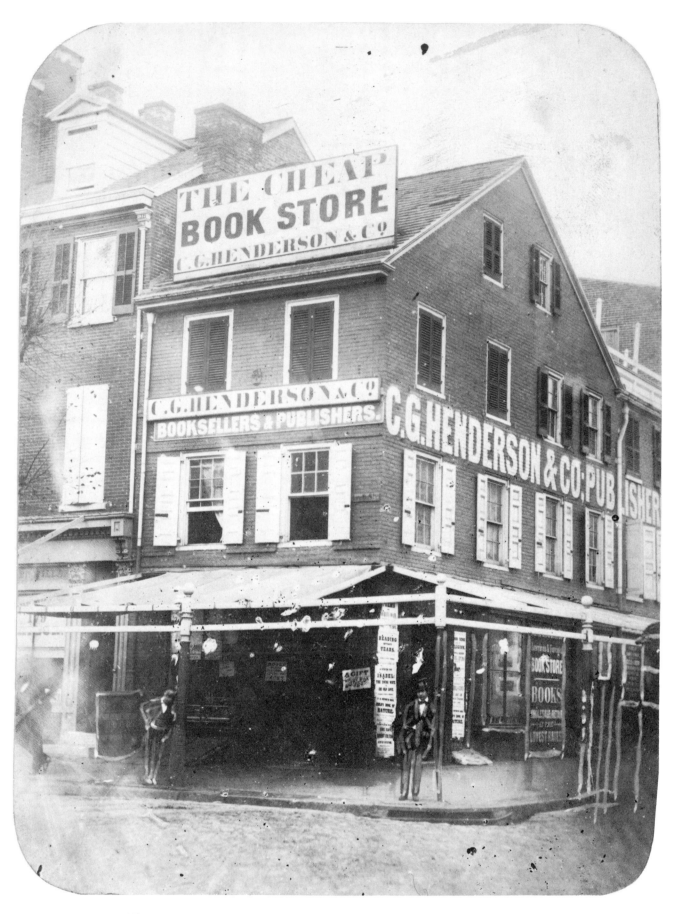

97. HENDERSON PUBLISHING COMPANY, 5TH AND ARCH STREETS, 1857. Henderson's Cheap Book Store was a block away from Brown's, and nearer the district of the more sensational theaters and entertainments. Signs near the doorway advertise available titles, among them "Reading without Tears." George W. Childs, later the publisher of the *Public Ledger*, owned this book store in 1858. The building ultimately succumbed to less cultural influences and became a taproom.

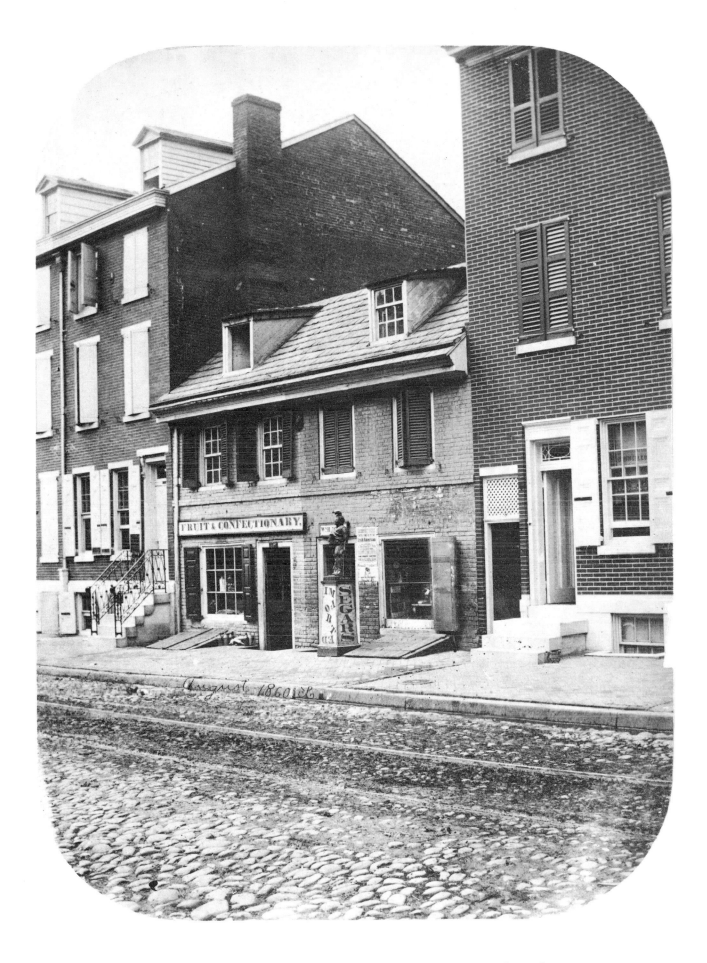

98. 5TH STREET AT ARCH, 1860. A nineteenth-century wooden Indian guards a tobacco shop and a confectionery housed in buildings of Colonial vintage. This scene is in the section of Philadelphia often referred to as the "Old City," which is roughly the area north from Society Hill to Vine Street, and west from Front to about 7th.

Opposite: 99. 5TH STREET AT ARCH, 1860. This scene is in the same immediate neighborhood as the view preceding. The archway at the extreme right opens into an alley, or "easement," between houses. *Above:* 100. ZION LUTHERAN CHURCH, 4TH STREET AT CHERRY, C. 1868. The first Zion Lutheran Church, built on this site in 1766, was used by the British as a hospital during the Revolution, and the Congress met there to give thanks for the surrender of Cornwallis. It was burned down in 1794. The second church, seen in the photo, was erected in 1796, and was considered the largest and finest church in America. The Congress came there in 1799 to mourn the death of George Washington. The building was razed in 1869.

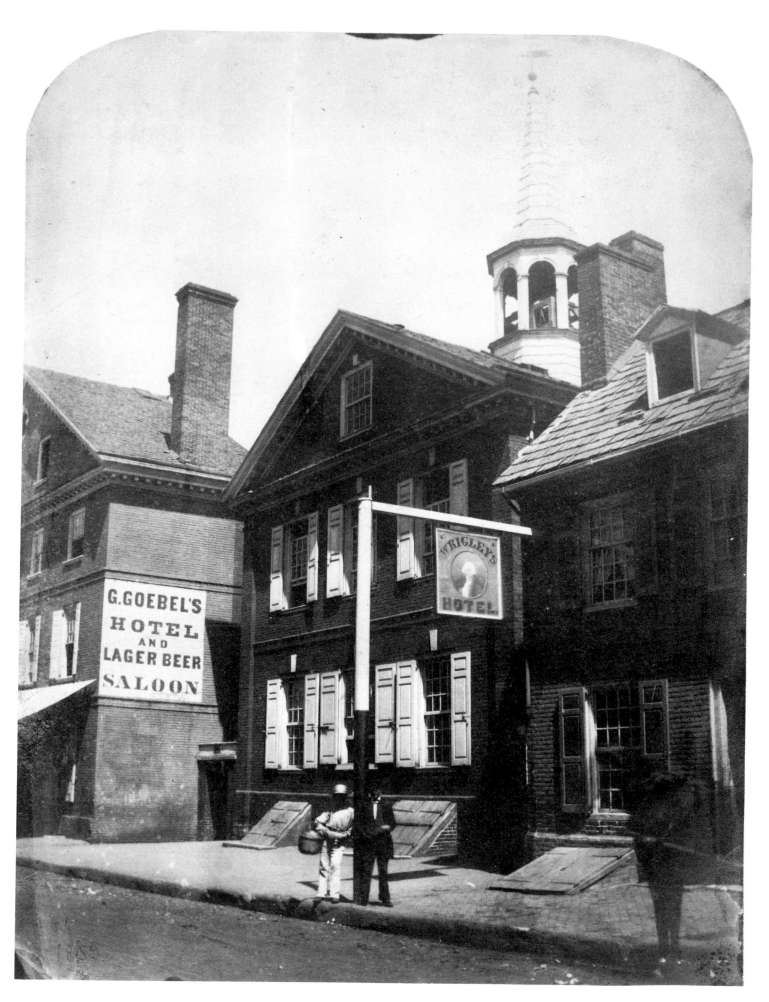

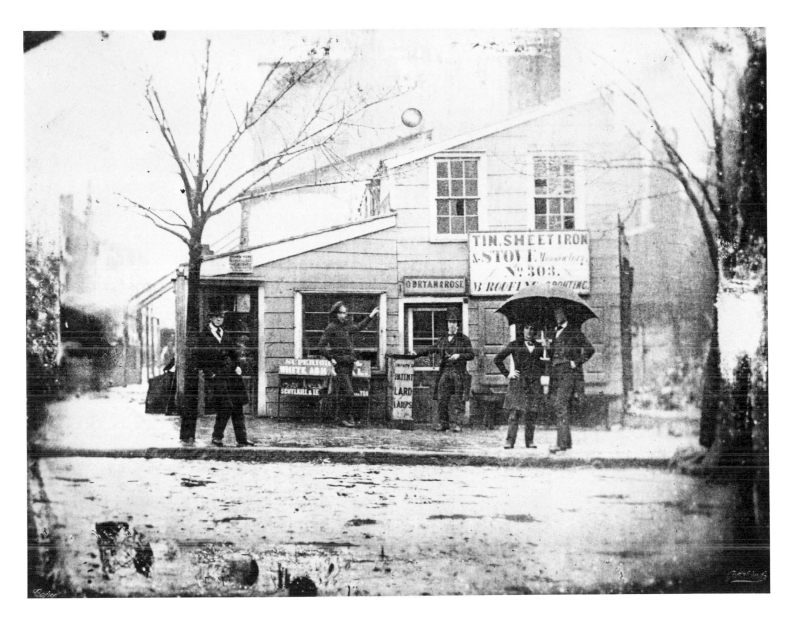

Opposite: 101. THE GERMAN LUTHERAN SCHOOL AND PARISH HOUSE, CHERRY STREET AT 4TH, 1859. Dating from before 1764, this school served the Zion Lutheran Church, which stood opposite across Cherry Street, in several capacities. It was used not only as an educational institution, but also as a parish hall and an early meeting place for the German Society. In its belfry hung the bells originally intended for the church. In later years the building was appropriated for commercial uses, as business and industry expanded westward from the Delaware River front. *Above:* 102. 8TH STREET AT ARCH, NORTHEAST CORNER, 1840/47. One of the earliest views of Philadelphia, this shows a group of men casually posed outside a sheet-iron dealer's establishment on the northeast corner of the intersection of 8th and Arch Streets. The area appears not to be densely populated, though at this time it was by no means remote from the center of business activity. A note on the reverse of the photograph states that the picture was taken from a daguerreotype of 1840/41. City directories, however, do not list the company of O'Bryan and Rose until 1847.

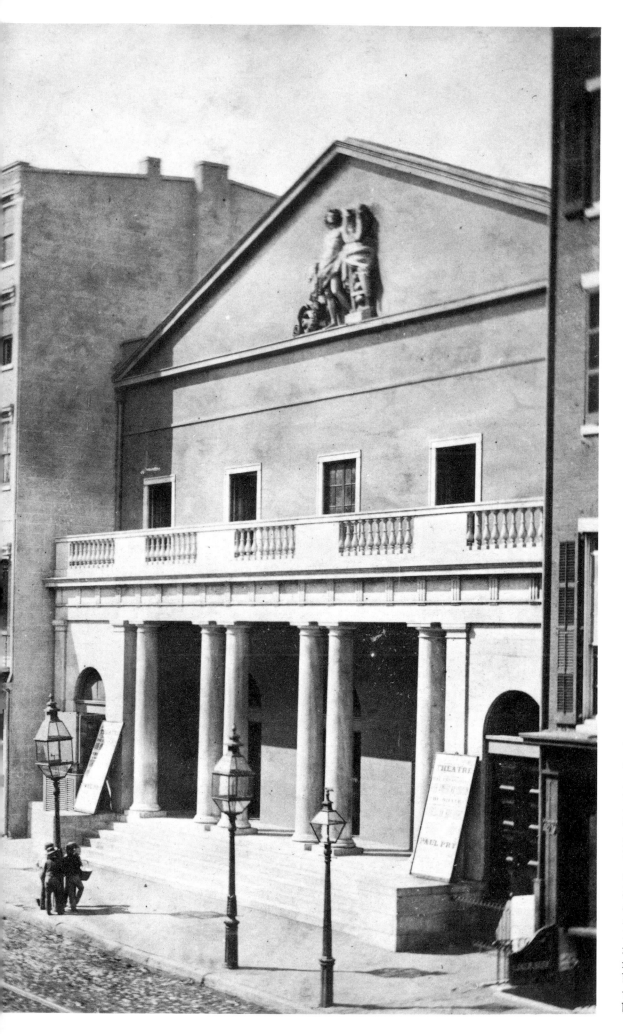

Left: 103. ARCH STREET THEATRE, ARCH STREET AT 6TH, 1860. This is the original theater in Arch Street which opened in 1828. It had a succession of managers, among whom were the famous Irish comedian John Drew and, later, his widow, Mrs. Louisa Drew (they were the parents of the more famous actor John Drew and the maternal grandparents of Ethel, Lionel and John Barrymore). The theater seen in this photo was badly damaged by fire in 1863 and subsequently remodelled extensively. *Photo by John McAllister.* *Opposite:* 104. ARCH STREET THEATRE, ARCH STREET AT 6TH, C. 1865. This photograph shows the remodelled theater. It underwent many structural and other changes but survived until 1936, when it was removed to make way for businesses.

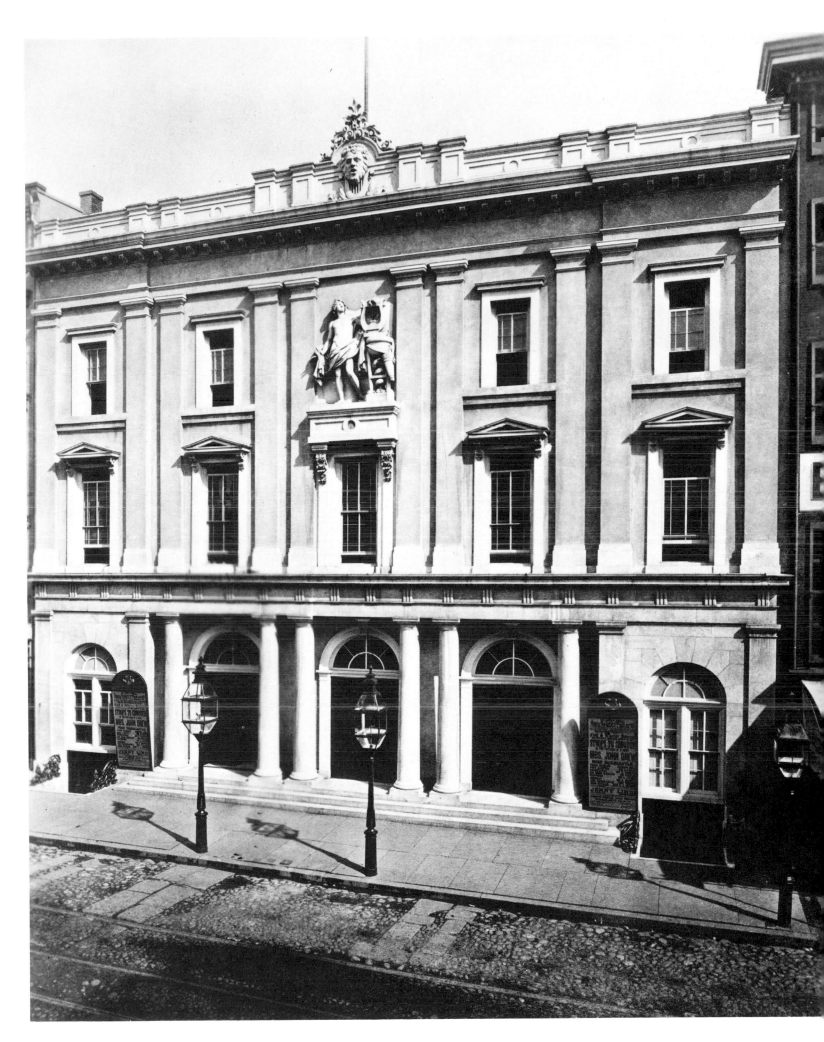

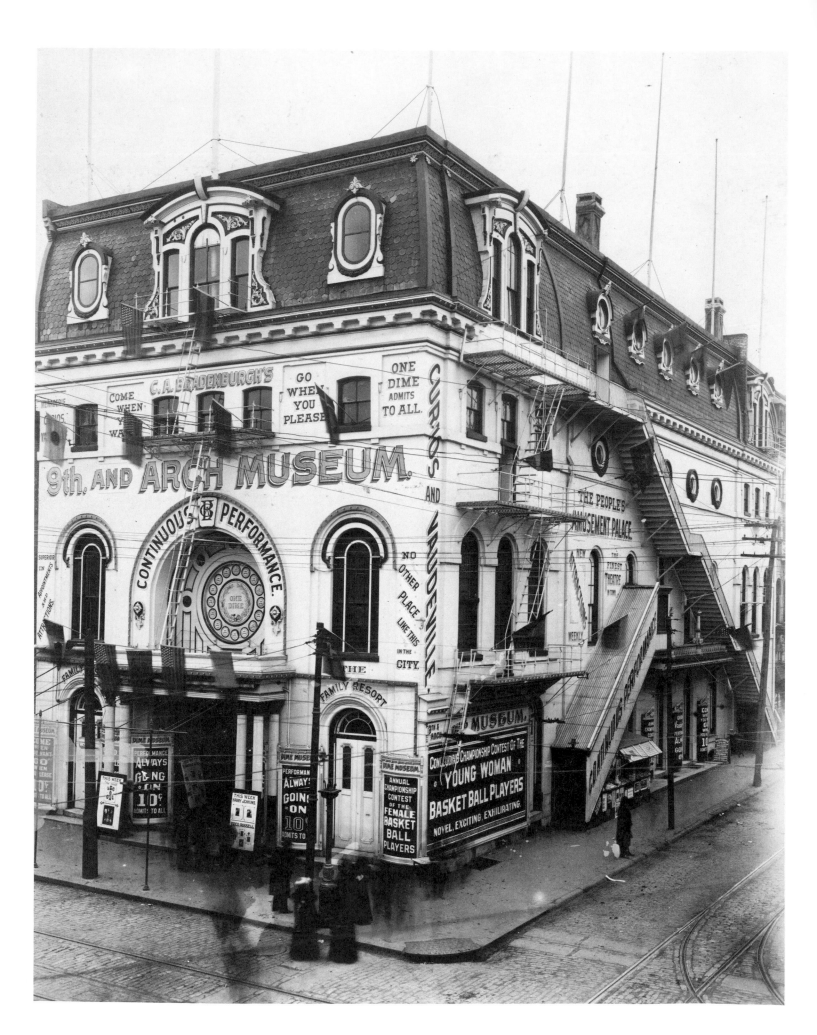

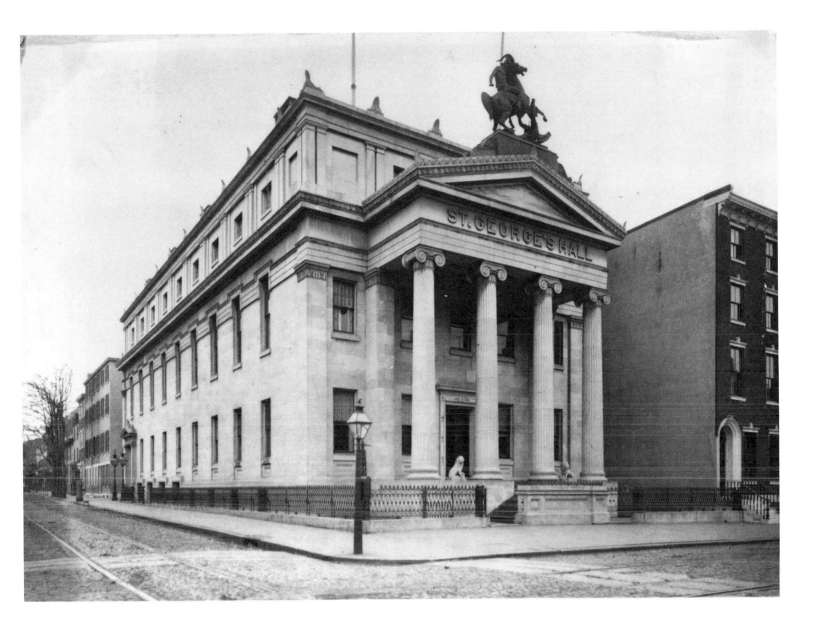

Opposite: 105. C. A. BRADENBURGH'S MUSEUM, 9TH AND ARCH STREETS, C. 1890. Amusement "palaces" of this kind were frequently called museums, partly because of the variety of their exhibits and partly for respectability. They not only displayed objects but also offered performances ranging from vaudeville acts to sports events. Philadelphia had a number of such museums, the one shown here typifying the kind of popular entertainment found on Arch Street. *Above:* 106. ST. GEORGE'S HALL, ARCH STREET AT 13TH, C. 1895. Originally the home of Matthew Newkirk, railroad executive, this spendid house was built by the famous architect Thomas U. Walter in the 1850s. In 1876 it became the headquarters of the Society of the Sons of St. George, organized in 1772 to assist Englishmen in distress in America. The building was sold again in 1901, when the Society moved to Arch Street at 19th, and was taken down soon after. The elegant old marble mansion once dominated an area of charming Victorian row houses, which themselves were displaced many years ago by stores and other buildings standing opposite the present Trailways Bus Terminal.

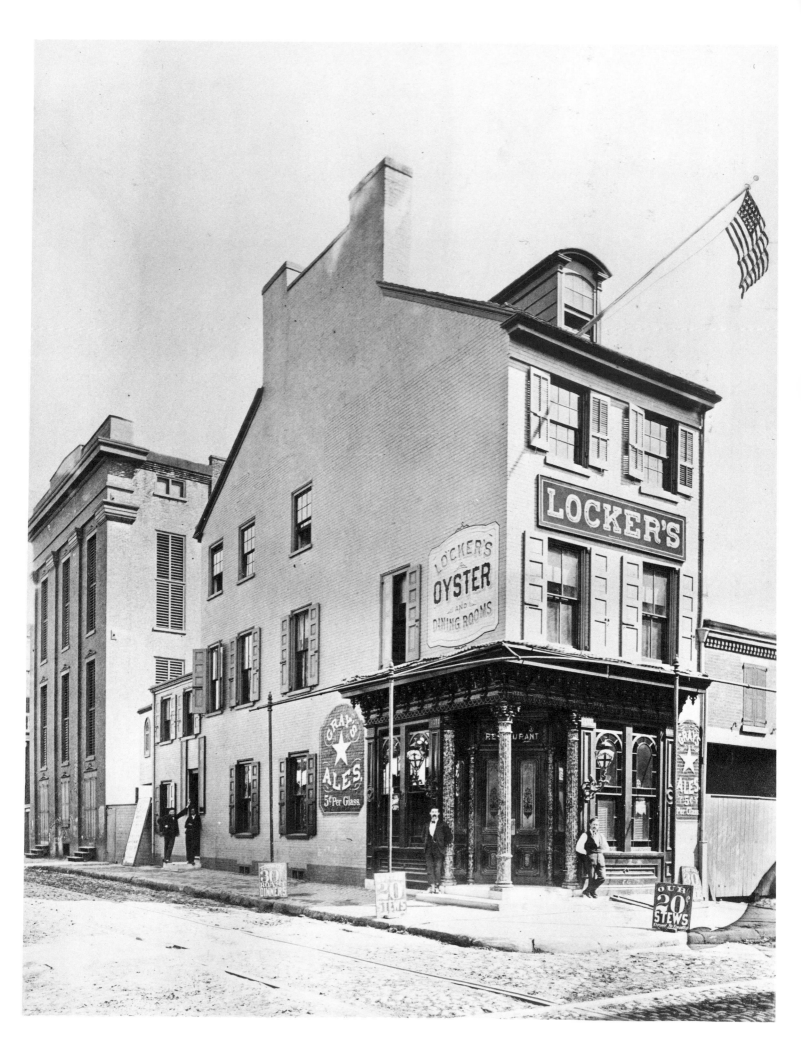

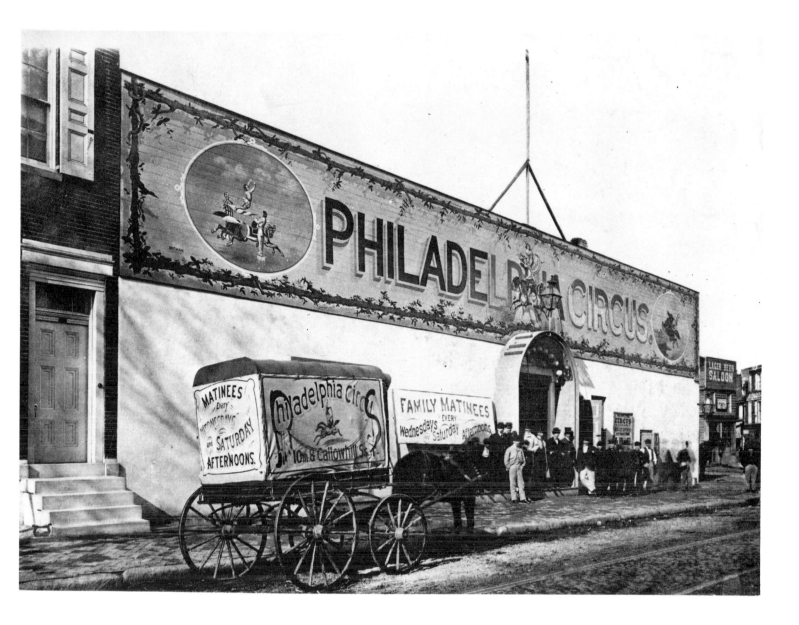

Opposite: 107. LOCKER'S RESTAURANT, 8TH AND VINE
STREETS, 1868. The specialty of this corner restaurant, as the
sign tells, was oysters, particularly oyster stew. The Victorian
corner doorway and windows have obviously been applied to a
building of an earlier period, a practice as much in vogue then as
now. *Above:* 108. PHILADELPHIA CIRCUS, CALLOWHILL
STREET AT 10TH, C. 1890. Formerly the New National Theater,
which had opened in 1876, this theater was outside what was
then considered the theater district, in a section on the northern
limit of the city. As the picture indicates, it offered vaudeville
entertainments and live animal acts. The wagon was a delivery
vehicle as well as a mobile advertisement.

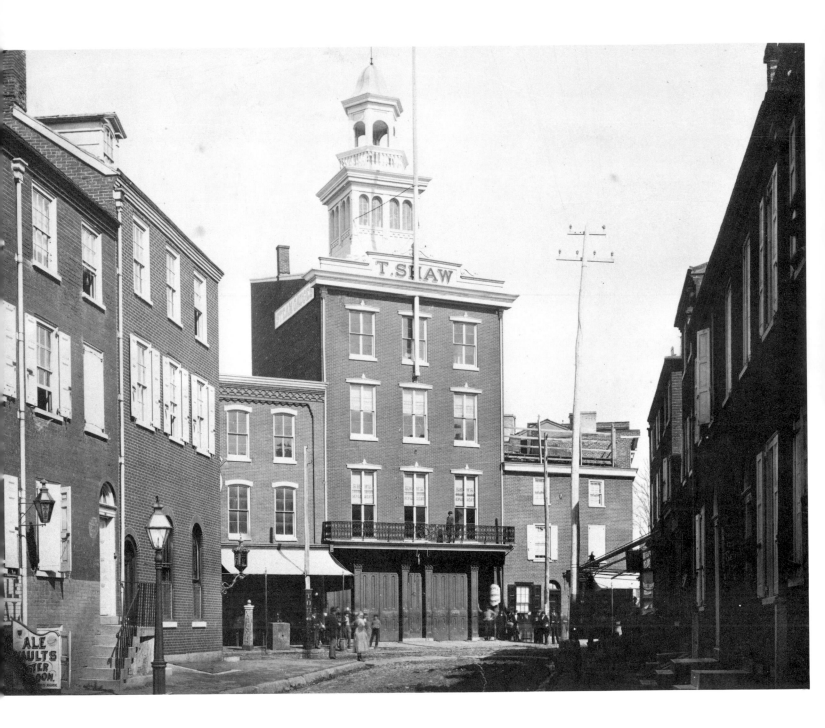

109. OLD FAIRMOUNT ENGINE HOUSE, RIDGE AVENUE AT VINE STREET, C. 1880. Shortly before this photograph was made, Thomas Shaw, who advertised as "Inventor and sole manufacturer of Steam, Vacuum, Hydraulic and Blast Gauges," and other similar machines, had moved into this old firehouse. The Fairmount Fire Company, to which the house originally belonged, was established in 1823, though the house dates from a later period. Shaw had not yet seen fit to make any structural changes in 1880, for the building still retained its double doors, gallery and watch tower. *Photo by R. Newell.*

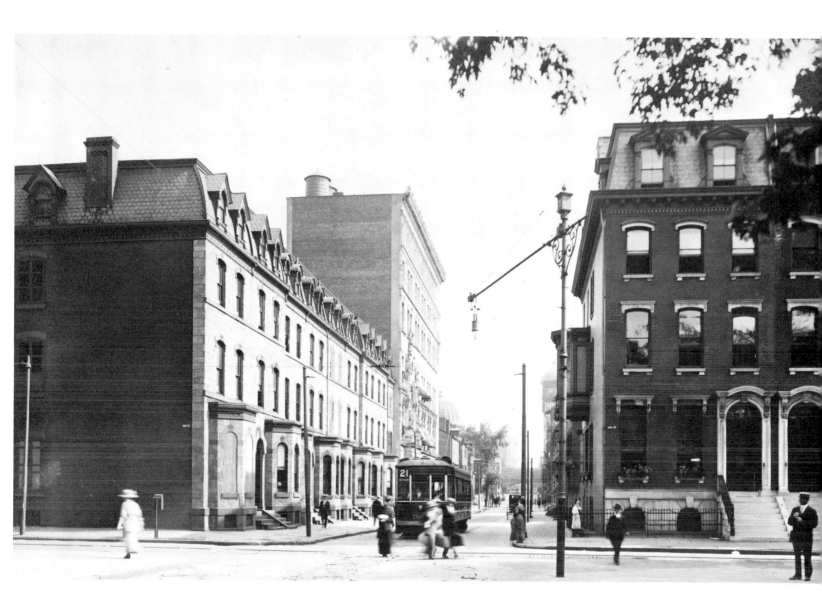

110. 18TH STREET AT LOGAN SQUARE, C. 1913. The view here is southward along 18th Street from the southeast corner of Logan Square. The dome of the Arch Street Presbyterian Church is just visible, center, and beyond it in the distance is a section of the old "Chinese Wall" (see No. 158). The houses at the right were removed in 1918 to make way for the construction of the Benjamin Franklin Parkway, which enters the square at this point and cuts across it on a diagonal.

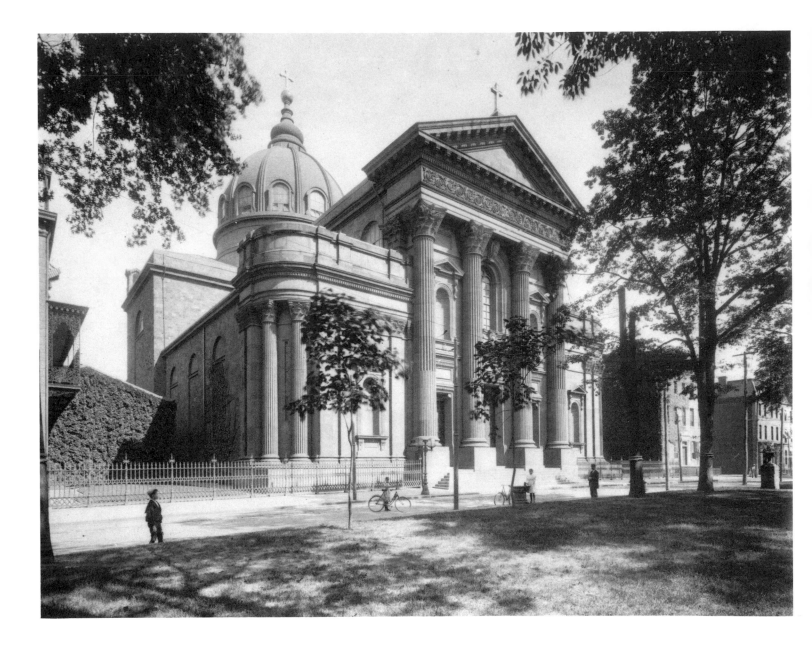

111. CATHEDRAL OF STS. PETER AND PAUL, 18TH STREET AT
LOGAN SQUARE, 1902. Napoleon Lebrun and John Notman were the
designers of this great brownstone cathedral, begun in 1846 and com-
pleted in 1862. It is the cathedral church of the archdiocese of Philadelphia.
It faces Logan Square, one of the five historic squares laid out in the original
plan of the city by Thomas Holme, Surveyor General, in 1682.

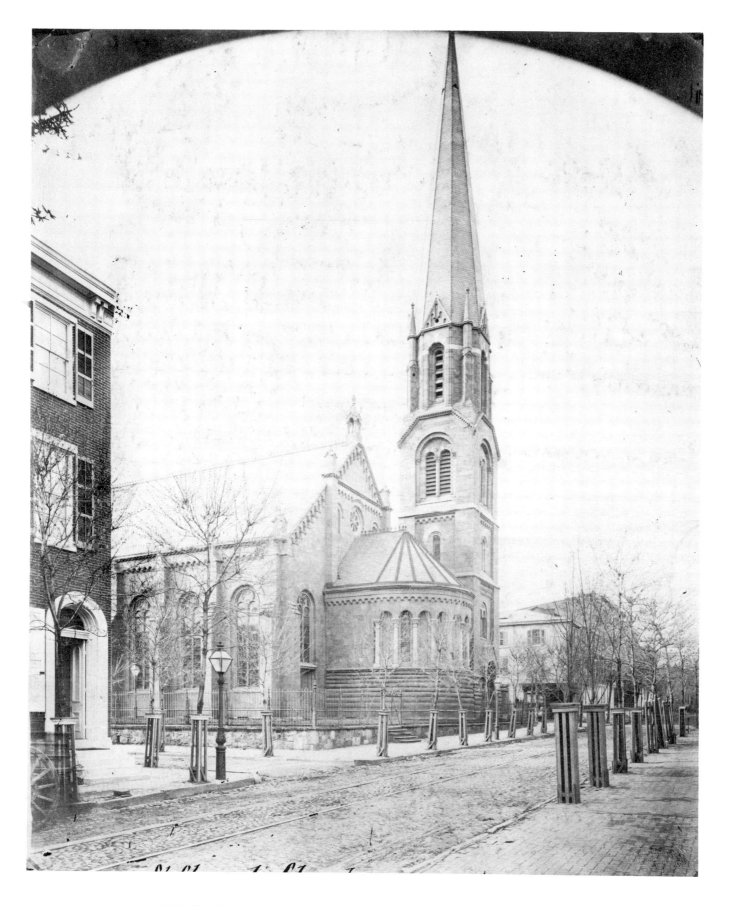

112. ST. CLEMENT'S CHURCH, 20TH AND APPLETREE STREETS,
C. 1865. Long before the Parkway was constructed and institutions of art,
education and scientific research were built in this area, 20th Street north
of Arch had the appearance of a quiet residential neighborhood. The impos-
ing spire of St. Clement's Church, built in 1854, dominates the scene
for several blocks. The street now has been widened, residences replaced
by large buildings, and St. Clement's spire removed because of structural
deteriorations.

VI

Chestnut Street, Walnut Street

and Adjacent Areas

CHESTNUT AND WALNUT STREETS run parallel to Market on the south. Chestnut Street seems to have had several names before William Penn decreed that east-west streets should be named after native trees and north-south streets should be numbered. Chestnut Street, now a major center of commerce, is associated with illustrious moments in American history: it is the location of Independence Hall and other historic monuments. It is also the location of famous early theaters which figured importantly in the development of the theater in America.

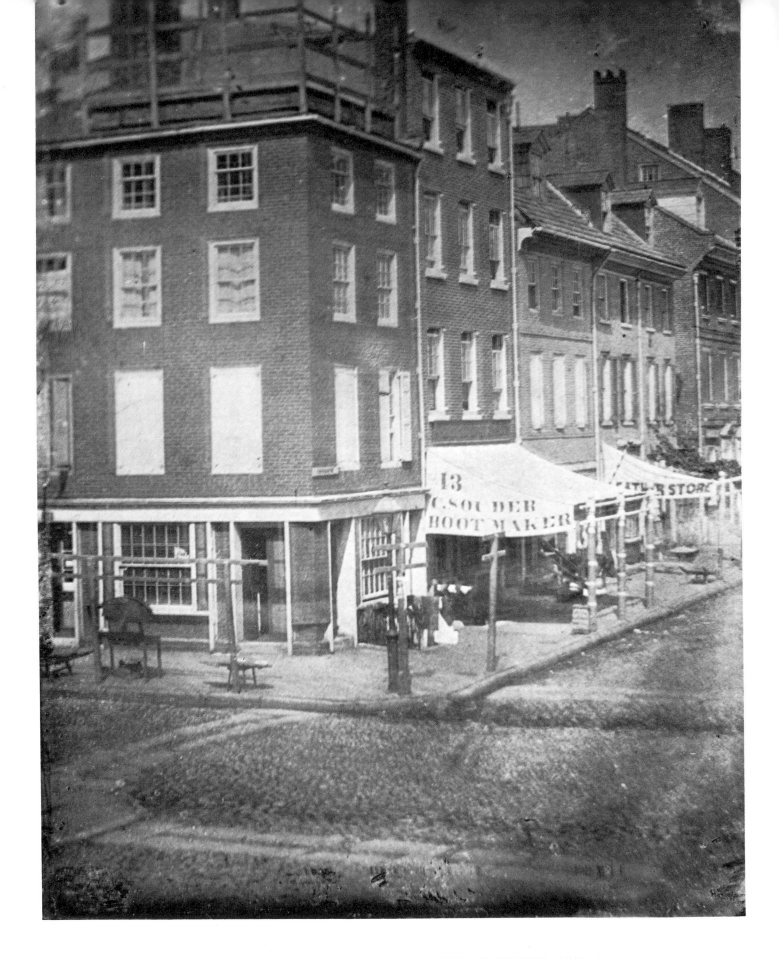

113. CHESTNUT STREET AT 2ND, NORTHEAST CORNER, 1843. A boot shop and a leather store make amiable companions at this corner near the waterfront. The building at the intersection was once a toyshop, though the signboard in the doorway suggests different wares such as seafood or other edibles. *Daguerreotype by William S. Mason.*

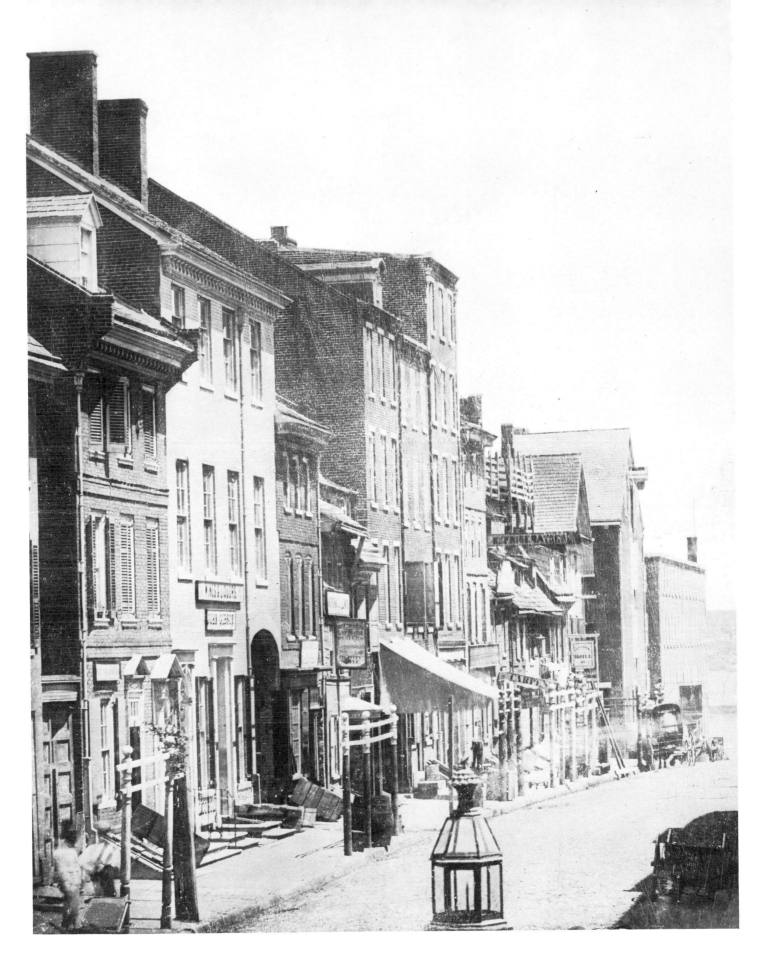

114. CHESTNUT STREET FROM FRONT TO 2ND, 1843. A companion to Mason's daguerreotype, this view shows the remainder of the block and a glimpse of the Delaware River beyond. The United States Post Office was once located on this block. From the wharf at this point, excursion boats sailed for such ports as New York, Baltimore and Cape May, New Jersey.

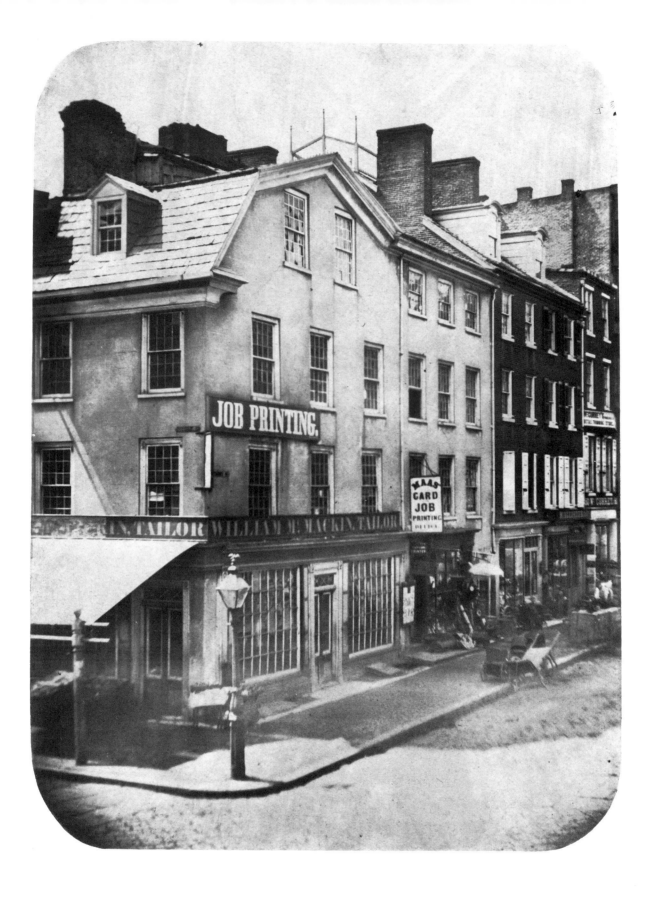

115. CHESTNUT STREET AT 2ND, SOUTHWEST CORNER, C. 1854.
Small businesses such as these were typical of the east end of Chestnut
Street in the 1850s. This view is toward the west, away from the waterfront.
The building on the near side of William Currey, wholesaler, was occupied
by John McAllister and Brother, photographers and sellers of mathematical
and optical instruments. John McAllister was also a noted antiquary of Phila-
delphia.

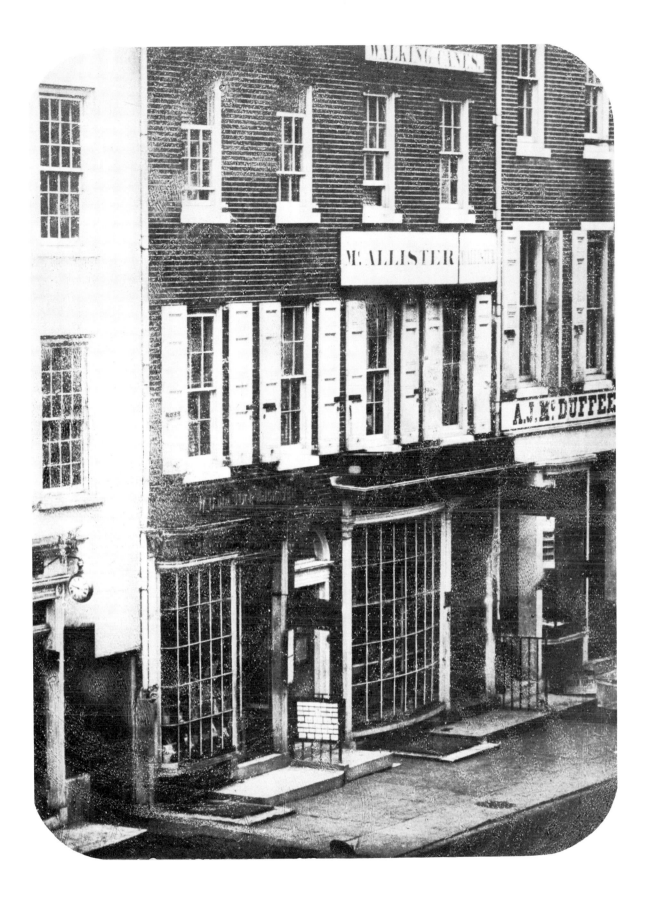

116. JOHN McALLISTER'S STORE, 48 CHESTNUT STREET, 1843.
Windows such as this were reminiscent of English storefronts, and endured
long after the Colonial period in Philadelphia. In the preceding view, taken
a decade later, this storefront had changed to a design more practical for
storekeepers. *Photo by William S. Mason.*

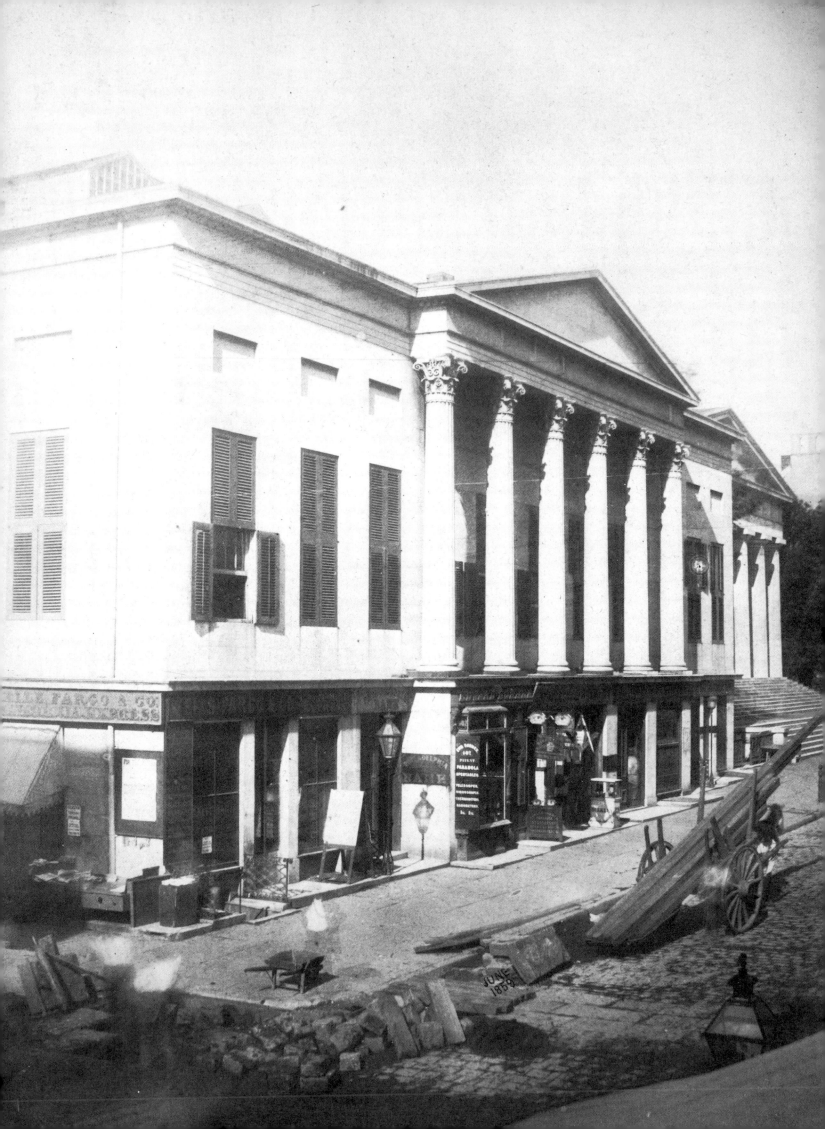

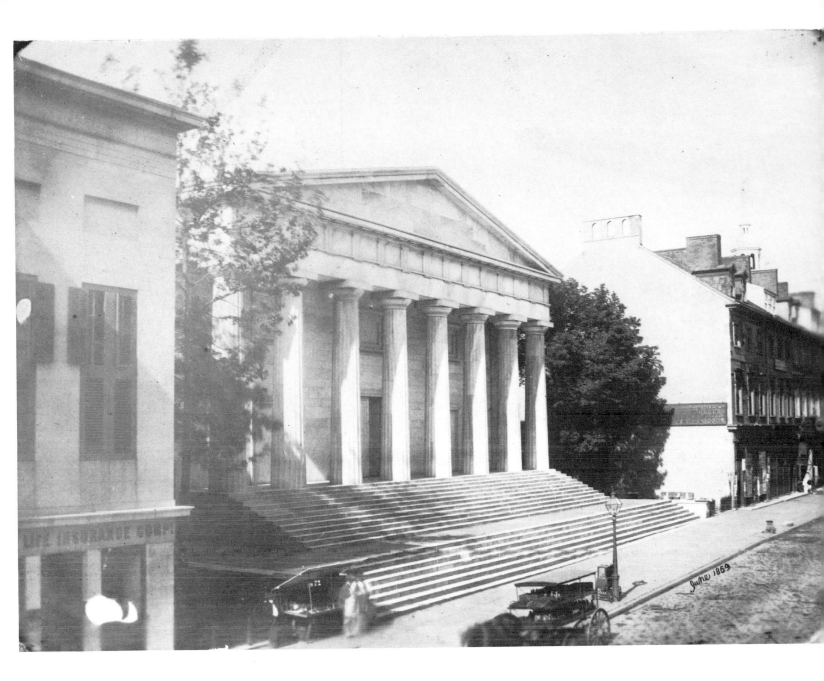

Opposite: 117. PHILADELPHIA BANK, CHESTNUT STREET AT 4TH, 1859. The neoclassical structure shown here was designed in 1836 by William Strickland, who also designed the Second Bank of the United States next to it. The second floor was reserved for banking while the street level was given over to a variety of unrelated enterprises, among them the offices of Wells Fargo and Company in the corner space at 4th Street. The view is toward the west. *Above:* 118. SECOND BANK OF THE UNITED STATES, 420 CHESTNUT STREET, 1859. The Second Bank of the United States was the epicenter of banking not only in Philadelphia but in the nation as well, after the First Bank's charter expired in 1811. The building shown here was opened in 1824. Like the First Bank, the Second Bank was also a depository of the Federal government, and in 1832, while Nicholas Biddle was its president, it became the focal point of the struggle between Andrew Jackson and the Whigs over national banking policies. Its charter expired in 1836 and was not renewed by the Federal government, and the bank then became for one year the Pennsylvania State Bank. The building was bought by the government in 1844 when it was remodelled and made the Customs House for the City and Port of Philadelphia. After a new Customs House was built in 1930, this building was leased to the Carl Schurz Memorial Foundation for 20 years. It is now a national historic monument and part of Independence National Historic Park.

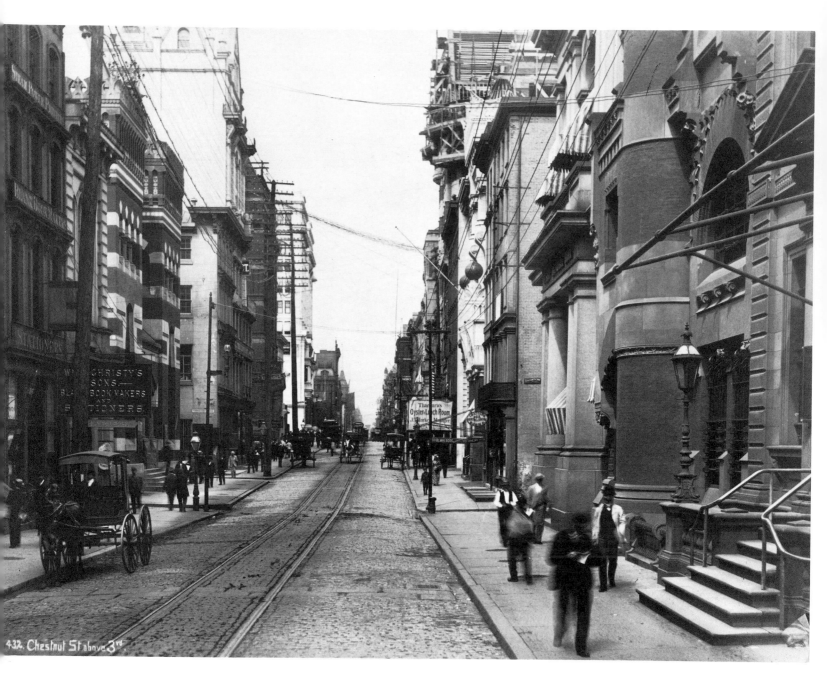

Above: 119. CHESTNUT STREET, WEST FROM 3RD STREET, C. 1885. The area on Chestnut Street between 2nd Street and Independence Hall at 5th was often called Bankers' Row. Two famous buildings by architect Frank Furness are visible here: the Guarantee Trust and Safe Deposit Company, left, next to Christy's, and the National Bank of the Republic, right, next to the lamppost. *Opposite:* 120. CHESTNUT STREET, EAST FROM 5TH, 1865. Just visible at the right is the Philadelphia Bank. *Photo by R. Newell.*

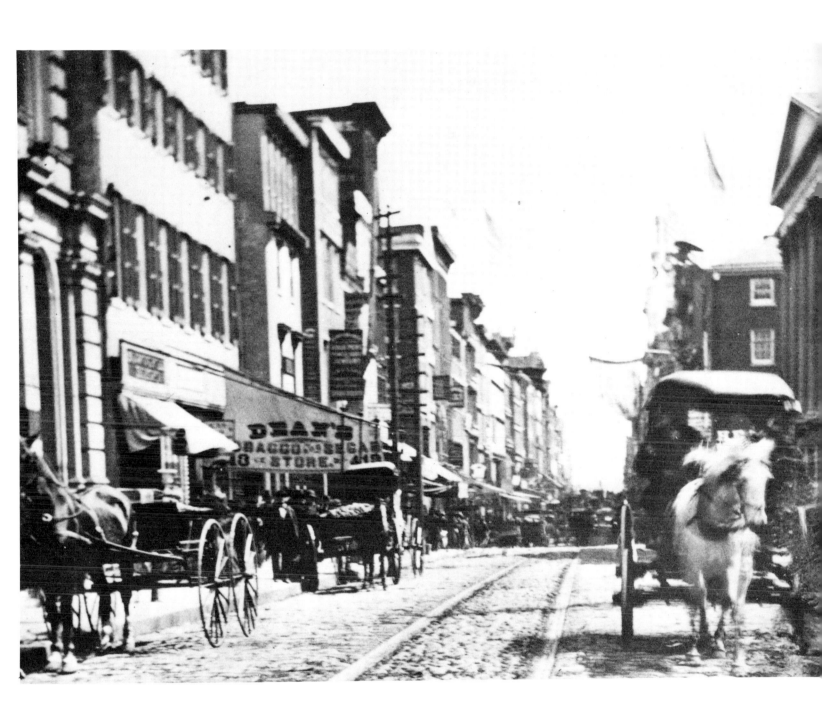

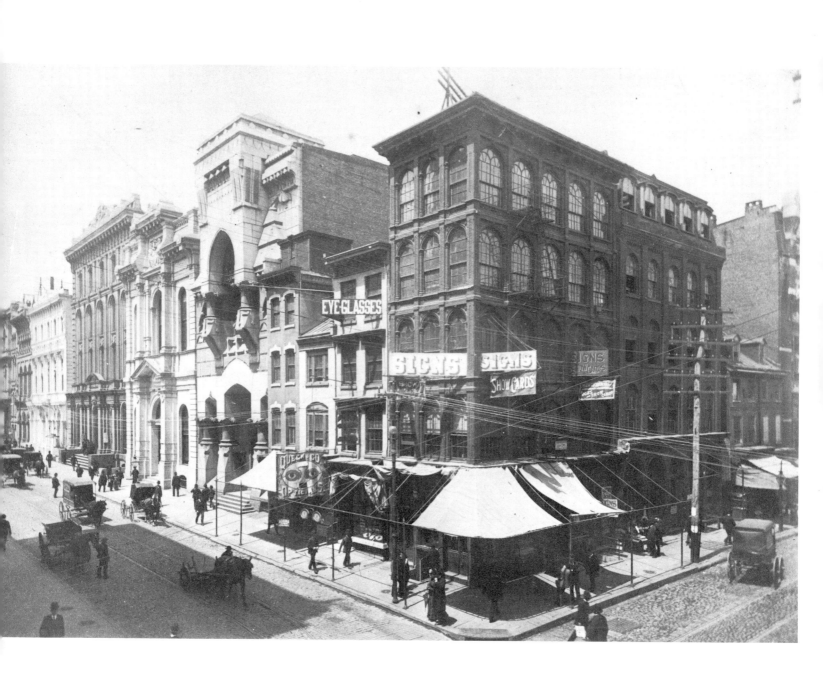

Above: 121. CHESTNUT STREET, WEST FROM 4TH, C. 1895. Frank Furness' building (fifth from the right) for the Provident Life and Trust Company at 408 Chestnut stands out among its more traditional neighbors, the Philadelphia National Bank and the Philadelphia Trust, Safe Deposit and Insurance Company. Vehicular traffic seems to match the architecture in variety at this busy intersection. *Opposite:* 122. CHESTNUT STREET, WEST FROM 5TH, C. 1865. Visible through the trees, left, is the Public Ledger Building. The waving flags are probably in celebration of the end of the Civil War.

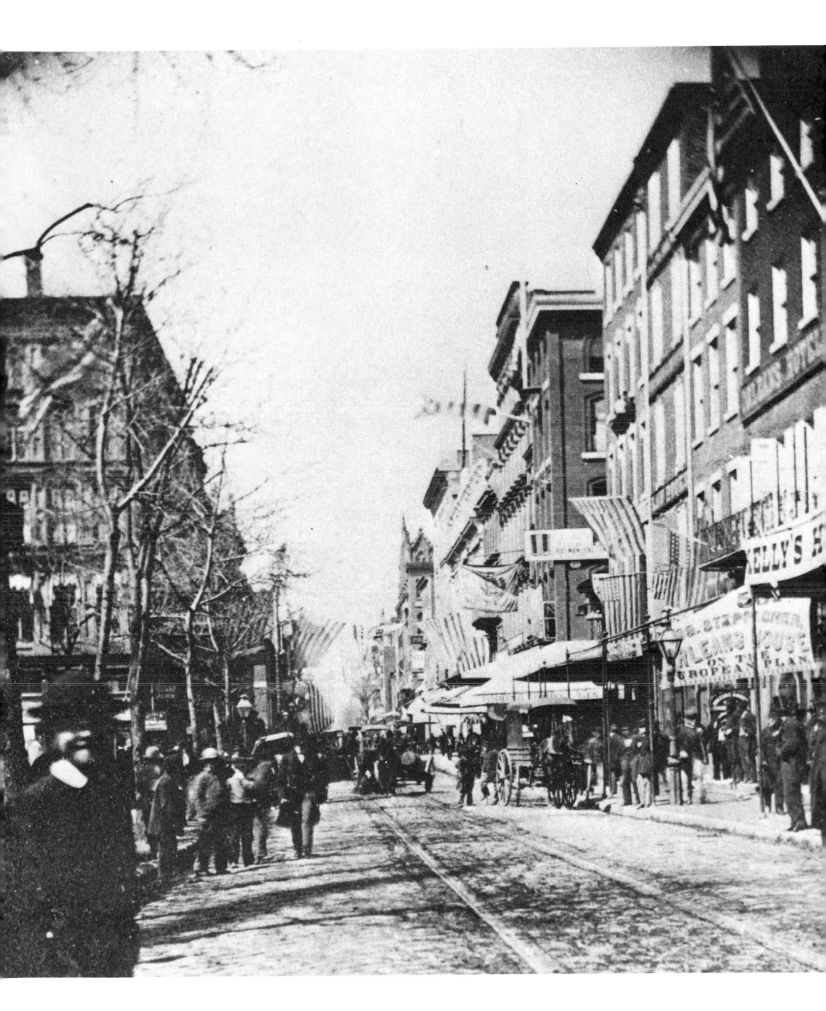

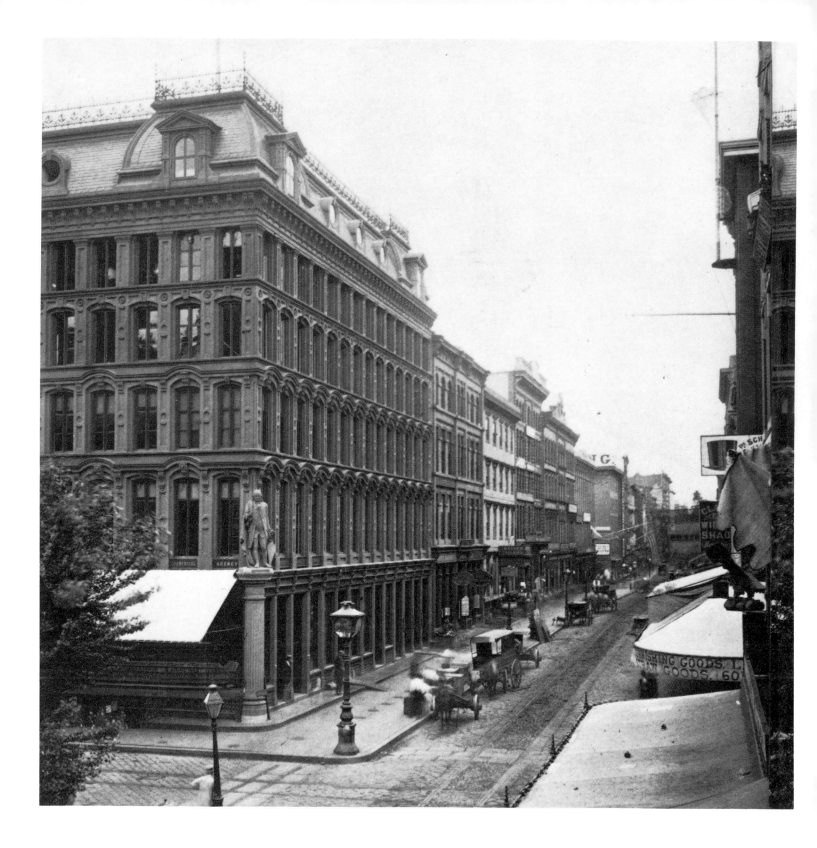

123. PUBLIC LEDGER BUILDING, 6TH AND CHESTNUT STREETS, C. 1870. Benjamin Franklin presides appropriately over the scene opposite the State House from his pedestal on the corner of the Ledger Building's imposing facade. Built in 1867, this was the home of the *Ledger* until it was sold in 1914.

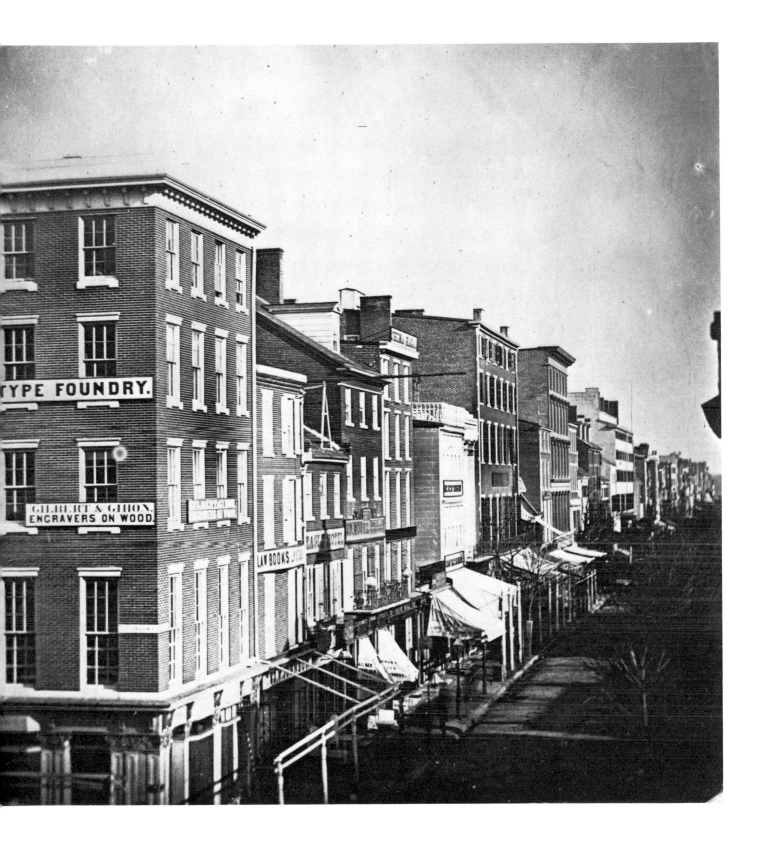

124. CHESTNUT STREET, EAST FROM 6TH, C. 1859. This row of buildings five blocks from the waterfront stood opposite Independence Hall. Here was a concentration of businesses related to the printing industry, from engraving and type founding to the finished book itself. It might seem an even more appropriate location for a seller of law books, whose sign is visible in this photograph.

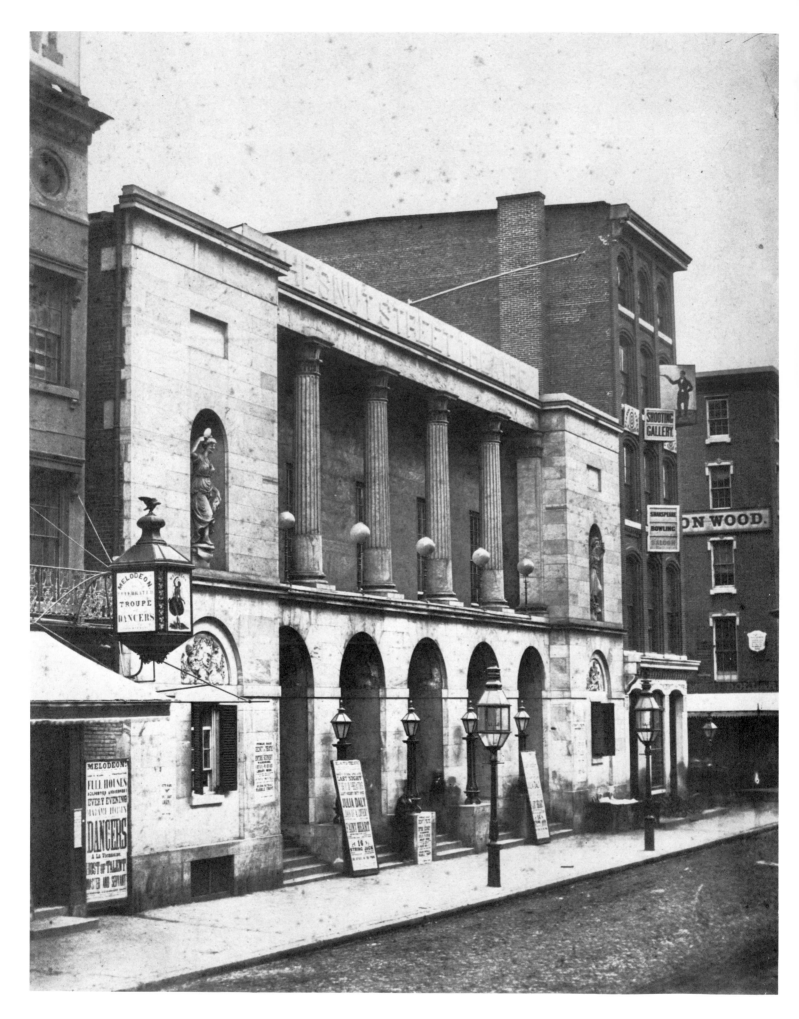

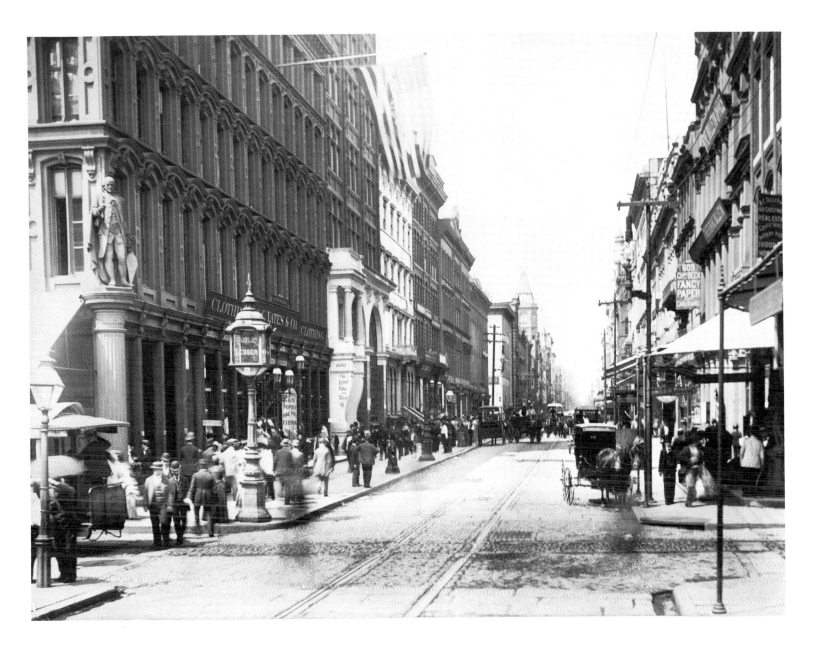

Opposite: 125. CHESTNUT STREET THEATRE, CHESTNUT STREET AT 6TH, 1855. The Chestnut Street Theatre figured prominently in the early development of the American theater in Philadelphia. The scene of many "firsts," it was also the subject of political and religious controversy. There were at least two theaters built on the site at 6th and Chestnut Streets. The earlier was opened in 1794 and was said to be the most elegant of its time. It burned down in 1820, and the building in the photo-graph, the reconstruction, was opened in 1822. Just visible on the left is the Melodeon, and on the right the Shakspeare Bowling Saloon. The photograph was made at the time of the last perfor-mance before the theater was taken down. *Above:* 126. CHEST-NUT STREET, WEST FROM 6TH, C. 1889. East Chestnut Street in the 1880s was the teeming center of Philadelphia's business district. This view is just west of Independence Hall. The Public Ledger Building is at the left.

131

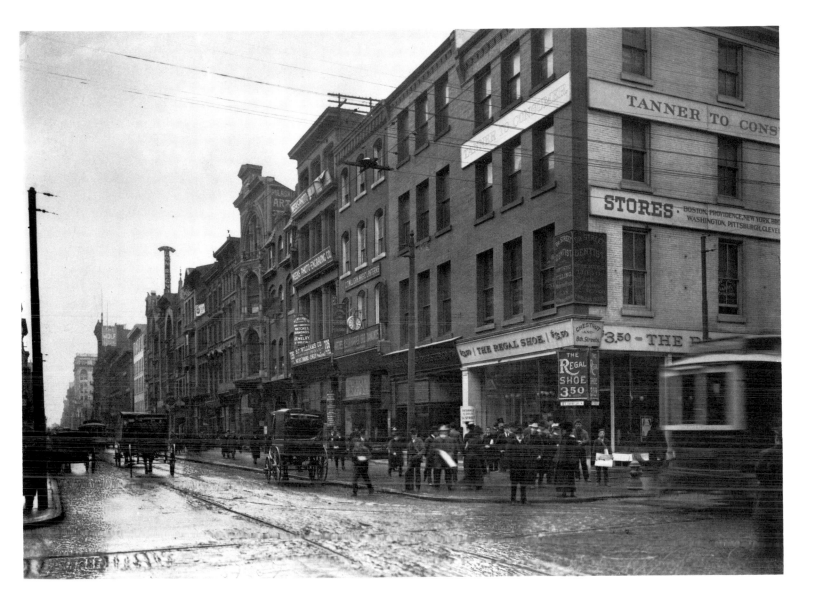

Opposite: 127. PIERCE BUTLER MANSION, 8TH AND CHESTNUT STREETS, C. 1855. The book stall against the Butler property on Chestnut Street was a harbinger of the encroachment of commerce upon private residences, as Philadelphia business moved steadily westward from the old city in the 1850s. Pierce Butler was a resident of Philadelphia from the 1780s to his death in 1822. Between 1789 and 1804 he was a senator to Congress from South Carolina, where he also owned property. The mansion shown here was demolished in 1859. *Above:* 128. CHESTNUT STREET, EAST FROM 8TH, C. 1902. This block is still a busy shopping center in the 1970s, and many of the buildings seen in this photograph are still standing, undetectable because of modern facades which cover the old.

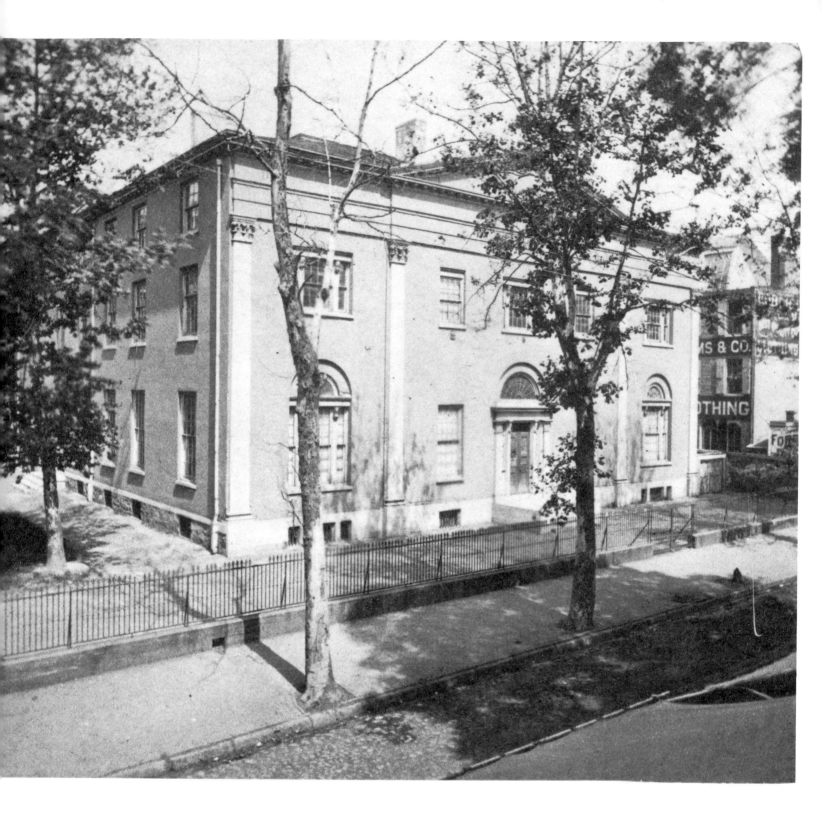

129. UNIVERSITY OF PENNSYLVANIA, 9TH AND CHEST-NUT STREETS, C. 1865. College Hall of the University of Pennsylvania stood on the site now occupied by the United States Post Office. The University remained here from 1802 to 1872.

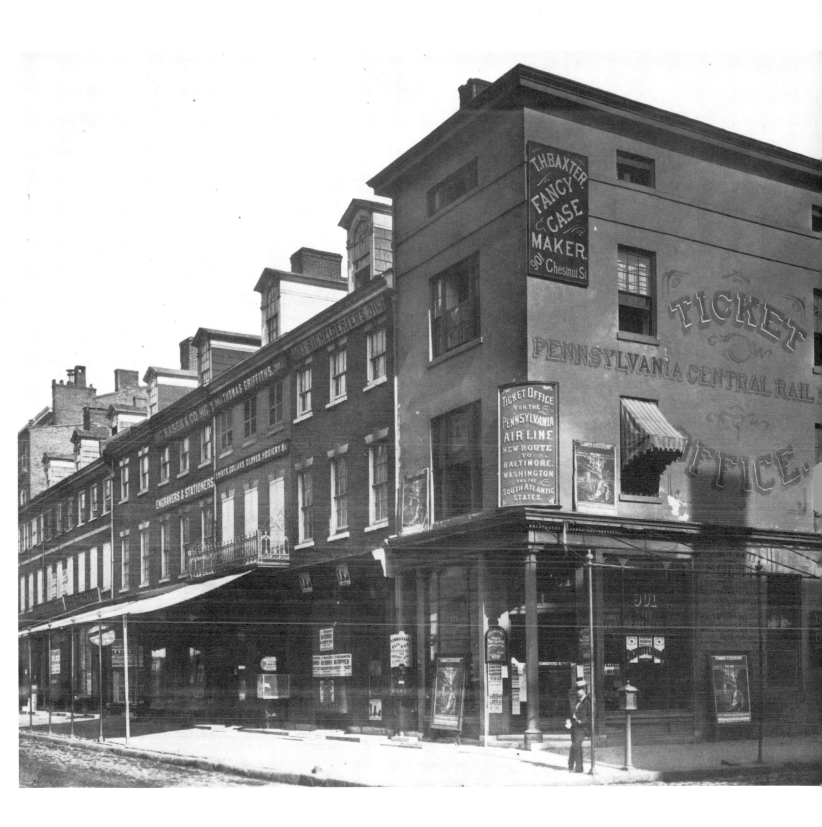

130. CHESTNUT STREET, WEST FROM 9TH, 1859. In the 1800s commerce and industry were in continuous competition with private property owners for space in areas such as the one shown here. This photograph shows that businesses have taken over the ground floors of the buildings nearer the center of the block which were once private residences. Competition on another level altogether is detectable in the advertisements of the Pennsylvania Central's ticket office, which proclaim a new route to Baltimore, Washington and points south.

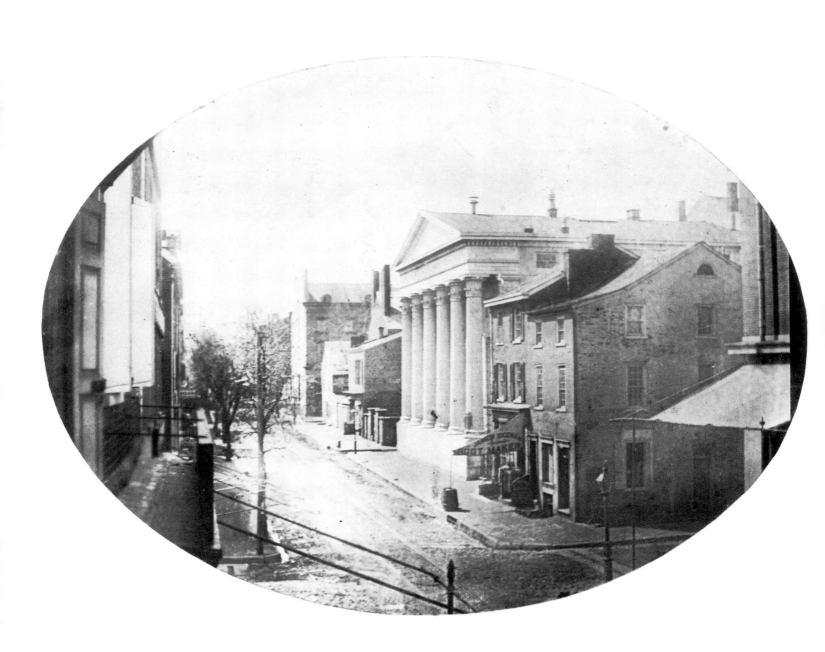

131. VIEW OF 10TH STREET, SOUTH FROM SANSOM, C. 1854.
Prominent in this picture of 10th Street is Jefferson Medical College's neo-
classical portico, designed and added to the building by architect Napoleon
Lebrun in 1845. The vast complex of the present Thomas Jefferson Univer-
sity now stands on this site and on properties extending south beyond Locust
Street and west to 11th.

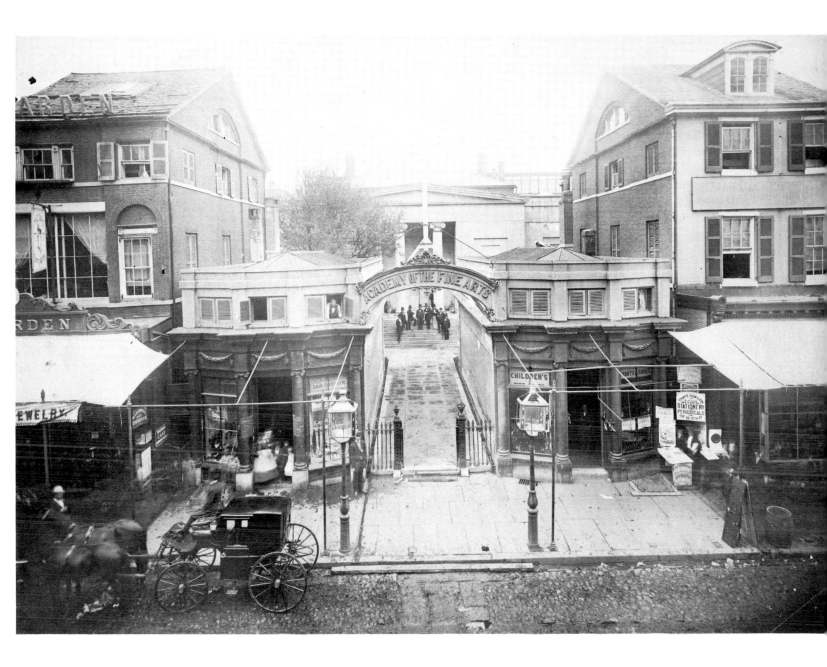

132. THE ACADEMY OF THE FINE ARTS, 1029 CHESTNUT STREET, 1869. When the Academy was first built in 1806, it was surrounded by a garden and the site had a frontage of one hundred feet on Chestnut Street. By 1869, however, most of this property had been sold and business establishments had almost hidden the Academy from view. The photograph was made just before the building was sold to Robert Fox, who opened Fox's New American Theatre (later the Chestnut Street Opera House) on this site in 1870.

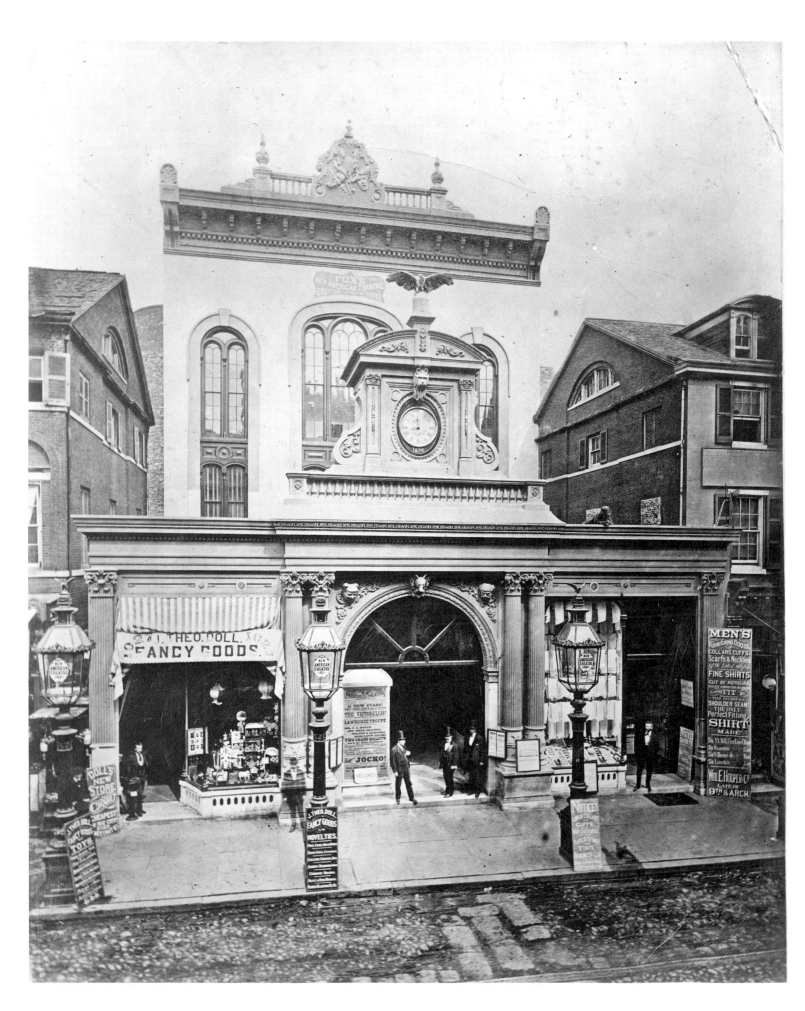

Opposite: 133. FOX'S NEW AMERICAN THEATRE, CHEST-
NUT STREET AT 10TH, C. 1885. This theater was built on the
site of the original Academy of the Fine Arts, and opened in
December 1870. It offered variety shows that included ballets,
musical performers, acrobats and magicians, and was in exis-
tence until after the turn of the century. *Above:* 134. UNION
LEAGUE, 1118 CHESTNUT STREET, 1863. The Union League,
whose first home is shown here, was organized in December 1862
as a patriotic association in support of the United States Govern-
ment and the Union cause. It moved into the Chestnut Street
building in January 1863. The photo was taken on Election Day
of that year, as the campaign posters on the wall, right, indicate.
The organization moved to its present location at Broad and San-
som Streets in 1865.

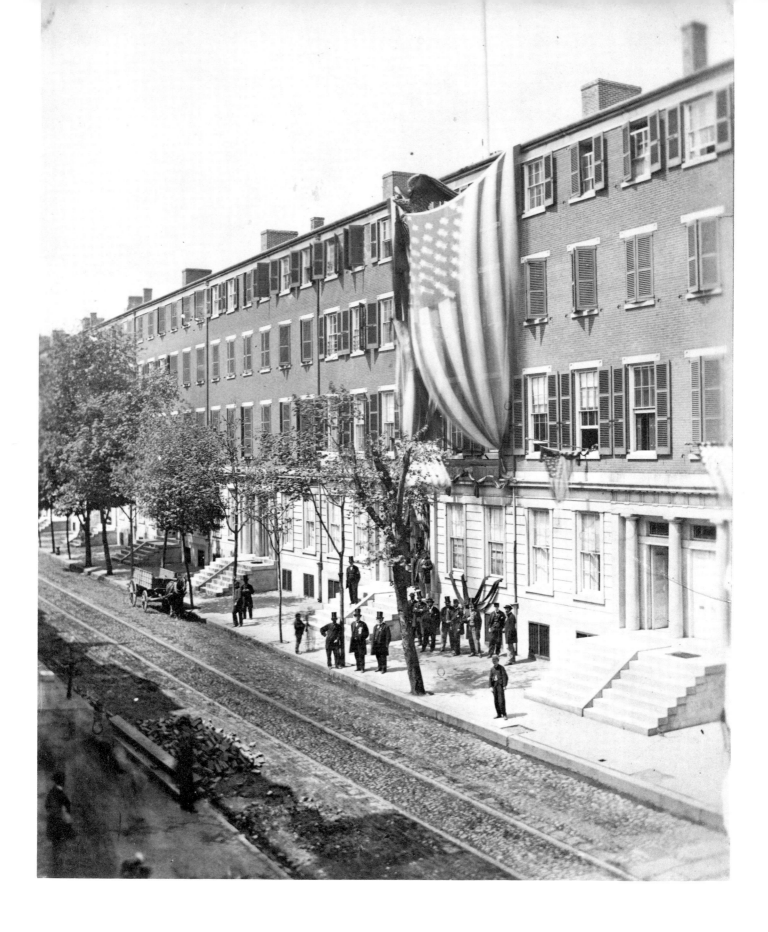

135. GIRARD ROW, CHESTNUT STREET BETWEEN 11TH AND 12TH, 15 APRIL 1865. The flag-draped building in this photograph is the headquarters of the National Union Club, which had learned of Abraham Lincoln's death a few hours before this photo was made. Girard Row was in the block between Chestnut and Market Streets and from 11th to 12th Streets. The block is now known as Girard Square. Once owned by Stephen Girard, financier and founder of Girard College, it is now the location of Community College.

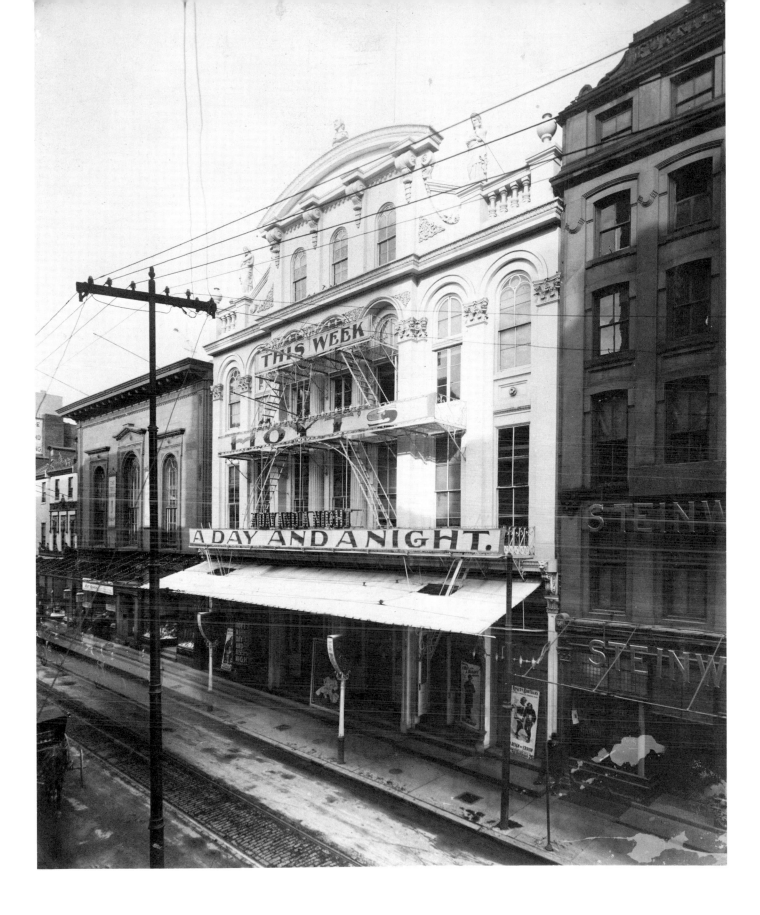

136. THIRD CHESTNUT STREET THEATRE, 1211 CHESTNUT STREET, 1898. The Chestnut Street Theatre's long history began in 1794, when the theater was first built at Chestnut Street and 6th. The building shown here was the third theater known by this name, and was opened in 1863 after the second building (at 6th) was closed in 1855. Its manager was William Wheatley, a former actor turned man-ager (he also managed Niblo's Garden in New York, where he produced The Black Crook in 1866). The attraction featured in this photograph is Charles Hoyt's play A Day and a Night. The signboard near the entrance announces John J. McNally's A Reign of Error, with the Rogers Brothers. Next to the theater, left, is the old Concert Hall, which had become the location of the Free Library.

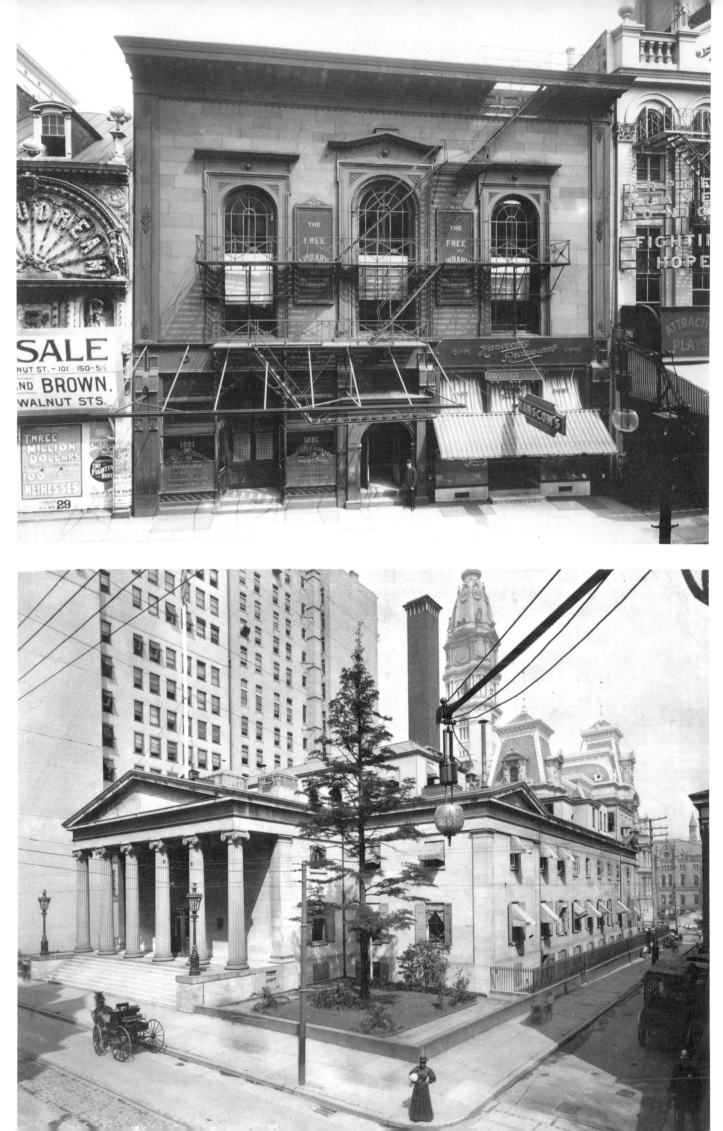

Opposite above: 137. FREE LIBRARY OF PHILADEL-
PHIA, CHESTNUT STREET AT 12TH, 1910. After moving
from its quarters in City Hall, the Free Library shared its
new home in the Concert Hall, which dated from the 1850s,
with Hanscom's Restaurant. The building was converted to
accommodate the Free Library in the 1890s. *Opposite
below:* 138. SECOND UNITED STATES MINT, CHEST-
NUT STREET AT JUNIPER, C. 1901. The first mint in the
United States was established by Congress in 1792 and was
located at 37–39 North 7th Street (see No. 77). This photo-
graph shows the second mint, which was built in 1833 and
occupied this Chestnut Street site until it was sold in 1902.
The Widener Building and Caldwell's store now stand at this
location, and the mint has removed to 16th and Spring
Garden Streets. City Hall tower looms in the background,
and in the distance the rear section of the Masonic Temple
is visible on the right. *Above:* 139. CHESTNUT STREET
AT BROAD, SOUTHEAST CORNER, C. 1897. The Real
Estate Trust Building, one of the first skyscrapers to be built
in Philadelphia, now stands on this busy corner, once occu-
pied by the establishment of Robert Steel, wine merchant.

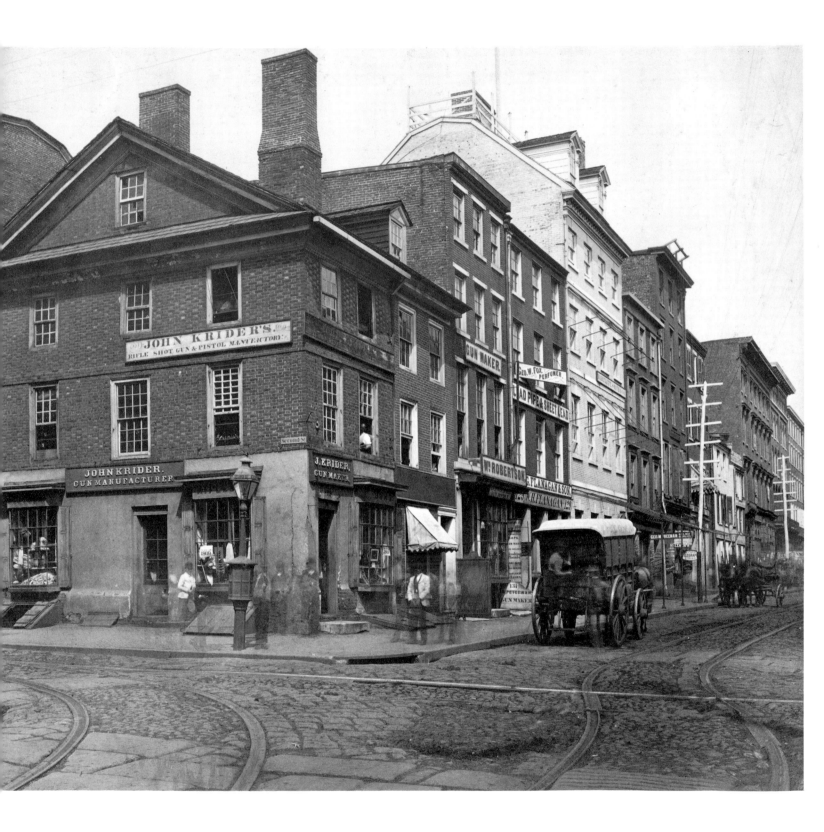

Opposite: 140. JOHN KRIDER'S SHOP, WALNUT STREET AT 2ND, C. 1871. John Krider's well-known gun shop was built in 1751 on the site where the Drinker residence had stood since the days of William Penn. Legend has it that in 1680 Edward Drinker fathered the first child to be born at the site of Philadelphia, though in 1682 William Penn himself proclaimed John Key to be the first child born in the city. Krider's shop, however, was famous in its own right, for it was well remembered by sportsmen for many generations as the source of excellent firearms and fishing rods, all made by John Krider himself. Robert Fulton, miniature painter and builder of the steamboat *Clermont,* is believed to have lived at this address also. The building remained standing until 1955. *Right:* 141. FREEMAN'S AUCTION HOUSE, WALNUT STREET AT 3rd, C. 1859. This establishment was a predecessor of the well-known auction house now located at 1808 Chestnut Street. *Photo by William and Frederick Langenheim (?).*

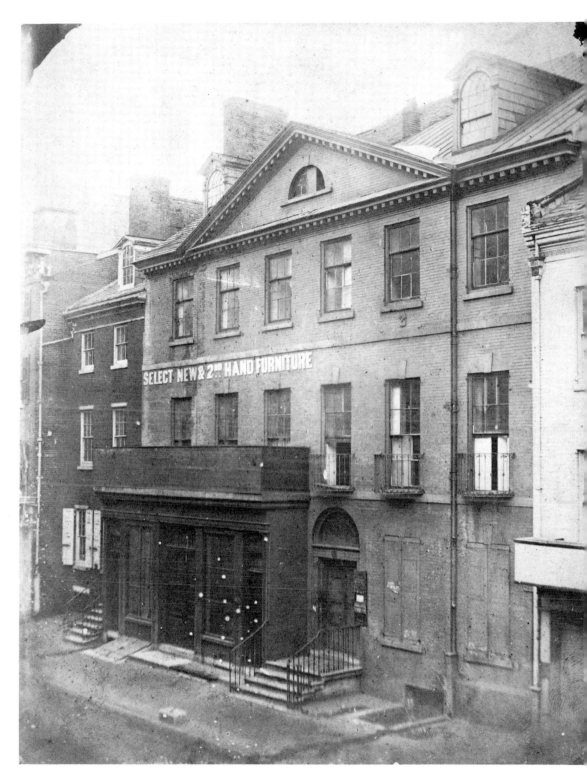

145

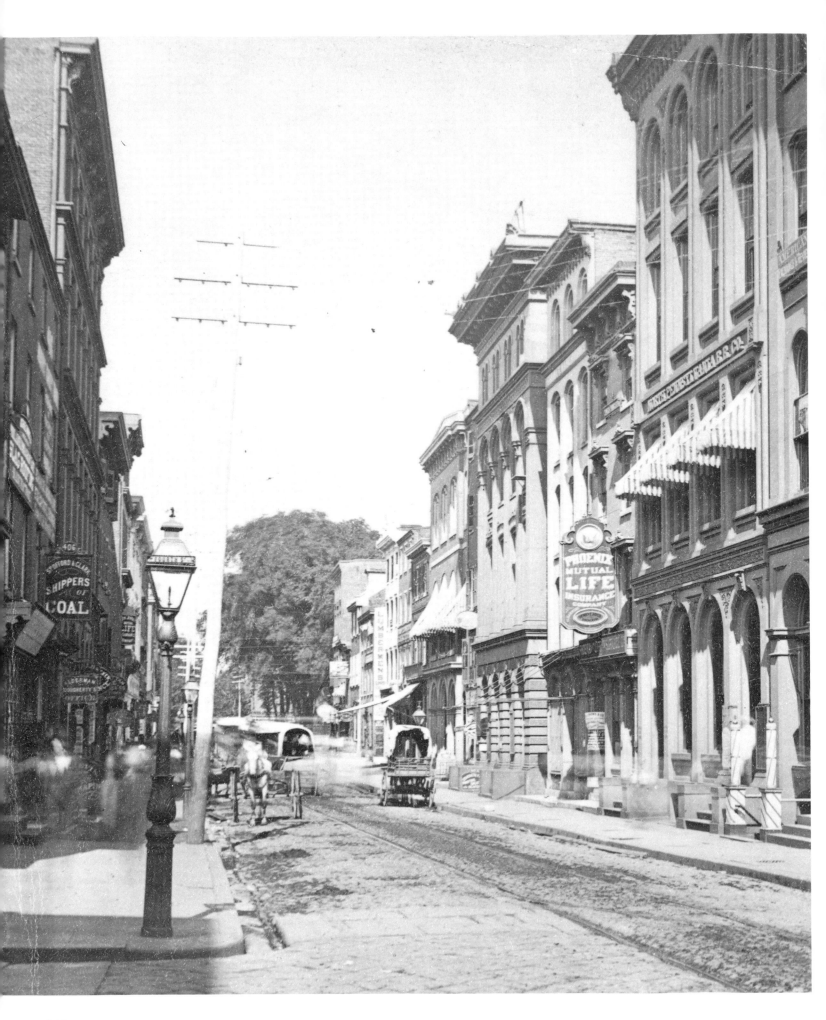

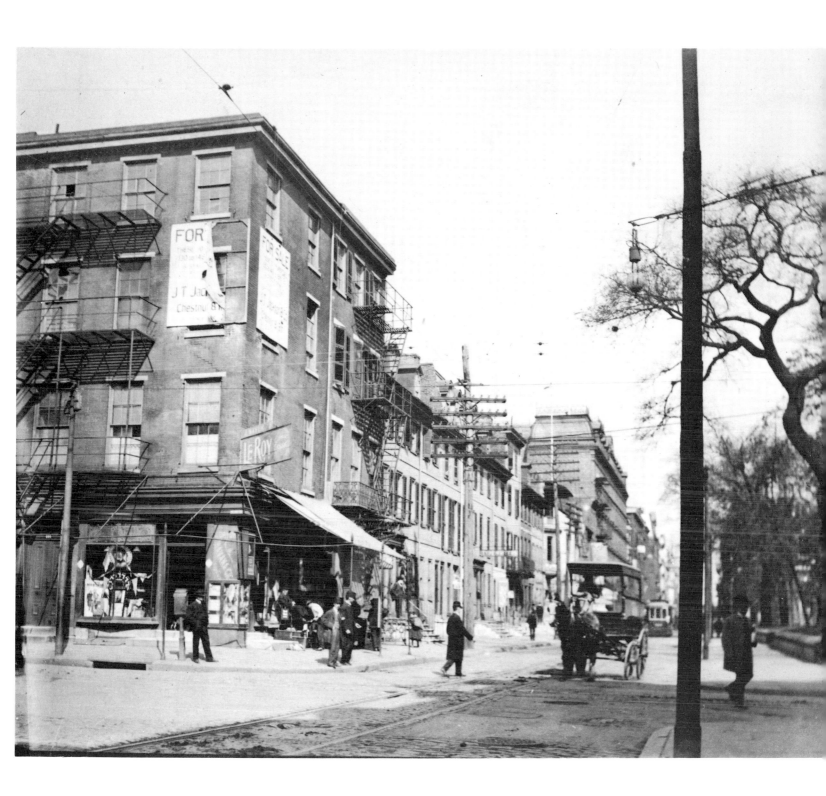

Opposite: 142. WALNUT STREET, WEST FROM 4TH, C. 1870. Covered wagons, a frequent sight in Philadelphia in the 1850s and 1860s, lend a rural atmosphere to this city scene. The trees of Independence Square are visible in the background. The gas lamp on the corner is fitted with an unusual accoutrement, a transparent street sign which was illuminated when the lamp was lighted. *Above:* 143. 6TH STREET, NORTH FROM WALNUT, C. 1902. These buildings and residences on the western side of Independence Square were soon to be replaced by the Curtis Publishing Company's building, which now stands on this site. The mansard roof of the Public Ledger Building can be seen in the distance.

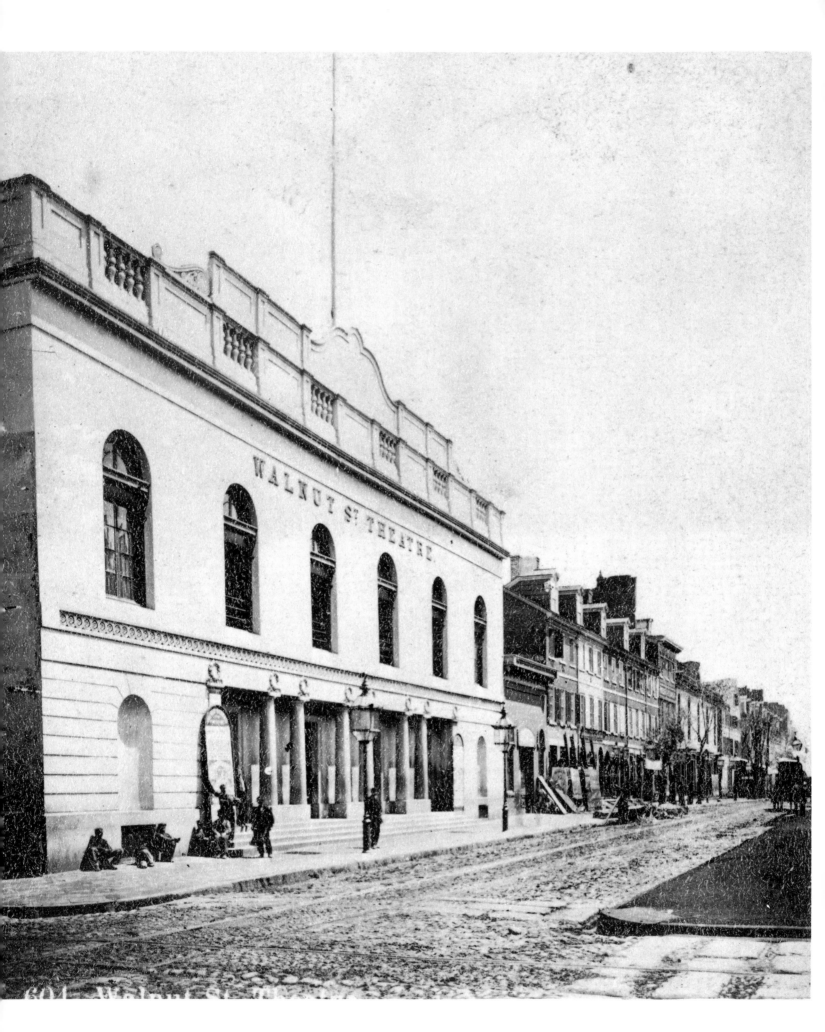

604. Walnut St. Theatre

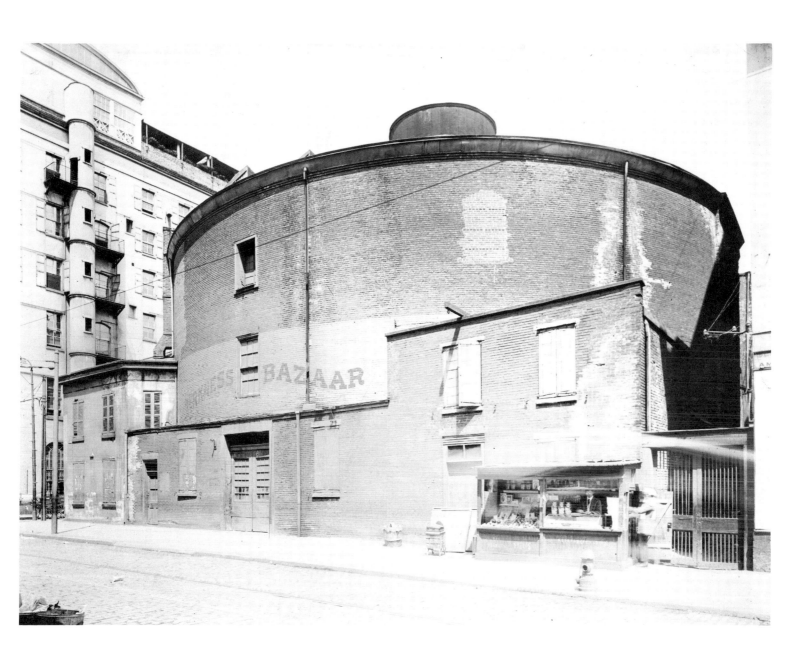

Opposite: 144. WALNUT STREET THEATRE, WALNUT STREET AT 9TH, C. 1865. The famed Walnut Street Theatre, oldest theater in continuous use in America, opened in 1809 as the New Circus, whose main attractions were equestrian and other circus acts. Through a series of structural changes it evolved into a playhouse for stage performances and became the Walnut Street Theatre for the first time in the 1820s. In the 1860s, when this photograph was made, little change in the original design of the facade could be detected. Walnut Street itself seemed to have undergone little change from its earlier residential character. *Above:* 145. HERKNESS BAZAAR, 9TH STREET AT SANSOM, C. 1910. Built before 1847 for the exhibition of a cyclorama of Jerusalem, the Herkness Bazaar was located in the theater district and stood just behind the Walnut Street Theatre. It later became a market for horses, and for carriages and other vehicles. It was demolished in 1913.

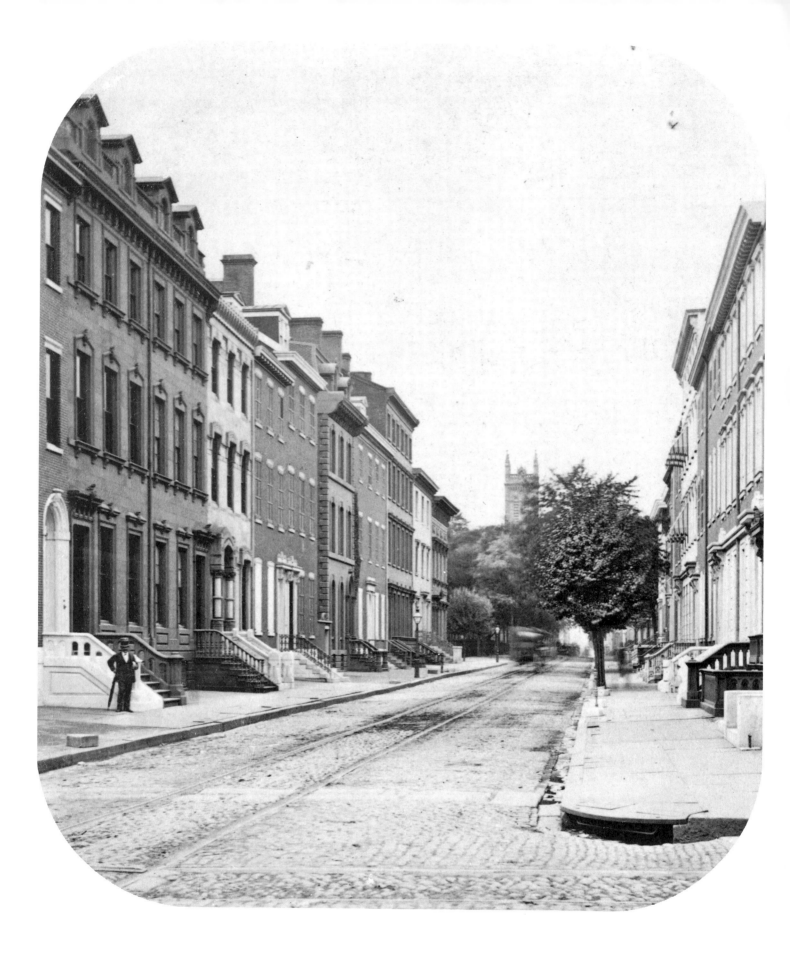

146. WALNUT STREET, WEST FROM 17TH, C. 1865. Beyond this block of fine residences can be seen Rittenhouse Square and the tower of Holy Trinity Church. The house at the corner of 18th Street, center, is the Weightman Mansion (see next picture).

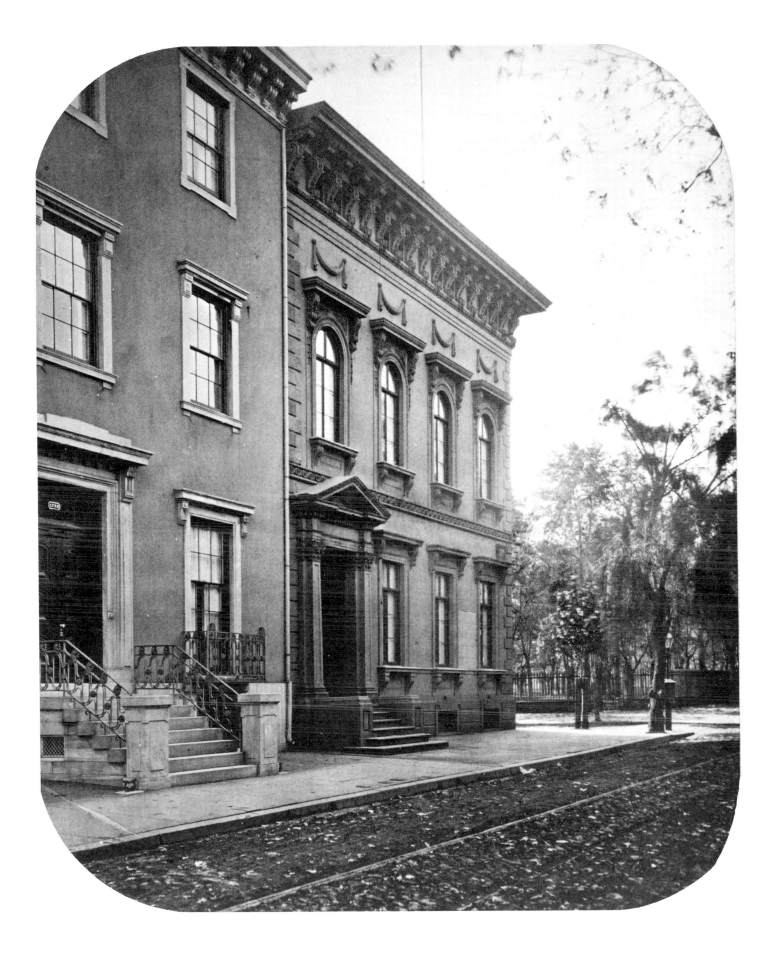

147. WEIGHTMAN MANSION, 18TH STREET AT RITTENHOUSE
SQUARE, C. 1865. This mansion owned by William Weightman, industrial
magnate, stood next to the Harrison house on the Square. It was later
remodeled and a third story was added. The Rittenhouse Claridge Apart-
ment Building now stands on this property.

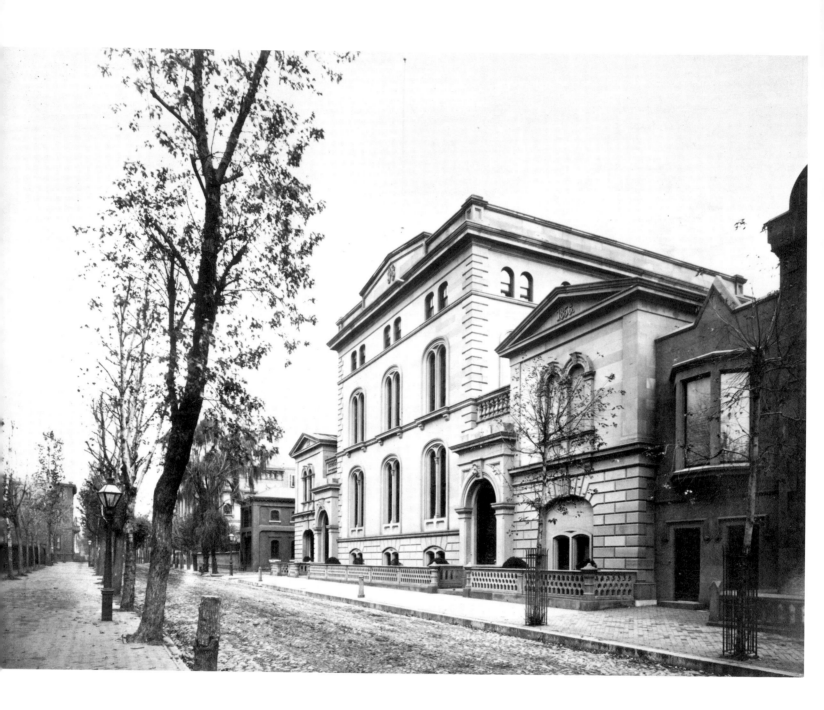

Above: 148. JOSEPH HARRISON RESIDENCE, 221 SOUTH 18TH, EAST RITTENHOUSE SQUARE, 1866. The Harrison Mansion was built in 1852 by Joseph Harrison, Jr., internationally famous engineer and inventor, who constructed Russia's first railroads. On this site now stands the Signal Corps Building, formerly the Penn Athletic Club. The house at the extreme right, at 18th and Locust, was the residence of J. Kearsley Mitchell, noted physician. *Opposite:* 149. LOCUST STREET, WEST FROM 16TH, C. 1869. St. Mark's Church designed by architect John Notman. It was built in 1848. The houses of Harrison Row, left, which stood adjacent to Joseph Harrison's mansion on 18th Street, were one of the earliest experiments in community housing in Philadelphia. They were built in 1856. The trees of Rittenhouse Square can be seen in the distance at the extreme left.

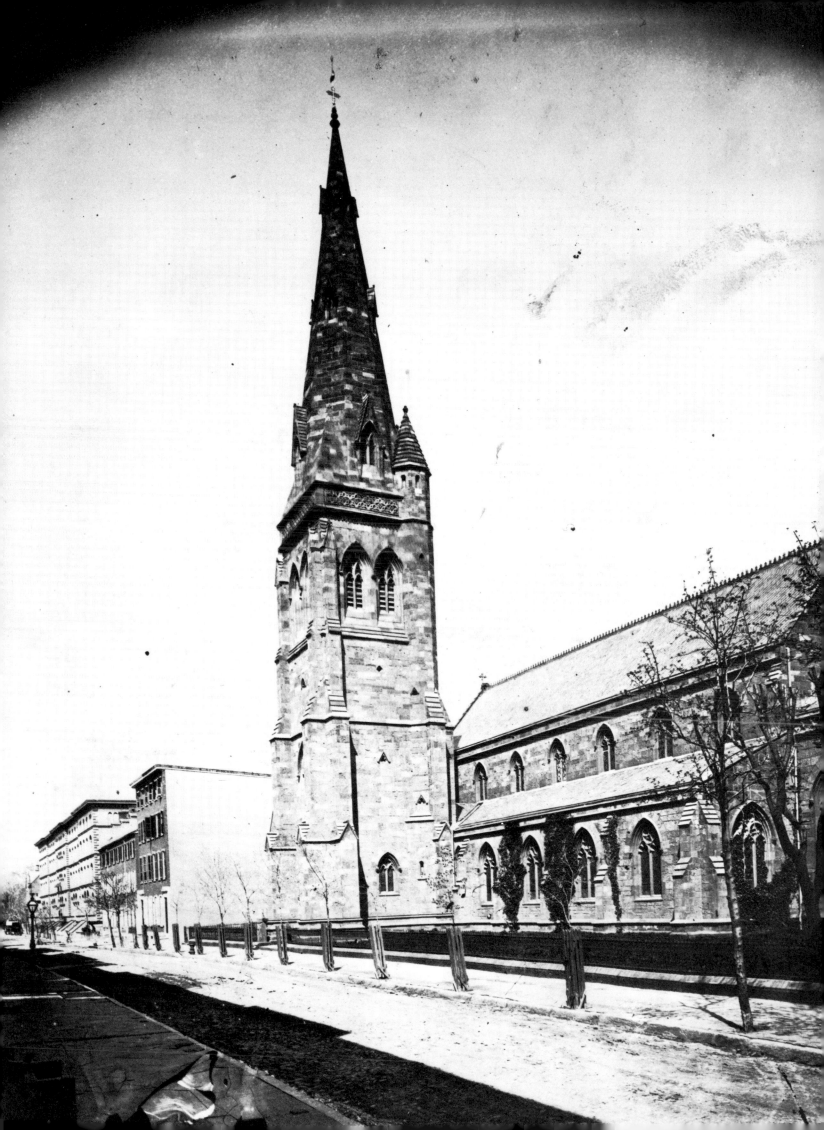

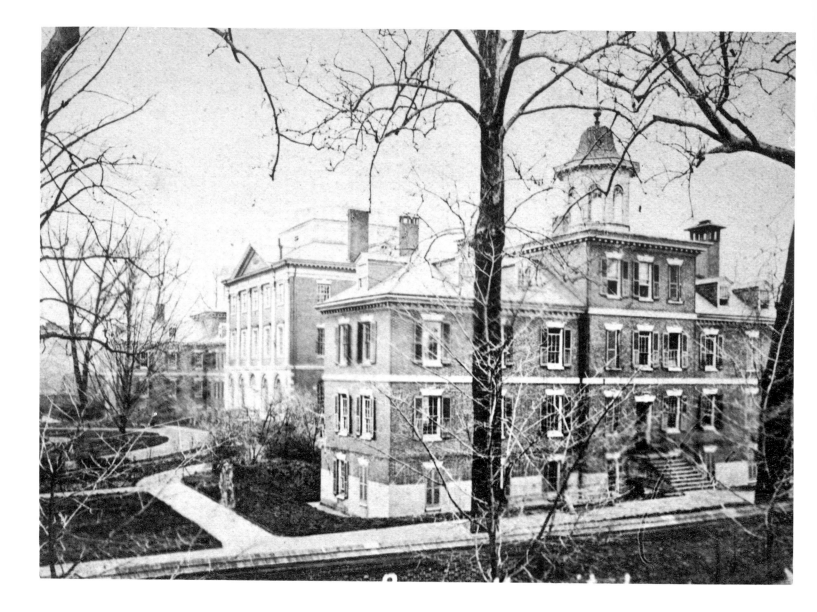

150. PENNSYLVANIA HOSPITAL, PINE STREET, FROM 8TH TO 9TH, 1876. A note attached to Newell's photograph states that Dr. Thomas Bond, with the assistance of Benjamin Franklin, founded Pennsylvania Hospital in 1750. After a charter and a monetary grant were obtained from the state, to which a larger amount from subscription was added, the hospital commenced operation in a house on Market Street between 5th and 6th. This was in 1752. The east wing of the hospital building, shown here, was completed in 1756, the west wing and the central pavilion around 1805, construction on them having been interrupted by the Revolution. Pennsylvania Hospital is the oldest hospital in the United States. *Photo by R. Newell.*

VII

Penn Square

PENN SQUARE was originally called Center Square because of its location in the virtual center of the city as planned by Thomas Holme in 1682. It was from the beginning meant to be the location of public buildings and the center of civic and recreational activities. But all plans for realizing these objectives met with strong resistance from the residents of the city until the early nineteenth century, when the city had expanded more fully and the square was felt to be more nearly a part of the old settlement along the Delaware River. The present City Hall was built on this site between 1872 and 1901.

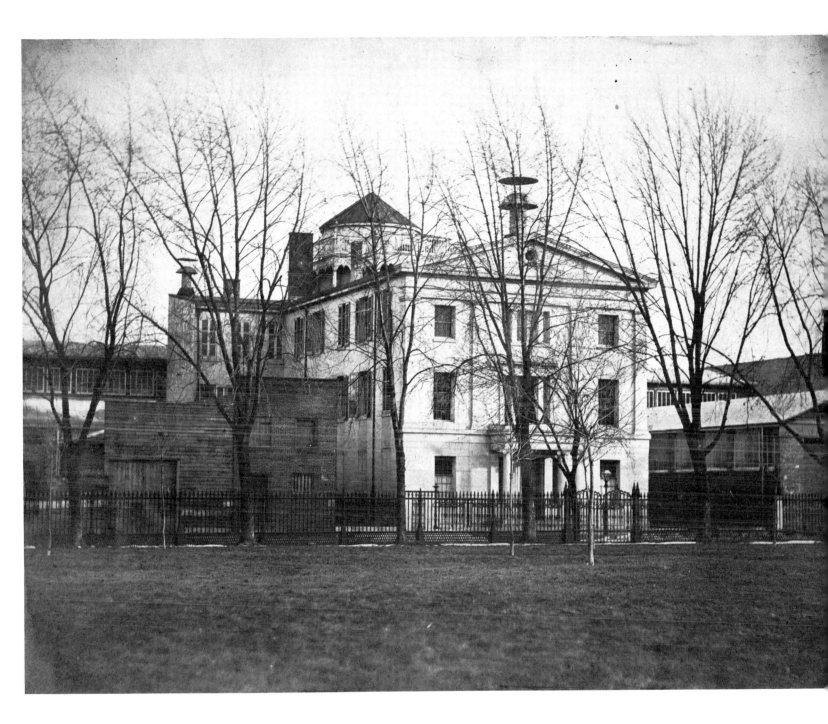

151. CENTRAL HIGH SCHOOL FOR BOYS, JUNIPER
STREET AT CENTER SQUARE, C. 1854. This is the building
whose rooftop appears in Joseph Saxton's daguerreotype of 1839
(No. 1). Opened in 1838, this school stood at the southeast corner
of Center Square. On the left are warehouses, and on the right
the Pennsylvania State Arsenal. In the rear are buildings belong-
ing to the Pennsylvania Railroad. John Wanamaker's store now
stands on this site. Center (now Penn) Square was still a green
park when the photograph was made just before the school was
taken down.

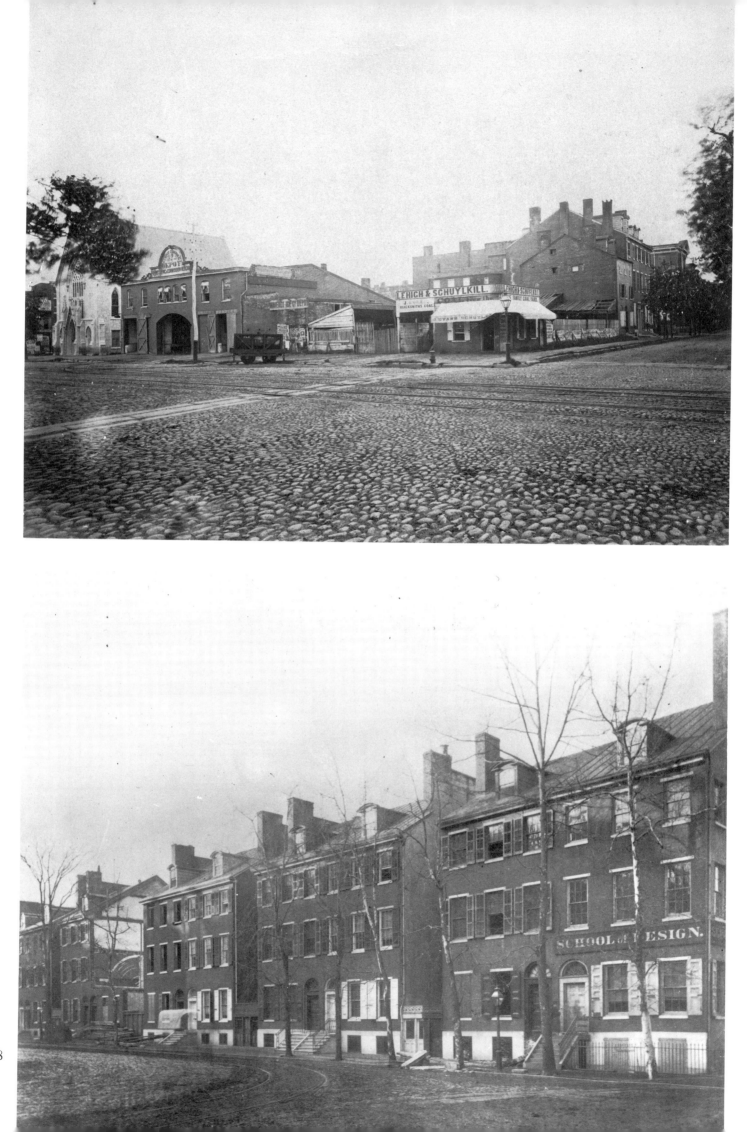

Opposite above: 152. BROAD STREET AT FILBERT,
NORTH PENN SQUARE, C. 1867. Standing on the site
where the Masonic Temple was soon to be built were a
number of small depots that received supplies from larger
industries located on the west bank of the Schuylkill River.
From this point coal, ice, produce and grain were distributed
to residents of the immediate area and to other parts of the
city. The Arch Street Methodist Church can be seen at the
left. The photo can be dated by the theatrical posters on the
billboards. *Photo by Samuel McMullin. Opposite below:*
153. PENN SQUARE, NORTHWEST CORNER, C. 1868.
This photograph was taken when the area around Penn
Square was largely residential, just before the present public
buildings were erected. It shows the site at Merrick Street
(now Broad along West Penn Square) from Filbert to Market,
upon which Broad Street Station was built. *Below:* 154.
PENN SQUARE, MARKET STREET TO FILBERT, C. 1868.
Penn Center now occupies this site at Broad and Market
Streets, west. The view is from Market Street

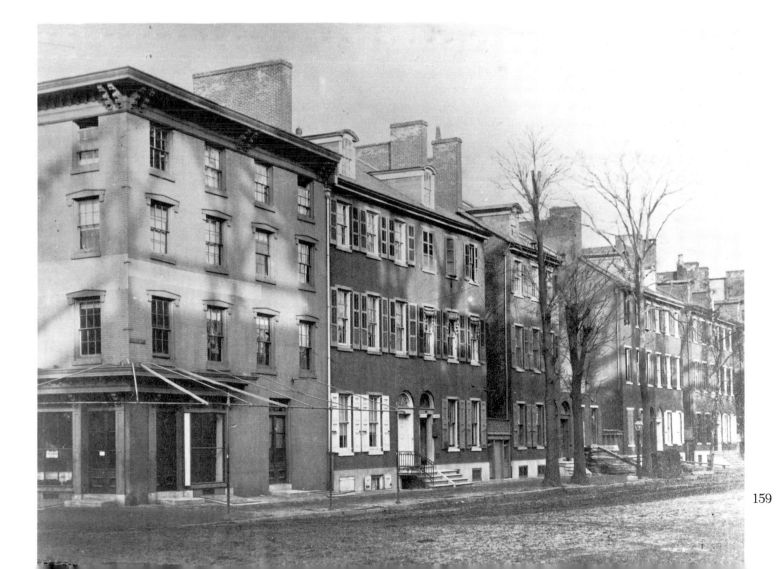

159

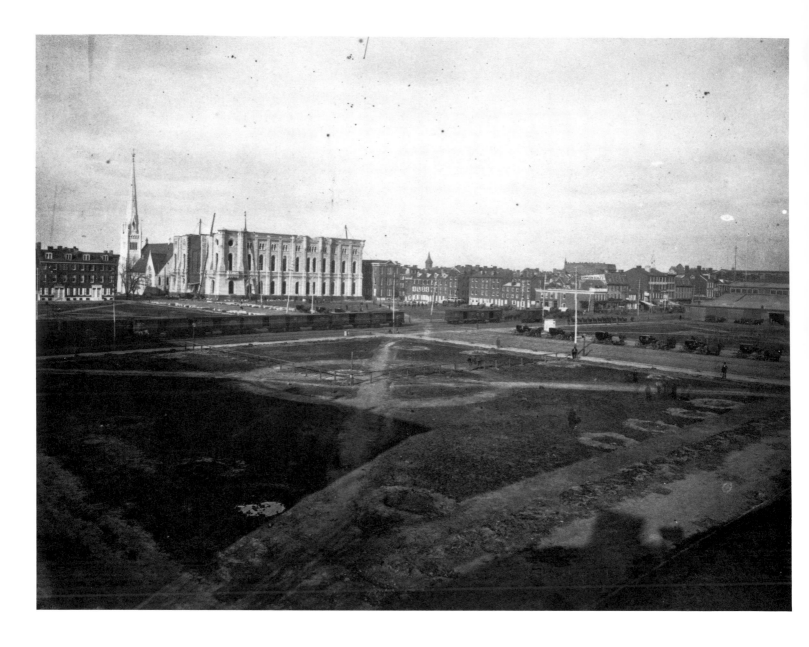

Above: 155. CENTER SQUARE, SITE OF CITY HALL, 1868. While the Masonic Temple was being constructed, the ground in Center Square was cleared to make ready for the new City Hall. Just to the right of the Masonic Temple is the first building occupied by LaSalle College at the corner of Juniper and Filbert Streets. The railroad cars are on tracks leading to the freight depot, seen at the right. *Opposite:* 156. PENN SQUARE, CITY HALL UNDER CONSTRUCTION, 1873. Looking southward across the newly laid foundations of City Hall, one can see here on the left the freight depot of the Pennsylvania Railroad. Next right is the United States Mint, and facing Broad Street is the Penn Square Presbyterian Church. Across Broad along South Penn Square are residences, one of which seems to have been converted to a taproom. *Photo by James Cremer.*

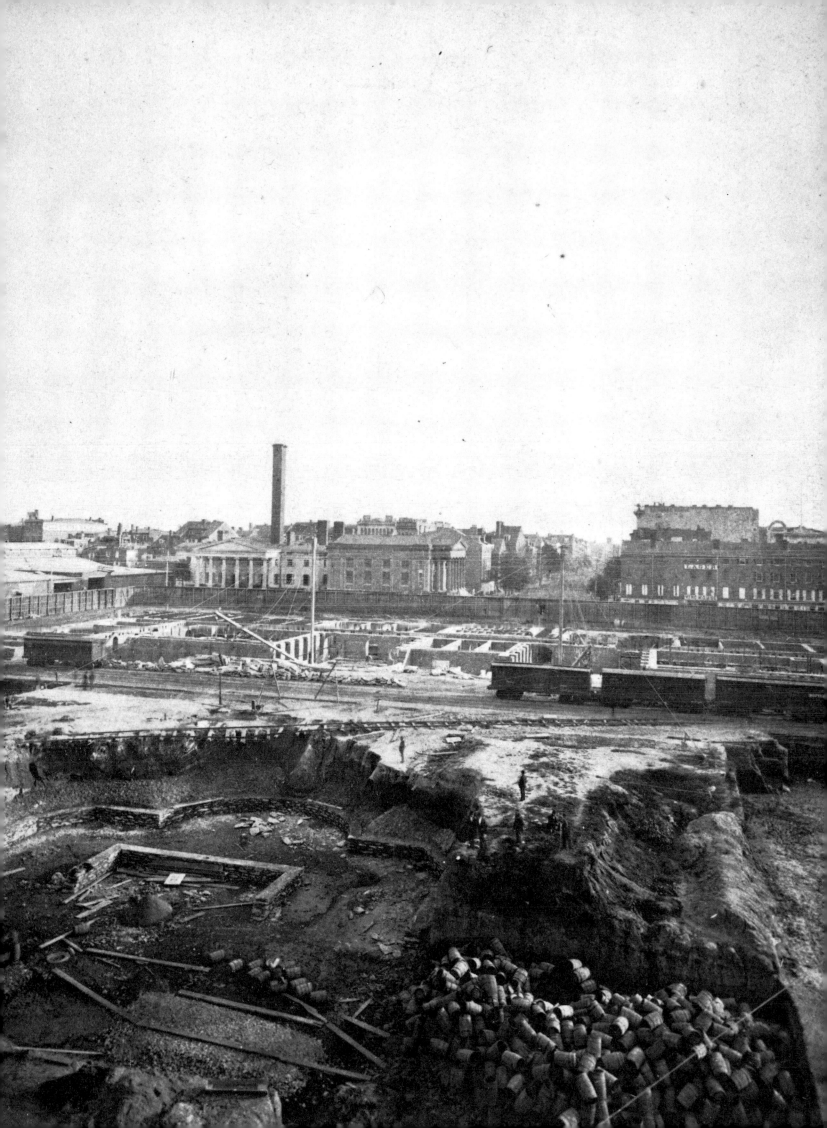

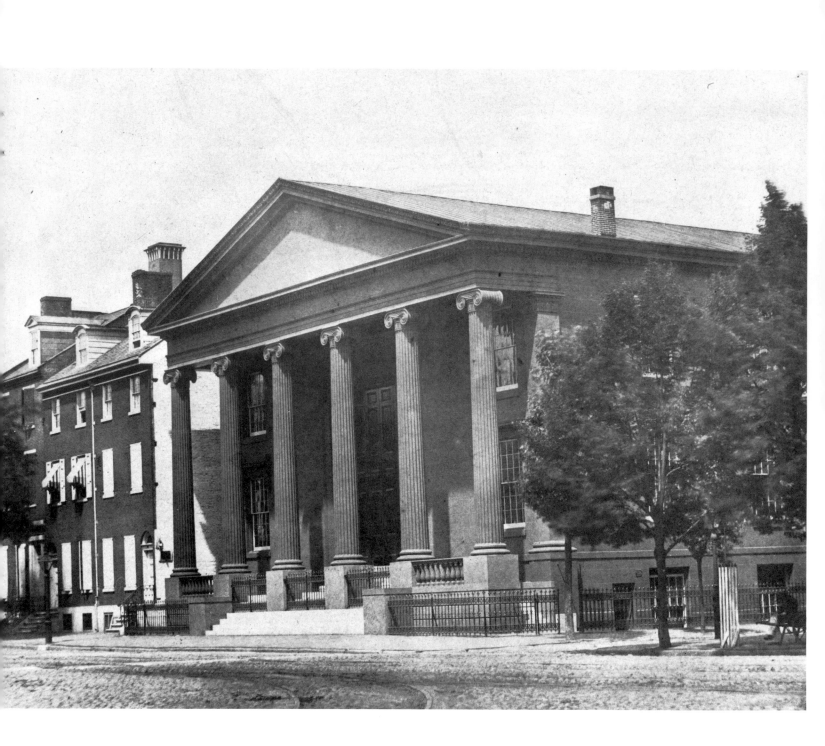

157. FIRST INDEPENDENT PRESBYTERIAN CHURCH (CHAMBERS' CHURCH), BROAD AND SANSOM STREETS, 1856. Chambers' Church, as it was called, stood just south of Penn Square. It was built in 1830 as the result of dissension in the congregation of the Ninth Presbyterian Church growing out of the appointment of the Rev. John Chambers of Baltimore to the ministry of that church. Chambers' supporters withdrew to establish an independent congregation under his guidance. The site is now occupied by the North American Building. *Photo by McClees and Germon.*

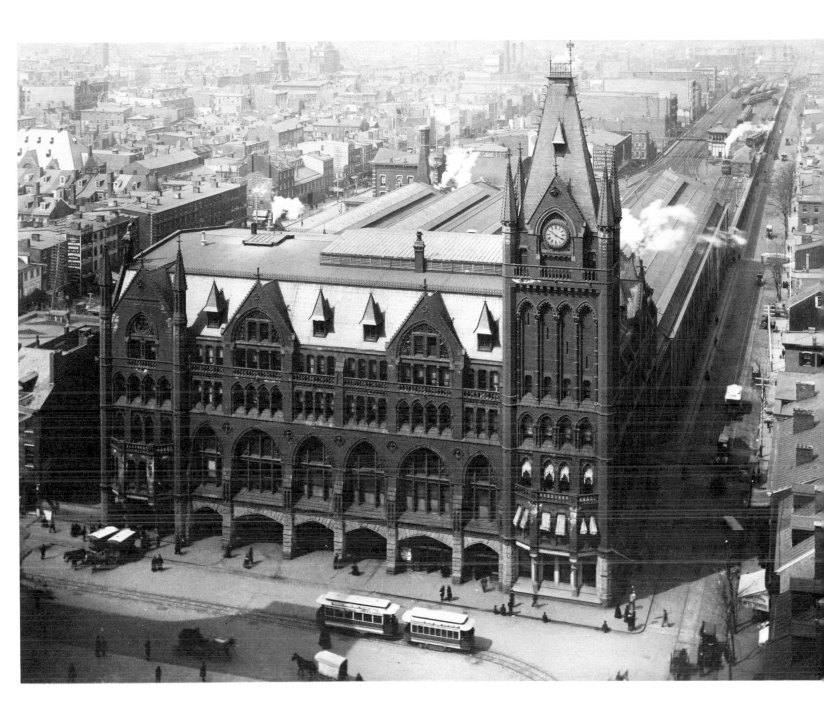

158. PENNSYLVANIA RAILROAD STATION, MARKET
STREET WEST AT PENN SQUARE, 1889. This high-angle
view of the famous station, built in 1881 in the heyday of monu-
mental railroad architecture, is along Filbert Street, and shows
the northern side of the old "Chinese Wall," which was actually
the viaduct for the tracks.

10-2-07

4382

159. MARKET STREET AT BROAD, 1907. This view is westward from City Hall beneath the bridge connecting Broad Street Station with the Arcade Building. The bridge, built around 1902, afforded pedestrian access to the station, and connected the station with Pennsylvania Railroad offices in the Arcade Building. Beyond the bridge at the right is the wall of the train shed and the old "Chinese Wall" extending along Market Street.

160. PENN SQUARE, WEST SIDE, 1903. By the turn of the century business had moved uptown and was clustering around City Hall, which is on the extreme right in this photo. Next to it in the background is Broad Street Station. In the center foreground is the Third National Bank and an office building.

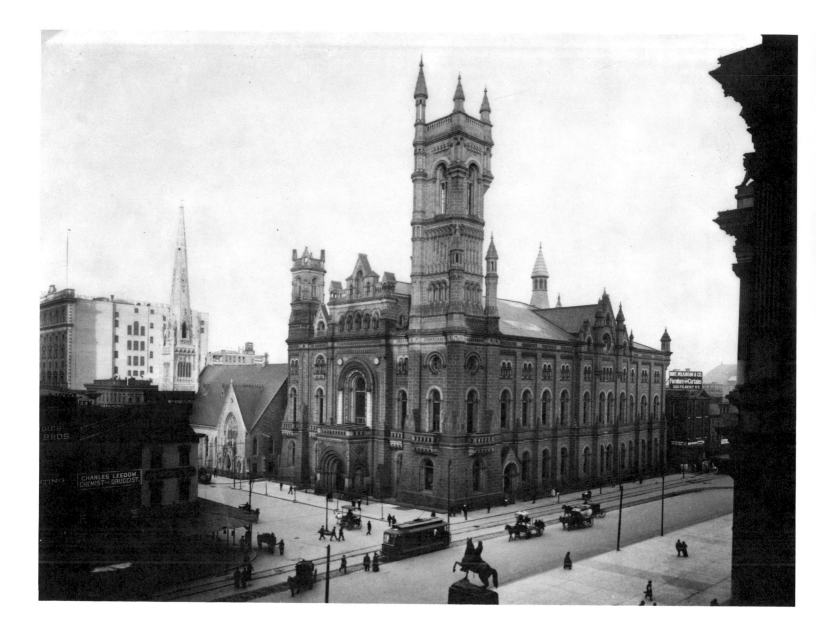

161. MASONIC TEMPLE, NORTH BROAD STREET AT PENN SQUARE, 1902. The stately Masonic Temple, some thirty years old at the time of this photograph, seems a symbol of stability, for it remains virtually unchanged today. Across Broad Street, however, the site of Reyburn Plaza and the present Municipal Services Building was filled with residences turned to the uses of commerce. These buildings, along with the structure belonging to Hunt, Wilkinson and Company, at the extreme right, were demolished after 1905, the latter giving place to the first home of the *Evening Bulletin.*

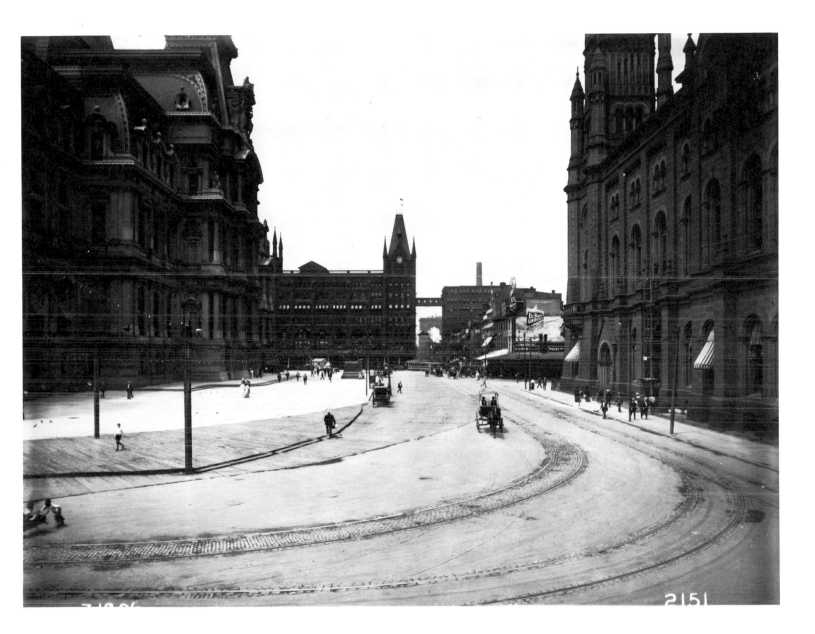

162. PENN SQUARE AT FILBERT STREET, 1906. This view is west from City Hall, north side, into what is now John F. Kennedy Boulevard. Broad Street Station, center, was demolished in 1954. The Masonic Temple is at the right.

163. WEST END TRUST BUILD-
ING, BROAD STREET AT
SOUTH PENN SQUARE, 1905.
This was one of the last photo-
graphs to be taken of this build-
ing, which was soon to be demol-
ished to make way for the Girard
Bank complex. *Photo by Franklin
D. Edmunds.*

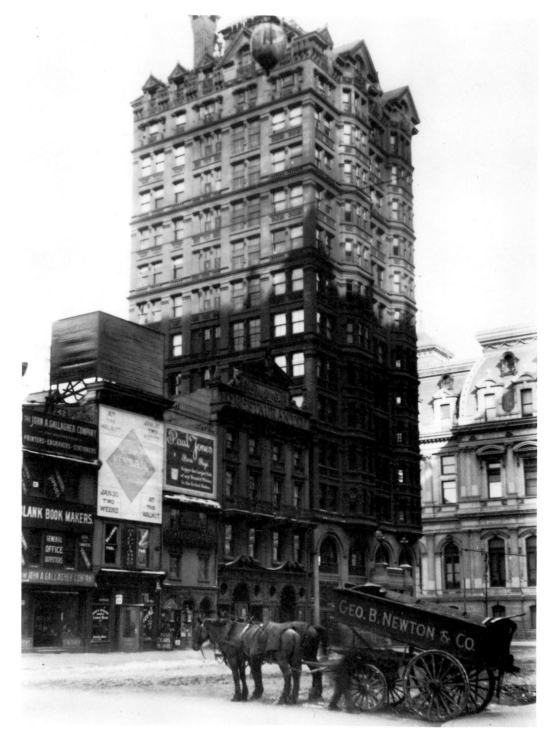

VIII

Broad Street

BROAD STREET is the north-south axis of the city, crossing Market Street at Penn Square. The original plan of the city called for a thoroughfare extending from League Island (now the Navy Yard) on the south to the Montgomery County line on the north, a distance of twelve miles. It was designed as a broad avenue comparable to Market Street, the two streets dividing the city into quadrants. As with other major avenues, its character was in early times essentially residential, though commercial development has long been its dominant feature.

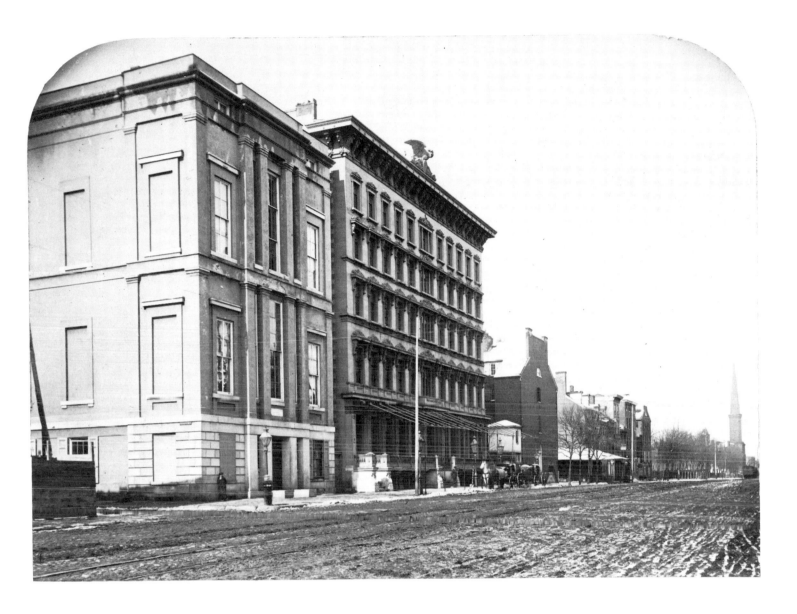

164. BROAD AND SANSOM STREETS, 1865. In the foreground of this view toward the north on Broad Street is the Academy of the Natural Sciences, and next to it, with its ornamental eagle, is the La Pierre House, celebrated as America's most luxurious hotel. Behind the fence at the extreme left, the Union League is under constuction. The spire in the distance is that of the First Baptist Church just north of Penn Square.

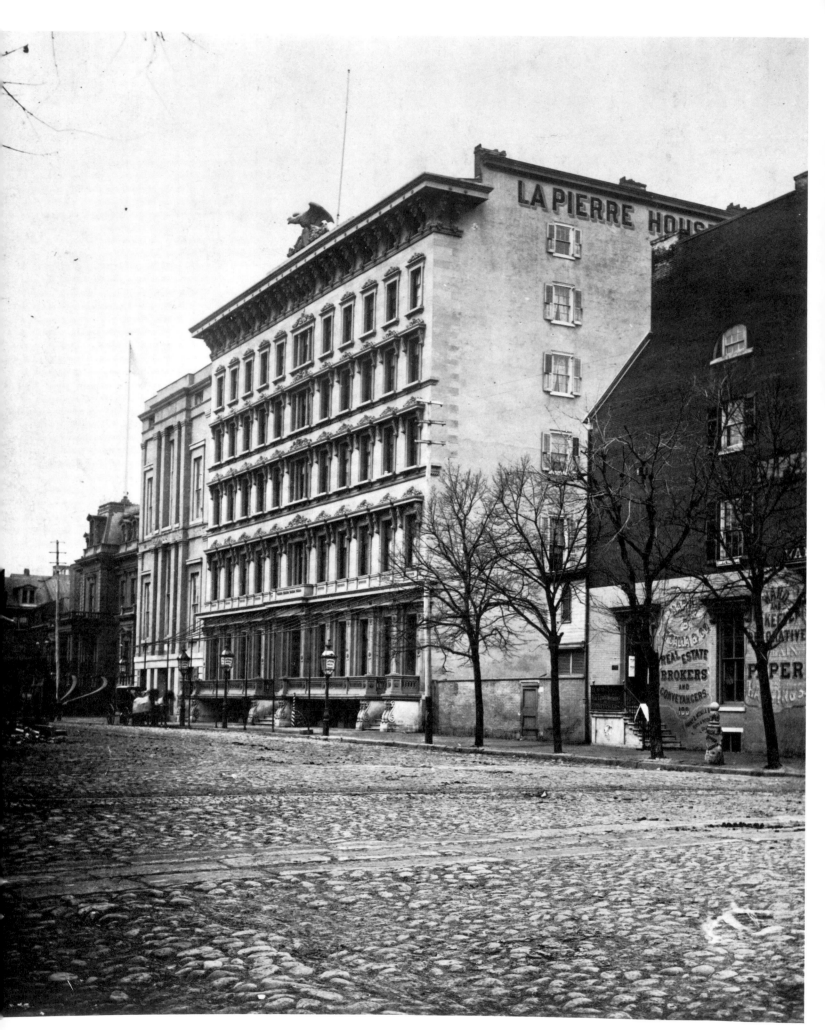

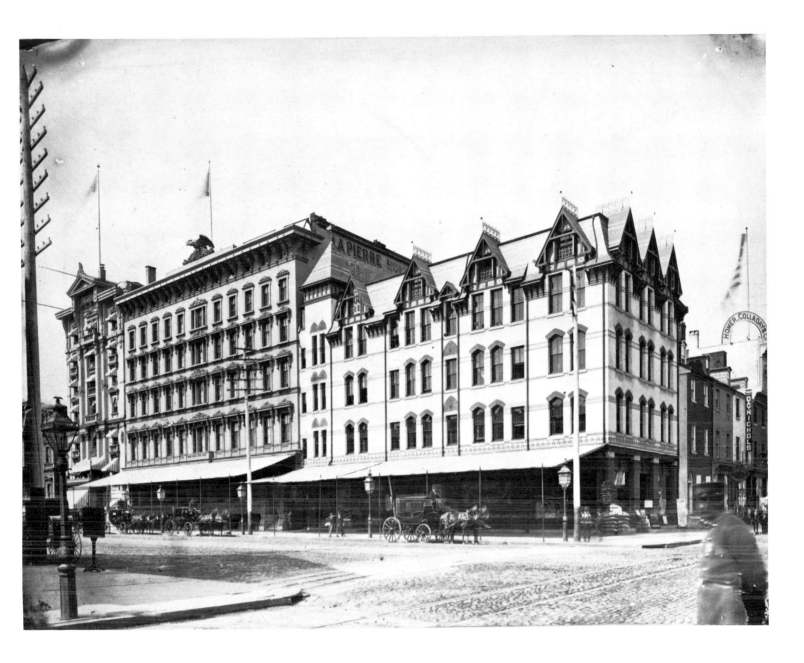

Opposite: 165. LA PIERRE HOUSE, BROAD AND SANSOM STREETS, C. 1869. The same scene a few years later shows the Union League completed and paving stones laid in Broad Street. The view is to the south. *Above:* 166. BROAD AND CHEST-NUT STREETS, SOUTHWEST CORNER, C. 1876. When this photograph was made the La Pierre House had just been taken over by the LaFayette Hotel, extreme left, and was soon to be remodeled to match that hotel. The building on the corner housed the Adams Express Company on the upper floors and a grocer at the street level.

Opposite above: 167. CHESTNUT STREET AT BROAD, C. 1902. Like other corners in Philadelphia's business district, this too was occupied by a colorful variety of enterprises long since displaced. Here, on the site that was soon to be occupied by Girard Bank, are a brokerage, a shooting gallery, a lunch room, an oriental rug salesroom and a Pennsylvania Railroad ticket office. The brokerage displays a poster announcing an international cricket match between "Marylebone Cricket Club and the Gentlemen of Philadelphia." *Opposite below:* 168. DUNDAS-LIPPINCOTT MANSION, BROAD AND WALNUT STREETS, C. 1890. Once a spacious residential property, the northeast corner of Broad and Walnut Streets is now one of the busiest intersections in the city and the site of Fidelity Bank. The Dundas-Lippincott, or "Yellow," Mansion was built in 1839 by James Dundas, a banker. It was bequeathed to Mrs. Joshua Lippincott in 1865, and remained standing until 1903. *Below:* 169. BROAD STREET, NORTH FROM WALNUT, C. 1894. Visible here, from the right, are the gardens of the Dundas-Lippincott Mansion, Chambers' Church, the Girard Life Insurance, Annuity and Trust Company, and City Hall.

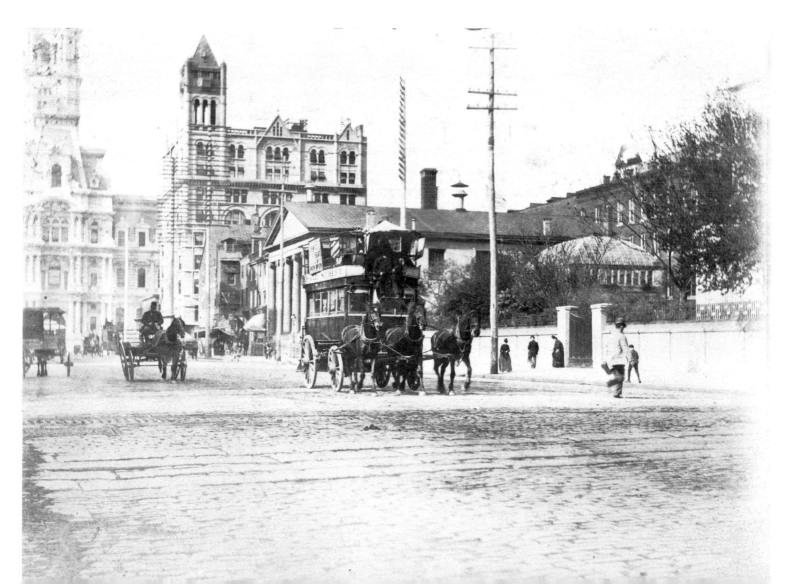

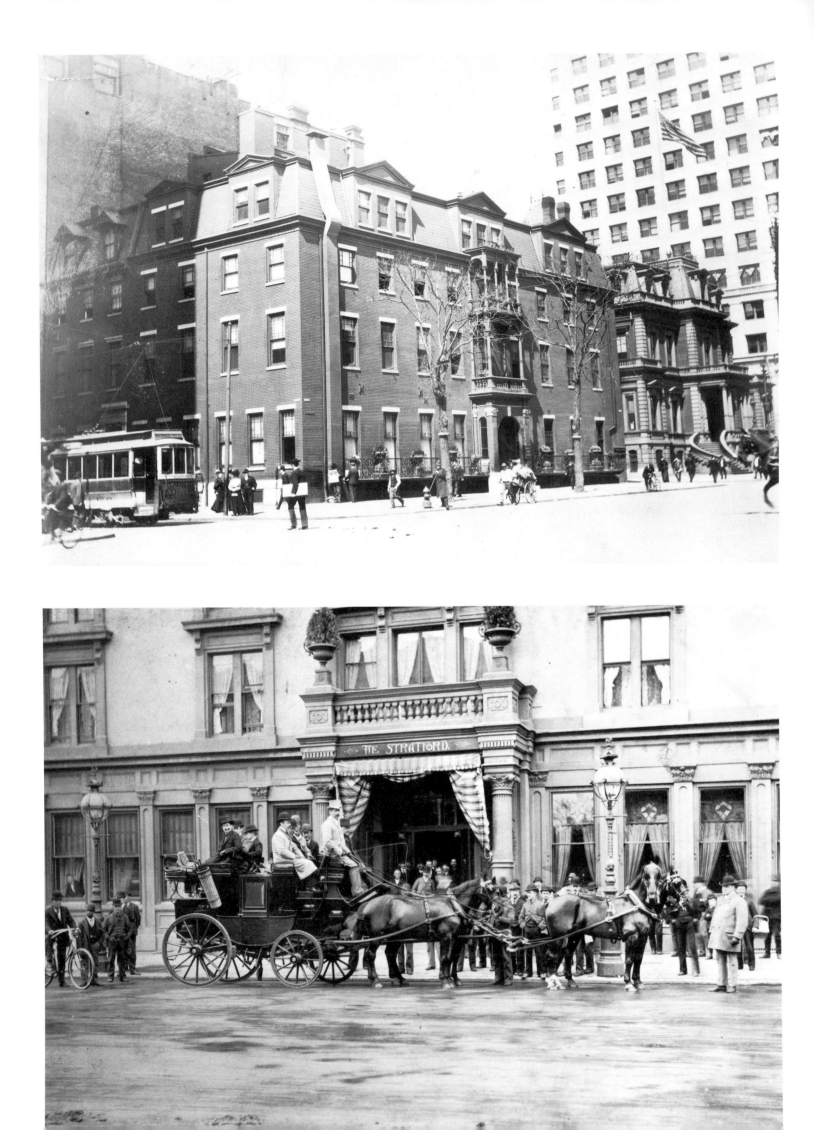

Opposite above: 170. BELLEVUE HOTEL, BROAD STREET AT WALNUT, NORTHWEST CORNER, C. 1899. Opened in 1882, the Bellevue soon became popular as a meeting place for socialites and fashionable clubs. It later merged with the Stratford. In 1904, only 19 hours after the Bellevue's ceremonious closing, the Bellevue-Stratford opened across Walnut Street on the site of the old Stratford. *Opposite below:* 171. STRATFORD HOTEL, BROAD STREET AT WALNUT, SOUTHWEST CORNER, C. 1895. This picture shows Col. Edward Morrell in the driver's seat of the carriage in front of the Stratford Hotel preparing for a coaching parade. Col. Morrell was a congressman, formerly Colonel of the Third Regiment, National Guard of Pennsylvania, and Director of the Pennsylvania Company for the Insurance of Lives. *Below:* 172. STRATFORD HOTEL, BROAD STREET AT WALNUT, SOUTHWEST CORNER, C. 1902. This photograph was made after the merger between the Bellevue and the Stratford Hotels had been agreed upon. The Stratford was closed quite some time before the Bellevue to make way for the construction of the Bellevue-Stratford. As the sign indicates, the furnishings were disposed of at public sale. *Photo by W. N. Jennings.*

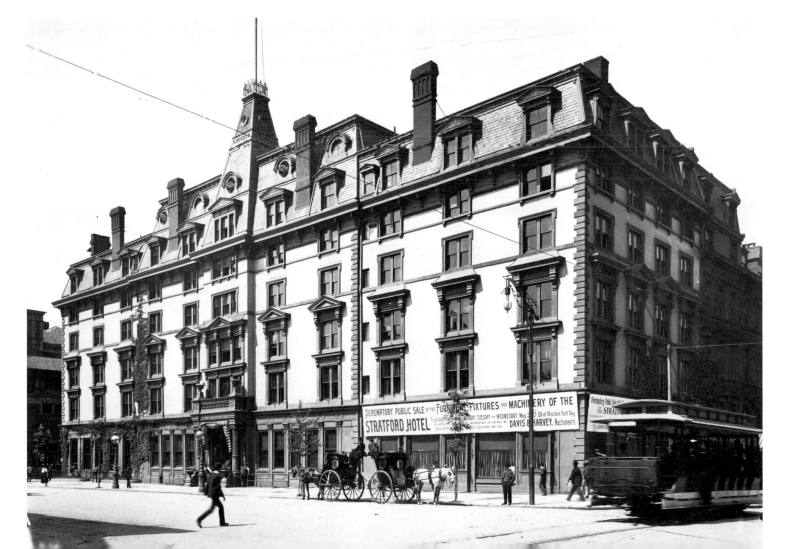

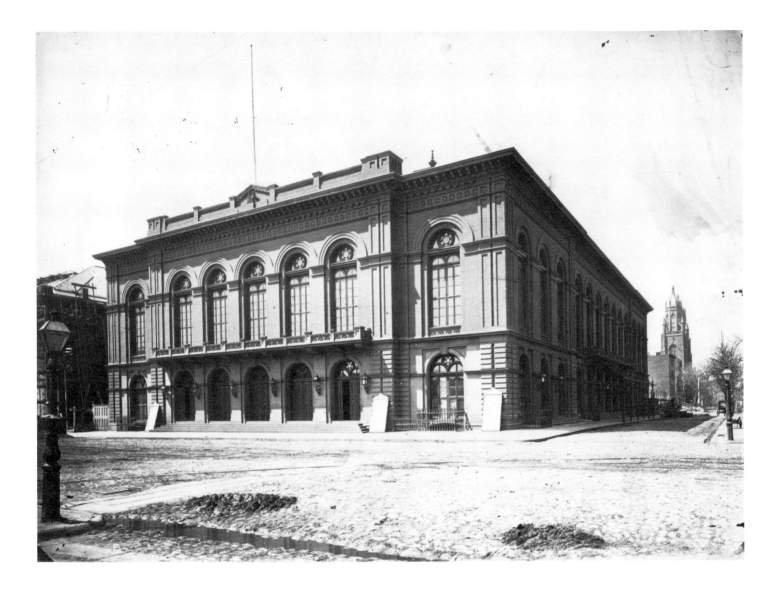

173. ACADEMY OF MUSIC, BROAD AND LOCUST STREETS, C. 1865. Built from 1855 to 1857, the American Academy of Music was the successor to the Chestnut Street Theatre as the permanent home for grand opera. Modeled after La Scala in Milan, it was acoustically the best theater in America. Down Locust Street to the right can be seen the tower of Calvary Presbyterian Church at 15th Street.

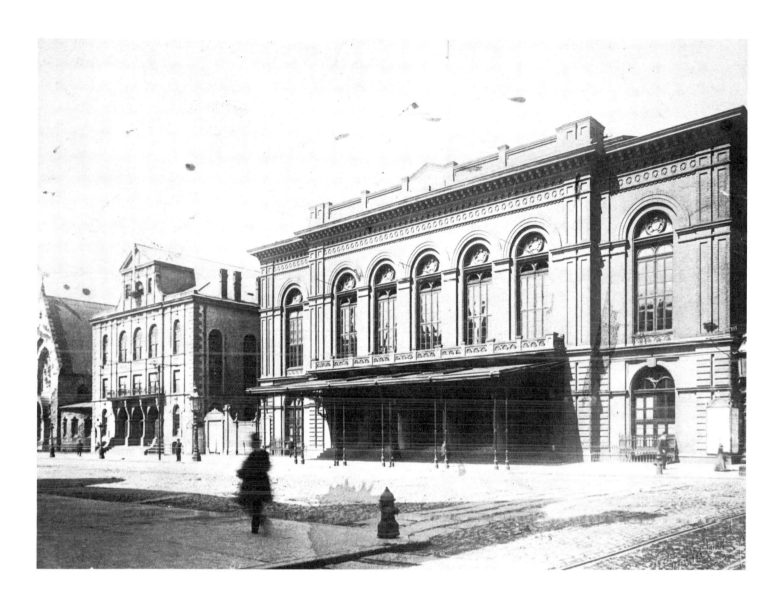

174. ACADEMY OF MUSIC AND HORTICULTURAL HALL, BROAD
STREET AT LOCUST, C. 1880. Another view of the Academy of Music
shows Horticultural Hall, left, which was the meeting place of the Associ-
ation of Philadelphians for the Advancement of Horticultural Interests. This
group of "gentlemen gardeners" was organized in 1827 to protect and
advance the cause of the gardening and fruit-growing industries in Penn-
sylvania. The building shown here was opened in 1865.

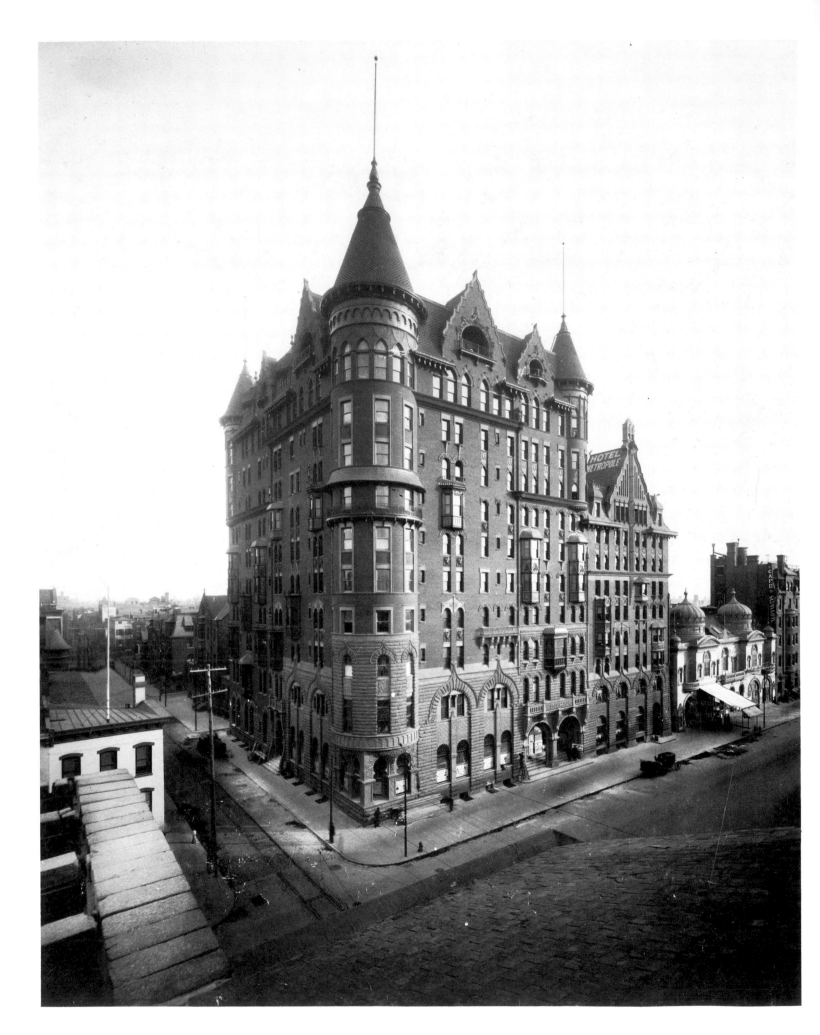

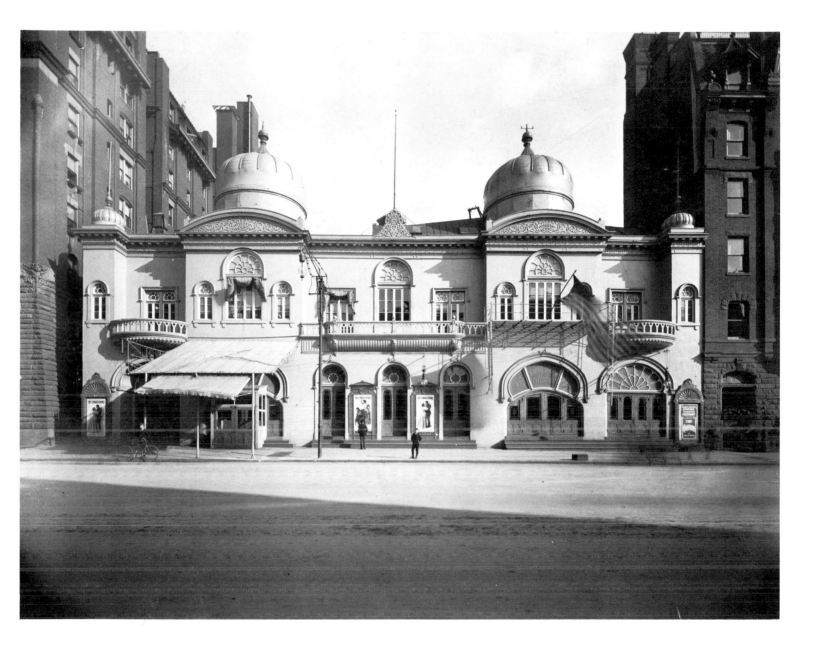

Opposite: 175. HOTEL WALTON, BROAD STREET AT LOCUST, C. 1898. This building remained standing until the early 1960s, when it was known as the John Bartram Hotel. Beside it on the south side is the Broad Street Theatre, with Lillian Russell's name in lights, and next to the right is the old Hotel Stenton. At present these lots are vacant and used for parking. The view is from the roof of the Hotel Windemere, a residential hotel where the famous artist Joseph Pennell once lived. *Above:* 176. BROAD STREET THEATRE, BROAD STREET AT LOCUST, 1898. This extraordinary building was opened in 1876 especially for the entertainment of the crowds expected to attend the Centennial Exposition. It was known as Kiralfy's Alhambra Palace (the Kiralfys were important performers and impresarios based in New York), and offered the general public not only theatrical extravaganzas but also a beer garden and an open-air restaurant. Its ornate interior was painted in brilliant colors meant to suggest its namesake in Spain. The theater underwent many architectural modifications during its long history, and by the time it was taken down in 1937 it had lost most of its original appeal. The play advertised in the photo is *The Conquerors,* performed by Charles Frohman's Empire Theatre (New York) Company.

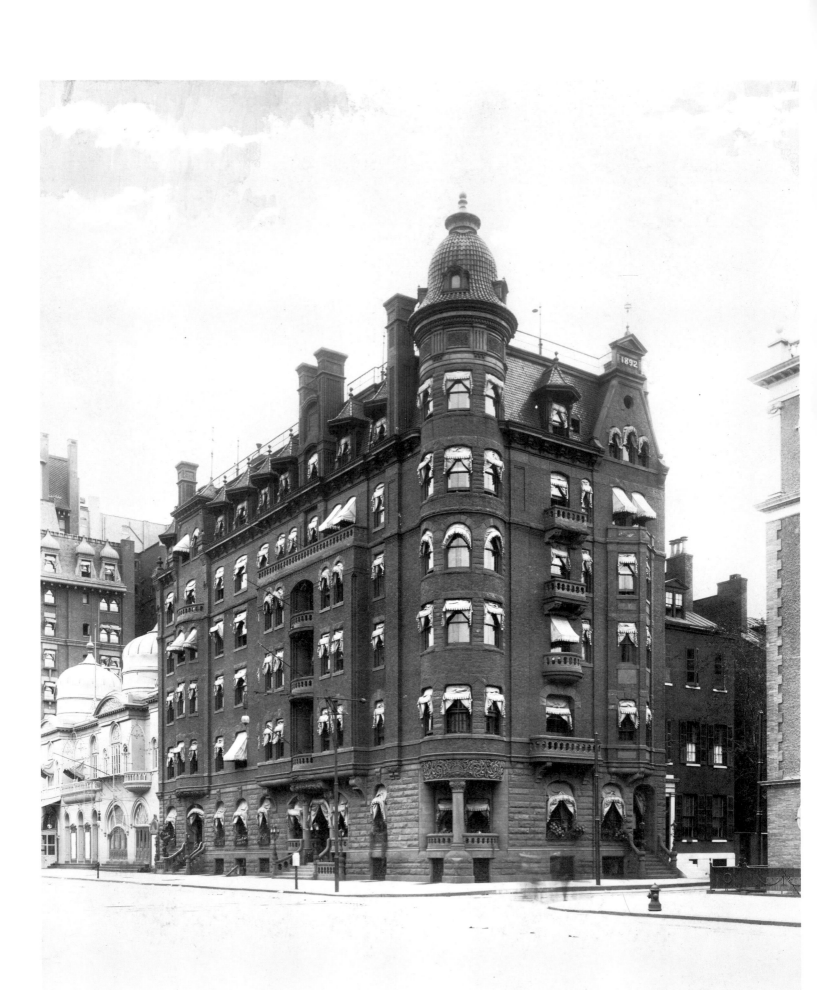

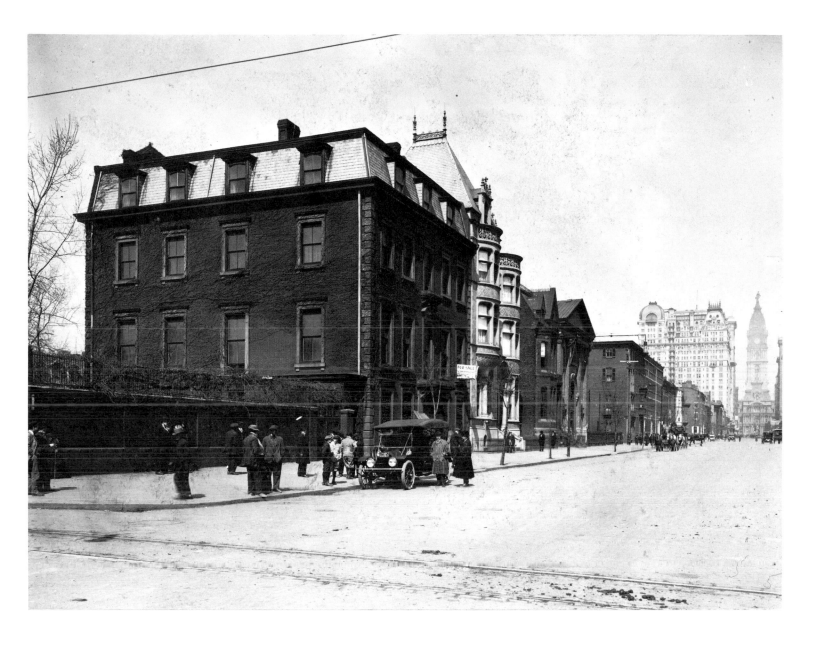

Opposite: 177. HOTEL STENTON, BROAD STREET AT SPRUCE, C.
1898. The view is to the northeast, showing the Broad Street Theatre and
the Hotel Walton. *Above:* 178. BROAD STREET AT SOUTH, 1914. The
mansions of South Broad Street were thought at the time they were standing
to indicate the direction in which affluent society was moving. The three
mansions viewed here northward from South Street are (left) the "Big Red
House" of J. Rhea Barton, M.D., and the residences of Francis T. Sully
Darley (musician and grandson of Thomas Sully) and John Grover Johnson,
lawyer and art connoisseur. In 1914 the Barton residence was for sale, and
the other two houses were also removed within the next two decades.

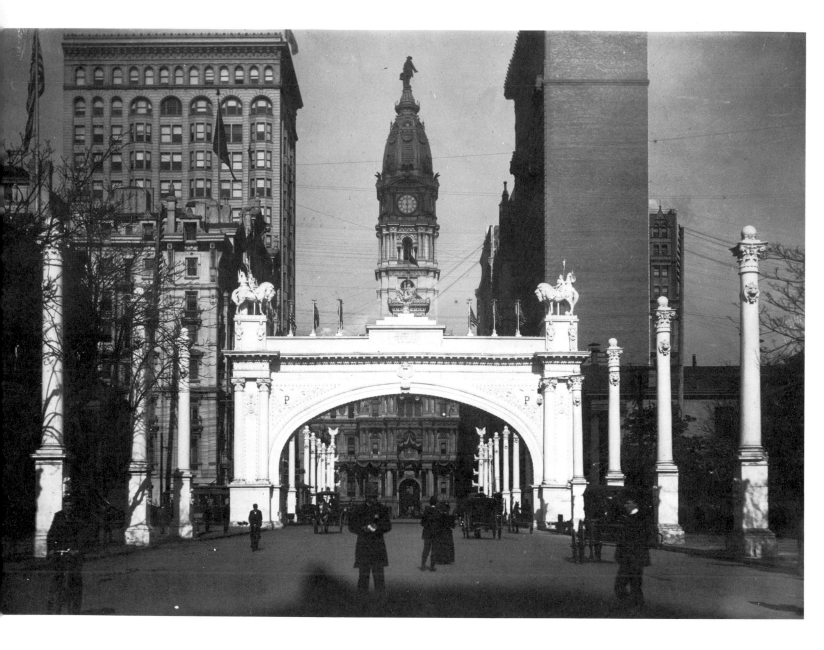

179. COURT OF HONOR, PEACE JUBILEE, 1898. The plans
for an observance of the end of the war with Spain in 1898 had
begun as a purely municipal project. However, having attracted
nationwide attention, it grew to a celebration that lasted for three
days in October 1898. It was attended by President McKinley,
many military leaders and large contingents of the Army and
Navy. The Court of Honor, seen here, was built on Broad Street
south from City Hall to Walnut Street, the great archway stand-
ing at Sansom Street. Its purpose was to pay tribute to the armed
services.

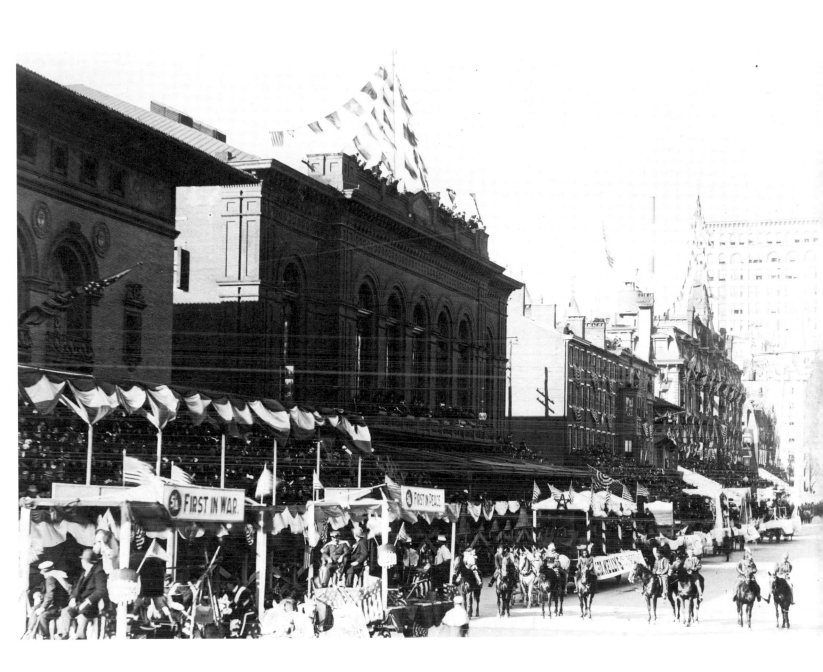

180. PARADE, PEACE JUBILEE, 1898. A view of the parade
proceeding south on Broad Street shows the horse-drawn floats
and the multitude crowding the stands which had been built
along both sides of Broad Street. The buildings here are, from the
left, Horticultural Hall, the Academy of Music, the Windemere
Hotel, the Stratford and Bellevue Hotels and, in the distance, the
Land Title Building.

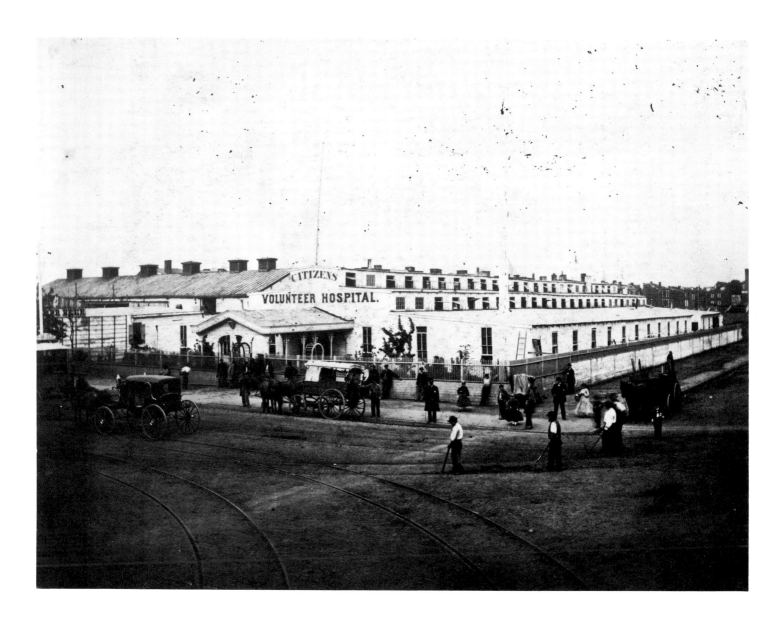

181. CITIZENS' VOLUNTEER HOSPITAL, BROAD AND PRIME STREETS, 1864. These were temporary buildings put up on South Broad Street, at what is now Washington Avenue, for the treatment of Civil War casualties. Volunteer refreshment centers were also constructed in 1863, when Philadelphia, feeling itself under siege from the approaching Confederate army, became virtually an armed fort.

IX

Schuylkill River Area

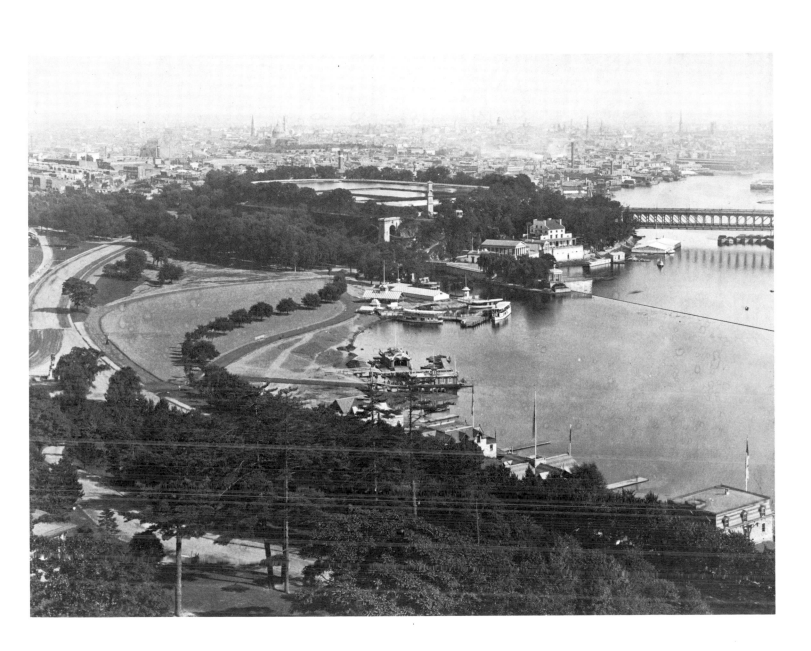

182. VIEW FROM LEMON HILL, 1876. The view southeast from the observatory at Lemon Hill, East Fairmount Park, shows the Centennial City in the hazy distance. Immediately below, on the east bank of the Schuylkill River, are the rowing clubs of Boathouse Row, the pleasure steamers at the landing stage, and the Fairmount Water Works below the reservoir. The Spring Garden Street Bridge stretches to the Centennial grounds, right. *Photo by James Cremer.*

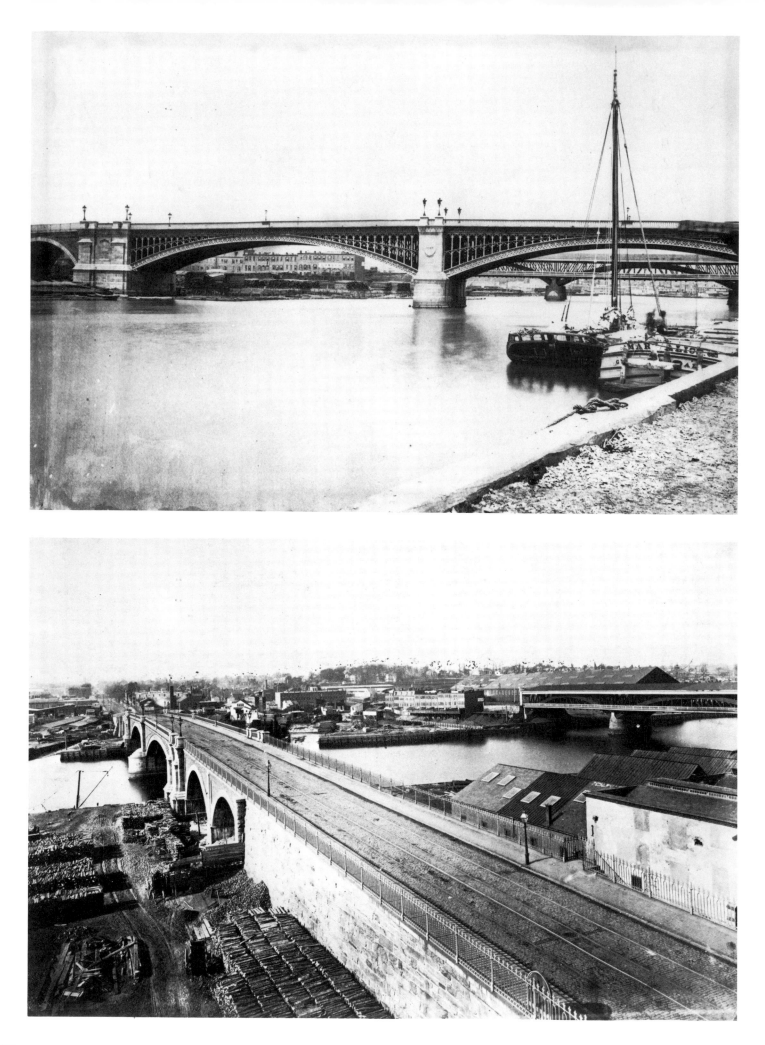

Opposite above: 183. CHESTNUT STREET BRIDGE, C. 1868. The Chestnut Street Bridge across the Schuylkill River was opened in June 1866, affording greater access to the west bank of the river, where much heavy industry was then located. Through the arch of the bridge, left, can be seen a lumber yard on the site now occupied by the United States Post Office at 30th Street. The river was busy with coal barges, canal boats and other craft as the small boats tied to the dock, right, indicate. *Opposite below:* 184. WEST FROM CHESTNUT STREET BRIDGE, C. 1869. This view into West Philadelphia across the Chestnut Street Bridge shows the river front to be dominated by storage yards for coal, lumber and ice, various light industries, and docks for

barges and small watercraft. In the left foreground is the site upon which the Baltimore and Ohio Railroad Station was built by Frank Furness in 1888. *Below:* 185. MARKET STREET BRIDGE AND THE SCHUYLKILL RIVER, 1900. This view along the Schuylkill River toward the southwest shows the principal bridges leading from Center City into the West Philadelphia area. At the upper left is architect Frank Furness' towered B.&O. Railroad Station at the east end of the Chestnut Street Bridge. It was just about here that John Fitch launched his experimental steamboat in 1785, carrying twenty passengers downstream to Gray's Ferry, about twelve miles distant.

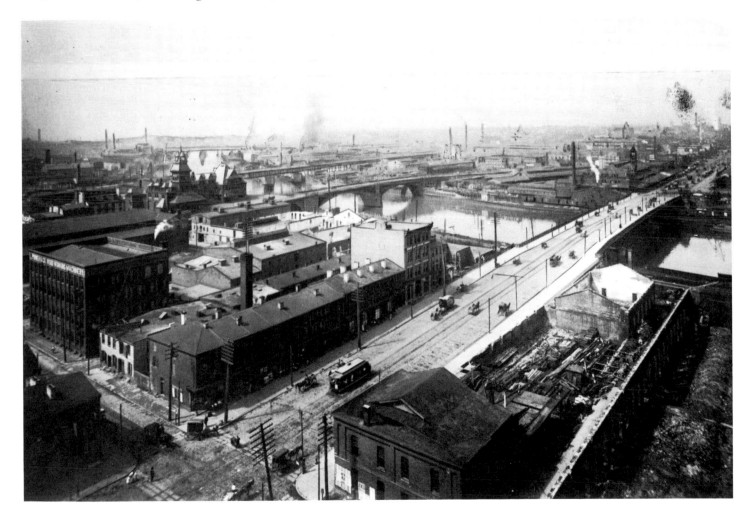

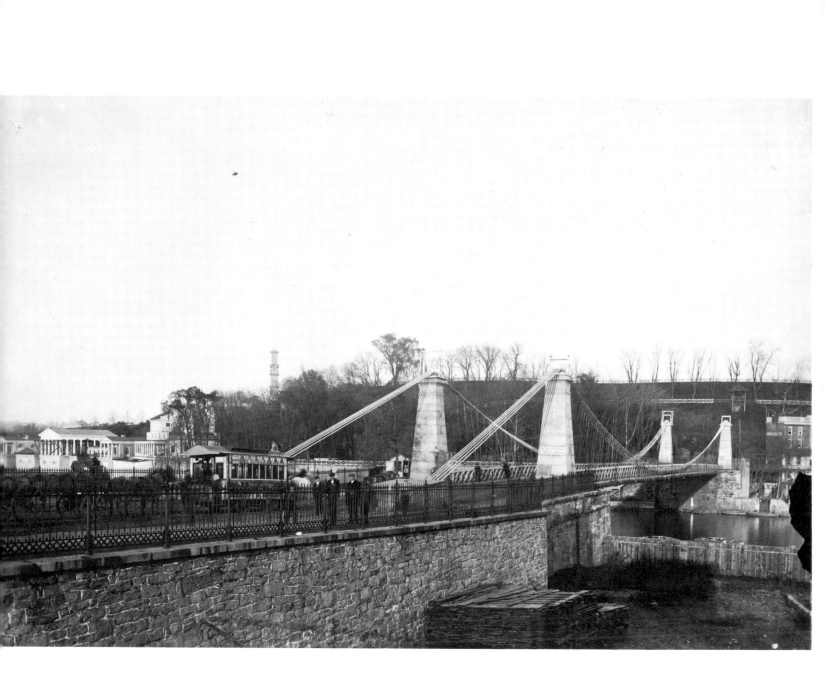

186. WIRE BRIDGE ON THE SCHUYLKILL RIVER AT SPRING GARDEN STREET, C. 1875. This was the first successful wire suspension bridge in America. It was built in 1842 by Charles Ellet, and connected Spring Garden Street with West Philadelphia. This photograph was made just before the bridge was removed in 1875, to be replaced by a structure of steel. The Fairmount Water Works and the Standpipe are seen at the left, and the skyline, from right to center, marks the former reservoir, now the site of the Philadelphia Museum of Art.

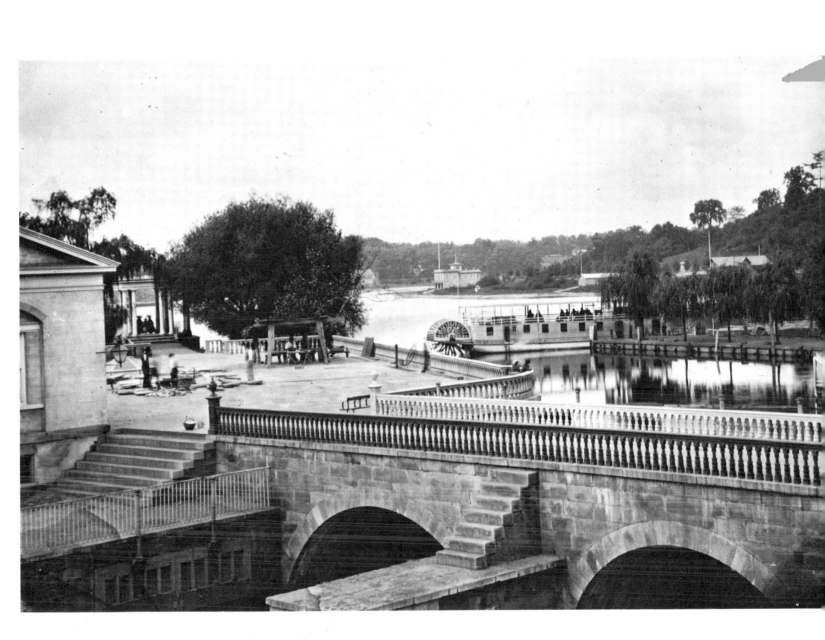

187. FAIRMOUNT WATER WORKS, FOREBAY AND PLEA-
SURE STEAMER, C. 1870. The Fairmount Water Works, with
its formal gardens and promenades, was a focal point for pleasure
seekers almost from the time these buildings were completed in
1822. Adjacent to the gardens and promenades was the landing
stage of a river steamer which took passengers on short cruises up
the Schuylkill River and back.

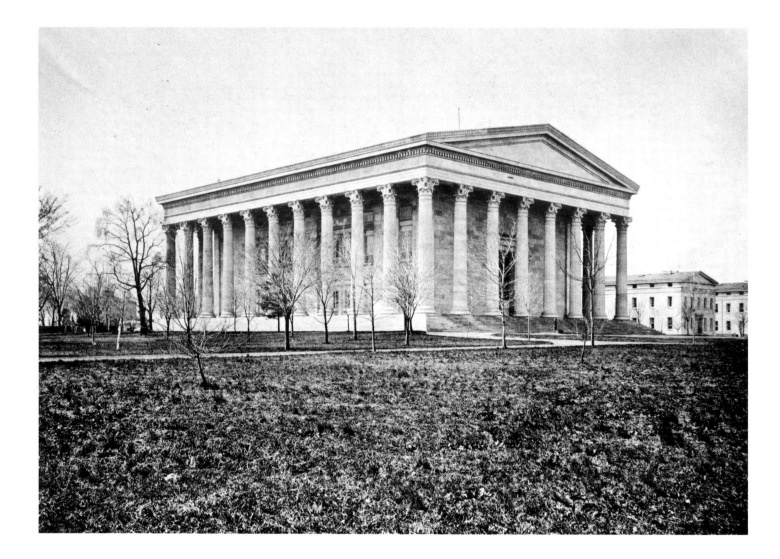

188. GIRARD COLLEGE, MAIN BUILDING, 1869. Designed by Thomas
U. Walter and completed in 1847, this imposing building orginally housed
the administrative offices of Stephen Girard's famous college for orphans.
From its position on a hill northwest of Penn Square it commands a sweep-
ing view eastward to the waterfront. The photograph won an award from
the Photographic Society of Philadelphia. *Photo by J. C. Browne.*

X

The Centennial Exposition of 1876

ACCORDING to *Frank Leslie's Illustrated Historical Register of the Centennial Exposition of 1876*, the opening day, May 10, was stormy and forbidding in the early morning hours. However, by the time the gates to the great Exposition opened at 9 o'clock, the sky was clear and a benevolent sun shone brightly on the thousands of people who pressed through the turnstiles, eager to see the distinguished guests on the speakers' stand, as well as the exhibits from the world over.

The Exposition was in effect a trade fair at which nations from around the world displayed their most recent and prized inventions and products. It was therefore not only an assemblage of curiosities, but also a show of worldwide technical advancement.

Probably the most outstanding exhibit was the giant 700-ton steam engine, whose dimensions and power staggered the imagination. The designer was George H. Corliss of Rhode Island. It was brought in from Providence on a special train, and installed in the center of Machinery Hall. From this strategic location it supplied the power for all mechanically driven exhibits in this building.

Among the curiosities was the disembodied colossal arm and hand of Bartholdi's *Liberty Enlightening the World* and the elevated, or "prismoidal," railway which crossed Belmont Ravine and must have been the earliest monorail.

The closing of the Exposition on November 10 was also plagued by bad weather, according to *Frank Leslie's*. In the months to come most of the buildings were dismantled. But the Art Gallery remains to this day as Memorial Hall, a reminder of a historically important celebration.

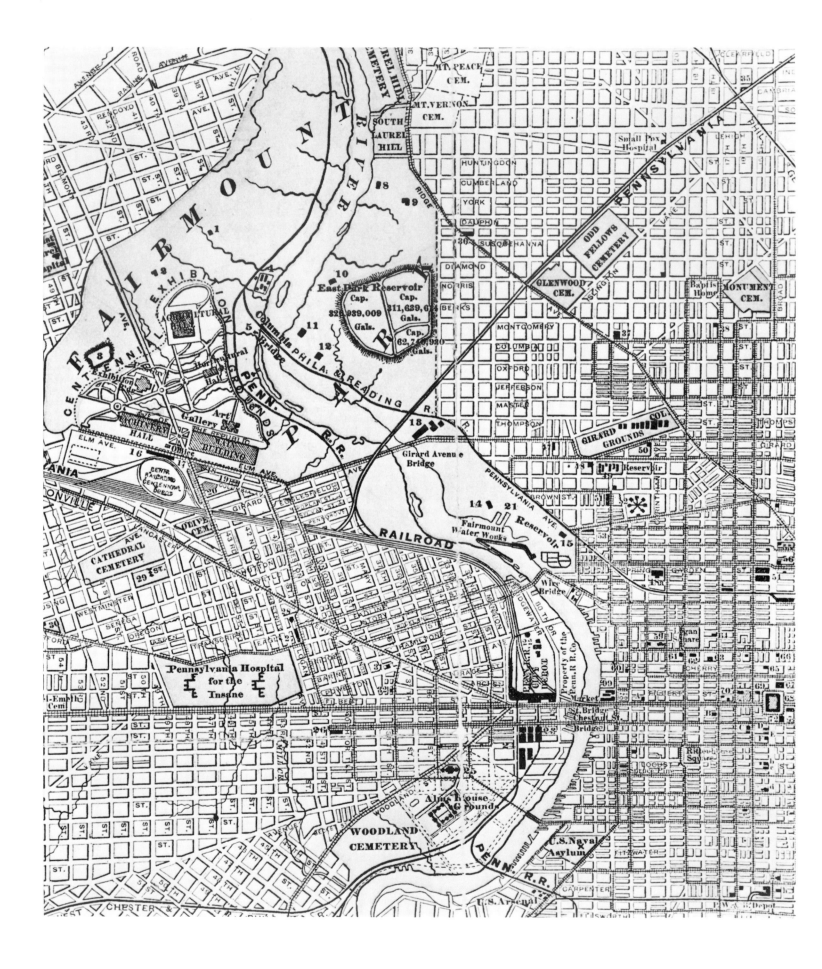

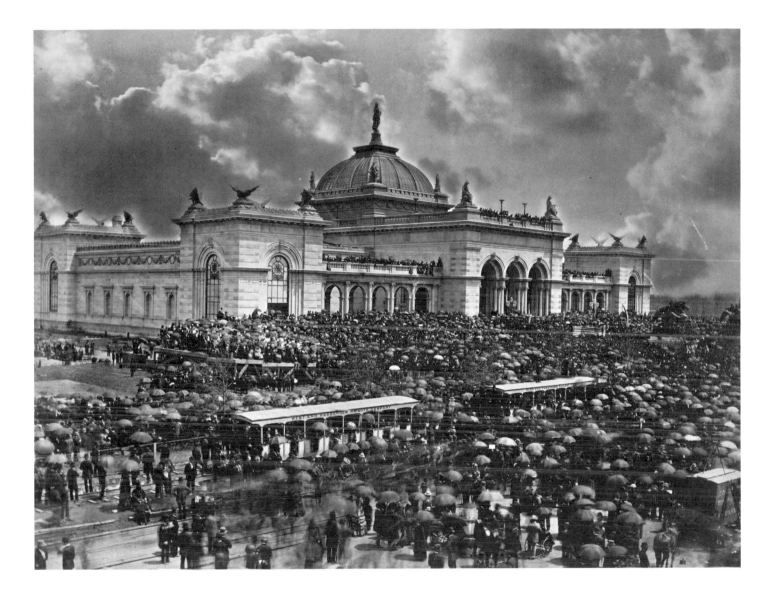

189. OPENING DAY, MAY 10, 1876. The opening ceremonies took place on the terraces of the Art Gallery and in the area facing the Main Building. Speakers' stands were erected in front of the Art Gallery, and stands for a great choir and orchestra were placed directly opposite, before the entrance to the Main Building. President and Mrs. Grant were present as were the Emperor Pedro II and Empress Theresa of Brazil.

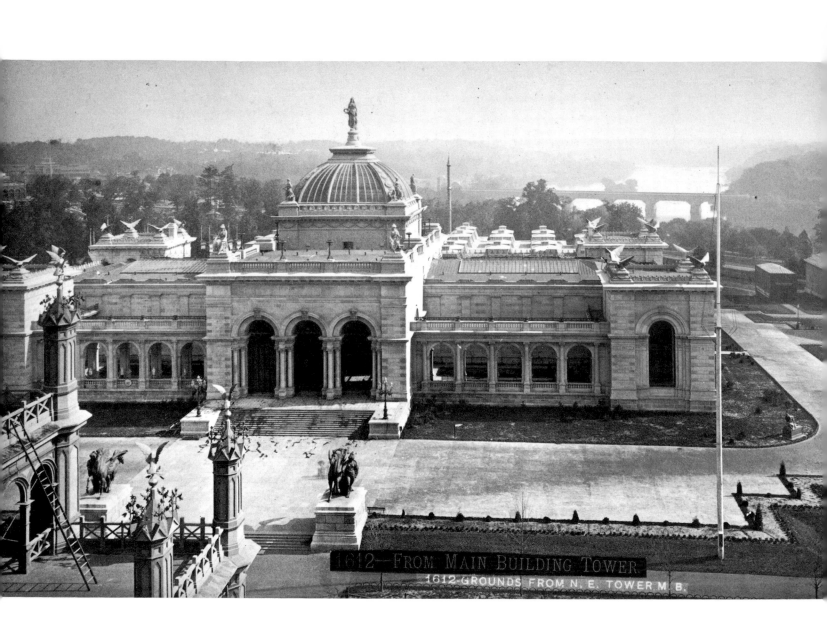

1612—FROM MAIN BUILDING TOWER.
1612-GROUNDS FROM N. E. TOWER M. B.

190. ART GALLERY. The Art Gallery and its terraces were designed by Herman J. Schwarzmann, the young Chief Engineer and Architect of the Centennial, who had come to this country from Germany around 1868. This building, in the "modern Renaissance" style, was one of five principal exhibition halls, the others being the Main Building, Machinery Hall, Agricultural Hall, and Horticultural Hall, of which Schwarzmann was also the architect.

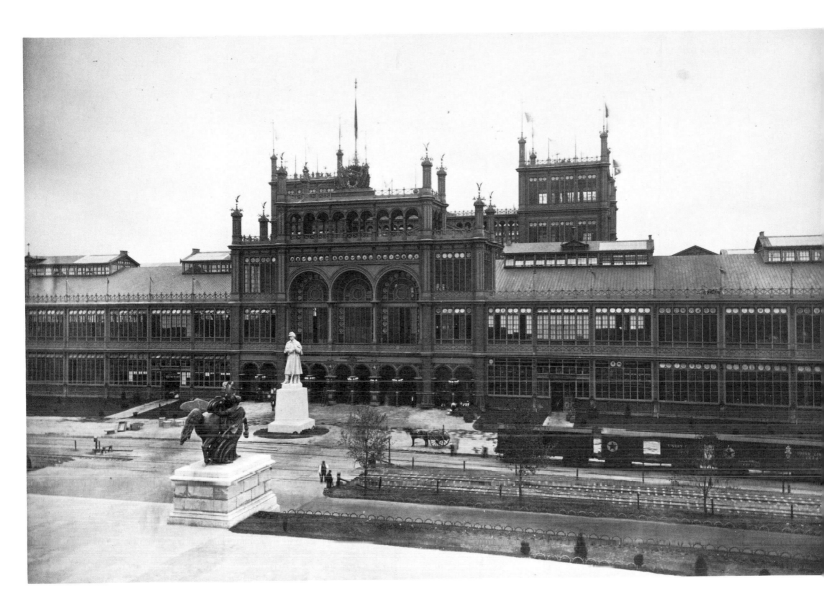

191. MAIN BUILDING. The Main Building, located opposite the Art Gallery, housed principal exhibits from all nations. It was built by Henry Petit and Joseph Wilson of Philadelphia, and was the largest building of the Exposition.

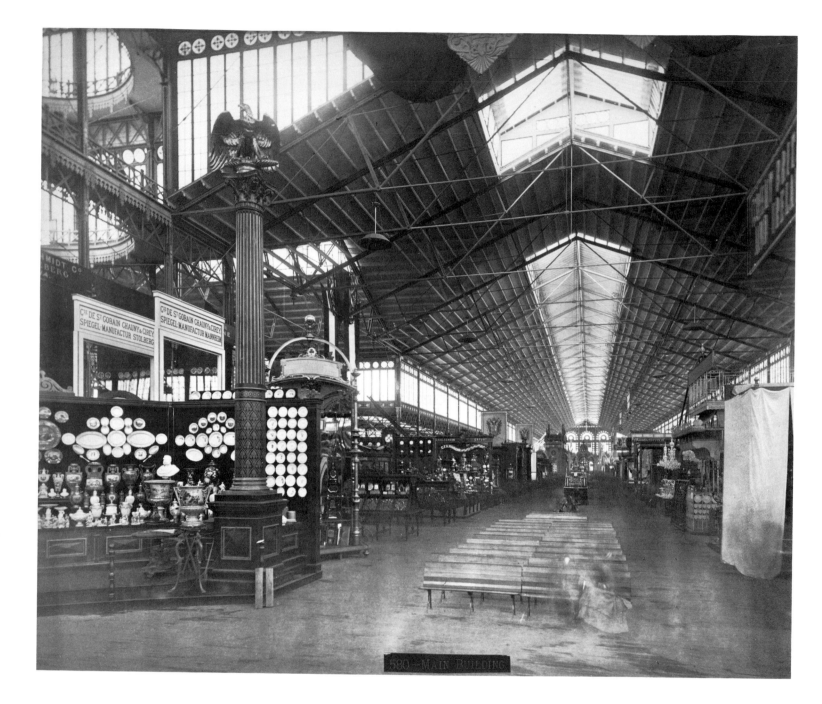

580 - Main Building

192. MAIN BUILDING, INTERIOR, NAVE. The rows of benches shown here are in the center of the Main Building facing the bandstand where periodic concerts were held. Located in the area surrounding this focal point are exhibits from France, Great Britain and other foreign nations.

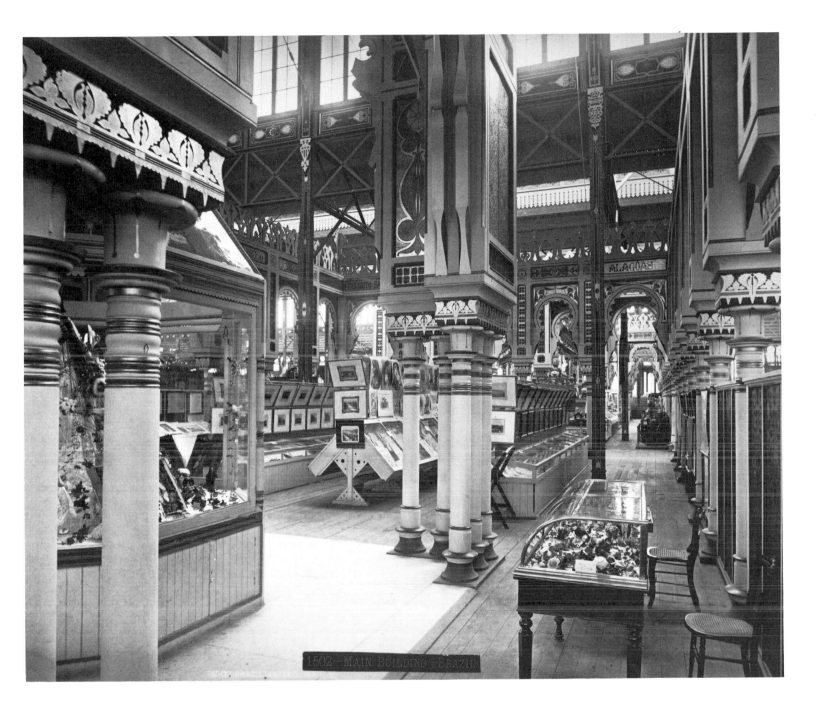

193. MAIN BUILDING, BRAZILIAN EXHIBIT. The individual exhibit areas in many instances were enclosed by elaborate constructions, as shown here. This one was designed by Philadelphia's Frank Furness. Brazil also maintained a separate pavilion as well, and a restaurant.

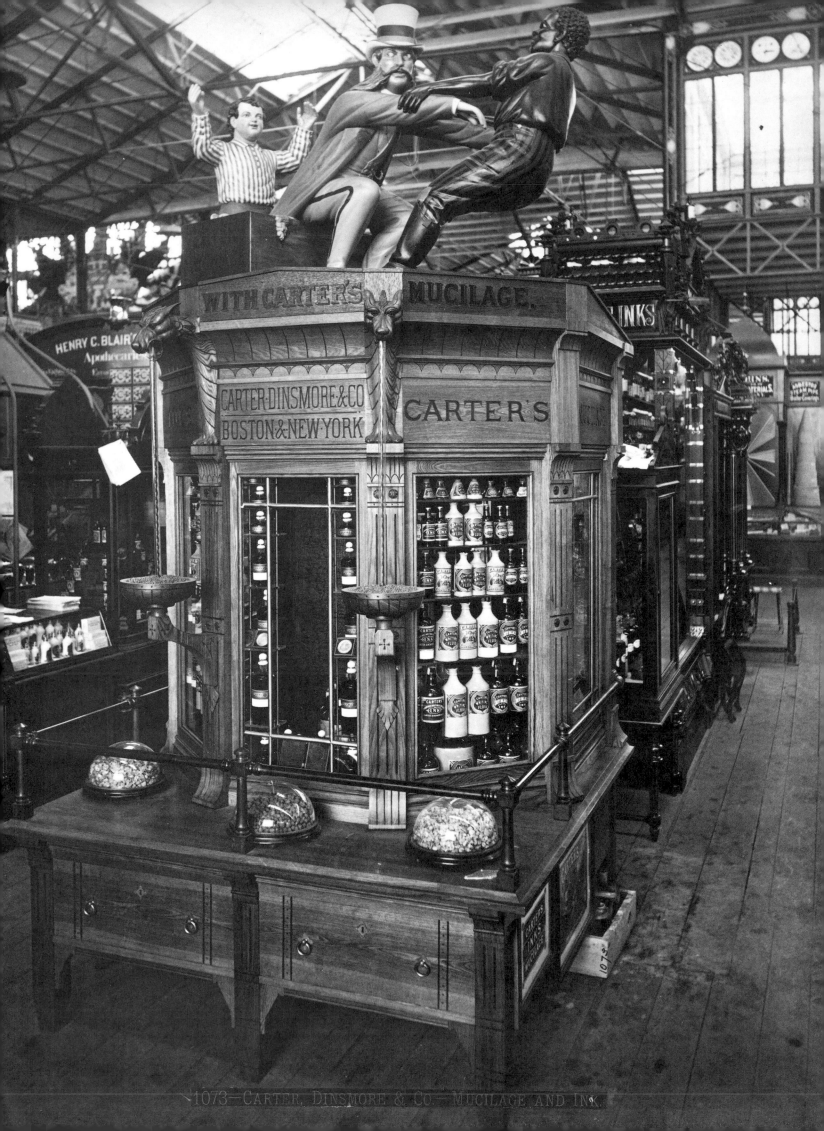

WITH CARTER'S MUCILAGE.

CARTER DINSMORE & CO
BOSTON & NEW YORK

CARTER'S

HENRY C. BLAIR
Apothecari

1073—Carter, Dinsmore & Co.—Mucilage and Ink.

Opposite: 194. CARTER, DINS-
MORE AND COMPANY'S EX
HIBIT. While many manufac-
turers displayed their wares in
elaborate showcases, Carter, Dins-
more further adorned theirs with
a lifesize representation of their
trademark. *Right:* 195. H.
DOULTON AND COMPANY'S
POTTERY EXHIBIT. The im-
pressive canopy of the English
potter's display was supported by
columns made of the company's
finest Lambeth faience.

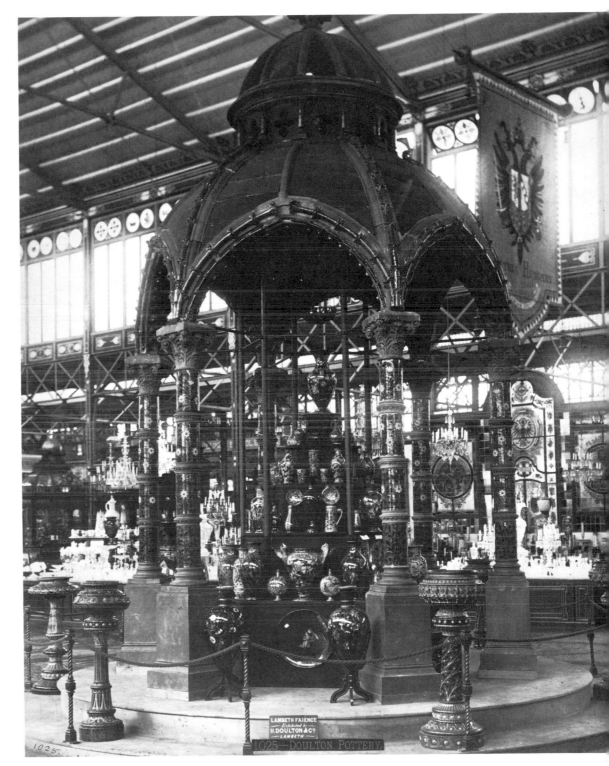

203

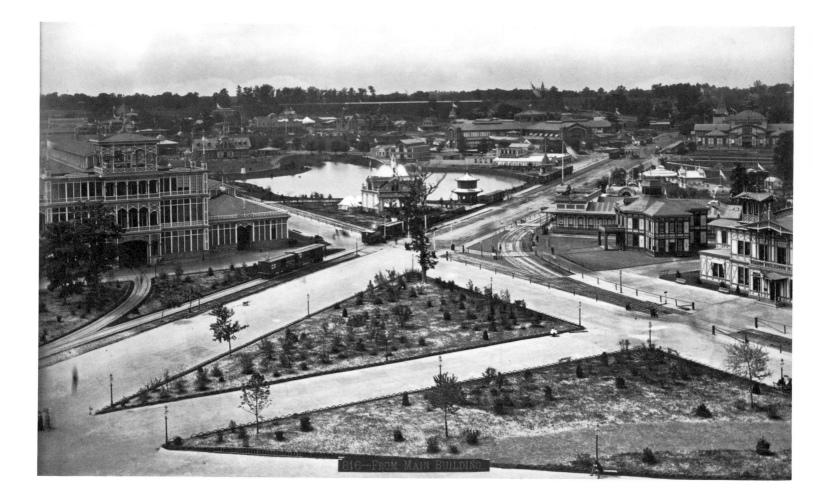

816—FROM MAIN BUILDING

Above: 196. VIEW FROM THE MAIN BUILDING. Toward the northwest from the main exhibition hall one can see Judges' Hall in the foreground at the extreme right, a railroad building, and the Photographic Company's studio, where the official photographic views of the Exposition were for sale. Machinery Hall is at the left, and at the intersection of Belmont Avenue and the Avenue of the Republic is the International Tourists Building. Near it to the right is the little pavilion erected by *Frank Leslie's*

Weekly. The Temperance Drinking Fountain is visible on Belmont Avenue to the right of the Tourists Building. *Opposite:* 197. AVENUE OF THE REPUBLIC, FROM MACHINERY HALL. One of the principal thoroughfares on the Centennial grounds, the Avenue of the Republic (as it was labeled on various maps) was the approximate east-west axis of the grounds. There was an observation point at either end: a steel tower at the eastern end and George's Hill observatory at the western extremity.

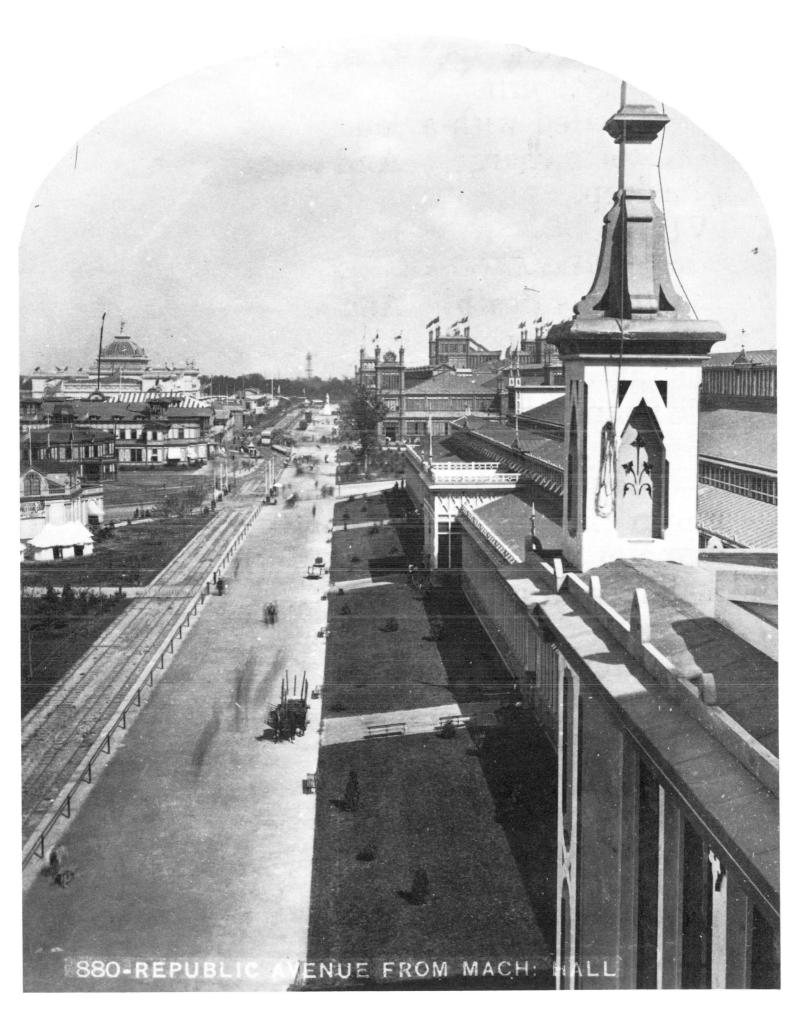

880-REPUBLIC AVENUE FROM MACH: HALL

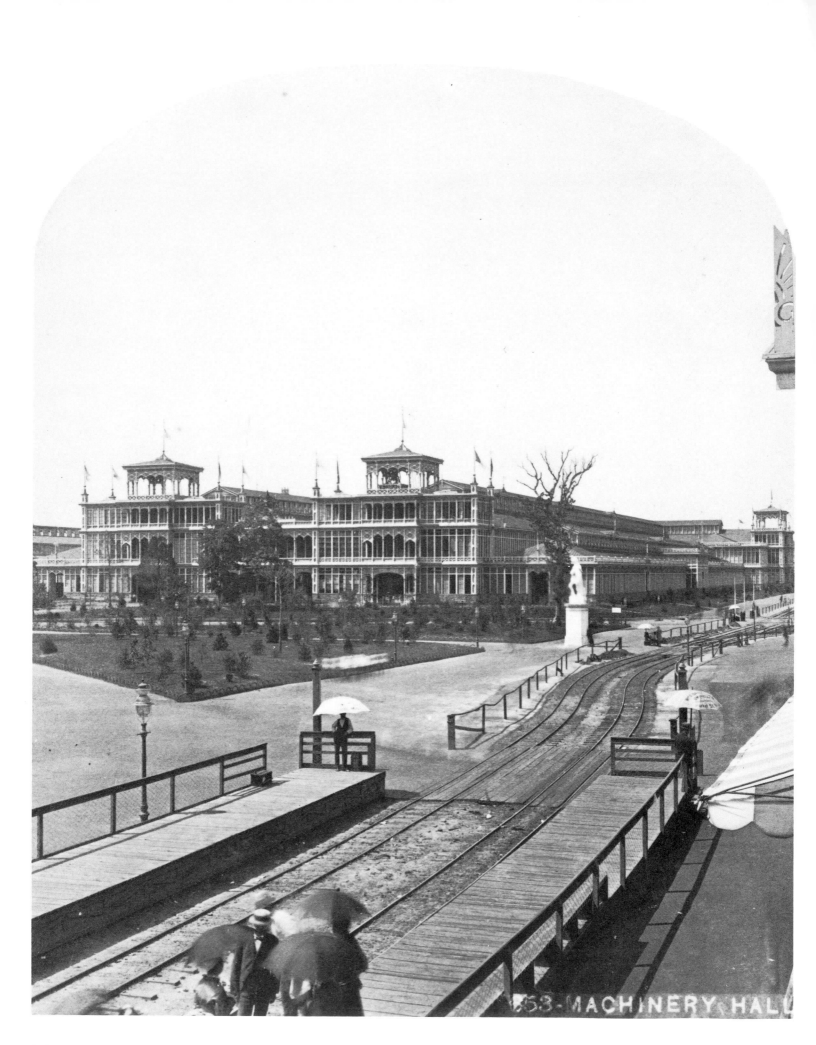

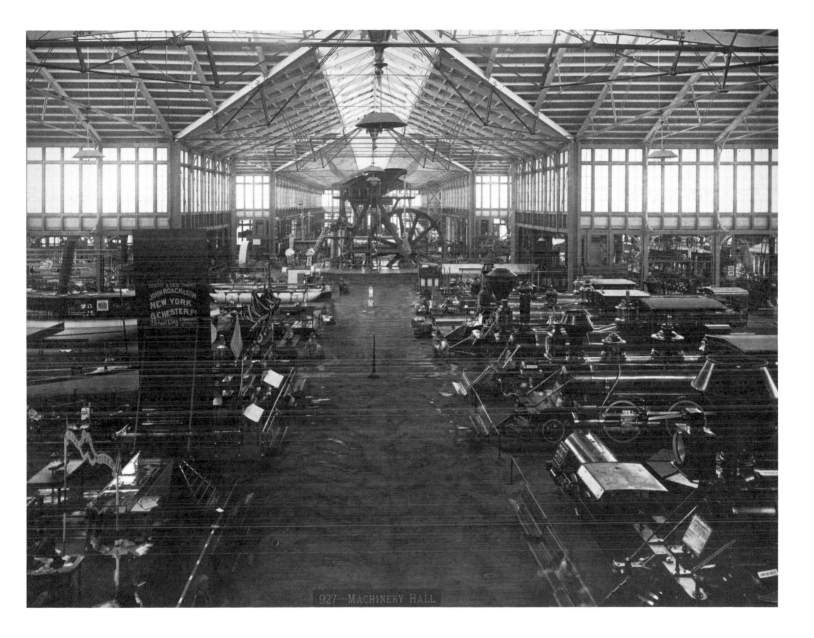

927 MACHINERY HALL

Opposite: 198. MACHINERY HALL. Machinery Hall was the second largest building of the Exposition, measuring 1402 feet from end to end. Like the Main Building, it was designed by Wilson and Petit. It was here that the great Corliss engine was located. *Above:* 199. MACHINERY HALL, INTERIOR. This dramatic view in Machinery Hall shows the great Corliss engine, located in the center of the building.

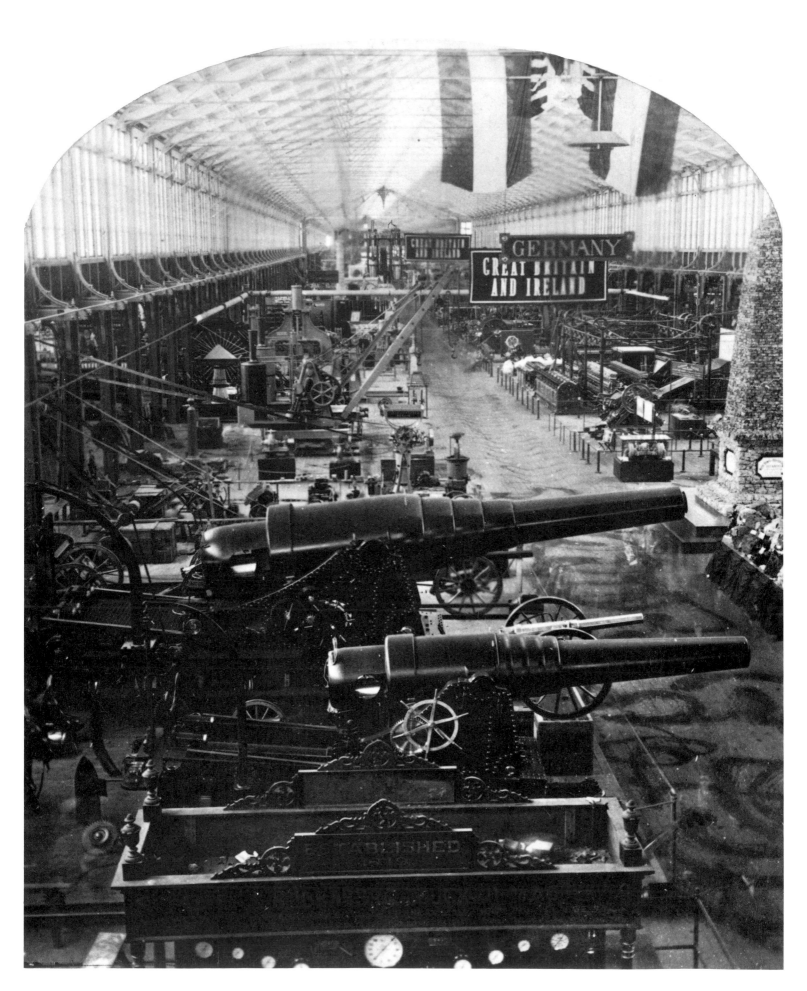

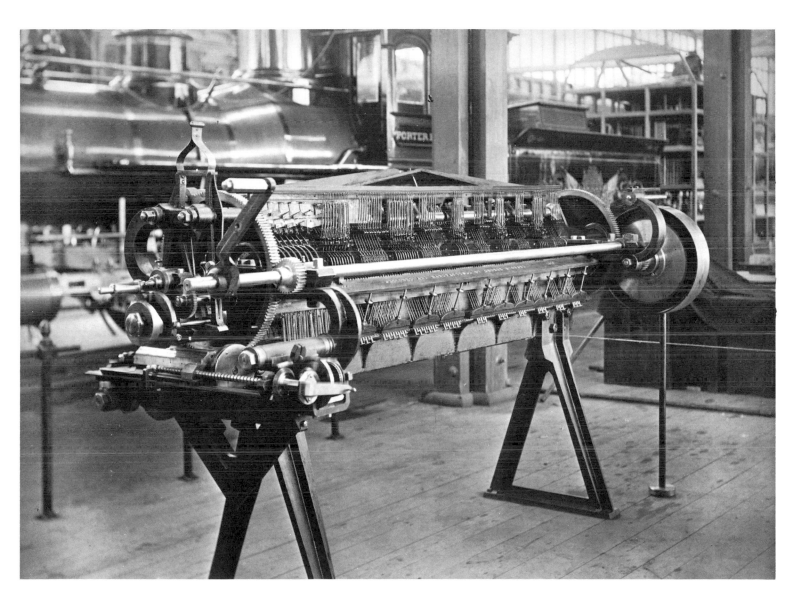

Opposite: 200. KRUPP'S GUNS, GERMAN EXHIBIT. Krupp's guns were among the marvels of Germany's displays. They were not, however, any more sinister than the heavy cannon mounted outside the United States Government Building, which seemed to invite a comparison of military strength. *Above:* 201. GRANT'S CALCULATING MACHINE. This device, exhibited in Machinery Hall, was evidently a forerunner of today's computers.

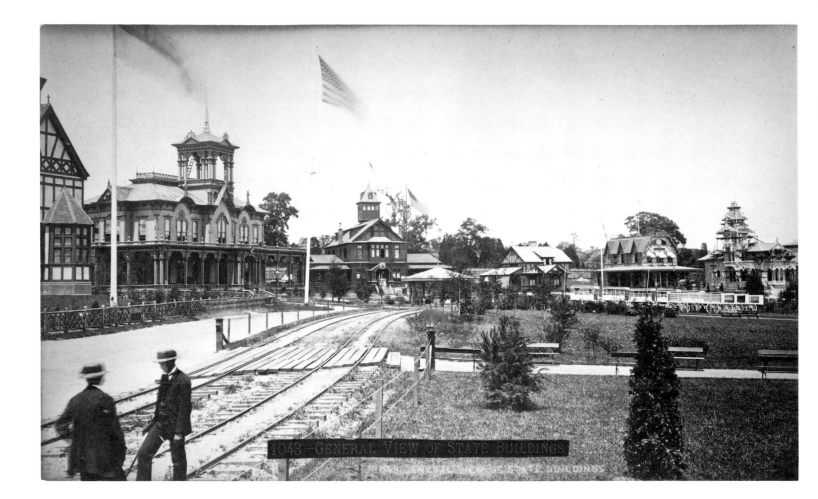

202. GENERAL VIEW OF STATE BUILDINGS

Above: 202. GENERAL VIEW OF STATE BUILDINGS. The state buildings seen here are, from the right, those of Michigan, New Hampshire, Connecticut, Massachusetts and New York. There were 24 separate state buildings in all at the Exposition. At the extreme left is one of the three British Government Buildings. The low round building in the center near the Massachusetts Building is a public comfort station. *Opposite:* 203. STATE BUILDINGS ON NEW HAMPSHIRE DAY. During the course of the Exposition, days were appointed for honoring the various states. This view shows crowds gathered at the New Hampshire Building on New Hampshire Day, Thursday, October 12.

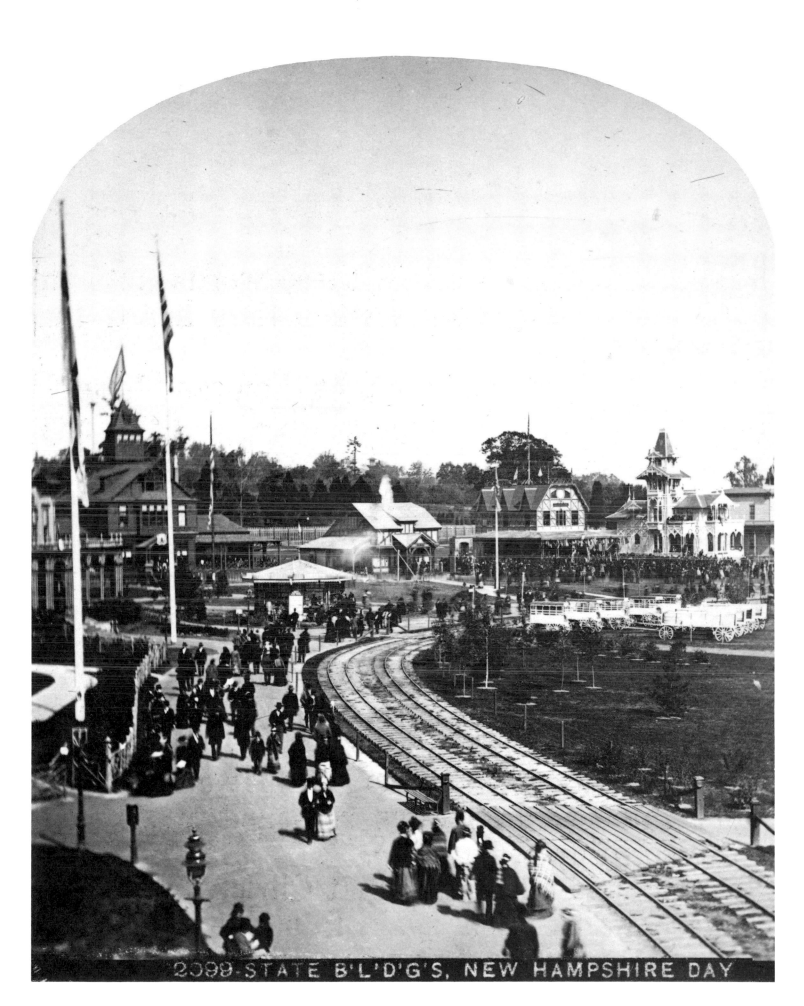

2098-STATE B'L'D'G'S, NEW HAMPSHIRE DAY

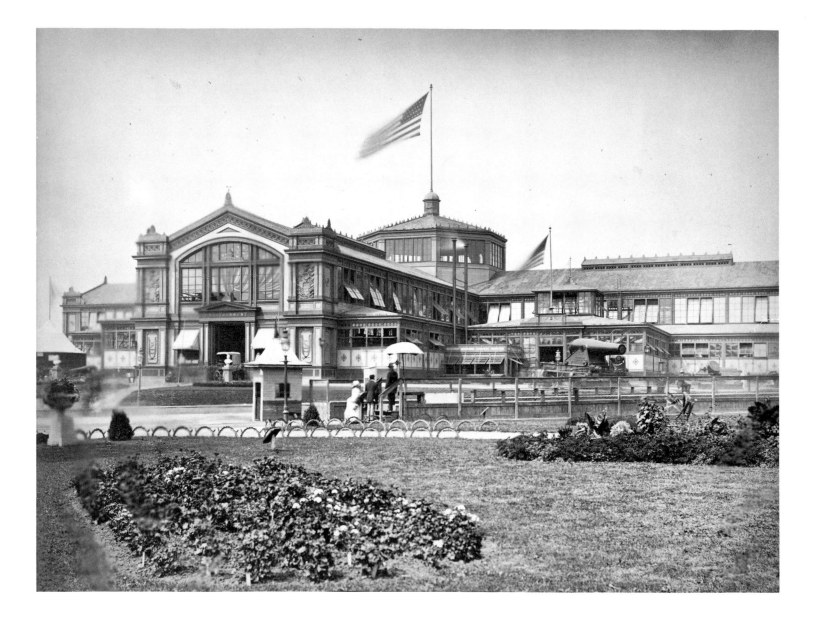

Above: 204. UNITED STATES GOVERNMENT BUILDING. The United States Government pavilion housed displays concerning the government departments, and the natural resources, manufactures and native customs of the entire country. Visitors in the foreground in this photograph await transportation by railway to other parts of the grounds. *Opposite:* 205. HORTICULTURAL HALL. Horticultural Hall, designed by Herman Schwarzmann, was a gigantic solarium containing plants from all parts of the world. It was a structure of iron, glass and colored brick, in many ways reminiscent of its predecessor, London's Crystal Palace of 1851 (which had been imitated in New York in 1853), and equally spectacular in the sheer fantasy of its color, light, vistas and ornamental details, and the richness of its displays. It remained standing until 1955, when it had to be demolished after it was damaged beyond repair in a hurricane.

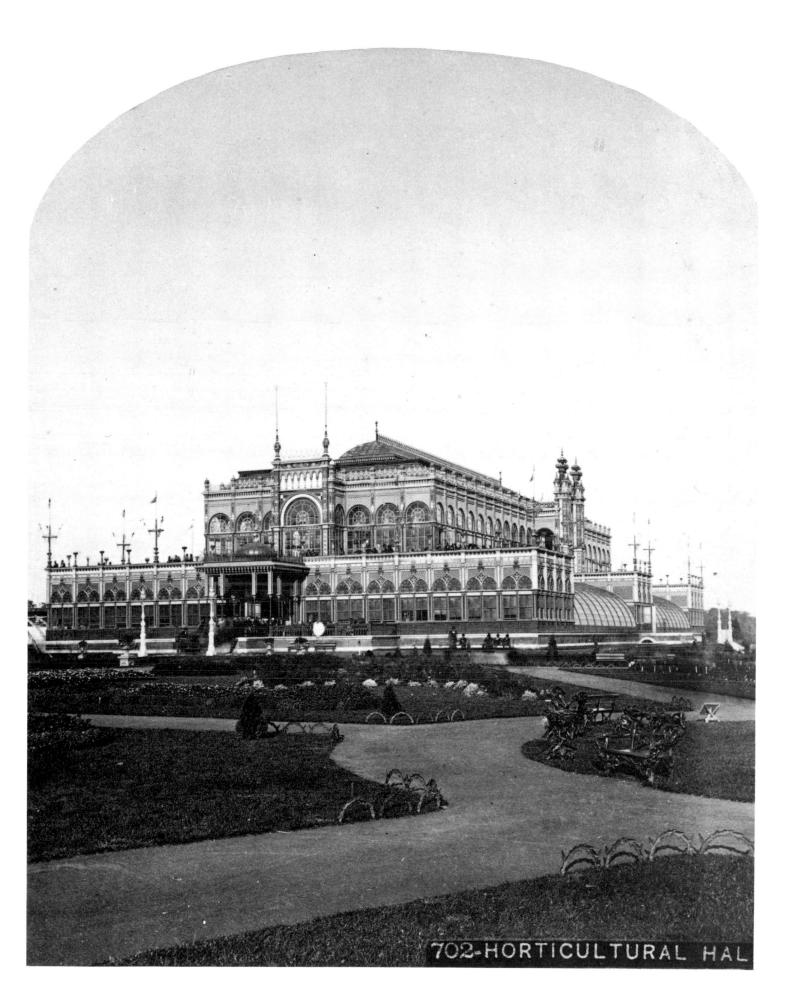

702-HORTICULTURAL HAL

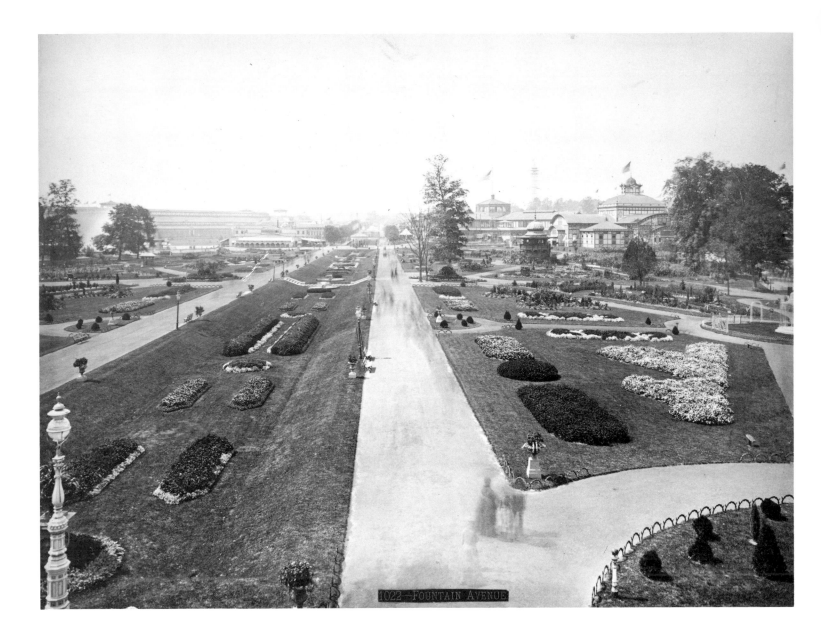

Above: 206. FOUNTAIN AVENUE. Fountain Avenue, with its sunken garden and formal arrangements of plants, was an extension of the exhibits in Horticultural Hall. *Opposite:* 207. ARM AND HAND OF THE STATUE OF LIBERTY. The arm and hand of Bartholdi's *Liberty Enlightening the World* were all that had been completed of the colossal sculpture in 1876, and figured prominently as a popular attraction. Literature available at the kiosk at the base informed visitors of the details of Bartholdi's plan and invited subscriptions of ten cents to one hundred dollars toward payment for a pedestal for the completed statue. After the Exposition closed the sculpture was transported to New York, where it was exhibited in Madison Square.

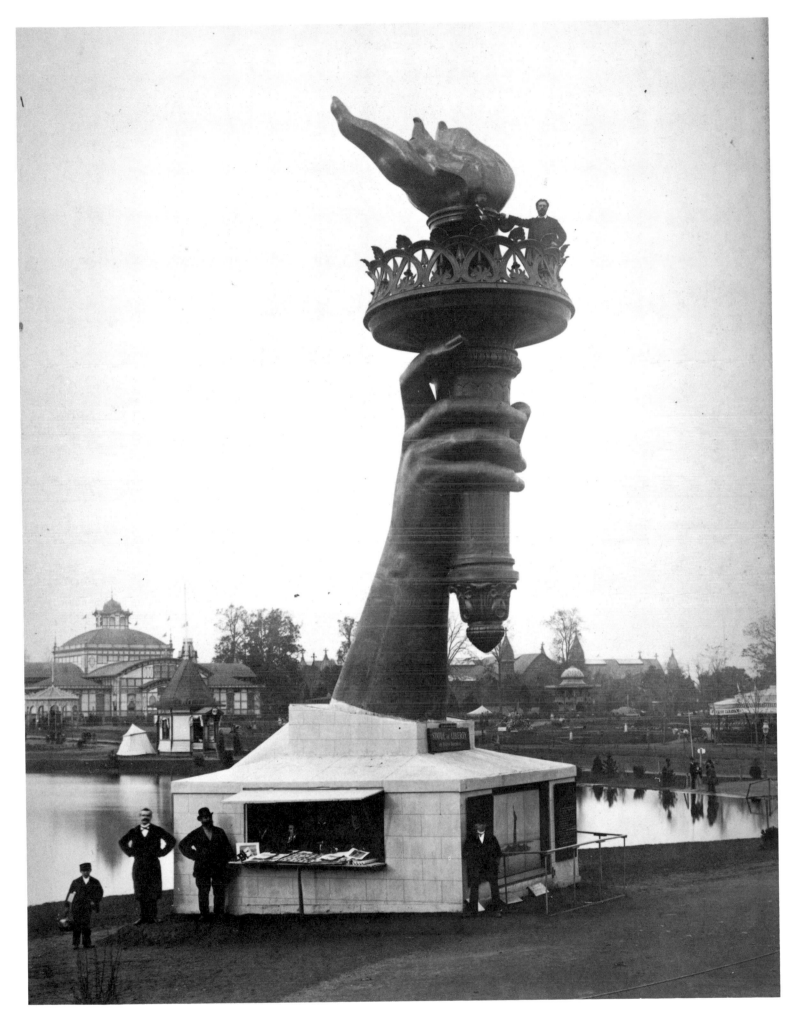

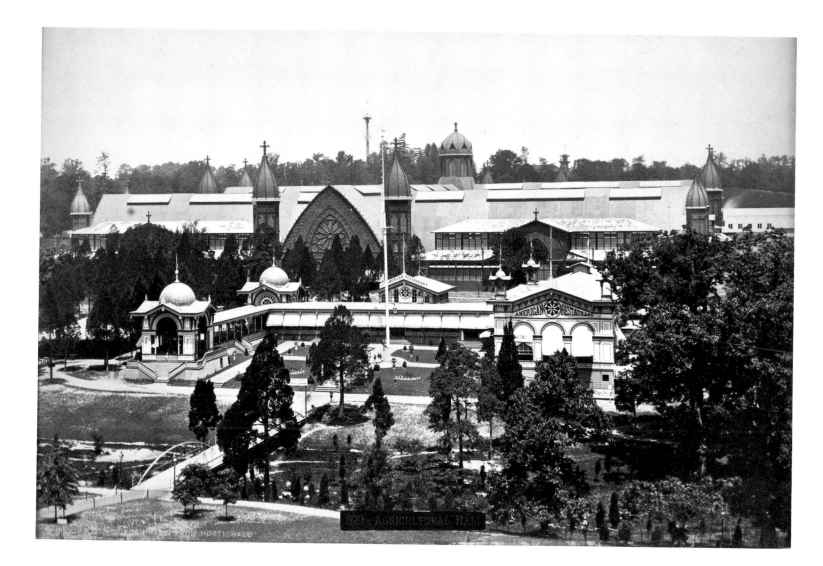

Above: 208. AGRICULTURAL HALL. Agricultural Hall, with its Gothic turrets and arches, was a giant structure of wood and glass housing international exhibits relating to all aspects of agriculture, including the world's largest potato. It was built by Philadelphia architect James H. Windrim. The American Restaurant is in the foreground. *Opposite:* 209. AGRICULTURAL HALL, INTERIOR. This view shows Windrim's wooden "girders" of Gothic design. Painted a light color, they reflected the sunlight pouring in through the skylights, giving the whole interior of this "nave" a bright airy appearance in contrast to the austere quality of the exterior of the building. Among the displays are those of three food firms still well known in the twentieth century: Crosse & Blackwell, Lea & Perrins and J. S. Fry.

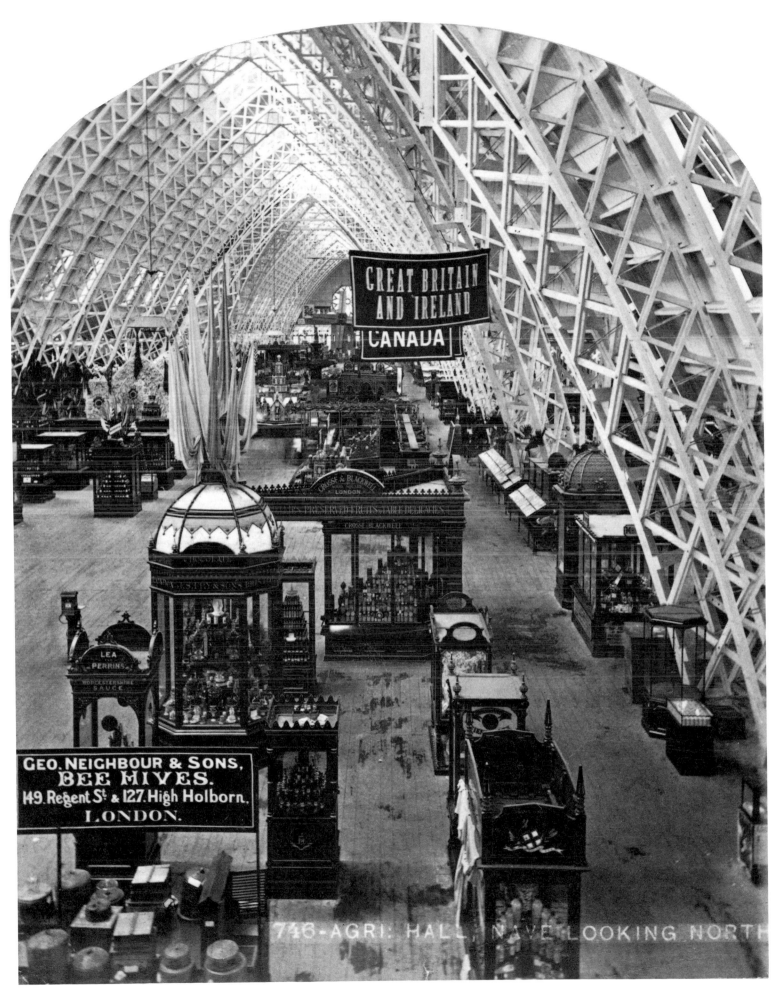

GEO. NEIGHBOUR & SONS,
BEE HIVES.
149. Regent St. & 127. High Holborn,
LONDON.

746-AGRI: HALL, NAVE LOOKING NORTH

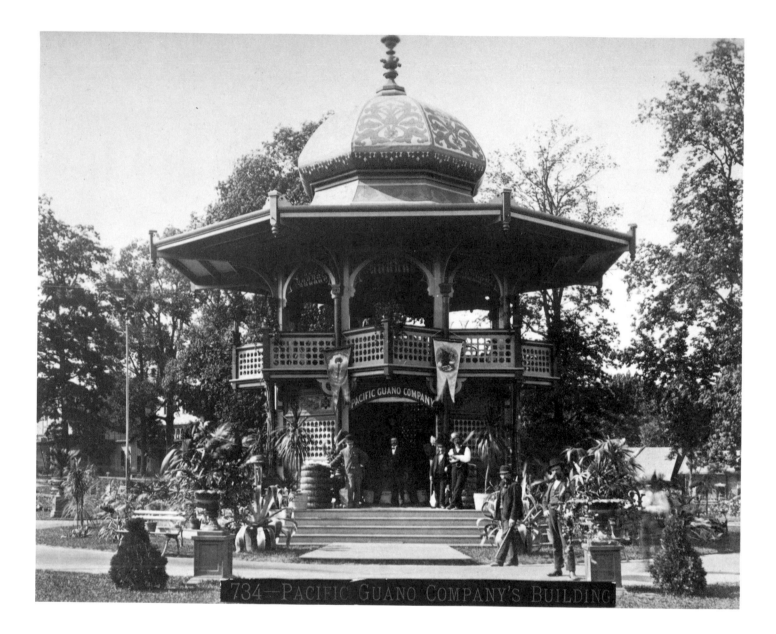

210. PACIFIC GUANO COMPANY'S BUILDING. This airy curiosity
erected by the famous fertilizer company was typical of the little pavilions
in high Victorian style scattered throughout the Exposition grounds.

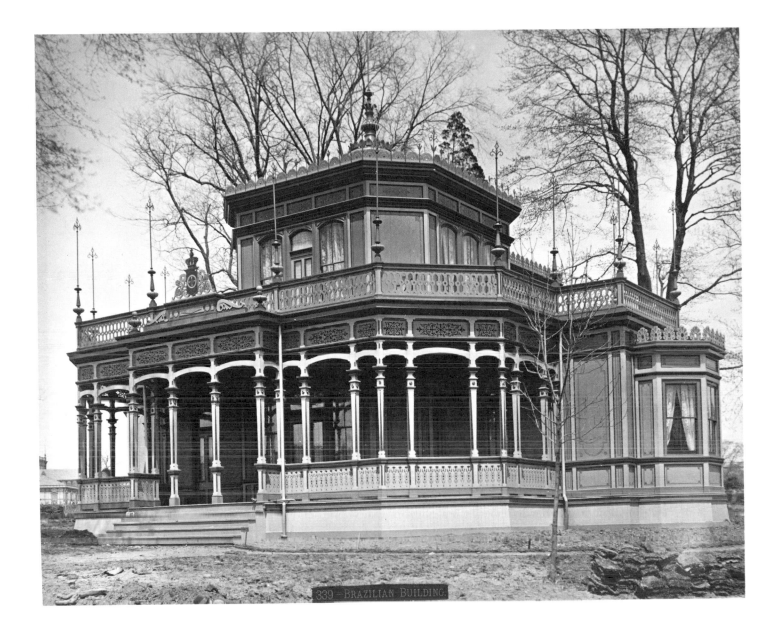

211. BRAZILIAN BUILDING. This was yet another example of lacy Victorian architecture. It was the headquarters for the Brazilian commission as well as an exhibition hall.

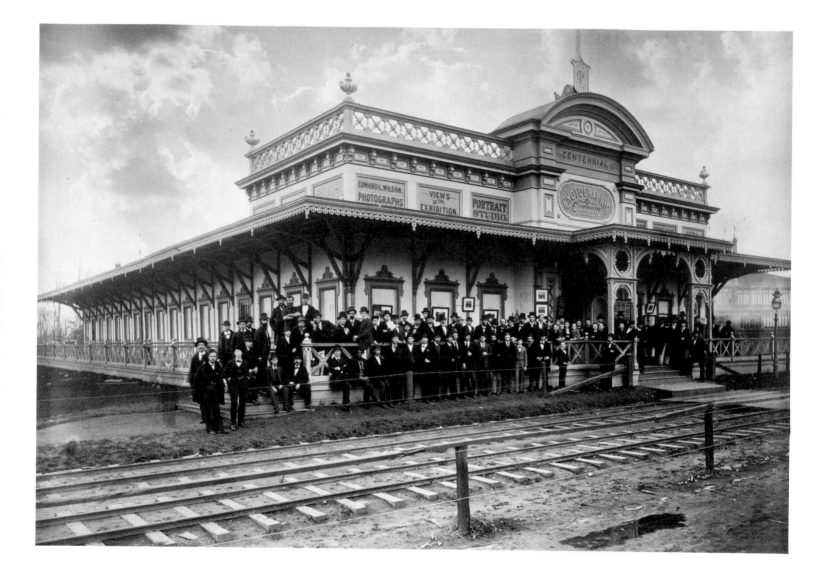

212. CENTENNIAL PHOTOGRAPHIC COMPANY. The official photographers of the Exposition are shown here before their studio and exhibition hall. Edward L. Wilson, whose name appears prominently on the building, was the editor of the *Philadelphia Photographer*, the outstanding American photography magazine of its time.

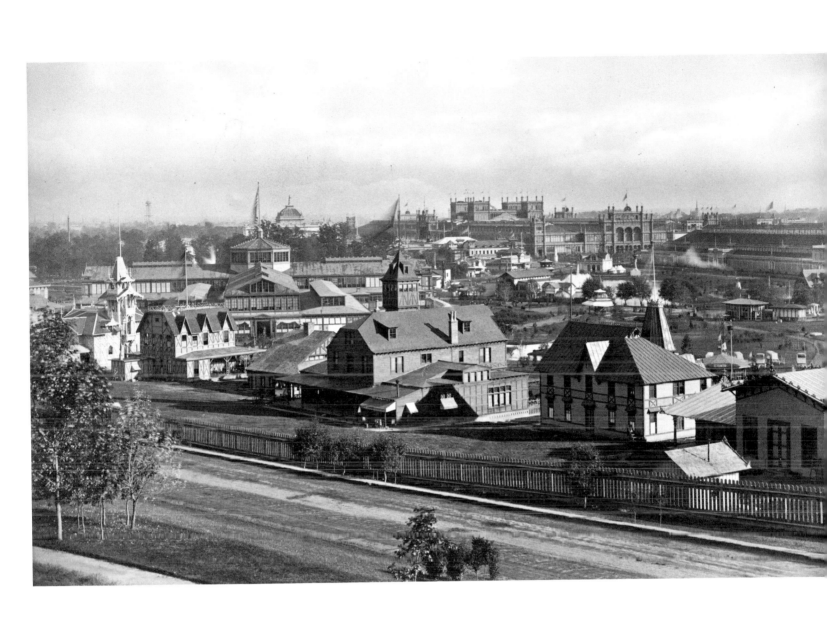

213. VIEW FROM THE RESERVOIR. The reservoir extended along the northwest boundary of the Exposition grounds. This view shows state buildings in the foreground (from the left: Michigan, New Hampshire, Connecticut, Massachusetts, Delaware and Maryland) and Machinery Hall, the Main Building and the Art Gallery in the distance.

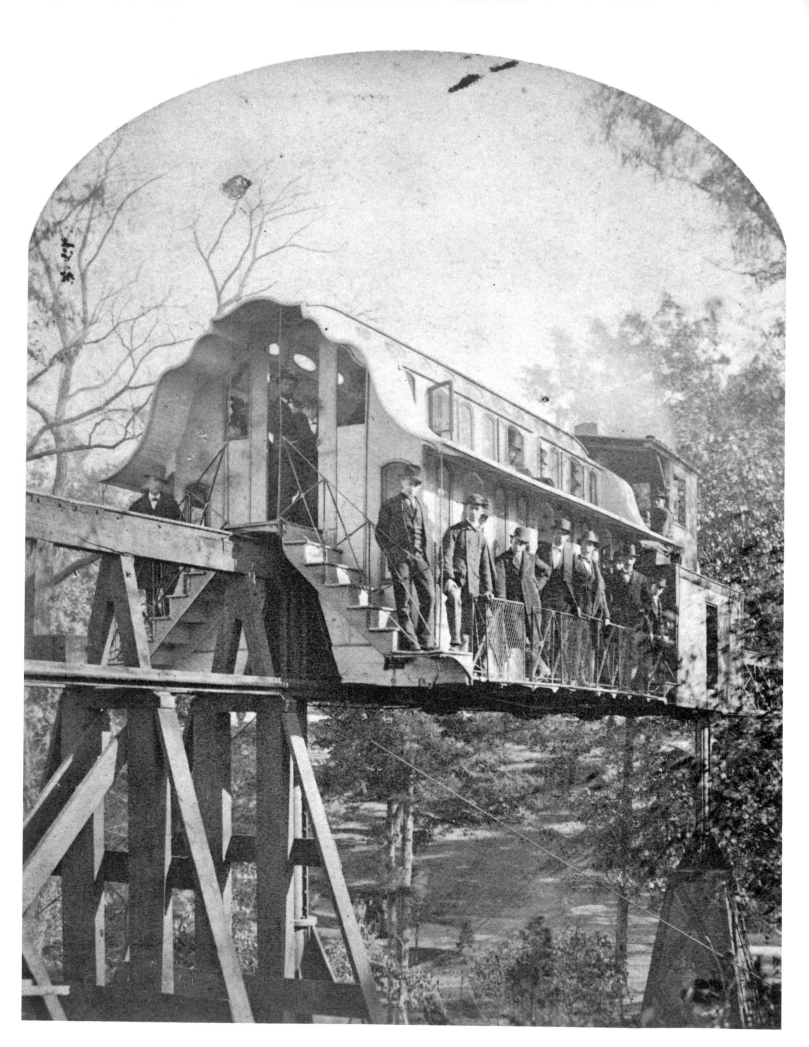

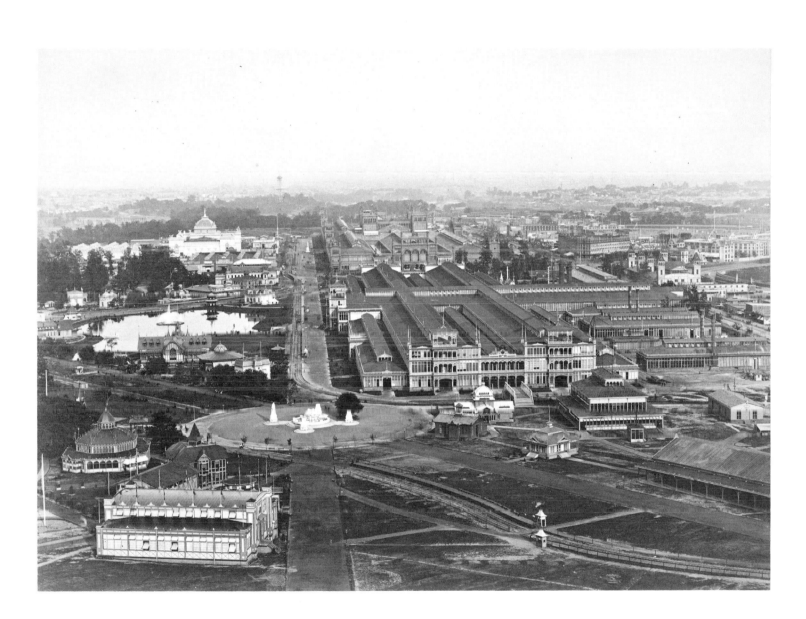

Opposite: 214. PRISMOIDAL RAILWAY. The elevated railway was one of the earliest monorails in America, if not the first. It crossed Belmont Ravine on the northwest side of the fairgrounds to Lauber's Restaurant, much patronized by visitors to the Exposition. It was manufactured in Phoenixville, Pa., where it was first set up. At the Centennial it was administered by the West End Railroad system. *Above:* 215. EXPOSITION FROM THE OBSERVATORY. George's Hill, from which this view was taken, has long been famous as a point from which to view the city. This view of the Exposition is toward the east along the Avenue of the Republic, dominated by the Catholic Total Abstinence Fountain. In the foreground, left, is the Spanish Government Building and just behind it the West Virginia Building and the octagonal Arkansas Building. In the right foreground are the tracks of the narrow-gauge railway by which visitors could be carried to all parts of the grounds. Machinery Hall is in the center and behind it the Main Building. At the far right, beside the Main Building, is the Occidental Centennial Hotel for guests who wished to stay on the grounds. *Photo by James Cremer.*

General Index

This index lists persons (including photographers), businesses, buildings, constructions, monuments, statues, squares and parks mentioned in the captions to the illustrations. The numbers used are those of the illustrations. Streets, rivers and other sites are not included.

Academy of the Fine Arts, 132, 133
Academy of Music, 173, 174, 180
Academy of the Natural Sciences, 164
Adams Express Company, 166
Agricultural Hall, Centennial Exposition, 190, 208, 209
American Philosophical Society, 62
American Restaurant, Centennial Exposition, 208
Anthracite Building, 27
Arcade Building, 159
Arch Street Methodist Church, 152
Arch Street Presbyterian Church, 110
Arch Street Theatre, 103, 104
Arkansas Building, Centennial Exposition, 215
Art Gallery, Centennial Exposition, 189, 190, 191, 213
Association of Philadelphians for the Advancement of Horticultural Interests, 174

Baltimore and Ohio Railroad Station, 184, 185
Bankers' Row, 119
Barrymore, Ethel, 103
Barrymore, John, 103
Barrymore, Lionel, 103
Bartholdi, Frédéric-Auguste, 207
Barton, J. Rhea, 178
Bartram (John) Hotel, 175
Beck, Paul, 34
Bellevue Hotel, 170, 172, 180
Bell Tavern, 79
Bennett, Col. Joseph M., 73
Bethel Baptist Church, 11, 12
Biddle, Nicholas, 118
"Big Red House," 178
Bijou-Dream Theatre, 90
Bingham, William, 41

Black Bear Inn, 72
Blackwell, Rev. Robert, 41
Blue Anchor Inn, 18
Boathouse Row, 182
Bond, Dr. Thomas, 150
Bourse, 72
Boylen, James, 79
Bradenburgh's Museum, 105
Brazilian Building, Centennial Exposition, 211
British Government Buildings, Centennial Exposition, 202
Broad Street Station, 94, 153, 159, 160, 162
Broad Street Theatre, 175, 176, 177
Browne, J. C., 188
Brown's Book Store, 96, 97
Butler, Pierce, 127

Caldwell's store, 77, 138
Call building, 76
Calvary Presbyterian Church, 173
Carpenters' Hall, 62, 63, 64
Carter, Dinsmore and Company's Exhibit, Centennial Exposition, 194
Cathedral of Sts. Peter and Paul, 111
Catholic Total Abstinence Fountain, Centennial Exposition, 215
Centennial Exposition grounds, 182, 189–215
Centennial Photographic Company, Centennial Exposition, 196, 212
Central High School for Boys, 1, 151
Chambers' Church, 157, 169
Chestnut Street Bridge, 183, 184, 185
Chestnut Street Opera House, 132
Chestnut Street Theatre, 2, 125, 136, 173
Childs, George W., 97
"Chinese Wall," 94, 110, 158, 159

Christ Church, 4, 45
Christina, Queen, 7
Christy's, 119
Citizens' Volunteer Hospital, 181
City Hall, 58, 92, 137, 138, 155, 156, 159, 160, 162, 169, 179
College Hall, 129
Collins and Autenrieth, 80
Community College, 135
Concert Hall, 136, 137
Congress Hall, 58
Connecticut Building, Centennial Exposition, 202, 213
Corliss engine, 198, 199
Cornelius, Robert, 78
County Court House, 59
Court of Honor, Peace Jubilee, 179
Cremer, James, 156, 182, 215
Currey, William, 115
Curtis Publishing Company, 143
Customs House: *see* Second Bank of the United States

Darley, Francis T. Sully, 178
Decatur, Stephen, 45
Declaration House, 75
Delaware Avenue Bridge, 33
Delaware Building, Centennial Exposition, 213
Deschamps, W. G., 35
Donnelly's Hotel, 53
Doulton and Company's Pottery Exhibit, Centennial Exposition, 195
Downing's Cheap Store, 53
Drew, John, 103
Drew, Louisa, 103
Drinker, Edward, 140
Dundas-Lippincott Mansion, 168, 169

Edmunds, Franklin D., 42, 163
Elfreth, Jeremiah, 35

Ellet, Charles, 186
Espen's store, 81, 82
Evening Bulletin building, 161

Fairmount Fire Company: *see* Old
 Fairmount Engine House
Fairmount Water Works, 182,
 186, 187
Farmer's Market house, 88
Fidelity Bank, 168
First Bank of the United States: *see*
 Girard's Bank
First Baptist Church, 164
First Independent Presbyterian
 Church: *see* Chambers' Church
First Presbyterian Church, 52, 57
Fitch, John, 185
Fitzgerald's grocery shop, 38
Frank Leslie's Weekly pavilion, Cen-
 tennial Exposition, 196
Franklin, Benjamin, 19, 62, 63, 150;
 statue, 123
Franklin Building, 65
Free Library of Philadelphia, 65, 136,
 137
Freeman's Auction House, 141
Friends' Meeting House, 96
Fox's New American Theatre, 132, 133
Fulton, Robert, 140
Furness, Frank, 119, 121, 184, 185, 193

Garitee and Son, 73
George's Hill, 197, 215
German Exhibit, Centennial Exposi-
 tion, 200
German Lutheran School and Parish
 House, 101
German Society, 101
Gimbel Brothers, 84
Girard, Stephen, 24, 135, 188
Girard Bank, 163, 167
Girard College, Main Building, 188
Girard Life Insurance, Annuity and
 Trust Company, 169
Girard Row, 135
Girard's Bank, 24, 118
Girard Square, 135
Gloria Dei Church: *see* Old Swedes'
 Church
Graff, Frederick, 75
Graff, Joseph, 75
Grand Depot, 92, 93
Grant, Ulysses S. (and Mrs.), 189
Great Ale Vaults, 28
Guarantee Trust and Safe Deposit
 Company, 119

Hanscom's Restaurant, 137
Harrison mansion, 147-149
Harrison Row, 149
Head House: *see* Market House
Henderson's Cheap Book Store, 97
Herkness Bazaar, 145
Hill, Henry, 55
Hill Meeting, 40
Holme, Thomas, 111
Holy Trinity Church, 146
Hopkinson House apartment
 building, 57
Horticultural Hall, 174, 180
Horticultural Hall, Centennial
 Exposition, 190, 205, 206
Hotel Stenton, 175, 177
Hotel Vendig, 89, 90

Hotel Walton, 175, 177
Houston, William C., 52
Howard, Eaton, 16
Howard's (George) Hotel, 16
Hoyt, Charles, 136
Hunt, Wilkinson and Company, 161
Hurrie, William, 52
Hurst Mansion, 56

Independence Hall, 61, 119, 124, 126
Independence Mall, 3
Independence National Historic Park,
 23, 62, 63, 118
Independence Square, 59, 65, 142, 143
International Tourists Building,
 Centennial Exposition, 196
Item building, 76

Jackson, Andrew, 118
Jefferson, Thomas, 75
Jefferson Medical College, 131
Jefferson University, 131
Jennings, W. N., 69, 172
Johnson, John Grover, 178
Judges' Hall, Centennial
 Exposition, 196

Key, John, 140
Kiralfy's Alhambra Palace, 176
Krider, John, 140

LaFayette Hotel, 166
Land Title Building, 180
Langenheim, Frederick, 2-5, 71,
 72, 79, 141
Langenheim, William, 2-5, 71, 72,
 79, 141
La Pierre House, 164, 165, 166
LaSalle College, 155
Lauber's Restaurant, Centennial
 Exposition, 214
Leary's Book Store, 84
Lebrun, Napoleon, 111, 131
Lehigh Valley Railroad building, 47
Lemon Hill observatory, 182
Levin, S. H. & H., 36
Liberty Enlightening the World, 207
Library Company, 62, 63, 65
Library Hall, 62
Lincoln, Abraham, 61, 135
Lippincott, Mrs. Joshua, 168
Lit Brothers Department Store, 80, 81
Locker's Restaurant, 107
Logan Square, 110, 111
London Coffee House, 30
Louis-Philippe, Duc d'Orléans, 51

Machinery Hall, Centennial Exposi-
 tion, 190, 196-199, 201, 213,
 215
Main Building, Centennial Exposition,
 189-193, 196, 198, 213, 215
Market House, 42
Market Street Bridge, 185
Market Street subway, 70, 90
Market Terminus, 67
Maryland Building, Centennial
 Exposition, 213
Mason, William S., 113, 116
Masonic Temple, 138, 152, 155,
 161, 162
Massachusetts Building, Centennial
 Exposition, 202, 213
McAllister, John, 103, 115, 116

McClees and Germon, 157
McKinley, William, 179
McMullin, Samuel, 152
McNally, John J., 136
Melodeon, 125
Mercantile Library, 65, 66
Merchants' Exchange, 23, 24, 62
Michigan Building, Centennial
 Exposition, 202, 213
Mitchell, J. Kearsley, 148
Montpensier, Duc de, 51
Morrell, Col. Edward, 171
Municipal Services Building, 161

National Bank of the Republic, 119
National Park Service Regional
 Office, 23
National Union Club headquarters,
 135
Navy Yard, 11, 12, 37
Naylor's Hotel, 20
Neal, William, 36
New Circus, 144
Newell, R., 60, 109, 120, 150
New Hampshire Building, Centennial
 Exposition, 202, 203, 213
Newkirk, Matthew, 106
New National Theater, 108
North American Building, 157
Notman, John, 111, 149

O'Bryan and Rose, 102
Occidental Centennial Hotel, Centen-
 nial Exposition, 215
Old Fairmount Engine House, 109
Old Swedes' Church, 11, 12, 17
Orange Street Meeting, 40

Pacific Guano Company's Building,
 Centennial Exposition, 210
Peale, Charles Wilson, 45
Pedro II, Emperor, 189
Penn, Letitia, 30
Penn, Richard, 45, 52
Penn, Thomas, 45, 52
Penn, William, 18, 25, 140
Penn Athletic Club, 148
Penn Center, 94, 154
Pennell, Joseph, 175
Penn Square Presbyterian Church, 156
Pennsylvania Central ticket office, 130
Pennsylvania Hospital, 150
Pennsylvania Railroad
 buildings, 47, 151
 ferries terminus, 69
 freight depot, 93, 156
 station, 158
 ticket office, 167
Pennsylvania State Arsenal, 1, 151
Pennsylvania State Bank, 118
Pepper, David, 71
Petit, Henry, 191, 198
Philadelphia Arcade, 2
Philadelphia Bank, 117, 120, 121
Philadelphia Circus, 108
Philadelphia Contributionship for the
 Insurance of Houses from Loss
 by Fire, 19
Philadelphia Dispensary, 65, 66
Philadelphia Library, 5
Philadelphia Museum of Art, 186
Philadelphia Stock Exchange, 23
Philadelphia Trust, Safe Deposit and
 Insurance Company, 121

Photographic Society of Philadelphia, 188
Physick Residence, 55
Pine Street Presbyterian Church, 52
Plough Tavern, 41, 44
Powel, Samuel, 40, 48
Provident Life and Trust Company, 121
Public Ledger building, 27, 122, 123, 126, 143

Race Street Wharf, 36
Rau, William H., 89
Reading Railroad Terminal, 88, 89
Real Estate Trust Building, 139
Reed, Charles, 30
Reyburn Plaza, 161
Richards and Betts, 17
Ridgway House, 32
Rittenhouse, David, 77
Rittenhouse, Claridge Apartment Building, 147
Rogers Brothers (Gus and Max), 136
Russell, Lillian, 175

St. Clement's Church, 112
St. George's Hall, 106
St. Mark's Church, 149
St. Peter's Church, 41, 45
Saturday Evening Post building, 24
Saxton, Joseph, 1, 51
Schwarzmann, Herman J., 190
Seckel, Frederick, 71

Second Bank of the United States, 5, 24, 62, 117, 118
2nd Street market shed, 44
Shakspeare Bowling Saloon, 125
Shaw, Thomas, 109
Signal Corps Building, 148
Smith, Robert, 71
Society Hill Synagogue, 46
Society of the Sons of St. George, 106
Spanish Government Building, Centennial Exposition, 215
Sparks' shot tower, 10, 11-14
Spring Garden Street Bridge, 182
Spruce Street Baptist Church, 46
Stamper, John, 41
Standpipe, 186
State House, 2-5, 58, 59, 60-62, 123
Steel, Robert, 139
Stratford Hotel, 170-172, 180
Strawbridge and Clothier, 83
Strickland, William, 23, 117
Sully, Thomas, 178

Temperance Drinking Fountain, Centennial Exposition, 196
Terminal Market, 88
Theresa, Empress, 189
Third National Bank, 160
Thornton, Edward, 28
Tower Hall, 73, 74
Trailways Bus Terminal, 106

Ulrich, G. and A., 30

Union League, 134, 164, 165
United States Government Building, Centennial Exposition, 200, 204
United States Mint, 77, 138, 156
United States Post Office, 85-87, 114, 129, 183
University of Pennsylvania, 85, 129

Walnut Street Theatre, 144, 145
Walter, Thomas U., 46, 106, 188
Wanamaker, John, 73, 74, 91-93, 151
Washington, George, 77, 100
Weightman Mansion, 146, 147
Wells Fargo and Company, 117
West End Trust Building, 163
Western Market, 94, 95
West Virginia Building, Centennial Exposition, 215
Wheatley, William, 136
Widener Building, 138
Willing, Thomas, 41
Wilson, Alexander, 17
Wilson, Edward L., 212
Wilson, Joseph, 191, 198
Windemere Hotel, 175, 180
Windrim, James H., 208, 209
Wistar house, 51, 55

"Yellow" Mansion: *see* Dundas-Lippincott Mansion

Zion Lutheran Church, 100, 101

Chronological Index of Photographs

The numbers used are those of the illustrations.

1839: 1
1840/47: 102
1841/42: 39
1843: 113, 114, 116
1846: 78
1850: 2–5
1854: 17, 30, 96, 115, 131, 151
1855: 58, 63, 125, 127
1856: 6, 7, 36, 75, 82, 157
1857: 97
1859: 23, 24, 26, 40, 46, 51, 56, 67, 68, 71, 72, 79, 94, 95, 101, 117, 118, 124, 130, 141
1860: 18, 20, 41, 53, 81, 98, 99, 103
1861: 61, 77
1863: 134
1864: 25, 181
1865: 8, 55, 104, 112, 120, 122, 129, 135, 144, 146, 147, 164, 173

1866: 27, 148
1867: 62, 152
1868: 9, 16, 19, 28, 29, 37, 38, 50, 52, 54, 59, 100, 107, 153, 154, 155, 183
1869: 10, 132, 149, 165, 184, 188
1870: 11–14, 15, 45, 49, 57, 65, 123, 142, 187
1871: 47, 140
1873: 60, 156
1874: 21
1875: 186
1876: 150, 166, 182, 189–215
1880: 31, 88, 109, 174
1885: 44, 119, 133
1889: 43, 76, 92, 126, 158
1890: 22, 33, 85, 105, 108, 168
1894: 32, 91, 169

1895: 106, 121, 171
1897: 139
1898: 73, 80, 83, 136, 175–177, 179, 180
1899: 84, 170
1900: 34, 42, 64, 69, 93, 185
1901: 138
1902: 66, 74, 111, 128, 143, 161, 167, 172
1903: 48, 160
1905: 163
1906: 70, 162
1907: 86, 87, 90, 159
1910: 35, 110, 137, 145
1912: 89
1913: 110
1914: 178